Impressionism

When Ford Motor Company was approached with the opportunity to sponsor *Impressionism: Selections from Five American Museums*, we responded with enthusiasm on more than one level. First, we were compelled by the depth and quality of the exhibition, which includes exemplary works by virtually every significant artist in the Impressionist movement—from Monet to Bonnard.

But our attraction to the exhibition went well beyond the works of art—to the people behind the exhibition. As a corporation where teamwork is a part of our lifeblood, we hold a strong identification with the goals and objectives of this effort, the pooling of human and financial resources, and the sharing of ideas. This exhibition salutes not only the cultural strengths of the five communities and their institutions, but also their visionary collectors, curators, and directors, both past and present. The results exceeded our expectations. Not only is this consortium of five distinguished museums unprecedented, it is also extraordinary. It is a model of successful teamwork, and it may well be an effort to be studied, copied, and repeated.

Ford's mission in supporting art and cultural activities is to expose more people to more opportunities and educational experiences and, by so doing, expand their horizons and contribute to their appreciation of the world around them. *Impressionism* will visit five communities of importance to Ford Motor Company, including four in which we have a strong manufacturing presence and are a major employer and economic contributor. Many of our employees, dealers, suppliers, and their families are among the nine million people in these five communities, and we hope that they, and their neighbors, will gain knowledge and inspiration from the unqualified excellence of this exhibition.

DONALD E. PETERSEN
Chairman and CEO
Ford Motor Company

THE CARNEGIE MUSEUM OF ART

THE MINNEAPOLIS INSTITUTE OF ARTS

THE NELSON-ATKINS MUSEUM OF ART

THE SAINT LOUIS ART MUSEUM

THE TOLEDO MUSEUM OF ART

Impressionism

SELECTIONS FROM FIVE AMERICAN MUSEUMS

MARC S. GERSTEIN

Introduction by Richard R. Brettell

GALAHAD BOOKS·NEW YORK

Copyright © 1989 The Saint Louis Art Museum

All rights reserved. No part of this work may be reproduced or transmitted in any form or by any means, electronic or mechanical, including photocopying, recording, or any information storage and retrieval system, without permision in writing from the publisher. All requests for permission should be directed to Hudson Hills Press, LLC 74-2 Union Street, Manchester, VT 05254.

First Galahad Books edition published in 1994.

Galahad Books
A division of BBS Publishing Corporation
450 Raritan Center Parkway
Edison, NJ 08837

Galahad Books is a registered trademark of BBS Publishing Corporation.

Published by arrangement with Hudson Hills Press, LLC

Distributed by Sterling Publishing Co., Inc.
387 Park Avenue South
New York, NY 10016

Distributed in Canada by Sterling Publishing Canadian Manda Group
One Atlantic Avenue, Suite 105
Toronto, Ontario, Canada M6K3E7

Distributed in Australia by Capricorn Link (Australia) Pty, Ltd.
PO Box 704
Windsor NSW 2756 Australia

Library of Congress Catalog Number: 89-30758
ISBN: 0-88365-871-2

Printed in China.

Published on the occasion of the exhibition *Impressionsim: Selections from Five American Museums*, organized jointly by The Carnegie Museum of Art, Pittsburgh; The Minneapolis Institute of Arts; The Nelson-Atkins Museum of Art, Kansas City; The Saint Louis Art Museum; and The Toledo Museum of Art.

The Exibition is supported by a grant from Ford Motor Company.
Edited by Mary Ann Steiner and Sandra E. Knudsen.

COVER DETAIL:
Camille Pissaro, 1830-1903
The Garden of Les Mathurins at Pontoise, 1876
Oil on Canvas
The Nelson-Atkins Museum of Art

Contents

Colorplates

Foreword

The present exhibition may be without precedent in the annals of American art museums. Never before have so many of our nation's eminent art museums joined together to exchange among themselves for temporary display so many works of importance and value. The commitment we have made to one another recognizes the strength of our collections, which reinforce one another remarkably well when shown collectively, and demonstrates our insistence on service of the highest quality to our communities.

These characteristics reflect an ethos that shaped our museums. It is not mere coincidence that the architecture of our original buildings is classicizing—mostly Beaux Arts—or that our collections are comprehensive and embrace all times, peoples, and places. In such elements we find the aspirations and values society has held for its public institutions. Our art museums were built to symbolize the identification of new cities and a new republic with an enduring tradition that stretches back to an ancient classical past. They heralded a coming of age, as well as a claim to status, of cities that only recently had been rough and tumble or burgeoning with America's industrial growth. Civic institutions would uplift the citizens who built them. Great art, made available to all, would edify the public generally and provide for its delectation, and so, in turn, speed the liberal progress of society and city alike.

Special exhibitions have become a key component in the way communities view and use their art museums. Unlike the permanent collections, the special exhibition is noteworthy primarily because it is ephemeral. In recent years, special exhibitions have grown ever larger and more expensive, the latter aspect abetted by an art market spiralling dizzily upward. This development has tended to exclude medium-size cities as venues for the most elaborate, and often most popular, exhibitions in favor of only the largest of our nation's metropolitan areas.

With these developments as background, the directors of the five participating museums met in 1985 to discuss this common problem. Within minutes, imaginative proposals to share our Impressionist and Post-Impressionist paintings were enthusiastically embraced. It was evident to all that the enormity of the task was magnified by the complexity of five autonomous institutions coming together to create patterns of cooperation that were out of the ordinary. The directors' enthusiasm for the project was promisingly shared by their trustees and staffs, and a first organizational meeting was held in Minneapolis. When the strength of the museums' holdings was analyzed to test the artistic feasibility of the proposal, it was quickly concluded that the collective holdings would result in a stunning panorama of French

Impressionist and Post-Impressionist art. Monet, Pissarro, Degas, van Gogh, and others would be represented spectacularly in both range and quality. The exhibition that would result promised to be one of the most impressive overviews of these important artistic movements ever presented in the United States.

Marc S. Gerstein, Associate Professor of Art at the University of Toledo, was commissioned to select the exhibition and to write the catalogue entries. The director of the Dallas Museum of Art, Richard R. Brettell, was invited to provide an introductory essay on the history of collecting Impressionist art in our five cities. The selection was made to show within necessary size limitations the chronological and stylistic development of each artist, as well as his or her range of subjects, while also maintaining a reasonable balance among the five collections. Thus, this is not an inventory of Impressionist and Post-Impressionist art in these museums, which in several cases have other admirable works of types already represented in the exhibition. The catalogue contains six works, chiefly pastels, that are shown only at their home museums due to the fragility of their medium, support, or structure. They are included because their omission would deny their stature as among the museums' best works by these artists. The catalogue format, including the decision to omit footnotes and the provenance, exhibition, and bibliographic citations of the works, was agreed to by the five museums at the project's outset. The Saint Louis Art Museum lent its effective publications department to the task of preparing the catalogue. Mary Ann Steiner, Director of Publications, worked with authors, curators, and publisher to bring the book to final publication.

Logistical assignments to each museum quickly followed. To the Minneapolis Institute of Arts fell responsibilities of serving as fiscal agent, assembling budgets, and planning the complex transportation and insurance arrangements. Gwen Bitz, Registrar, and Timothy Fiske, Associate Director, coordinated the many details of those efforts.

The Carnegie Museum of Art, Pittsburgh, took up the task of developing a scheme of national publicity and informational materials to be used locally by all museums as well. Planning the schedule and necessary materials for this campaign was ably managed by Janet McCall, Director of Public Programs and Services.

The Toledo Museum of Art agreed to write grants for government support, to develop common educational materials, and to coordinate the printed materials for the exhibition. We thank Joan Babkiewicz, Coordinator of Grants, Rose Glennon, Chairman of Museum Education, and Sandra E. Knudsen, Coordinator of Publications, for their ideas and perseverance on these fronts. William Hutton, Senior Curator,

served as project liaison with the author. Toledo also accepted the mantle of administrative coordination, graciously accepted first by former Director Roger Mandle and later by Roger M. Berkowitz.

Kansas City's Nelson-Atkins Museum of Art agreed to provide conservation expertise for the exhibition as well as curatorial overview of educational materials. Roger Ward's constant curatorial attention guaranteed the consistency and quality of many aspects of the exhibition, while Associate Paintings Conservator Scott Heffley provided the necessary care for the travelling works of art. Kansas City also was charged with securing national sponsorship.

This exhibition could not have come to fruition without the early vision and commitment of John R. Lane, Roger Mandle, and Alan Shestack, former directors of the Carnegie Museum of Art, the Toledo Museum of Art, and the Minneapolis Institute of Arts, respectively. We acknowledge and appreciate their insistence on an exhibition of great quality and their encouragement toward the realization of the project.

We are profoundly grateful to Ford Motor Company, employer of a great many persons in our five cities, for its financial support of the exhibition, its catalogue, and many related programs.

We are also pleased to acknowledge the financial support received from our regional arts organizations. The Saint Louis Art Museum and the Nelson-Atkins Museum of Art have benefited from funding from the Missouri Arts Council, a state agency, and the National Endowment for the Arts, a federal agency. The Toledo Museum of Art has received funding for this exhibition from the Ohio Arts Council, a state agency.

Our institutions have benefited in so many ways from the cooperative process. We have learned much from one another about techniques and procedures. Perhaps the most memorable benefit, however, of this unique organizational approach will prove to have been the experience of assembling a variety of teams, each with a specific task, composed of persons from the different museums. This process, which required the exercise of leadership as well as of deference, has enhanced our esteem for one another and for the institutions we represent.

It is clear that our respective cities will be beneficiaries as well. Their citizens will have an opportunity to enjoy one of the most impressive exhibitions ever presented to the American public. Even more, it is our hope that the exhibition will contribute to the betterment of our profession and the advancement of museums generally by demonstrating the bountiful future that can be secured through cooperation and the sharing of precious resources.

James D. Burke, Director
The Saint Louis Art Museum

Phillip M. Johnston, Director
The Carnegie Museum of Art,
Pittsburgh

Evan M. Maurer, Director
The Minneapolis Institute of Arts

David W. Steadman, Director
The Toledo Museum of Art

Marc F. Wilson, Director
The Nelson-Atkins Museum of Art,
Kansas City

Roger M. Berkowitz, Deputy Director
Impressionism Consortium Coordinator
The Toledo Museum of Art

Preface

Any catalogue of this scope is of necessity heavily dependent upon previous research. As the decision was made to dispense with footnotes, I would like to cite here my significant debts to many distinguished scholars in the field for their ideas and findings, and in many cases, too, for their translations of period texts; any errors or misstatements are mine and not theirs. I would refer readers to publications by the following scholars, many of which are included in the Further Reading section of this catalogue: Kathleen Adler; Götz Adriani; Ronald Alley; Marie Berhaut; Merete Bodelsen; Jean Sutherland Boggs; Alan Bowness; Richard R. Brettell; Françoise Cachin; Anthea Callen; Philippe Cazeau; T. J. Clark; Jack Cowart; Anne Distel; Michael Paul Driskel; John Elderfield; Richard S. Field; Andrew Forge; Tamar Garb; Robert Goldwater; Robert Gordon; Lawrence Gowing; George Heard Hamilton; Anne Coffin Hanson; Victorine Hefting; Robert L. Herbert; William I. Homer; John House; Jan Hulsker; Joel Isaacson; Lincoln Johnson; Suzanne G. Lindsay; Eunice Lipton; Christopher Lloyd; J. Patrice Marandel; Nancy Mowll Mathews; Charles W. Millard; Charles S. Moffett; Linda Muehlig; Sasha M. Newman; Remus Niculescu; Linda Nochlin; Ronald Pickvance; Griselda Pollock; Karen Pope; Theodore Reff; John Rewald; Robert Rosenblum; Meyer Schapiro; William P. Scott; Grace Seiberling; George T. M. Shackelford; Richard Shiff; MaryAnne Stevens; Charles F. Stuckey; Belinda Thomson; Richard Thomson; Carol Troyen; Paul Tucker; Kirk Varnedoe; Béatrice de Verneilh; Martha Ward; Bogomila Welsh-Ovcharov; Barbara Ehrlich White; Daniel Wildenstein; Eric Zafran.

I also owe a special debt to John House and Joel Isaacson for the probing, sympathetic, and balanced model their writings provided.

I am most grateful to Roger Mandle, formerly the director of the Toledo Museum of Art, for his initial invitation to select the exhibition and write the catalogue. I am pleased to have had the opportunity to work with the staffs of the five participating museums and am indebted to them for their very helpful cooperation. I have received unstinting aid from the Library of the Toledo Museum of Art. Mary Ann Steiner of the Saint Louis Art Museum has been a most skillful and patient editor to whom the final form of the catalogue owes a great deal. To William Hutton of the Toledo Museum of Art, I am especially indebted; his vital encouragement, advice, and support sustained my confidence throughout my work on the exhibition and catalogue.

All titles have been translated into English, with the exception of those that name a location or landmark (e.g., nos. 67 and 68). In some instances, the titles given here differ from those most commonly used so as to reflect the original titles or the reidentification of sitters or sites (e.g., nos. 8, 29, 33, 71, and 79).

Marc S. Gerstein
Associate Professor of Art
University of Toledo

<div align="right">Richard R. Brettell</div>

In Search of Modern French Painting

Pittsburgh, Toledo, Saint Louis, Minneapolis, and Kansas City— these five cities define the parameters of the American heartland. Four border a mighty river. Each has played an important role in the history of the American landscape. Each has forged its own culture, with the fine arts having been a critical ingredient in that cultural identity. Their art museums were founded in the last decades of the nineteenth century—that crucial period of American cultural enterprise sometimes called the American Renaissance.

The oldest of the museums is in the vast center of the Midwest dominated by the Mississippi River. The Saint Louis Museum and School of Fine Arts was established in 1879 and administered by Washington University until 1909 when it became a civic institution. The Carnegie Institute was established in 1895 not as an art museum, but as a general museum and library with a major commitment to the fine arts. And, to follow the logic of geography—the youngest of them being the farthest west—the Nelson-Atkins Museum in Kansas City was founded by the William Rockhill Nelson Trust in 1930 and formally opened in its present building in 1933. Curiously, the two museums that are farthest east and farthest west bear the names not of their cities, but of their benefactors, while the "middle" three shared in the American civic movement by taking the names of their cities.

For the citizens of these five cities, their art museums are synonymous with cultural excellence. The collections are at once varied and distinguished, and there is scarcely a time or a place in the history of art unrepresented among them. If their collections were somehow magically combined, the "collective institution" would rival the great capital museums of the world, and even individually they are required stops for any culturally minded foreigner who visits our country. Yet perhaps because they are scattered across such an immense territory, the quality and depth of their holdings have not been sufficiently recognized by Americans in other regions. For that reason, this selection of modern French paintings from their holdings is particularly welcome.

At this point in the twentieth century, many people throughout the world know about Impressionism and Post-Impressionism. Exhibitions of the masters of these oddly named movements draw record crowds from Tokyo to Lugano, and books with glossy color reproductions of their paintings and texts in various languages must certainly number in the thousands. One reads about the record prices reached at auction for paintings by Cézanne, Monet, Gauguin, Manet, Renoir, or van Gogh, and wonders whether there is anything left to say or to think about Impressionism, Post- or otherwise.

The seven world centers for holdings of art by these artists can be listed easily: Paris, New York, Washington, Chicago, Boston, London, and, increasingly, Tokyo. But this list tells us far less than the true story of the worldwide dispersal of modern French painting. In fact, major public and private collections also can be found in Argentina, Brazil, Scotland, South Africa, Canada, Denmark, Sweden, Switzerland, Germany, Holland, Korea, and the Soviet Union; many other cities of the United States have superb holdings. For this reason alone, the organizing of major monographic exhibitions of Impressionist and Post-Impressionist masters requires travel that would hardly be imagined in preparing an exhibition devoted to the work of Michelangelo, Leonardo, Velázquez, Rubens, Hals, Titian, or any of a number of the greatest painters in the history of Western art. The Impressionists and their followers have quite simply conquered the world.

This exhibition celebrates the collections of five American institutions better known for their general excellence than for their particular focus on French painting. When visiting any of them, the viewer sees the works of the Impressionists and Post-Impressionists as part of the grand flow of the history of Western art from antiquity to the present. This general aim was most succinctly expressed in the catalogue for the 1933 opening of the Nelson Gallery in Kansas City: "It is the aim of the collection here to give a comprehensive survey of the history of painting from the 14th century when Giotto . . . started the break from the Byzantine formula, to the 20th century [with its] more individual and hence subjective painter." Indeed, the very balance of these museums, so admirable in their comprehensive approach to Western painting, has created a situation in which their holdings of modern French painting are not pivotal or even especially prominent; the obvious contrast to them in the American heartland is the Art Institute of Chicago, a museum that displays modern French painting as the *central* movement in the history of art. In Chicago the nineteenth and twentieth centuries are predominant in its highly focused—and severely edited—"history of art." If there is one Ingres, one Rembrandt, one Hals, and one David in Chicago, there are over thirty paintings by Monet and more than a dozen each by Manet, Renoir, and Degas. The galleries swell with the brilliance of France, almost as if Chicago in the early twentieth century really did want to be what it sometimes has been called, the "Paris of the Prairies." No one would think of applying such a grandiose epithet to Pittsburgh or Minneapolis—indeed to any of the five cities under investigation here. Rather, the museums in each of these cities searched seriously through the history of Western art, acquiring a key figure painting by Caillebotte (no. 6), a wonderful

late Bonnard (no. 4), a brilliant portrait by Manet (no. 45), a major Tahitian Gauguin (no. 29), a luminous Signac (no. 80), a cerebral Seurat seascape (no. 77), because each work was individually important to the larger history of painting.

What has been accomplished in this superbly chosen exhibition is the creation of a major survey simply by sharing collections, and the results are extraordinary. Even if a connoisseur of modern French painting had been given the unlikely opportunity to choose an exhibition of eighty-five masterpieces from anywhere in the world, the results could be only slightly more brilliant. Almost every facet of the complex and highly varied careers of the individual painters is represented, and many of these paintings are recognized as part of the museological "canons" of these artists. The collections have inevitable weak points: the formative years of the movement, the 1860s and early 1870s, are less thoroughly represented than they might have been; but the selection for the exhibition is both balanced and masterly.

How did these five collections come to possess such a thorough and imaginative group of Impressionist and Post-Impressionist paintings? The question, like many involved with the history of taste and collecting, is easier to ask than to answer, but its answer helps us to dig into the core of America's abiding and deeply committed cultural appropriation of European painting. The most obvious place to turn is to the early private collectors of these midwestern cities and the professional staffs who directed their civic museums.

American collectors of Impressionism often have been lionized by their countrymen. Most Chicagoans know about Mr. and Mrs. Potter Palmer and Frederick Clay Bartlett, and New Yorkers have often acknowledged their debt to Mr. and Mrs. H. O. Havemeyer. Bostonians revere their early collectors of Millet and Monet, who were among the first in America to purchase vanguard French art. Even later collectors have entered a sort of American pantheon of "advanced" taste, and the most famous of these is surely Chester Dale, whose carefully controlled galleries of Impressionism and Post-Impressionism at Washington's National Gallery of Art ensure that his name will be prominently recognized forever.

Surely it is not wrong to treat these collectors with respect. Yet we must remember, in analyzing the history of institutional taste in America, that they are not our only heroes. The collections of the five museums featured in this exhibition have been determined by their professional staffs to a much greater extent than by their donors. For all the importance of James J. Hill in Minneapolis, Edward Drummond Libbey in Toledo, William Rockhill Nelson in Kansas City, Sarah Mellon Scaife in Pittsburgh, or the Steinberg family in Saint Louis, it has been the curators and directors who have formed the great part of the collections. Their praises have been sung in the boardrooms and bulletins of their respective museums, but many of them are little known outside their cities, and the ways in which they shaped American understanding of French art are worthy of serious consideration.

Before shifting our attention to the delicate dance between donor and director in these five institutions, it is necessary to recall the importance of the greatest international art dealer of Impressionism in the late nineteenth and early twentieth centuries, Paul Durand-Ruel.

A good deal of attention has been paid in the literature to the great Impressionist exhibition sponsored by Durand-Ruel in New York City in 1886. Chicagoans also have become familiar, particularly through the brilliant research of the German art historian Stefan Germer, with the importance of Durand-Ruel in the development of the so-called Chicago taste for Impressionism. However, little research has been done on the series of Durand-Ruel exhibitions and private sales outside of New York and Chicago. In fact, Durand-Ruel was so enterprising in the early years of this century that his firm mounted a major exhibition of Impressionist painting that appeared in Toledo (1905), Saint Louis (1907), and Pittsburgh (1908). The catalogues of this exhibition serve as testimony to the subtle, and ultimately successful, strategy of Durand-Ruel in bringing advanced art to the attention of average Americans through their newly created art museums. Although direct sales from these exhibitions to institutions or private collectors were rare, the works were respectfully received and probably did more than the scores of early monographs or the numerous private dealers' exhibitions to secure the reputation of French Impressionism in the popular imagination of Americans.

Since the earliest of these exhibitions was held in Toledo, it is perhaps best to accept it as the paradigm and to analyze it in some detail. Like most nineteenth- and early twentieth-century exhibitions, it was fairly large, consisting of 103 paintings by fourteen artists. The exhibition was held in November 1905 in conjunction with the opening of Toledo's newly formed permanent collection galleries, which featured works by now-forgotten artists such as Gustave Henry Mosler, S. F. Jozan, and Willem Steelink. The introductory text to the catalogue crystallized in a paragraph the aims of both the great French dealer and the enthusiastic director of the new museum, George Stevens:

For something like a period of fifty years, the impressionistic idea in painting has been asserting itself. Its earlier years were fraught with disappointments, rebuff, lack of recognition, and oppression; but like all great movements, it has come into its own at last, and the eyes of the world are now gazing with admiration and wonder at the works of impressionist painters living and dead.

The exhibition included four works by Cassatt, five by Degas, two by Manet, thirteen by Monet—the hero of the movement— and twelve each by Renoir, Pissarro, and Sisley. In addition to these now-famous paintings, Durand-Ruel added works by lesser-known— and more reasonably priced—artists such as Albert André, Georges d'Espagnat, Gustave Loiseau, Maxime Maufra, Henry Moret, and Federico Zandomeneghi. Also included were three major paintings by Pierre Puvis de Chavannes, an artist who never exhibited with the Impressionists and whose work falls outside their loosely defined style, but who acted as a kind of mediator between them and their contemporaries in the official Salons of the nineteenth century. Interestingly, and not accidentally, *The Reaper* by Puvis de Chavannes was the only painting in the exhibition reproduced in the *Toledo Daily Blade's* account of the exhibition opening. Durand-Ruel himself furthered the cause of Impressionism by donating two minor paintings by Moret and Loiseau to the four-year-old museum.

Criticism of the exhibition was, from all accounts, favorable and respectful. Indeed, the *Toledo Daily Blade* waxed eloquent in the flowery syntax of turn-of-the-century journalism:

The galleries of the second floor were a riot of color and the walls blazed with the intensity and insistence of nature. . . . When one has relinquished one's mental hold of the painting to which one has become accustomed, and has approached this new art with a reverence and a mind open to conviction, and when one begins to understand something of the theory of light and color vibrations, one begins to realize the almost miraculous work these men have done.

Indeed, it was to science and color theory that these earnest American viewers turned when forced to explain Impressionism. Even George Stevens, the brilliantly articulate first director of the Toledo Museum of Art, called "the whole key of impressionistic painting . . . the scientific application of color," and went on to stress the experimental nature of the movement in his remarks to the Toledo press in November 1905. It was the hope of Stevens, and most early American apologists for Impressionism, that viewers would come to the work with open minds, unfettered by prejudice, in order best to judge this newest and most modern of art styles. Such an approach was strategically sound, for it placed Americans in a position that many of them considered to be naturally American, at once open to the new and unprejudiced.

Durand-Ruel circulated this exhibition in essentially the same form throughout the United States in the first decade of the century, sending it to a new museum wherever there was a sympathetic director or trustee. Its appearance in three of the five museums celebrated in this exhibition goes a fair way to explain the existence of important Impressionist paintings in the permanent collections of these institutions. One must remember, however, that the early directors, curators, and trustees of these institutions were a good deal more selective in their purchases of modern French painting than Durand-Ruel had been in his exhibition. Aside from the early gifts from Durand-Ruel himself, the Impressionist and Post-Impressionist collections in the five cities concentrate on the works of major artists; paintings by Moret, Loiseau, André, and Maufra were never consciously sought for the permanent collections.

Perhaps one way to gauge the relative importance of Impressionism in the American heartland is to measure its strength in the series of international exhibitions inaugurated by the Carnegie Institute in 1896. These exhibitions were immense surveys of contemporary art throughout the world and were designed to place American art in a worldwide context. They were conceived like international competitions, with the paintings of each nation segregated so that contrasts were apparent to every viewer. In the first Carnegie International, French art was represented by such successful Salon painters as Besnard, Breton, Cazin, Gérôme, Harpignies, Lerolle, Lhermitte, and Puvis de Chavannes. The work of such mid-century masters as Millet and Diaz de la Peña also was represented, but the Impressionist "rebels"—Degas, Fantin-Latour, and Monet (all in late middle age!)—were the spice of this thoroughly democratic stew. Degas was represented by two works, one each from his two favorite subjects: horse racing, which was

illustrated in the catalogue, and ballet. Monet was represented by four landscapes, all of which were probably from Durand-Ruel's stock. These six paintings, together with the lone painting by Fantin-Latour, must have drowned in the immense sea of international art, where Scandinavian, German, English, Italian, and Spanish masters fought for dominance with their French and American contemporaries.

In 1900 there were paintings by Cassatt, Degas, Boudin, Monet, Sisley, and Pissarro, and the Carnegie thought well enough of the eldest Impressionist, Pissarro, to purchase for its own collection *Le Grand Pont, Rouen* (no. 67). Yet, as in 1896, these paintings seem to have been included in the spirit of egalitarianism rather than out of a conviction that they were the best art of their time. Indeed, if the international exhibitions at the Carnegie are used as indicators of taste, Americans were "fair" to Impressionism rather more than they were partial to it.

The presence of Impressionist painting in the international exhibitions continued to be felt in the same marginal way throughout the period around World War I. Curiously, it was not until 1920, when Robert Harshe organized a Rodin exhibition in Chicago, that the work of the sculptor was connected with the paintings of his Impressionist colleagues, and it was not until 1927 that younger French artists were suddenly included. Indeed, the Post-Impressionists—Cézanne and Gauguin—were conspicuously absent from all the international exhibitions during their lifetimes; the work of Seurat and van Gogh, though safely dead, had never been seen. The major figures of Impressionism were all "skipped over" in 1927, when the first prize for the exhibition went to Matisse and the French organizing committee included Bonnard and Maurice Denis. The year 1927 was a crucial one for the proponents of Modernism. Andrew Dasburg, the American vanguard painter, won third prize, and from that year onward the work of advanced painters, French and American, was embraced by the International.

Two points need to be made before rushing to congratulate the International on its progressive Modernism during the late 1920s. First, modern French art itself had lost a good deal of its "edge" by the time it was allowed into the International. With the possible exception of the work of the young Surrealists, which was absent from all the international exhibitions, the masters of Modernism in France—Picasso, Matisse, and Bonnard—were middle-aged and thoroughly established members of the French cultural community. And secondly, their work was still presented in the Carnegie International as part of a larger field of international artists who were seen as competitors in the arena of world culture. Indeed, the variously decorated "national" rooms in the University of Pittsburgh's great "Cathedral of Learning," designed and built in the late twenties, can easily be related to the "national" committees and galleries in the Carnegie International. The cultural imperialism is only clear from hindsight. America in the 1920s viewed itself as the encyclopedic nation that could embrace all the world equally. In this orderly universe, modern French art played its "proper" role and nothing more.

From Durand-Ruel's exhibition in Toledo in 1905 to the Carnegie International of 1927, there actually had been a gradual decrease in the importance of vanguard French painting in the five cities represented

in this exhibition. A notable exception was Saint Louis's farsighted purchase of Monet's 1903 *Charing Cross Bridge* in 1915. However, the triumphant Durand-Ruel survey was never quite repeated, although in 1929 there was a smaller exhibition in Toledo of sixty-two Impressionist and Post-Impressionist paintings, mostly culled from New York dealers, and a wonderfully odd group of paintings by Manet, Renoir, and Morisot that was presented in Pittsburgh in 1924. And, of the eighty-five major works in the present exhibition, only eight were in the collections of these museums when the great crash hit in October of 1929. No visitor to any of the four museums during the 1920s—the Nelson-Atkins Museum did not open until 1933—would have had a sense that French Impressionist and Post-Impressionist painting would become the predominant—almost the *only*—modern painting other than American painting in their permanent collections by the 1950s.

It is to the directors and curators already mentioned in passing that we must now return. They and their theories of the history of Western art are the most important forces in our story. They formed the collections. They negotiated with New York and Paris dealers. They read the early monographs on individual artists and devoured John Rewald's monumental *History of Impressionism*, whose appearance in 1946 can be considered among the most important moments in the history of French Modernism in America. These directors formed the collections and convinced their trustees that Impressionism and Post-Impressionism were crucial movements in the history of modern art.

Who were these men? Their names are scarcely household words, even in the cities whose taste they formed. Gordon Bailey Washburn, John Beatty, and Leon Arkus from Pittsburgh; George Stevens, Blake-More Godwin, and Otto Wittmann from Toledo; Samuel Sherer, Charles Percy Davis, Robert Holland, and Perry Rathbone from Saint Louis; Anthony M. Clark, Richard S. Davis, and Russell Plimpton from Minneapolis; and Paul Gardner and Ralph T. (Ted) Coe from Kansas City. This list is by no means complete, and it includes no one currently on their distinguished staffs. On it are a few names that every serious museum professional knows. Yet even some of these names have fallen into the abyss of local history.

Russell Plimpton, for instance, was instrumental in bringing the Frederick Clay Bartlett Collection of Post-Impressionist painting to Minneapolis in 1925, the year before it entered the collection of the Art Institute of Chicago. During his subsequent tenure, the Minneapolis Institute of Arts bought masterpieces by Seurat, Cézanne, and Gauguin, all of which are in the present exhibition.

Paul Gardner, the first director of the Nelson-Atkins Museum in Kansas City, managed to work around Colonel Nelson's real dislike of modern painting and the resulting rule that an artist had to be dead for thirty years before his work could be considered for the permanent collection. In fact, when the Nelson-Atkins Museum was forming the core of its collection in the 1930s, Gardner managed to acquire paintings by van Gogh, Cézanne, Gauguin, Pissarro, Manet, Sisley, and Seurat, although it was impossible for him to purchase works by Monet, Degas, or Renoir because they had died "too late." It was not until 1957, thirty-one years after Monet's death, that Patrick J. Kelleher, then curator of European Art at the Nelson-Atkins, was able to purchase one panel of Monet's monumental *Water Lilies* (no. 56) from

the dismembered triptych owned by the art dealer Knoedler. Saint Louis had also acquired a section of the same *Water Lilies* (no. 55) triptych a year earlier, when Mrs. Mark Steinberg was inspired to purchase the central panel and give it to the museum. In Kansas City a second wave of serious purchasing of Impressionist and Post-Impressionist painting began with the arrival of Ted Coe as curator in 1959.

In general, the Impressionists and their great teacher, Manet, were the earliest to enter the collections of these museums. Landscapes by Pissarro, Sisley, and Monet were already in Saint Louis, Pittsburgh, Toledo, and Minneapolis by the time of the Great Depression, and the major Manet figure paintings in Saint Louis and Toledo were early acquisitions, easily justifiable as extensions of an old-master sensibility. The taste for Post-Impressionist painting came later in every city, and much of every collection was acquired during the period following World War II. Blake-More Godwin, director for Toledo from 1926 to 1959, and Otto Wittmann, associate director between 1946 and his assumption of the directorship in 1959, bought major paintings by Jongkind, Pissarro, Degas, Renoir, van Gogh, Gauguin, Signac, and Sisley, forming a superb collection over the years.

The last spurt of collecting Impressionist and Post-Impressionist paintings came in the 1960s and early 1970s and was centered in Pittsburgh. During a period of relative stability and availability in the art market, Leon Arkus, director of the Museum of Art, Carnegie Institute, between 1968 and 1980, worked with Sarah Mellon Scaife and her family to assemble a major collection of French vanguard painting of the late nineteenth and early twentieth centuries. This group of paintings is among the most distinguished assembled by any museum in America during a comparatively short period of time and must be regarded as the principal contribution of Leon Arkus to American collecting. It should also be added that the Scaife family's generosity is virtually unparalleled in America during the 1960s and early 1970s, and several of the greatest paintings in the present exhibition (nos. 4, 10, 13, 17, 20, 33, 39, 54, 57, 61, 71, 80, and 84) were purchased during those years. The Scaife family is among the rare but vitally important group of American postwar donors who purchased works of art not for themselves but for their cities, and who were guided in their quest for excellence by the curatorial intelligence of the institution.

A word must be said for two curators with somewhat opposite sensibilities who oversaw the purchasing of French painting in Kansas City and Minneapolis. The more traditional of the two was Ted Coe, the scholar-connoisseur who guided the collection in Kansas City during the 1960s and 1970s. Shortly after his arrival in Kansas City in 1959, he spearheaded the purchase of Pissarro's largest and most complex painting of the mid-1870s, *The Garden of Les Mathurins at Pontoise* (no. 62). In 1972 Coe acquired Monet's famous *Boulevard des Capucines* (no. 49) and the next year Degas's *Ballet Rehearsal* (no. 18). The latter painting had been purchased by Louisine Elder, later Mrs. H. O. Havemeyer—probably the same year it was made—and seems to be the first Impressionist work of art owned by an American. Both acquisitions were made with funds provided by the late Helen Foresman Spencer, one of Kansas City's most notable philanthropists. Later in that decade an anonymous benefactor made possible the addition to

the collection of works by Morisot, Cassatt (no. 8), Degas (no. 19), Signac (no. 79), Gauguin, and Redon. As a group, the ten Impressionist and Post-Impressionist works acquired for Kansas City by Coe as curator and director (the period 1959–1982) embody his preference for mainstream paintings of the 1870s—a distinctive feature of the Nelson-Atkins's collection.

Anthony M. Clark, who bought brilliantly for the Minneapolis Institute of Arts before continuing his distinguished career at the Metropolitan Museum of Art in New York, is an unlikely hero of this essay. His knowledge of the history of European painting was both prodigious and at odds with the fundamental canons established by other museum curators and academic art historians in the first half of the century. Clark saw beyond the "heroic," antitraditional Impressionism and Post-Impressionism defined by John Rewald, the Art Institute of Chicago, and New York's Museum of Modern Art. Although his major purchases were in the area of the Italian Baroque, his eyes were open to the qualities of later academic art, and he made superb additions of paintings by Gérôme and Tissot to the permanent collection in Minneapolis. Yet he also looked into the careers of forgotten or short-lived Impressionist painters, purchasing for the museum the monumental late landscape by Frédéric Bazille that capped the Barbizon tradition already so well represented in Minneapolis because of James J. Hill. One of his boldest purchases, in 1966, was the great female nude by Gustave Caillebotte (no. 6). Together with Toledo's Caillebotte (no. 7), acquired as a gift in 1953, and Chicago's *Street in Paris*, acquired in 1964, these were the most extraordinary paintings by that now-revered Impressionist painter to enter public collections in America. Indeed, even in Caillebotte's native France, there was just one major work by him in the national collections when Clark purchased the daringly conceived and beautifully realized nude.

In our zeal to recognize the achievements of the champions in Impressionism and Post-Impressionism in these five cities we must remember that it was a man who loved Italian Baroque painting who was able to appreciate aspects of Impressionism ignored by admirers of the movement.

The story that has been told in these brief pages is by no means complete. There were many other heroes. Gordon Bailey Washburn created a brilliant survey of French painting at the Carnegie in 1951 that started with the late Middle Ages and culminated in the work of the Post-Impressionists. The departments of Museum Education in Pittsburgh and Toledo presented ground-breaking didactic exhibitions in the 1940s and 1950s devoted to Impressionist technique. Joseph Pulitzer, Jr., in Saint Louis has turned his perfectly tuned eye to the modern French masters and added to the collections both of the Saint Louis Art Museum in his native city and of the Fogg Art Museum at Harvard University, his alma mater.

The efforts of Paul Durand-Ruel early in this century paid off, but probably not in the way he anticipated. His vision of the American museum is most perfectly embodied in Chicago, where the Durand-Ruel stock of late nineteenth- and early twentieth-century art dominates the museum. The collectors, curators, donors, and directors of the five museums discussed here never embraced Durand-Ruel's aesthetic so fervently or so totally. For them, Impressionism and Post-Impressionism were put into the context of a much larger world, the history of Western easel painting from the Renaissance to the present. The selections made by all these men and women were judicious and discriminating. When combined, the Impressionist and Post-Impressionist paintings in the permanent collections of these five museums rival any in the world.

Impressionism

I

Bazille is one of the least known of the Impressionists. His life was short and he produced only a small body of work. He was a striking figure, immensely tall and lanky; Emile Zola described Bazille in notes for his novel *The Dream* as "tall, slim, very distinguished, a little in the style of Jesus, but virile. A very handsome fellow. Of fine stock, with a haughty, forbidding air when angry, and very good and kind usually. . . . All the noble qualities of youth: belief, loyalty, delicacy." This compelling self-portrait was one of six Bazille painted, two of which are part of large outdoor group portraits of his family. It was probably while finishing *The Family Reunion* (Paris, Musée d'Orsay; the largest and best-known of these family portraits) in his Paris studio during the winter of 1867–68 that this self-portrait was painted.

This self-portrait follows what by then were commonplace conventions of Realist portraiture of the 1850s and 1860s. The format, view, pose, strong side lighting, and shadowed face were all to be seen in numerous portraits and self-portraits by Courbet, Fantin-Latour, Bonnat, Bonvin, Vollon, and others, with their ultimate ancestry in Rembrandt. Bazille's is distinguished by a rugged handling of light and paint that was informed by Manet's and Monet's recent work. Bazille had been a close friend of Monet since their student days in Gleyre's atelier. They worked together in the summers of 1863, 1864 (see no. 47), and 1865 and shared a Paris studio. Bazille also had posed for, bought, and stored Monet's paintings and often lent him money in times of dire need. Bazille knew Manet only socially but had been deeply impressed by his paintings since first seeing them in 1863.

Bazille's technique in this self-portrait draws on shared characteristics of Manet's paintings of single figures of the early 1860s (see no. 43) and Monet's portraits and figure paintings of 1864–65, for some of which Bazille had posed. He worked both darks and lights directly onto a light ground without the traditional dark underpainting, painted the lighter tones more thickly, and rubbed on the shadows thinly and transparently. The light effects are treated bluntly and abruptly, without the traditional and expected graded transitions. Broken planes of sharply shifting values model roughly faceted forms from the background shadows. Contours are angular and deliberately awkward; drawing is nearly dispensed with. The execution is broad and vigorous, the shorthand of strokes conferring a sense of controlled strength and tight-strung energy. Bazille seems to share with his contemporaries a belief in the value of the rough and brusque to convey artistic sincerity. The shadowed face, muted color, blunt handling, stiff pose, and staring eyes seem to lay bare the artist's forbidding yet brooding and troubled state of mind. Bazille creates an intense psychological presence that is somber and arresting.

Oil on canvas, 21¼ × 18⅛ inches (54 × 46 cm)
The Minneapolis Institute of Arts 62.39
The John R. Van Derlip Fund

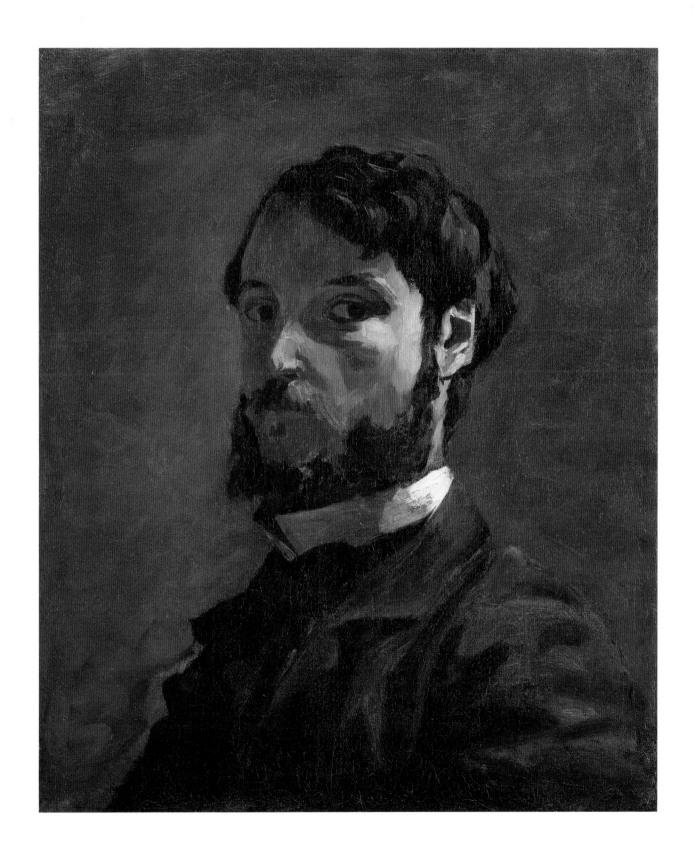

After 1900 Bonnard spent more time in the country than in Paris. He went to the south of France in winter and to places in the Seine valley in spring and summer. In 1912 he bought a house called "Ma Roulotte" (My Caravan) at Vernonnet, a tiny town on the Seine outside Vernon between Paris and Rouen. This large painting of his dining room and garden at Vernonnet, which he finished by November of the following year, depicts a comfortably bourgeois subject of the sort he most often preferred. It is the uncomplicated and familiar world of ordinary events and daily routines—here the cats perched on the dining-room chairs, the young woman picking flowers in the garden, and Bonnard's lifelong companion, Marthe de Méligny (actually Maria Boursin), at the window.

He enhanced the charm and beauty of the scene by combining the interior with the landscape in a single comprehensive view. In this painting he explored again a favored theme of the open window or door, which enabled him to conjoin disparate spaces and to present a wide range of light effects, here in the view from the softly shadowed room into the sunlit landscape. He integrated house and garden, inside and outside, enclosed and open, simple and complex, near and far, and the human and natural environments.

The openings from inside to outside became for Bonnard a device rich with formal and expressive possibilities, one by which he also structured the multitude of elements of the view. The architectural forms, along with the furniture, establish a loose geometric scheme that divides and organizes the scene into a sequence of interlocking screens. These framing elements, along with the bright palette and active brushwork, pull the landscape forward, uniting interior and exterior into a coherent decorative surface, while simultaneously expressing the variety of spatial effects. During this period Bonnard had begun to feel that his work was not strong enough in drawing and composition. He later recalled to his nephew Charles Terrasse: "I had been carried away by color. I was almost unconsciously sacrificing form to it. But it is true that form exists and that one cannot arbitrarily and indefinitely reduce or transpose it."

Through the order and definition he imposed on this view, Bonnard sought to bring coherence to the representation of his perceptual experiences. After about 1900 he turned away from the Symbolist search for the mysterious reality within surface appearances and found his point of departure and constant reference instead in his careful scrutiny of nature. This stress on observation linked his art to Impressionism, as did his subject matter, high color, rhythmically broken brushwork, softened contours, odd perspectives, asymmetrical compositions, and dispersed focuses. He was later even to describe himself to Matisse as the last of the Impressionists. For paintings like *Dining Room in the Country*, the strongest affinities may lie with the later work of Monet, Bonnard's close friend and neighbor who lived across the river from Vernonnet at Giverny. Like Monet, Bonnard responded to the myriad nuances of atmospheric light, seeking not so much to reproduce nature as to create pictorial equivalents for his sensations of it through color and touch. Each artist brought out in his works the highly subjective character of both his visual experiences and their representation.

Bonnard, however, was far less concerned than Monet to re-create the fleeting effects of nature, and focused far more on the subjective rather than the objective components of perception. He gave to the emotions that a subject aroused in him, to the "attraction" that he felt, a primary generative role. It was the feelings stirred as he observed something that became for him the essential subject of his painting. In an effort to preserve and distill this emotional response, he worked completely from memory. He thereby avoided the disturbing presence of the motif, which he felt caused him to lose what he termed his primary conception.

Bonnard strove to find the pictorial means to express his subjective response to the world as it was shaped by emotion, memory, and imagination, and thus freely manipulated color and touch, objects and spaces. The shimmering color, softly vibrant brushwork, and richly layered spaces of *Dining Room in the Country* evoke an atmosphere of tranquillity, comfort, and pleasure, and confer on the things and experiences of daily life an unexpected and enchanting lyricism.

Oil on canvas, 64¾ × 81 inches (164.5 × 205.7 cm)
The Minneapolis Institute of Arts 54.15
The John R. Van Derlip Fund

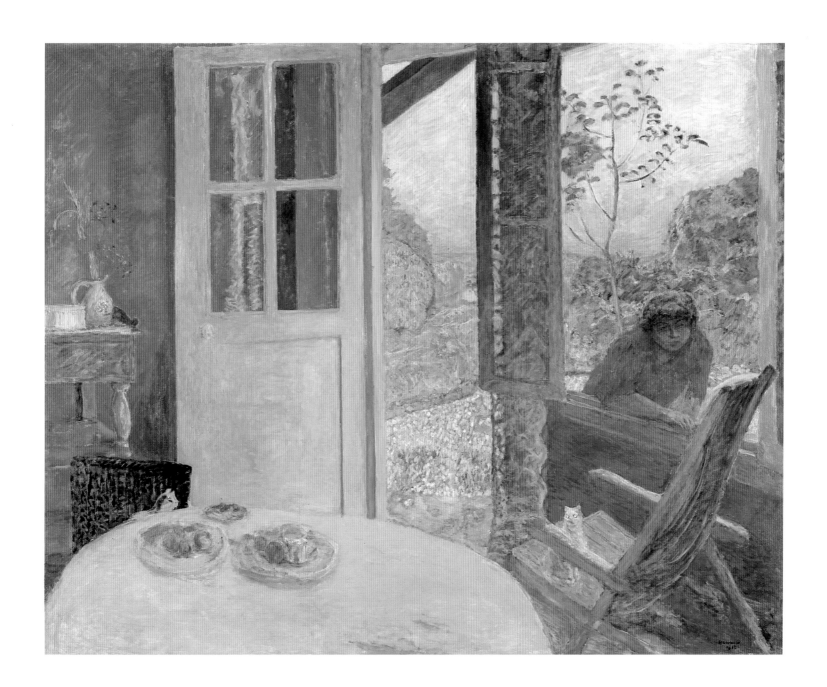

The Abduction of Europa

1919

3

Bonnard most often took his subjects from the world he knew at first hand, but during the first two decades of the century, he became increasingly involved with Arcadian imagery. On occasion he represented mythical figures, although he rarely treated specific mythological narratives. His interest in such subjects was related to his broader artistic goals of evoking a world of comfort and pleasure, and to his lifelong taste for classical literature and sculpture. It was further stimulated during this period by his contacts with the Mediterranean region, first in 1908 on a brief trip to Italy and North Africa, and then by extended stays of several months in the south of France almost every year beginning in 1909.

For him, as for countless others, the south was a traditional and timeless world of sunlight and sensuous ease. His response to the place seems to have encouraged him to explore Arcadian themes, at times classical ones, set most often in a Mediterranean landscape; during these years he generally reserved his more modern and everyday subjects for the landscape of northern France (see no. 2). He was not the only artist or writer of the period to view the south in such terms; it was, indeed, a common stereotype to see it as a pre-modern and unchanging world of indolence and sensuality, as the land of *dolce far niente*. Other artists of the late nineteenth and early twentieth centuries, such as Puvis de Chavannes, Renoir, Cézanne, Gauguin, Denis, Maillol, and Matisse, also represented pastoral themes in southern settings, and a few even treated mythological subjects at this time.

Bonnard probably painted *The Abduction of Europa*, at least in part, during his stay at Antibes on the Mediterranean coast in the winter of 1918–19. The landscape was loosely based on one he had done during that same visit, but he replaced a goatherder and his goats with the god Zeus, transformed into a white bull, abducting the beautiful Europa across the sea to Crete. His treatment of the myth may have been inspired by Titian's famous painting of the subject (Boston, Isabella Stewart Gardner Museum). Bonnard revered Titian and may have responded to his resonant colors and rich painterly effects. In spirit, however, Bonnard's interpretation is far more reminiscent of Boucher's painting in the Louvre. Like Boucher, Bonnard represented the moment when Europa first mounted the bull, and he surrounded the principal characters with other figures along the shore: here Europa's companions, one of whom looks on with alarm, and two fauns, the younger joyously piping to his lolling elder. Both artists depicted the playful flirtation between Europa and the bull rather than, as Titian had, the young woman's struggle and distress as she was carried far out across the water.

For both Bonnard and Boucher, the greatest concern was with the creation of a powerfully sensuous effect. Bonnard's colors, loosely based on those of nature, are radiant and sumptuous. He elaborated a rich and nuanced harmony within a relatively narrow range of hues, modulating and varying them in a closely coordinated scheme. By repeatedly introducing the principal colors of one area as accents and inflections into another, he knit the whole into a unified chromatic composition. He coupled the coherence he obtained through color with free-flowing, amorphous brushwork to establish a continuous mobility and flux across the entire surface. In a notebook he later explained that "the picture is a series of blotches which are joined together and finally form the object, the finished work, over which the eye may wander completely unhindered." He applied the washlike paint thinly, wet in wet, producing in his colors a veiled and glowing translucence.

Bonnard structured the fluctuant fields of color through submerged drawing and a loose system of broad horizontal bands and zones, framing the vista with active landscape forms stretched across the bottom and top and up along the sides. The overall effect of the color, touch, and organization flattens the image into a decorative surface of luminous, shimmering tones. In his treatment of the subject, he merged the mythic figures into a dreamlike harmony with nature and transformed the Mediterranean landscape into a timeless world of luxury, calm, and voluptuousness.

Oil on canvas, 46¼ × 60¼ inches (117.5 × 153 cm)

The Toledo Museum of Art 30.215

Gift of Edward Drummond Libbey

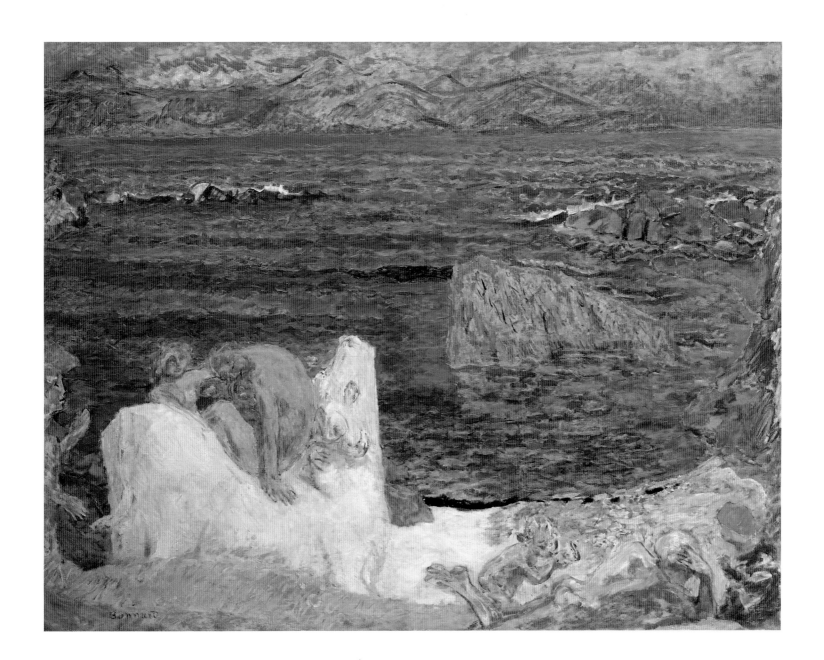

Pierre Bonnard
1867–1947

Nude in Bathtub
c. 1941–46

After 1900 the female nude became one of Bonnard's principal subjects: it fascinated, even obsessed him. He represented his nudes bathing, drying off, or dressing, and, from 1925, set them in the modern bathroom of the house he bought that year at Le Cannet near Cannes. This theme was another in the generally limited repertoire of ordinary, domestic subjects he tended to favor throughout his career (see no. 2). His model for his nudes almost invariably was his lifelong companion Marthe de Méligny, as she called herself. They had met and become lovers in about 1893 and married in 1925. Over the years she became quite difficult and reclusive, and was increasingly obsessive about her cleanliness, which led her to spend a good part of each day at her bath, where Bonnard often depicted her.

Bonnard previously had represented the nude in active poses, but in 1925 he also began to show her peacefully stretched out in a long bathtub. The Carnegie picture, which he began in 1941 and worked on until 1946, was the last of his paintings of this motif. It appears to have been finished, but was uncharacteristically left unsigned at his death in 1947. His earlier nudes had been inspired by Degas's bathers (see no. 20) in their energetic poses, odd framings and angles of view, and habitual and unselfconscious actions. His new motif, however, lacked the movement and strain characteristic even of Degas's nudes reclining in a bath (see no. 26). Instead, Bonnard evoked a state of self-absorbed and sensuous languor: here the body floats weightlessly in the tub, which itself hovers suspended in the iridescent surroundings.

Weight, volume, and space are displaced by color, which acts as a shimmering, translucent veil dissolving forms and surfaces. Spatial distinctions among floor, walls, and objects are minimized, and tile patterns and brushwork rhythms are stressed, thereby collapsing space into a glowing chromatic surface. The complex of colors and patterns is structured around the floating body whose shape is freely echoed in the shifting lines of the bathroom interior.

Bonnard had, for most of his long career, worked from memory in a process in which he transformed his passing experiences of everyday life through a protracted effort of meditation and will. As he worked on *Nude in Bathtub*, and also in the years before, memory came to play an even more crucial role: painting became for him an act of recovering what had long since ceased to exist. When he began this painting in 1941, Marthe, his wife and model, was in her early seventies; after she died in 1942, he continued nevertheless to work and rework it for years. He had long ago decided that she would never age and showed her, instead, as she had looked when she was young. What he painted was his emotional response to a remembered image and his unwillingness to accept aging and change. In his representation he fixed the past in a poetic vision of youthful sensuality, restoring to the eternal present what time had long since ravaged. Although his images may appear utterly visual, their subject is not seeing, but remembering. Through painting, he transformed the most ordinary and fleeting ritual into a strange and enchanted epiphany.

Oil on canvas, 48 × 59½ inches (121.9 × 151.1 cm)
The Carnegie Museum of Art 70.50
Acquired through the generosity of the Sarah Mellon Scaife family

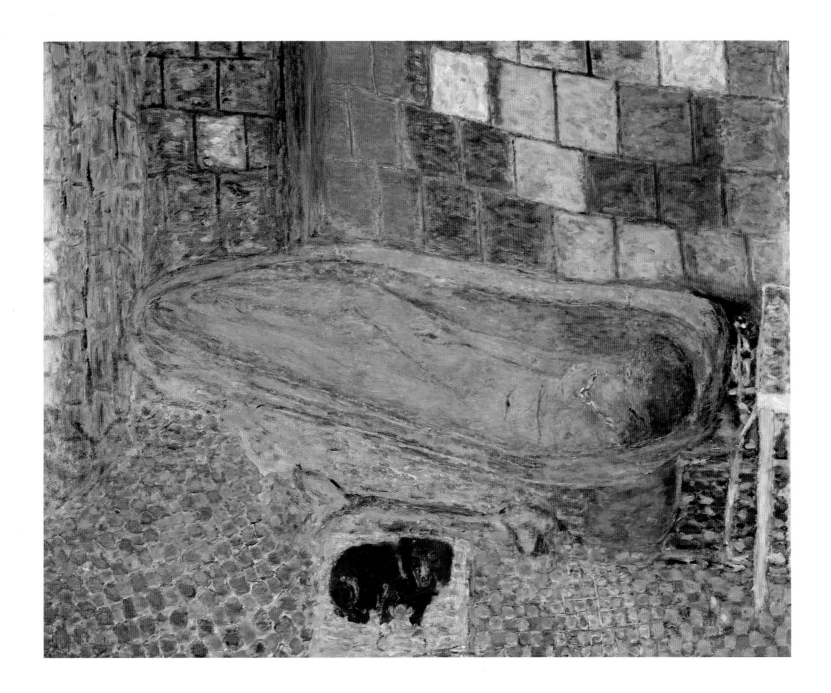

In 1862 Boudin began to paint beach scenes peopled with elegant Parisian vacationers, a genre his contemporaries credited him with having invented. The Romantic artists had represented what the critic Duranty called "la mer à drames et à mélodrames" (the sea as drama and as melodrama), the coastal landscape of shipwrecks and tempests with a few desolate wanderers or picturesque fisherfolk. Boudin was struck instead by "la mer moderne" (the modern sea), the newly fashionable resorts of Trouville and Deauville on the Normandy coast.

Boudin first sent a painting of the beach at Trouville to the Salon in 1864 and soon successfully established himself as a specialist in the subject of well-dressed society gathered on the beach to stroll and converse amid comfortable chairs, bathing cabins, and distant bathers. Although Boudin had already tired of this subject by 1867, he himself noted his achievement in a letter of 1868 to his friend M. Martin:

These gentlemen congratulate me for having dared to put down on canvas the things and people of our own time, for having found the way to gain acceptance for men in great-coats and women in waterproofs. . . . The peasants have their favored painters . . . but the bourgeois who walk on the jetty toward the sunset, don't they have the right to be fixed on canvas, to be brought out into the light?

Boudin's involvement with these subjects probably owes a debt to the persuasive views of the poet and critic Charles Baudelaire. Like Manet in his open-air scenes of modern life, Boudin joins attentive observation of the crowd's attitudes and dress to a sense of physical distance and psychological detachment. His composition of densely packed figures clustered in small groups and loosely aligned in a frieze lacks either a strong and stable focus or a sense of narrative ordering. To Boudin this favored composition must have seemed better suited to re-creating the experience of the contemporary scene in all its distracting diversity than did traditional ones. It also acted to emphasize the peculiar relationship of these figures with their surroundings, this Parisian world transported to the edge of the sea.

If Boudin's aim was to paint the modern scene, it was also to transcribe his sensations of the natural environment in which he experienced it. He was called "le roi des ciels" (the king of the skies) by Corot not only for the ample place given to the sky in his compositions, but also for its vivid luminosity and shifting movements. Boudin achieves this clarity and brightness in the sky and throughout the composition by the predominance of clear, light tones and the high, generally narrow range of values. Light blues, grays, and tans convey the luminous effects of water, sky, and sand, while whites, dark blues, blacks, and a few strong touches of red describe variations in costume and provide warming spots and accents. This clear, bright, generally even tonality—referred to at the time as *la peinture claire* (clear, bright

painting)—was Boudin's means of translating the light of the landscape into paint.

Lively, varied brushwork also plays a role in conveying the natural effects. Boudin's brushwork describes something of the weight and texture of things, but also expresses the movements and rhythms of the sky and water, the rustle of clothes in the light sea breeze, and the small, animated gestures of the crowd. The faces are not individuated, but Boudin's subtlety and finesse in establishing the silhouettes vividly characterize and animate them. The summary handling of detail emphasizes the overall visual effect and reinforces the dispersed focus of the composition.

The lively effect that Boudin creates may seem to suggest a rapid and spontaneous execution, and Boudin himself touted the virtues of painting directly from nature. But the effect in this case is probably deceptive since the painting was built up slowly and deliberately. The figures and sand were developed over a traditional layer of dark underpainting applied to the mahogany panel, with the sky and water filled in later around them. For at least one large section of the figure group, Boudin relied on a pencil and watercolor sketch inscribed and dated "Trouville 65." It was a notation from life done, no doubt, on the beach that summer. Such evidence strongly suggests that the painting was not made out-of-doors in the summer of 1865, but afterward in his Paris studio where each year he worked during the winter months. During that same winter Boudin painted another panel of equal size, this one dated 1866, drawing on the same motifs. These elaborate and finished compositions were the products of a composite process in which the artist worked from watercolor, pencil, pastel, and oil sketches from nature; from his own previous paintings of the subject; from his general store of knowledge and experience; and from the remembered impression. Each was part of Boudin's ongoing variations on the theme of natural phenomena and Parisian pleasures at the seashore.

Oil on wood panel, 13⅝ × 22⅝ inches (34.5 × 57.5 cm)

The Toledo Museum of Art 51.372

Gift of Edward Drummond Libbey

8

At the Theater (*Woman in a Loge*)

c. 1879

At the Theater's glittering color and spirited execution make it one of Cassatt's most brilliant performances. Cassatt's art was profoundly transformed by her entry into Impressionist circles in 1877, when she was introduced to Edgar Degas by a mutual artist friend. She already had known and admired his work and had advised her friend Louisine Elder to buy one of his ballet pictures (no. 18). He, in turn, had responded to one of her paintings when he saw it at the Salon of 1874. She developed a long-lasting if volatile friendship with Degas, but their relationship was of even greater significance for her art.

At the Theater is one of a group of paintings, pastels, and prints with theater subjects that Cassatt did between 1878 and 1880. Degas and Renoir had done notable works devoted to the theater audience, which Cassatt adapted to her own endeavor of providing a sympathetic exploration of the social experiences of the modern middle-class woman. In place of Degas's focus on the performance on stage seen from within the audience, Cassatt stressed the individual spectator within her surroundings. In this and similar works, Cassatt sought to create the kind of genre-portrait hybrid often favored by her colleagues (see nos. 18 and 43). Its portraitlike quality has led this work and numerous others to be described as likenesses of her sister Lydia, who was forty-two in 1879, but it evidently represents instead a much younger model Cassatt often used at this time.

Cassatt's focus on the single female audience member was shared with Renoir. His painting *The Loge* (London, Courtauld Institute Galleries) of 1874 may be of special pertinence to this pastel. It shows an attractive and fashionably dressed young woman seated in a box and viewed from in front. Renoir's young woman is accompanied by a young man who looks through opera glasses, while the woman receives and returns the viewer's gaze. Cassatt's woman instead leans forward and smiles with pleasure as she looks intently out and away, enthralled by the unseen performance on stage. Her pose conveys her rapt and unselfconscious absorption. Unlike Renoir's woman, she responds to the spectacle of the theater rather than to the viewer's appraising gaze.

Cassatt evokes a sense of lively excitement and an immediacy of experience with her pictorial strategies. The oblique and elevated view, large forms pushed close and cropped by the edges, and asymmetrical organization—devices all borrowed from Degas—lend an appearance of unmediated and direct vision. Like Degas and so many of her Impressionist colleagues at this time, Cassatt investigates ambiguities in the perception and representation of space, here with the mirror behind the figure. The mirror indistinctly reflects both the figure and the dimly lit theater interior, the faint curving yellow bands representing the fronts of the tiered loges. The mirror's position and size are not clearly specified, and the distinction between the

mirror reflection and the object itself is blurred, deliberately confusing any precise reading of the forms and spaces.

As a part of her scrutiny of optical experience, Cassatt, like Degas, was preoccupied with effects of strong artificial light. Here the chandelier illuminates the figure from behind, both directly and by reflection, creating sparkling streaks and patches of light while veiling her face and torso in luminously transparent shadows. The unusual patterns suggest the peculiar lighting effects of a theater box during a performance. Cassatt's interest in these effects was noted by most critics in 1879 and 1880 and, with great approval, by Degas himself in a letter of c. 1880 where he observed that she was "at this moment engrossed in the study of reflections and shadows on skin and costumes for which she has the greatest feeling and understanding." She shows herself independent of and more adventurous than Degas, and closer to the interests of Manet and Renoir (see nos. 44 and 73), in the brilliant, high-keyed color and the broken, agitated pastel strokes. Strong colors are boldly juxtaposed and interwoven, and color is used to represent shadow, creating a vivid overall scheme. The web of crisscrossing and slashing pastel strokes, finer in the head and shoulders and more vigorous elsewhere, renders the shimmering patterns of light and expresses the physical and psychological excitement of the subject.

At the fifth Impressionist exhibition in 1880, Cassatt's work received more qualified and guarded praise than it had the previous year. *At the Theater* was singled out by most critics for its treatment of color and light and, in repeated fits of gender-induced blindness, for its lack of strength and uncertainty of execution. Its characterization by Philippe Burty was the most memorable, if unfortunately one of the most scathing: "a young person with a fish face and orange hair who is dressed in yellow muslin and seated on a tomato-colored sofa; the reflection of the furniture, costume, and hair in the mirror vaguely suggests the image of a basket of fruit."

Pastel on paper, 21¹³⁄₁₆ × 18⅛ inches (55.4 × 45.9 cm)

The Nelson-Atkins Museum of Art F77-33

Acquired through the generosity of an anonymous donor

Exhibited only at Kansas City

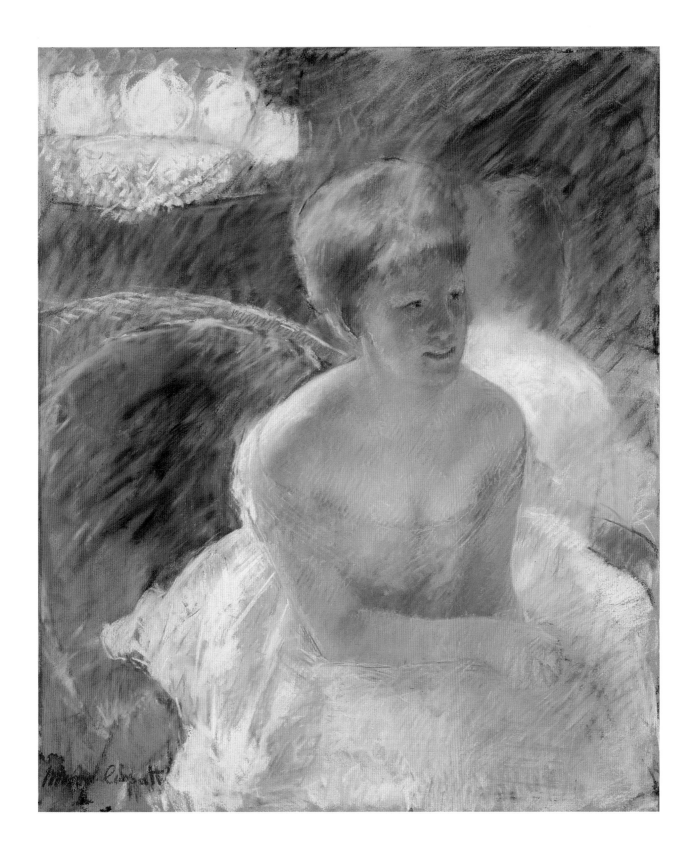

This stately canvas was painted in 1891 in the country north of Paris at Cassatt's rented summer villa at Bachivillers, according to the artist's recollections and the records of her dealer, Paul Durand-Ruel. She sold it to Durand-Ruel in August 1892 and included it in her first solo exhibition in November–December 1893 at Durand-Ruel's Paris gallery, an event that was both a critical and commercial success. The painting was sent to Durand-Ruel's New York gallery in 1895 for Cassatt's first solo exhibition in her native country and was widely shown here during her lifetime. Although it received repeated exposure in the United States, this painting, and her art in general, to Cassatt's regret, did not garner the appreciative responses that it had in Paris.

The figure in the garden was a popular subject in Impressionist painting (see nos. 59, 62, and 71), one that Cassatt had often treated since the late 1870s, and the specific theme of women picking fruit attracted Degas, Pissarro, Renoir, and Morisot in the 1880s and early 1890s. Cassatt's treatment, like similar works by Degas and Morisot, shows fashionably dressed women engaged in conversation rather than hard work. Cassatt costumed her figures in expensive couturier dresses from Paris, but suprisingly she chose as models two young peasant women from nearby. Both the dresses and the women (Clarissa standing and Celeste seated) recur in a number of other paintings and prints of that time. Cassatt's choice of models for this genteel subject was singular. Neither conventionally attractive nor stereotypically fragile, her women are robust and powerful, especially Clarissa, who was perhaps Cassatt's favorite model from 1891 to 1893. In 1911 Cassatt wrote to a friend: "So you think my models unworthy of their clothes? You find their types coarse. . . . I confess I love health and strength." She went on to describe a Botticelli Madonna in the Louvre as "a peasant girl and her child clothed in beautiful shifts and wrapped in soft veils."

If the subject of stylishly dressed modern women in everyday activities and the portraitlike fidelity to specific models persist from her earlier work, Cassatt's emphasis has nonetheless shifted away from the re-creation of momentary experience toward the statement of something more durable and serious. The composition is rectilinear and stable, the squared-off poses and gestures interlocking with the garden setting in a quasi-geometrical pattern of linking, rhyming, and echoing elements. In what appears to be a reverse pencil study for the painting, the view is oblique from below, the bodies tilted and twisted, the arms more angled, and the whole more unstable and dynamic than the painting. Space in the painting is more compressed and fitted to the figures than before, the high horizon and muted contrasts minimizing recession and flattening the landscape into a steep, vertical plane. The figures are modelled in shallow relief; the drawing is crisper and tauter, stressing arabesque and silhouette; intricate ornamental patterns and sumptuous textures are more defined; the brushwork is more controlled and less animated; the color is richer, and its harmony more subtly balanced. Cassatt stresses the creation of a deliberate, clarified, and stable order from the material of modern life.

This evolution in her style was already underway during the 1880s but received confirmation and stimulus from an important exhibition of Japanese prints held in Paris in 1890. She visited the exhibition at least twice—once with Degas and once with Morisot—began to purchase Japanese prints, and worked on translating their style into color prints. What seems to have impressed her was the crisp drawing, rich patterns, flattened space, and, especially in Utamaro, tightly knit compositions of large-scale figures cropped by the edges of the sheet.

By 1890, however, she wanted not only to transform her style but also to invest her scenes from the contemporary world with deeper meaning. In this she was inspired by the modern mural paintings of Puvis de Chavannes. Like so many of her contemporaries, Cassatt respected Puvis's modern re-creation of the classical tradition for its quiet grandeur and understated, yet evocative mood. She sought to integrate Realist imagery with allegorical content to convey meaning for the modern world. Cassatt modified the theme and amplified the composition in the central section of her mural *Modern Woman* for the Woman's Building of the 1893 World's Columbian Exposition in Chicago.

The monumental forms, stately gestures, and dignified air of her women confer on their mundane activity a classical gravity and seriousness of purpose. Cassatt has evoked a modern Eden, one, however, where there is "no serpent . . . for today the forbidden fruit is no longer forbidden," as the American critic Mariana van Rensselaer remarked in 1892. Cassatt's modern Eve serenely and confidently picks the fruit of knowledge, while remaining within the reassuringly protected and domesticated space of the walled garden, an image of woman's traditional realm. Yet if the painting suggests allegory, it also remains assertively real, an image of absorbing conversation and friendly intimacy between women.

Oil on canvas, 51½ × 35½ inches (130.8 × 90.2 cm)

The Carnegie Museum of Art 22.8

Patrons Art Fund

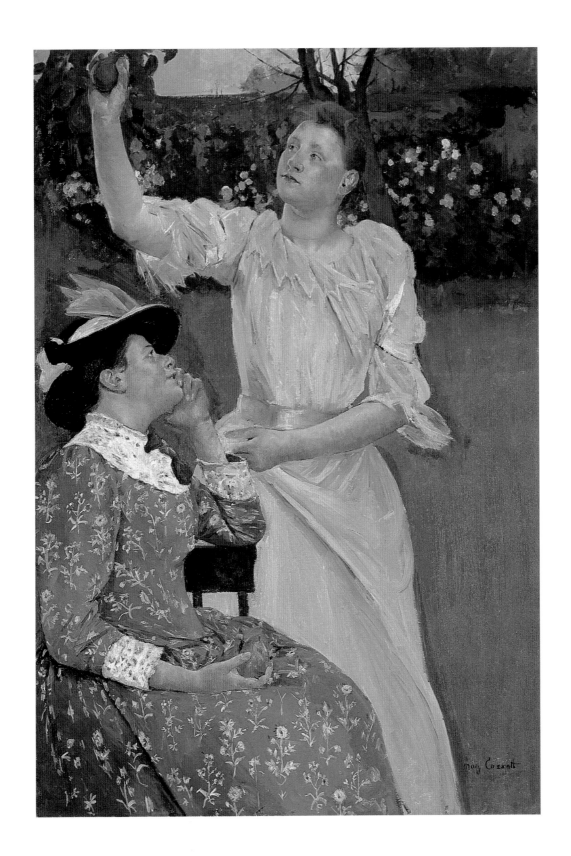

Self-Portrait

c. 1883–87

IO

In self-portraits there is typically a large element of self-revelation or self-dramatization (see no. 1), qualities not often associated with Cézanne. Among major nineteenth-century artists, however, it was he who did more self-portraits than anyone except van Gogh, painting and drawing at least fifty over the course of his career. Together they indicate a surprising degree of self-concern, even if this one, like several others, appears rather mute and restrained. Cézanne painted it in the mid-1880s but based it on a photograph dating from the early 1870s or possibly slightly earlier. This was not his usual practice, and he did perhaps only one other self-portrait from an old photograph.

Here he followed the photograph in the pose and angle of view, details of costume, and patterns of light and shadow. Since the photograph was in a vignette format, fading out below his left cuff and along his right sleeve, he added on both hands, the rest of the sleeve, and the torso below the waist, which he set behind a chair back. He seems to have had trouble with the parts that were not in the photograph, as these are more awkwardly handled and less fully developed.

In the painting, he pulled in the contours, straightened the slope of the shoulders, simplified the shape of the sleeves, and elongated the head. Evidence of these and possibly other alterations is visible in the paint surface around the head and body where the background was reworked in a slightly whiter and more opaque tone. He brought out and expanded angular zigzag rhythms in the jacket's folds, lapels, shadow patterns, and outer contours, which he played off against the more rounded forms of the head and the long, winding curves linking hands to chin. He enhanced these angular patterns with brushwork running in short, shifting sequences of loosely parallel strokes. This handling animates parts of the surface and harmonizes with the overall network of rhythmic echoes and rhymes. Modelling is suggested by directional changes in the brushwork, along with modulations in color or value and broad contrasts between the figure and the thinly brushed, translucent background.

Like Pissarro and Renoir during this period (see nos. 64 and 74), Cézanne, through his handling, sought to impose a firm order on his forms and to unify the surface of his painting. His interest here, however, must have been in something more than just the exercise of turning an old photograph into a painting, i.e., of translating patterns of light and shadow into color and brushwork, and of creating a coherent composition. From the photograph to the painting, he significantly changed the expression: the set of the body became less relaxed and assured, and the eyes, which in the photograph are focused in a confident, determined stare, were altered to gaze uncoordinated in different directions, with his right eye half-closed and averted.

Cézanne made himself appear more constrained and inaccessible—an effect reinforced by the barrierlike chair—and more inward and unsettled. His decision to paint an image of himself as he had been some fifteen years earlier strongly implies a desire to reflect on his past, something that may have been occasioned by the important changes in his life that took place in 1886. In that year he finally asked for and obtained his father's consent to marry Hortense Fiquet after having hidden or denied their relationship since 1869 and the birth of their son Paul in 1872. Later that year Cézanne's father died, leaving him a large inheritance and his long-awaited independence. Although neither the photograph nor the painting can be precisely dated, the former is of the period when his liaison with Fiquet began and his son was born, and the latter from when both were legitimized and the artist finally was granted his autonomy. This self-portrait may have been, in some sense, an act of remembrance, summation, and closure. But little of this is directly expressed in the painting, which remains introspective, melancholic, and unresolved.

Oil on canvas, 21¹¹⁄₁₆ × 18¼ inches (55.1 × 46.4 cm)
The Carnegie Museum of Art 68.11
Acquired through the generosity of the Sarah Mellon Scaife family

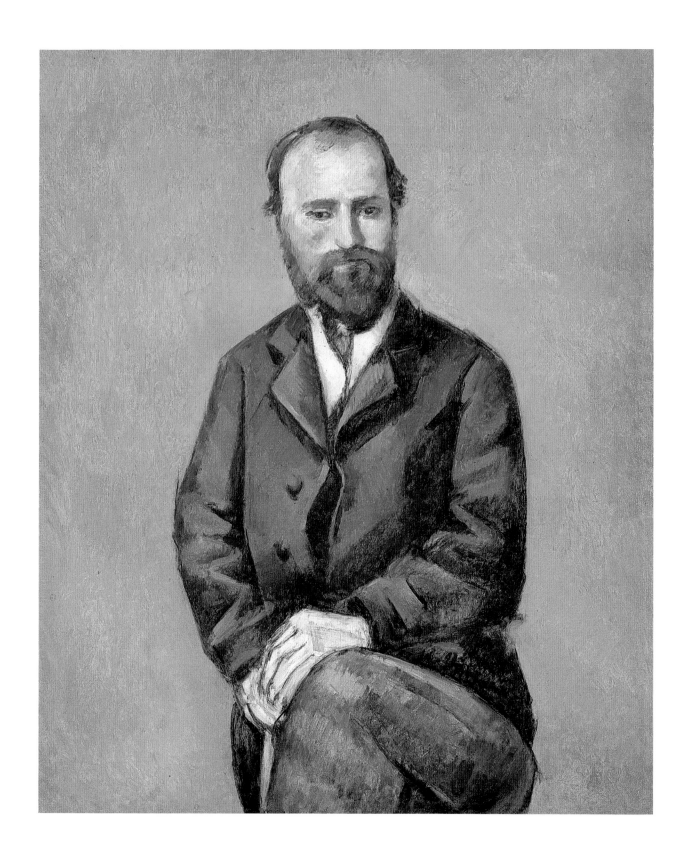

11

Chestnut Trees at Jas de Bouffan

c. 1885–87

Landscape was Cézanne's primary theme throughout his career. During the late 1870s and 1880s one of his favored subjects was the Jas de Bouffan, his family's house and estate on the outskirts of Aix-en-Provence in the south of France. The Jas had been bought as a country home in 1859 by his father, Louis-Auguste Cézanne, a wealthy banker, and remained in the family until 1899 after his mother's death. The house, dating from the seventeenth century, and the extensive grounds provided the artist with a wide range of motifs. The one he returned to most frequently was the avenue of chestnut trees that led from the gate back to the house. This is the motif that he depicted here, looking through the avenue of trees (the house is just outside the painting to the left), with farm buildings at left and right, an orchard in the middle ground, and Mont Sainte-Victoire in the distance (see no. 14). It is a winter landscape of leafless trees and bare fields.

The view is dominated by the screen of trees, a type of motif Cézanne favored (see no. 13) and one that he shared with Pissarro, with whom he had worked regularly during the 1870s and early 1880s (see no. 63). From Pissarro, Cézanne had learned the discipline of working from his direct observation of nature, from his repeated, prolonged, and careful scrutiny of the motif. Pissarro had guided him to focus on his sensations and had taught him to translate these sensations into small, varied touches of color. Like Pissarro and other landscape Impressionists, he sought to evoke the vibration and spread of atmospheric light and to convey its effects on the landscape's appearance. He became attuned to subtle variations according to time of day, weather, and season. Even as late as about 1905, he could write to Emile Bernard, in a way that recalls Monet (see no. 53), "Draw, but [remember that] it's the light reflection that is *enveloping*; light . . . is the envelope."

Here the modulated and nuanced touches of color express the action of light and atmosphere on the landscape forms: in the short, broken strokes on the ground; the softer patches and hatchings on the farm buildings and low wall; the irregular, quavery marks for the sky; and the eroded, fragmented streaks for the tangled filigree of branches. The effect of aerial perspective is suggested by the transition to washed-out tones, decreased detail, and softened forms in the orchard, farm buildings, and distant mountain. Through brushwork and color, Cézanne re-created impalpable effects and fugitive appearances on a cold, clear day.

As he and most other Impressionists had since the late 1870s, Cézanne sought to organize the observed world, to impose a taut, overall pictorial coherence onto his visual sensations. He chose a subject offering a tightly interlocking structure and comprehensive rhythm of repeated verticals and horizontals, whose larger lines he simplified and then tempered by myriad small deviations from regularity. The composition is centered and nearly symmetrical, although sighted along a diagonal from a vantage at the left, thus complicating and enlivening the appearance of order and balance. The landscape elements are disposed in a sequence of planes neatly stepped back in parallel strata into space, without resorting to conventional perspective.

Color is carefully organized following the broader compositional structure, with a single tone tending to dominate in a given area, and accents and inflections exchanged from other areas. In most places the brushwork is coordinated in sequences of regular strokes somewhat independent of the forms they represent—horizontal in the foreground, vertical in the tree trunks, and more diagonal in the wall, field beyond, distant farmhouse, and mountain. This handling, although not so systematic as it had been in Cézanne's paintings of around 1880, is taut and orderly, a development of ideas he evolved in working with Pissarro (see no. 64). But it is the intricate mesh of trunks and branches intersecting, aligning, and merging with one another and with many other elements in different spatial planes of the landscape that, more than anything else, binds the natural scene into a harmonious unity and reconciles the three-dimensional world with the surface of the painting.

Cézanne's efforts to obtain a greater coherence and structure in his re-creations of his experiences of nature are akin to Monet's and Pissarro's during these years (see nos. 52, 53, and 64). If his work differs noticeably from theirs, it is, in part, because his color is less intricate, elaborate, and complex than theirs, and his forms less subject to the dematerializing action of atmospheric light. Instead, he inclines toward a greater definition of shapes through drawing and modelling, with a greater stress on material and structural effects. But like them, he sought to reveal the harmony he found within nature, to convey here the spare and delicate beauty of the chestnut trees and countryside in winter.

Oil on canvas, 27¾ × 35⁵⁄₁₆ inches (70.5 × 89.7 cm)

The Minneapolis Institute of Arts 49.9

The William Hood Dunwoody Fund

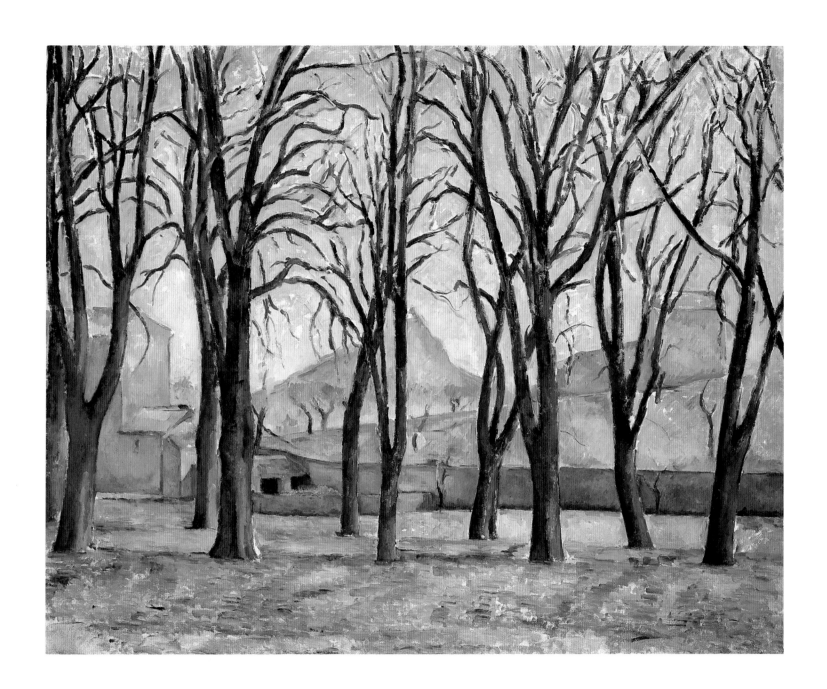

12

This painting of male bathers, which once belonged to Monet, was done in the early 1890s. It was one of Cézanne's largest and culminating statements of a theme that he had repeatedly explored since about the mid-1870s. For several decades he created variations on the same limited repertoire of figures and groupings, which he constantly re-examined in his lifelong ambition to create monumental compositions of the nude in the landscape. He was inspired in this endeavor by the grand tradition of this theme, established by such artists he admired as Titian, Poussin, and Rubens, but he sought to restate the theme in modern terms without mythology, religion, or even narrative.

After the early 1870s he rarely depicted male and female nudes together and developed, instead, two parallel series. Although his later female nudes had their origins in his early erotic images, his male bathers seem to have had their roots in idyllic memories of his youth in Aix-en-Provence, of summer days spent swimming and idling with Emile Zola and other friends along the Arc River in the valley below Mont Sainte-Victoire. Cézanne fondly recalled these experiences in letters of the late 1850s to Zola, even describing a shady pine tree on the riverbank, and Zola incorporated them into his novel of a painter's life, *The Masterpiece*, published in 1886. In his representations of the subject, however, Cézanne concentrated on creating integrated groupings of vigorous and expressive bodies. He placed his bathers in nearly timeless contexts containing only slight references to personal experience, here in the flanking pine tree and the vague form of Mont Sainte-Victoire in the distance.

While he executed his landscapes, still lifes, and the majority of his portraits from direct observation, for his bathers, both male and female, he depended on his study of the old masters and classical sculpture, on his own early academic drawings, and on his imagination. He seems to have felt strong inhibitions about working from the nude model and to have conceived of the subject as an Arcadian vision, rather than as a scene from the observed world. Over the years he built up a relatively small group of poses, which he often borrowed and adapted from his extensive copies of older art, although he avoided direct quotation in constructing his compositions.

In the Saint Louis *Bathers*, the left standing figure was derived from a Signorelli drawing, *The Living Carrying the Dead* (Paris, Louvre), of which Cézanne owned two reproductions and made repeated copies beginning in the late 1860s; this was fused with features of a Roman marble in the Louvre then known as *The Roman Orator*, also repeatedly copied. The right standing bather was also inspired by a Signorelli drawing of a nude (Paris, Louvre) that he had first copied in the 1880s; this was joined with elements from Michelangelo's *Dying Slave* in the

Louvre, which he had also copied. Cézanne had recourse to these and other works not only to furnish himself with usable poses, but also for the model they provided of sculptural power, muscular vitality, and rhythmic vigor. He reimagined and rephrased what he borrowed, creating nudes that are generally bulkier and more strained and awkward than their models, but whose distortions make them singularly robust and animated.

He charged and modelled his figures through their accentuated contours, which he repeated and varied to convey shape, volume, weight, movement, and strength. Contrasts of warm and cool and delicate modulations of color also suggest modelling and the play of light. He linked the figures with their surroundings through color —repeating their orange-pinks and blues in the earth, water, and sky—and diffused the energy of their bodies throughout in the lively sequences of hatched brushstrokes.

He grouped the figures tightly in a shallow frieze spanned by a broad arc and framed at both sides by trees rhyming with the outer figures. The design seen here, with two central, standing figures viewed from behind alternating with others seated, bending, or immersed in the water, was one he used constantly from the 1870s for his male bather compositions. This one, in particular, was based closely on a watercolor of about 1885–90 (New York, Museum of Modern Art). He established interconnections among the elements of the scene by the repeated contacts, crossings, rhythmic echoes, and mergings. Through such unexpected congruities and continuities as the peak of the distant mountain intersecting with the towel that covers the hand of the standing bather, linking with the head and spine of the bather seated below, and then again with the towel lying on the bank and the foot of the bather standing adjacent, Cézanne created a taut and rigorously cohesive composition.

Through the finely meshed composition, Cézanne expressed his vision of a harmonious accord among men and between man and nature. He conveyed powerful but unspecified emotions in his bathers in a scene of natural rejuvenation. In his images of male bathers, he restated the European tradition of the nude in terms of his private world of memories and dreams.

Oil on canvas, 20¾ × 25¼ inches (52.7 × 64.2 cm)

The Saint Louis Art Museum 2:1956

Gift of Mrs. Mark C. Steinberg

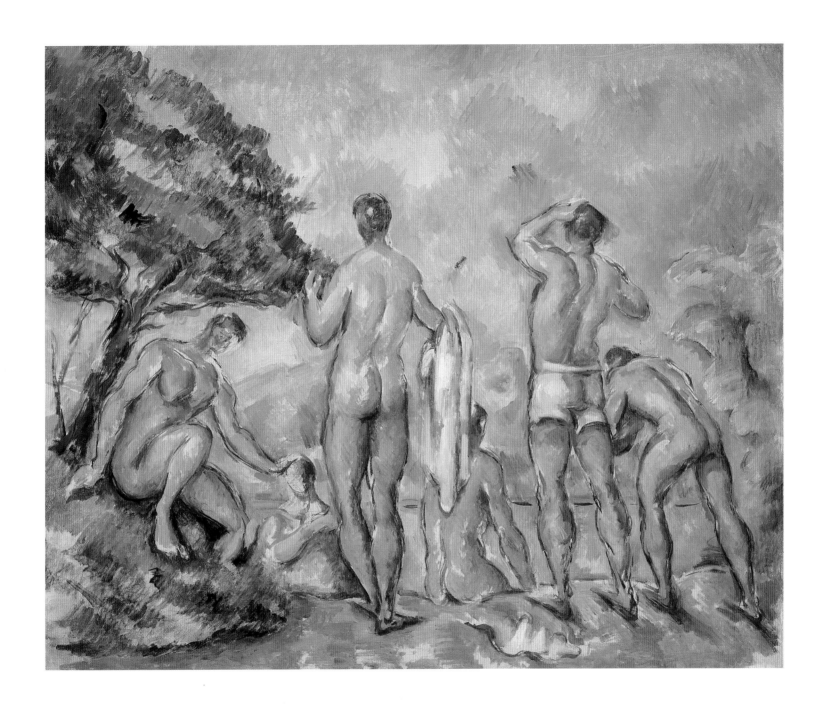

13 *Landscape near Aix, the Plain of the Arc River*

c. 1892–95

Cézanne often painted the valley of the Arc River in the country-side outside Aix-en-Provence. He represented it here, showing little interest in topographical precision, from a slightly raised position behind a screen of pine trees through which its farmhouses, fields, and vegetation are partly seen. This type of motif was one he had favored since the 1870s (see no. 11), a fascination that he shared with his friend Pissarro. Like his Impressionist colleague, he remained committed to realizing, in his words, the sensations he experienced before nature. Here, as Pissarro had in certain works of the late 1870s (see no. 63), he seems to have been concerned with exploring the imprecise distinction between sensation and perception. He brought out the irregularity and diversity of the scene before him, expressing through the seemingly random discontinuities, fragmentations, and elisions the instability, confusion, and complexity both of nature itself and his experiences of it. He seems not to have been looking at distinct and separate things, but at how they are seen together, at how they interact and interrelate in sight.

He could simply observe to the painter Emile Bernard around 1904 that painting from nature "is realizing one's sensations," but could also tell him:

There are two things in the painter, the eye and the mind; each of them should aid the other. It is necessary to work at their mutual development, in the eye by looking at nature, in the mind by the logic of organized sensations, which provides the means of expression.

In these remarks and elsewhere, he repeatedly indicated that painting for him was as much a question of creating pictorial unity and coherence as of translating his direct experiences of nature—that it was for him the making of a deliberate and ordered re-creation of his confused sensations.

In this view of the Arc valley, color, which is stronger and less naturalistic than before, conveys the intense southern sunlight, differentiates forms, and expresses modelling and distance, while also binding together elements separate in space through a network of interchange and recurrence. The broken, rhythmic brushwork animates the forms and suggests the shapes and textures of the natural scene, but also blurs the distinctions and furnishes an overall structure through the sequences of freely parallel strokes. Although he often said that in nature "there is no such thing as line," he used a kind of fragmentary drawing, which he laid in early and, in places, reinforced later, to define and place objects—to help to express what he called "the breaks in space" established by color and brushwork. But through the ragged gaps in the drawing, things adjacent only in sight seem to open and merge one into the other.

Above all, it was through the pattern and handling of the screen of trees that Cézanne knit the elements of the view into a coherent whole. In the intricate tangle of trunks, branches, and foliage, each shape seems to respond to the pressures and attractions of others located nearby—both in actuality and in sight—crossing, touching, bending into and out of alignment among themselves and with other parts of the scene. A branch at center curves down to, joins, then strays from the distant horizon, its arc echoed by branches above and below, and extended and modified by branches to either side. Things located in separate places and distinct planes are linked and related, thus collapsing the spaces and unifying the surface. As he wrote to his son Paul in 1906, to make a picture harmonious "is all a question of establishing as much interrelation as possible." He made from his endlessly varied sensations of a world in continual flux a logical and enduring order.

Oil on canvas, 32½ × 26 inches (82.6 × 66 cm)

The Carnegie Museum of Art 66.4

Acquired through the generosity of the Sarah Mellon Scaife family

<div align="right">

Paul Cézanne
1839–1906

Mont Sainte-Victoire
c. 1902–1906

</div>

From the 1880s until his death in 1906, Cézanne was deeply fascinated with Mont Sainte-Victoire, a large mountain about twelve miles to the east of Aix-en-Provence. It was the most prominent landmark in the region and a popular motif in the nineteenth century with local artists. It must have held great significance for Cézanne, as he repeatedly depicted it, especially late in his life, but since he rarely discussed his subjects, he left no explanation of what it meant. Over the years he painted the mountain from many different sides, angles, and distances, and under varying effects of light.

The view here was made from the steep slopes above the studio Cézanne used from late 1902 on the hill called Les Lauves just to the north of Aix. He had built the studio to work on his large bather compositions but also discovered nearby a new and exciting view of Mont Sainte-Victoire. During his last four years he represented this view over twenty-five times in oil and watercolor from different positions on the hillside, varying the angle, framing, weather, and light, as well as the size and shape of the support. From Les Lauves he had a vast panorama at his feet, here with a sloping meadow and trees below, and a broad plain with fields, houses, and vegetation beyond, from which Mont Sainte-Victoire rose abruptly and dramatically in the distance.

In these late views, he minimized the evidence of human presence. He stressed the extraordinary extent of the landscape and the craggy profile and rugged bulk of the mountain. He reduced the effect of complexity and diversity seen in his earlier landscapes (see no. 13), concentrating instead on a relatively spare design of broad horizontal zones broken by the rising forms of the mountain, which are here faintly echoed in the largest of the foreground trees. More than ever, he obliterated small distinctions and merged separate forms, forcefully subordinating the individual elements to the pictorial whole.

He translated his sensations of nature into small colored patches of paint, through which he created modelling and depth, structure and surface. The patches were formed from small sets of parallel strokes or were laid on in broad, flexible touches. Their general shape and scale are largely maintained throughout, and their relative uniformity provides scant indication of the features and textures of the landscape. The patches are oriented predominantly along horizontal and vertical axes, and are organized following the broad lines of the landscape, thereby producing an arrangement that gives structural coherence to the entire composition. Deviations from regularity suggest something of the variety of the landscape and indicate modelling, especially in the tiered foliage of the foreground trees, the angled and canted planes of the mountain, and the arcing diagonals of the sky. But it is through color, more than anything else, that Cézanne expressed distance and modelling.

In his late works, color is more somber and muted than in the decade before, while similarly serving to bind the whole image together through sequences of repetition and variation. Each patch of color is modulated in hue, value, and intensity in relation to adjacent ones, thereby subtly evoking volume and depth. As he observed to the painter Emile Bernard in 1904: "Modelling results from the exact relationship of colors. When they are harmoniously juxtaposed and complete, the picture develops modelling of its own accord." He also remarked in 1906 to Karl Osthaus, a German collector, that "color has to express all the breaks in space." In many places he clarified the spatial function of his color by adding contours to a color patch or to a small group of patches. Such drawing helps to distinguish between contiguous planes, while simultaneously allowing them to fuse through their breaks and ragged edges. At the same time that the colored patches evoke space, such mergings, along with their shape and orientation, act to dissolve volume and interlock near and far in a unified surface pattern.

This sense of order is, however, confounded by a new restlessness and emotional intensity: the surface appears more agitated and pulsing, the color heavier and more somber. Cézanne's late images of Mont Sainte-Victoire often became intensely private meditations on the solitary grandeur of the mountain and the immensity of the visible world, while also expressing his continued struggle to realize his sensations of nature. A month before his death in October 1906, he wrote to his son Paul:

I must tell you that as a painter I am becoming more clear-sighted before nature, but with me the realization of my sensations is always painful. I cannot attain the intensity that is unfolded before my senses. I do not have the magnificent richness of coloring that animates nature.

Oil on canvas, 25⅛ × 32⅛ inches (63.8 × 81.5 cm)
The Nelson-Atkins Museum of Art 38-6
Nelson Fund

15

Portraiture occupied a significant place in Degas's work and was for him a far more challenging subject than for any of his Impressionist colleagues. About one-fifth of his enormous production was devoted to portraiture; it was a special focus of his attention in the 1860s and early 1870s. His ambition was to make of portraiture something more than a pleasing reflection of the sitter's own high opinion. He rarely took on a portrait commission and chose his sitters instead from relatives and close friends, freeing himself from paying customers who expected propriety and flattery delivered to order. Degas sought to present the physical, social, and psychological reality of his chosen sitters, to summarize in a fleeting glance, a passing gesture, a casual pose, a specific and modern individual. During the late 1860s he intensified the exploration of the pictorial expression of character and personality that already had begun to germinate in his earlier portraits. He read traditional and modern theories of physiognomic expression, jotting in his notebook a reminder to make his figures a study of modern feelings and to integrate their surroundings with them. A few pages later he wrote, "Do portraits of people in familiar and typical attitudes, above all give to their face the same choice of expression that one gives to their body."

It was during this period that Degas developed and executed his portrait of Victoria Dubourg (1840–1926). She was an accomplished painter of floral still lifes who regularly exhibited at the Salon from 1869. Degas undertook her portrait between about 1865 and 1868, the dates of a notebook in which a study for her portrait appears. The painting seems never to have been completed to Degas's satisfaction, as it was neither signed, exhibited, nor delivered to the sitter but, like many others of his portraits, remained with the artist until his death.

He approached the composition carefully and methodically, in a traditional manner much like that of his early idol, Ingres. Of the four surviving studies, the earliest lays out the basic compositional idea. Before beginning the painting, he seems to have decided to turn the figure's head to the right and recast the surroundings, adding a fireplace, mantel, mirror, and vases on the right, an empty chair in place of the window on the left, and two paintings, one above the other, on the wall to the left of her head. In one of two careful and refined drawings, he worked out the new view of the head, studying the position and glance as well as the lighting, and in the other, the exact pose and modelling of her clasped hands.

After working up the composition on the canvas, Degas rethought parts of it in a small drawing. He then reworked the painting (as he had probably already done more than once), redoing the left side of the dress and repositioning the folds, going back over her hands and sleeves, changing the height of the chair backs and struggling with the

perspective and cast shadows of the empty chair (probably taking out an object resting on the seat), repainting the mirror and flowers, and painting over the two framed canvases on the wall at center. The multiple revisions and provisional adjustments left undecided are still evident in the painting's surface. At this point in his career, Degas's expectation was that a finished painting would show no trace of the artist's working procedures and would, like the canvases of the greatly admired Ingres, be smoothly polished.

Degas struggled to create a deceptively casual and seemingly fortuitous composition of unexpected asymmetries and croppings that would convincingly re-create the ways that one might actually see and experience a person in a setting appropriate to her. The elaborate and fully described setting here may be yet another thing he owed to Ingres (and certain details may even allude to that debt), yet the intelligence, warmth, candor, intimacy, and informality of pose and expression are far outside the conventions of Ingres's portraiture. Indeed, Degas seems to question, in this and other female portraits, not only conventions of portraiture but even assumptions about gender and its representation. In place of the typical emphasis on dignity and prosperity or grace and coquetry, Degas offers an inquiring intelligence and relaxed frankness more often seen in male portraits.

What Degas withheld from his unconventional image of Victoria Dubourg, however, was any sign that she was an artist. In his portraits of the painters Manet (c. 1864–65) and Tissot (c. 1866–68), for instance, Degas situated each in a studio surrounded with paintings. But for Dubourg he removed from the wall behind her the paintings that would have been her "accessory symbols," leaving only the rather stereotypically domestic environment of fireplace, ceramic pots, flowers, and mirror.

Oil on canvas, 32 × 25½ inches (81.3 × 64.8 cm)
The Toledo Museum of Art 63.45
Gift of Mr. and Mrs. William E. Levis

Degas was generally unsentimental about children, but he did like them and occasionally portrayed them, especially the children of his closest friends. Hortense Valpinçon (b. 1862) was the young daughter of Degas's lifelong friend Paul Valpinçon. His father, Edouard, in turn, had been a friend of Degas's father and was renowned as a leading collector, most notably of Ingres, whose early *Bather* (now in the Louvre) still bears the family name. Beginning in 1861 Degas often visited Paul Valpinçon at his estate Ménil-Hubert near Ornes in the lush countryside of Normandy. It was to Ménil-Hubert that he retreated in May 1871 following the siege of Paris and where he remained for two months during the short-lived Commune.

According to Hortense's recollections sixty years later, the artist's visit was made in haste and, since the idea of a portrait was impromptu, he had not brought his usual painting materials. For this portrait, she recalled, he rigged up a stretcher and used a piece of mattress ticking. This charming account is nonetheless unlikely, since the painting was executed on a heavy, herringbone-weave fabric of a standard type commonly sold for painting. It also leaves unanswered the question of how he improvised brushes, paints, and priming.

She also recalled that the quarter of an apple she holds was what remained of the reward for good behavior during the sitting. But Degas seems to have given greater significance to this piece of apple held poised between plate and mouth. He carefully placed the hand holding it on the center axis of the canvas and repainted it at least once, raising it clear of her other hand and isolating it more against the background. He never fully resolved this area, but continued to revise and rework the right arm and both hands. He previously had made significant changes on the left side of the canvas, scraping away and repainting the area above the sewing basket (the physical evidence is too inconclusive to deduce what had first been there). He was to continue to reconsider the contour of her back, testing ways to sharpen and enliven its definition. Despite the slightly provisory state of the canvas, Paul Valpinçon persuaded Degas to deliver it over to the family as is, rather than sacrifice what he had already achieved to his obsessive perfectionism.

The composition is striking and unusual. The long horizontal format is unexpected for a single-figure portrait and allots a far greater place than usual to the environment. With the composition shifted to the left, the objects are aligned along a rising and receding diagonal that forms a base for the sides of the abruptly truncated pyramid established by the child on the right and the canted mass of yarn and fabric on the left. The dynamic effect of this asymmetry is amplified in the interplay of the complex and varied patterns and colors of the wallpaper, the embroidered table cover, and the needlework spilling from the basket. The muted blocks of color that compose the figure play off against the liveliness of the setting.

If the emphasis on enveloping pattern, shallow space, and uncentered composition owes something to Japanese art, it is not a specific debt but one at the level of general principles. What may have been as germane to the invention of the image was one of the horizontal versions of Chardin's *Boy with a Top* or *House of Cards*. Chardin was by the 1860s firmly established as a significant figure in the genealogy of French Realism. His images of a child playing with ordinary objects that also serve as symbols may have had meaning for Degas not only for the unusual horizontal composition, but also for the way in which the ordinary is invested with great significance.

The apple that Degas troubled to emphasize in Hortense's hand seems as much a traditional symbol as it is an accessory to an anecdote. Within an environment filled with signs of her mother, the apple Hortense holds part way to her mouth and her subtly inquiring, even challenging expression may signify her nearness to the knowledge that will separate her from her still-childish innocence. That suggestion is reinforced by the firm handling of the face and jaw, the tightly curving lines of the hand gripping the apple section, and the taut arcs of the body that impart a somewhat tightly strung and determined quality.

Hortense is characterized by suggestions of impatience, or at least of fidgetiness, inquisitiveness, and self-confidence, and perhaps a sly mischievousness. Degas offers an acute and seemingly truthful image that calls into question the stereotypical representations of children. As against a commonplace view that considered children to be without specific personality of their own, Degas defines a markedly distinct individual. She is neither the sweet cipher nor the miniature adult that convention construed, but instead a complex, convincing, engaging, and memorable child.

Oil on canvas, 29¹⁵/₁₆ × 43⅝ inches (76 × 110.8 cm)

The Minneapolis Institute of Arts 48.1

The John R. Van Derlip Fund

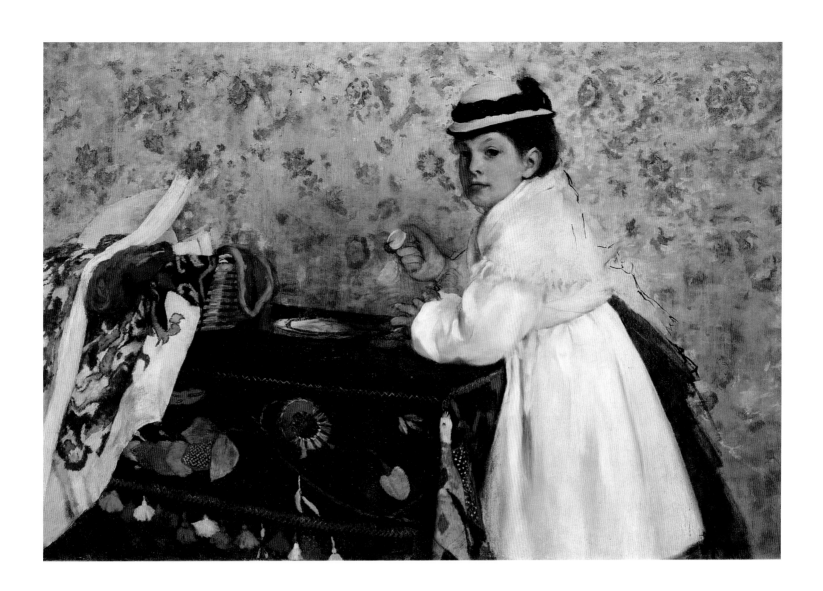

17

Of the lifelong friends Degas met as a young man, the one to whom he grew and remained closest was Henri Rouart (1833–1912). Degas and Rouart lost contact with each other as they pursued separate careers, Rouart first in the military and then engineering. They renewed their friendship in 1870 during the Prussian siege of Paris when Degas, by chance, was assigned to the artillery battery commanded by Rouart. From then until Rouart's death in 1912, they saw each other at least weekly, Degas nearly becoming a part of the family. Degas and Rouart carried on a regular correspondence when they were apart, at times revealing, on Degas's part, an emotional bond of unexpected intensity. He wrote to Rouart on August 8, 1874: "The heart is like many an instrument, it must be polished and used a lot so that it shines and runs well. As for mine, it is you who polish it, rather than its owner."

Rouart had an avid interest in art. He was a fine connoisseur, assembling an extensive collection of old and modern masters. A serious artist himself, Rouart primarily painted landscapes in a Barbizon-influenced manner, showing them at the Salon from 1868 to 1872 and then with the Impressionists at seven of their eight exhibitions. It was at the third Impressionist exhibition of 1877 that Degas showed this portrait of Henri Rouart, probably painted a few years earlier. Rouart participated that year in three ways: as artist, as collector (he lent this and another Degas), and as portrait subject.

The image of Rouart that Degas presents, however, is not that of artist and connoisseur, but of engineer and entrepreneur. Rouart held several patents for diverse mechanical inventions; he was a pioneer in the field of refrigeration mechanics and the joint head of a prosperous metallurgical enterprise. Degas portrays him finely dressed in a top hat and velvet-collared overcoat standing amid railroad tracks that lead back to coal piles and a smoke-belching factory. It is Rouart epitomized as the successful industrialist, standing before the factory that is an emblem of his profession and a sign of his achievement. Degas is, however, only generally concerned with the nature of Rouart's work, labelling him but not specifying the particulars of his occupation. Degas's profound artistic interest in work, in the form both of genre subjects and portraiture, encompassed laundresses, milliners, prostitutes, dancers, ballet masters, jockeys, authors, artists, even, one might say, dandies, but seems to have stopped short of the engineer-industrialist.

His image of Rouart does, however, convey the respect he felt for his friend's accomplishments. He profiles the figure against the landscape and directs his gaze to the side, disengaging him from both the viewer and from his environment. The profile view is cool and distant, offering a description of his features and bearing, but no access to his character. Degas organized the setting to express a quality of effortless control and domination in his sitter. The looming figure imposes himself on the landscape through a discrepancy of scale that is abrupt and unmodulated. The figure is set against, rather than within, the represented space, a dramatic juxtaposition in which space is telescoped and flattened. The setting seems to organize itself around the figure. The high horizon passes through his head, and the railroad tracks converge on his far eye and align themselves with the contours of his body. The factory buildings lock in tightly around his head, establishing rhymes of color and shape between their roofs and smokestacks and his costume and features. Even the piles of coal have the peculiar effect of seeming like appendages to his head. The environment is compressed and geometrized, painted broadly in flat planes and horizontal and vertical strokes that contrast with the irregular shapes, tight drawing, and full modelling of the head. The effect is that of a top-hatted ruler who quietly commands the scene.

The compositional and spatial ideas that Degas develops here may have had their sources in the long-outdated conventions of fifteenth-century Italian profile portraiture. The dominating bust-length figure silhouetted in profile against a distanced landscape and the discontinuities of near and far may have been suggested to Degas by Renaissance models. He was familiar with earlier Italian art from years of study and retained deep admiration and respect for it throughout his life. In his desire to find modern forms for portraiture and in his re-examination of the conventions of perspective and composition, he repeatedly saw the relevance of the old masters. Not long before painting Rouart, he wrote in a notebook he used in the late 1860s, "Ah! Giotto! let me see Paris, and you, Paris, let me *see* Giotto," and later was to remark more prosaically that "the secret is to follow the advice the masters give you in their works while doing something different from them."

Oil on canvas, 25¹³/₁₆ × 19⅞ inches (65.6 × 50.5 cm)

The Carnegie Museum of Art 69.44

Acquired through the generosity of the Sarah Mellon Scaife family

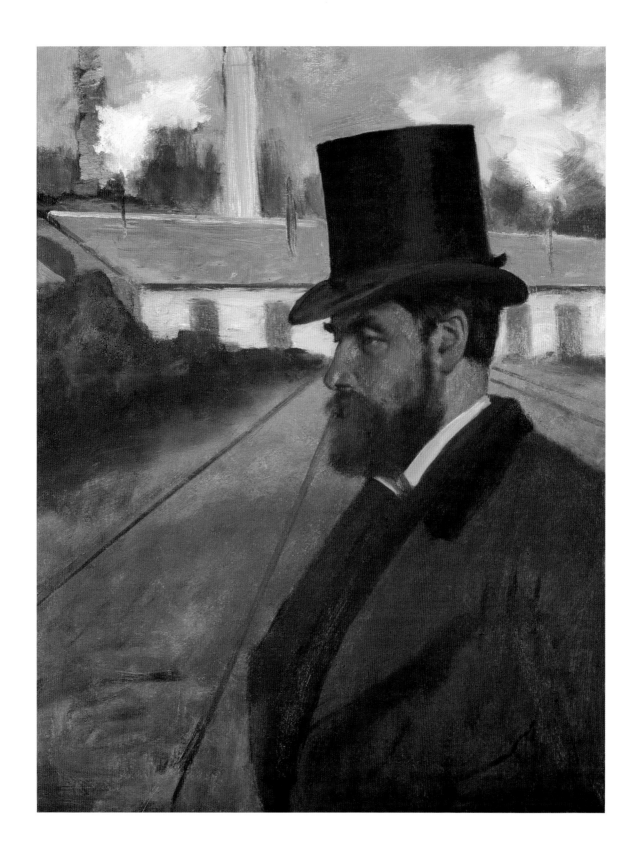

By 1874 Degas had already established a reputation for himself as a specialist in dance pictures. Ballet was an unusual subject for high art, the only real tradition being the portrait of a dance star in her most famous role. There were many reasons for his fascination with the dance. It was a familiar part of the urban scene to the bourgeois male and was one of the principal Parisian entertainments. It was a characteristic type of women's work, yet was also, as he seems to have persuaded himself, "all that is left of the synthesized movements of the Greeks." He may have seen in it analogies to his own art, as both were highly formalized, disciplined, and deeply informed by tradition, yet made to seem free and effortless. He seems to have found appealing the conflict inherent in the subject between artifice and nature, between the charmed and make-believe world of choreographed gestures, fantastic costumes, and painted scenery and the mundane reality of women rehearsing, waiting, stretching, and scratching, accompanied by male onlookers.

Part of what initially seems to have made the subject attractive was the potential to pursue the study of modern male–female relations that Degas had undertaken in some earlier works. Here a dark-suited subscriber observes quietly from the side while the ballet master directs the rehearsal, both men playing privileged roles within the scene. The figure of the wealthy subscriber was a ubiquitous one at the Paris Opéra. Given free run of the theater, he had a reputation for prowling the practice rooms and stage during rehearsals, the wings and corridors during performances, and the dressing rooms and foyer during intermissions. Despite his privileged position, he is treated here with a degree of mockery. He is made exaggeratedly tall and gawky, ignominiously clipped by the frame, and juxtaposed to a delicate disembodied leg emerging from behind him.

Degas represents the dancers in often unexpected ways. While the principal dancer is graceful and glamorous, the others are given awkward and unselfconscious attitudes and lack altogether any air of charm or seduction. The stereotype of the dancer established in literature and popular prints was that of young and pretty girls, suggestively attired and coyly flirtatious. Degas's image undermines these clichés and restores his dancers to the world of work.

If Degas's general attitude was one of detachment touched with irony, the commanding gesture and firm stance of the ballet master suggest instead a certain admiration and respect. It is a portrait of Jules Perrot (1810–1892), one of the most acclaimed dancers and choreographers of nineteenth-century ballet. Degas had twice previously represented Perrot teaching a dance class, although it is not certain that he actually worked at the Opéra during the 1870s. Perrot had long been retired, but in these works Degas offers an unusual homage to this legendary artist, representing him in a way that conveys a great deal about his profession and character. It is an unconventional portrait, one that assumes the appearance of an anonymous scene from everyday life.

Degas's study of the modern urban world entailed an investigation of how one sees and experiences. In the *Ballet Rehearsal*, the view is raised and angled, as if from an imaginary box near the side of the stage, rather than from front and center. Perrot is seen from behind while other figures are cropped at the edges, blocked and fragmented, or drastically foreshortened, thus denying them the expected sense of order and completeness. The composition is made to seem random and dispersed, without balance and coherence, expressing the fugitive and contingent character of vision and experience.

The effect of immediacy and informality was the product of elaborate compositional processes. In general, Degas worked with a relatively limited repertoire of motifs that he repeated, revised, and recombined. The two principal figures here had already seen repeated use in two distinct sequences of pictures. They were combined for the first time in a monotype print of c. 1876, Degas's first and largest, which he made with the assistance of his friend Ludovic Lepic and which both men signed (Washington, D.C., National Gallery of Art). Degas alone completely worked over this second (weaker) impression in pastel and gouache using the monotype base as a point of departure.

In his extensive reworking of the monotype, Degas expanded his original composition of two figures, including from the beginning the three dancers on the left around Perrot and later adding the subscriber and the dancer's leg on the right. He developed the drawing, lighting, modelling, and details of setting, costume, pose, and expression that were only broadly defined in the monotype. In this deliberate and extended process, Degas, as the poet Paul Valéry wrote, "dared to try to combine the snapshot with the endless labor of the studio, enshrining his impression in prolonged study—the instantaneous given enduring quality by the patience of intense meditation."

Gouache and pastel over monotype, 21¾ × 26¾ inches (55.2 × 68 cm)
The Nelson-Atkins Museum of Art F73-30
Acquired through the Kenneth A. and Helen F. Spencer Foundation
Acquisition Fund

Exhibited only at Kansas City

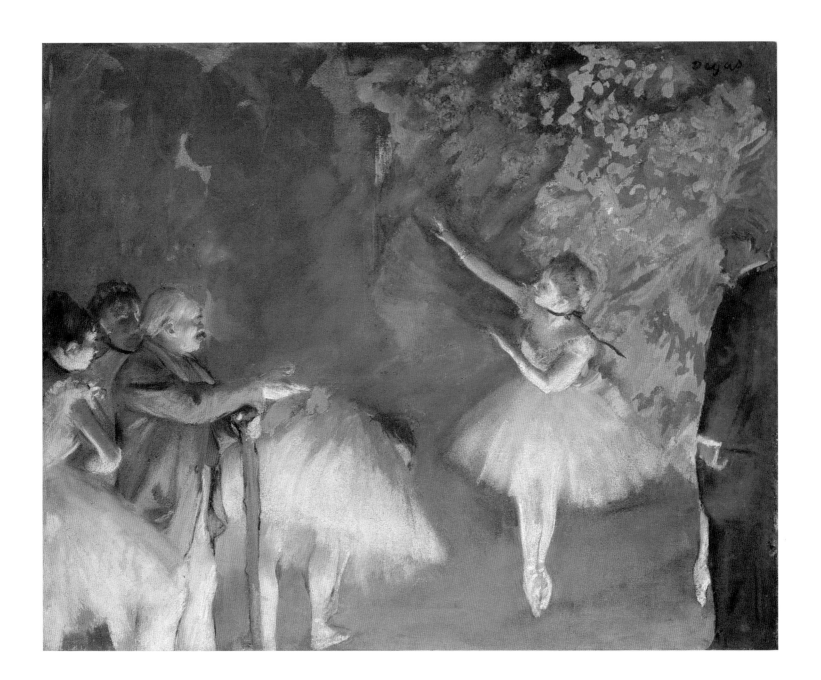

Degas displayed his fascination with the subject of milliners in a group of about ten works made c. 1882. When asked what he found so appealing about this subject, he reportedly quipped, "The red hands of the little girl holding the pins." It was one of several types of working women that Degas studied during the 1870s and 1880s, among them dancers, café singers, prostitutes, laundresses, and ironers. The essential starting point in each instance, much like that for the Naturalist novelists Zola, Duranty, and the Goncourts, was a careful scrutiny of the actions and gestures most characteristic of a profession. He paid visits to the shops of fashionable milliners in the company of Mary Cassatt or Geneviève Straus, Bizet's widow and Degas's devoted friend.

It was a subject that Degas had treated once before in a work shown at the 1876 Impressionist exhibition and that Manet's pupil Eva Gonzalès and Manet himself had depicted in about 1877 and 1881 respectively. The evident attraction of the subject to artists devoted to modern urban life had its roots in Baudelaire's stress on the importance of fashion in his essay *The Painter of Modern Life* and elsewhere—as perhaps more than anything else epitomizing the transience of the contemporary. Baudelaire exhorted artists to observe and record fashion so that each would become "the painter of the passing moment, and of all the suggestions of eternity that it contains." Degas may also have responded to Baudelaire's argument for the superiority of artifice over nature and his praise of fashion as a repeated attempt to reform "Nature" in the direction of "Beauty."

For both Degas and Baudelaire, the fascination with fashion was likely to have been stimulated by their interest in popular Romantic prints and journalistic illustration. Millinery shops were often depicted by such artists as Gavarni, whose work Degas admired and collected. These images expressed the nearly ubiquitous assumption of the sexual availability of young working-class women who were represented as charming and flirtatious with no real evidence of their hard labor. As he often did for the subjects he took up, Degas subverted public expectations of sexualized images of women, offering instead modestly dressed, ordinary women deeply absorbed in their work. In the *Little Milliners*, physical entry is blocked by the worktable and psychological access deflected by the turned bodies and averted gazes.

Degas's own complex feelings about his subject are partly revealed in Berthe Morisot's recollection (possibly colored by her own biases) that he "professed the liveliest admiration for the intensely *human* quality of young shopgirls," suggesting that something present in them was found more often lacking in other members of their gender or class. Such an attitude of subtle superiority was reinforced when this picture was shown in 1886 at the eighth (and last) Impressionist exhibition under the diminutive title *Petites modistes* (Little Milliners). A comparable view was expressed in the review of Gustave Geffroy who, like other critics, paired it with another pastel of a millinery shop, despite noticeable differences in size. The latter, entitled *Woman Trying on a Hat at Her Milliner's*, presents a customer standing before a tall mirror to assess the effect of a hat. Geffroy called the customer "graceful" and compared her "astonishing silhouette" to a "frescoed profile against a gold ground," an allusion to Degas's beloved early Italian noble portraits. Of the shopgirls in the *Little Milliners* he wrote, "They possess a suburban grace with their monkeylike movements," equating their place in the social order (suburban, working class) with that in the natural order (monkeylike). Other critics were equally ideological, if more fully sympathetic to the milliners. Jean Ajalbert described them as anemic and ragged, and identified them as "surely those who earn two francs per day, composing hats of twenty louis, waiting to deliver them," words perhaps more deserved by Signac's large canvas of two milliners in the same exhibition. Even Degas's friend George Moore, in a passage in his novel *Confessions of a Young Man* (1888) devoted to this exhibition, dramatically wrote of "the years of bonnet-showing and servile work these women have lived through" and in his 1890 article on Degas called this picture "full of the dim, sweet, sad poetry of female work. For are not those bonnets the signs and symbols of long hours of weariness and dejection?"

The impact of Degas's mute social narrative is strengthened by his precise observation of costume, gesture, and physiognomy, expressed both in finely wrought descriptive passages and in telling use of silhouette. The shallow friezelike space, large-scaled figures, and relieflike conception of form that increasingly characterized his work from the late 1870s intensify the striking visual effects.

Pastel on paper, 19¼ × 28¼ inches (49 × 71.8 cm)

The Nelson-Atkins Museum of Art F79-34

Acquired through the generosity of an anonymous donor

Exhibited only at Kansas City

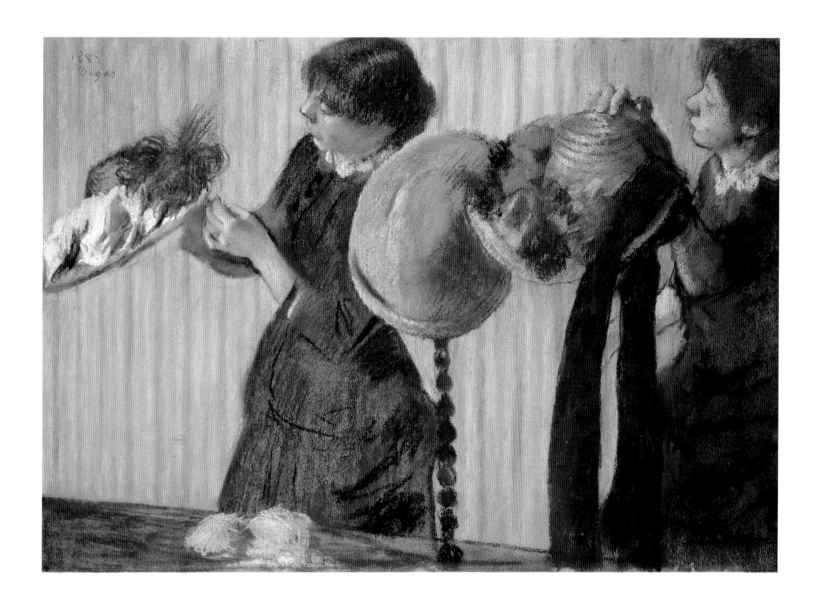

The female bather was a subject with which Degas was obsessively preoccupied during the last three decades of his career. He increasingly focused on it from the mid-1880s, making it one of the favored subjects in his diminishing repertoire. He found in it the possibility for unlimited variations and recapitulations on related themes.

This painting was prepared by four charcoal and pastel drawings. In this sequence of studies, Degas considered the pose and foreshortening of the bather and her position in the tub, and worked away from a more naturalistic conception toward a more abbreviated and schematic one. For the painting, the composition was extended to the right to include the curtained-off bed, making it a larger than usual work for Degas at this time. From the late 1870s he had increasingly favored pastel and executed the majority of his bathers in that medium, but here, in what was presumably intended as a major statement, he worked in the more conventional medium of oil on canvas. His technique, however, was unorthodox, the paint applied with rags and fingers as well as brushes, and laid on with a bold vigor absent from his earlier work.

From the early 1880s to the early 1890s Degas's work shifted away from naturalism and individual characterization toward a heightening of pictorial expression. More clearly than before for Degas, "Drawing is not the same as form, it is a way of seeing form," as he so often liked to say. The play of light and shadow is simplified and abbreviated and treated more as rough patches than as continuous gradations. Color is markedly intensified and handled intuitively and arbitrarily, in place of the muted, restrained, and more conventionally descriptive schemes of his earlier art. A free pattern of disks, streaks, and splotches of color is widely distributed, shapes are juxtaposed and interlocked, and space is collapsed, all linking near and far into a unified decorative image. The composition is animated by a powerful tension between controlling line and explosive color, artful structure and improvisatory freedom, modelled forms and spaces and decorative surface unity.

Degas's interest in the bather theme was an outgrowth of his early artistic education, since the nude was considered a fundamental component of history painting. His bathers may have been contemporary Parisian women rising from their bed to take their bath, but they often contain reminiscences and references to the Venuses, Susannahs, and Bathshebas of Western tradition, to Ingres's odalisques and Turkish baths, and to Japanese prints. Here the inspiration was a powerfully energetic male bather from Michelangelo's *Battle of Cascina* that Degas had copied from an engraving at least four times about 1856–57. Degas realized that the traditional nude subjects were no longer meaningful and could joke (or lament), "Two centuries ago I would have painted *Susannah at Her Bath*; now I only paint women in their tubs." The question of the modern, Realist nude had been raised by

many critics, and its challenge was taken up by Manet and on occasion by Bazille, Caillebotte (see no. 6), and Cézanne (see no. 12), but Degas gave it its most sustained realization. His initial statements of the theme in the mid-1870s were in the form of brothel images, but in his later ones he made the social identity of his nudes far less certain. One of his favored forms of the subject was the bather in an apartment setting. Rather than nudes (an ideal state), these are women simply without clothes, stripped of personality, emotion, and social identity, performing habitual, unselfconscious actions. Degas reportedly told George Moore in the later 1880s that his bathers show "the human animal preoccupied with herself—a cat who licks herself. . . . Hitherto the nude has always been represented in poses which presuppose an audience, but these women of mine are honest and simple folk, unconcerned by any other interests than those involved in their physical condition. . . . It is as if you looked through a keyhole."

Degas's representation manipulates and controls the female body, making it one element in a tautly integrated formal arrangement. But in its aloofness and detachment (both physical and emotional) and its bold generalization of form, it does not seem designed to elicit a conventional male sexual response. This contemporaneity and nakedness; this disregard of the (male) viewer; this lack of idealization, erotic charge, or even coy modesty; and this emphasis on the natural and the physical seem to have led most contemporary critics, even those sympathetic to Degas, to identify his bathers as slatterns and streetwalkers and to characterize them as repulsive, indecent, and degraded. But Degas's treatment, particularly as it had evolved by the early 1890s, is distanced if not neutral and offers a grandeur of form, vibrancy of drawing, and resonance of color that transmute the subject.

Oil on canvas, 31¹⁵/₁₆ × 45¾ inches (81.2 × 116.2 cm)

The Carnegie Museum of Art 62.37.1

Acquired through the generosity of Mrs. Alan M. Scaife

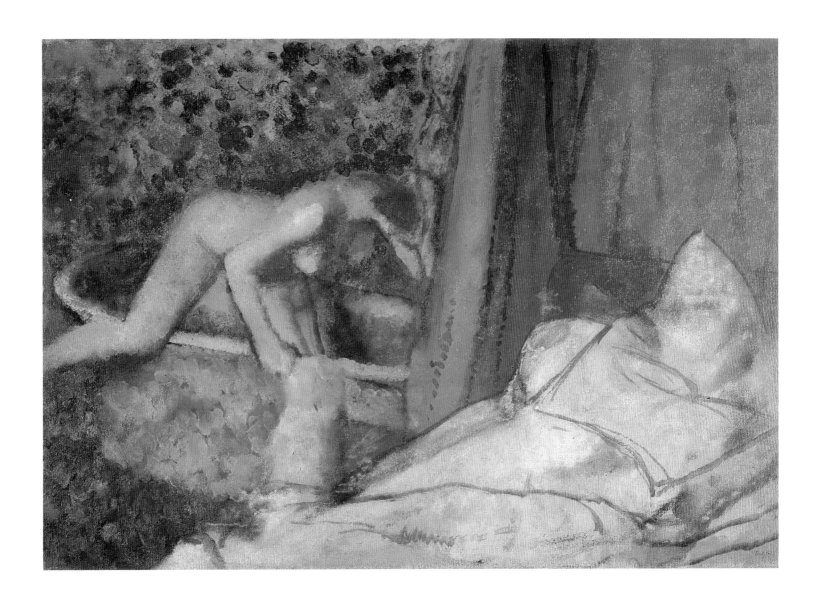

This late pastel is a fully elaborated and signed work. It had generally been Degas's practice to sign and release works at varying degrees of completion; *The Dancers*, however, is not only fully realized but also is carried to a high state of finish for him. He sold it July 7, 1899, shortly after its completion, to the dealer Paul Durand-Ruel, who kept it for his personal collection.

The subject of half-length dancers adjusting their costumes or relaxing in the wings while waiting to go on stage is one that Degas had treated from the mid-1870s and that he returned to frequently in his later works. As with his bathers (see no. 20), the actions are habitual and unselfconscious, de-emphasizing the characterization of the individual sought in his earlier images. The composition is more narrowly focused and the scene stripped of dance masters and male observers, suppressing references to the social ambience of the Opéra if not to work itself (see no. 18). In his later years Degas seems to have stopped attending the Opéra regularly, maybe even altogether. His images thus became even less dependent on any observed event. Memory and imagination, "freed from nature's tyranny," as he remarked, played a more dominant role in his practices.

More and more he tended to repeat obsessively a shrinking repertoire of poses and a limited number of compositional ideas. He worked in suites, recycling, rephrasing, and regrouping the same few figures studied from the model, from photographs, or from his own drawings, singly or in pairs, nude or clothed. The Toledo *Dancers* was part of one such extended suite that Degas worked on from about 1895 to 1900 and can possibly be regarded as its culmination. It is hazardous to assign privileged places in a sequence, since Degas tended to develop many compositional variations simultaneously, but its greater concentration, tautness, and concision suggest that it is the distillation of the idea.

The actual execution of the pastel was also the result of a long, deliberate process. If by the 1890s Degas generally eschewed the complex mixtures of media with which he had experimented in the 1870s, his use of more established techniques was still convoluted and innovative. The Toledo *Dancers* was executed on two unequally sized sheets of paper, the smaller horizontal strip abutting the larger about a fifth of the way down from the top. The two sheets were mounted on a secondary support of thin cardboard, which in turn was affixed to thick bookbinder's board. For these procedures, Degas turned to a professional mounter (see no. 22).

Parts of the design may have been traced by pencil or stylus from another sheet. Charcoal was used to lay in the basic outlines of the composition and was stumped or smudged in places to establish the modelling. The pastel was applied in layers of color, each layer fixed with the exception of the top one. In places the pastel sticks were probably moistened or the already applied surface steamed and worked with a stiff-bristled brush. Along the right side and bottom, the surface was burnished, smoothing and flattening the texture. The final touches were the small yellow flecks scattered as glittering ornament over the costumes and the startling blue contours in the heads that energize and accentuate the divisions between forms. The technique of superimposed layers enabled Degas to achieve effects of translucency and depth and to create vibrant interactions and mixtures of colors.

The incandescent chromatic display is, as in other late works, based on the play of complementary colors, here bunching around blues and oranges. Color is less naturalistic, with more descriptive passages overlaid with strokes of contrasting and varying hues. In his insistence on the expressive role of color, Degas did not accentuate drawing as much as in the past. Line is woven into the skeins of color, but still functions to control, shape, and divide forms and spaces. Vigorous parallel hatchings cut across the modelling planes of the figures, and short strokes and scribbles move independently of them, working against the powerful volumetric effects of light and color. The heavy texture of pastel and densely layered webs of strokes create a complex and vividly animated surface.

The composition is organized along a network of crisscrossing diagonals rising from a base of triangular skirts anchored to the bottom edge. Torsos, arms, and heads bend and twist against this more geometrical, flattened, and stable base, and the muscular volumes of the bodies overlap and thrust into space. This effect of a shallow yet dense relief is in counterpoint to the insistent rhymes and echoes of the gestures, the repeated cropping of forms by the edges, the compressions and elisions among figures and between figures and ground that together establish a bold surface design and a forceful rhythmic arabesque.

Degas never severed his links to the model and to tradition, yet in *The Dancers* and other late works, his art, like Monet's, Gauguin's, and van Gogh's, had become passionate and subjective, and artifice had grown to dominate nature.

Pastel on paper, 24½ × 25½ inches (62.2 × 64.8 cm)
The Toledo Museum of Art 28.198
Gift of Edward Drummond Libbey

Exhibited only at Toledo

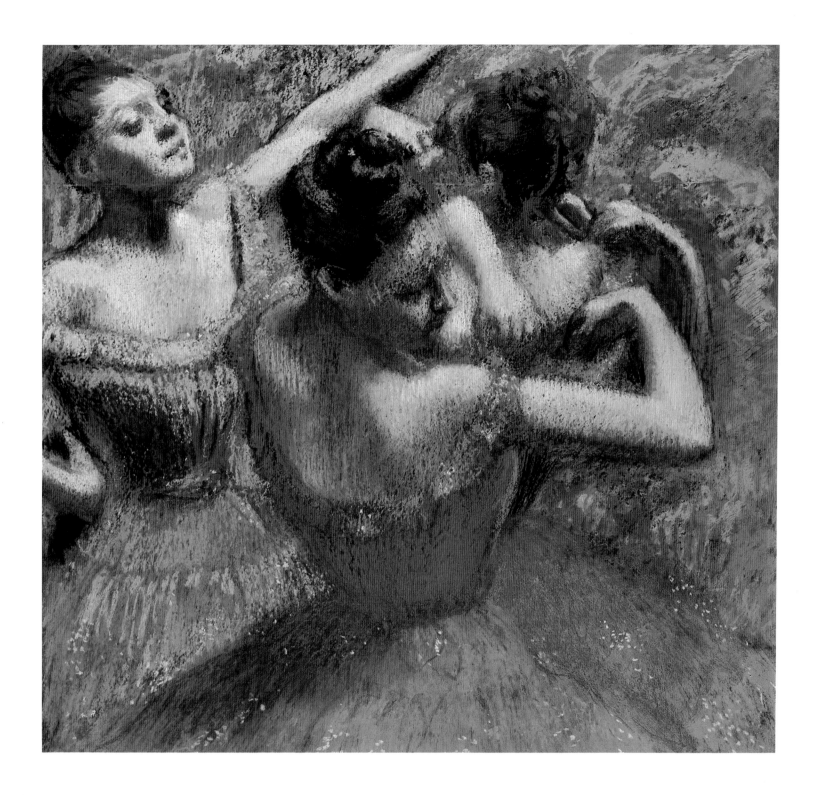

22 *Ballet Dancers in the Wings*

c. 1900

Although less heavily worked than the Toledo *Dancers* (no. 21), this pastel was signed by Degas and sold sometime prior to his death, probably to the dealer Ambroise Vollard. The pastel is applied dry, the layers are fewer, and the tan paper showing through in many places plays a part in the tonal structure. The image is built up over a design that Degas first traced in charcoal. He appears to have wrapped the edges of this sheet of tracing paper around another contemporaneous version of this composition, as there are horizontal folds near the top and bottom that loosely correspond to the dimensions of some of the other sheets. The traced design was partially worked, probably in smudged layers of pastel, then was sent to be mounted on thin cardboard that was attached to heavy bookbinder's board covered with blue paper, a composite mount fairly common for Degas's later pastels. The mounter, whose label is still on the back, was the firm of Adam-Dupré, whose specialty was the framing of drawings, watercolors, and pastels. It was located very close to Degas's studio in the rue Victor-Massé and did his mountings on more than one occasion.

Tracing enabled Degas to rework or reconsider a motif or composition without destroying the previous form. By the 1890s it had become an essential part of a studio practice that was geared to the generation of suites of related works (see no. 21). *Ballet Dancers in the Wings* was one of six versions of this composition of four full-length dancers in the wings, two standing and two seated on a bench, organized along a diagonal of descending heights. The poses and groupings of the figures were investigated in a large number of studies and pastels of single and paired figures, either both standing or both seated, from which the four-figure composition was assembled. The basic compositional idea and the specific poses had their roots in some of the horizontal frieze-format paintings of dancers that Degas began working on around 1880. In those works, a four-figure grouping of two standing and two seated figures constituted only about half of the total composition, but in the 1890s Degas extracted the idea from the wider context and changed the setting from the rehearsal room to the wings.

In taking this tracing, Degas altered the composition by placing it on a taller sheet and shifting the entire group of figures slightly to the right, thereby opening up space on the left and cropping the dancer on the right. He modified the poses after beginning to build up their forms in pastel, changing the position of the arms and legs and the tilt of the heads of the dancer standing at far left and the two seated on the right. He tightened the linkage between the two pairs facing in opposite directions by extending the skirts across the center. From a construction of two distinct units added together, Degas created a unified and coherent composition through the counterpoint of the angular rhythms of limbs and torsos, the spreading curves of sectioned circles formed by dresses and fans, the radiating and parallel hatchings and scattered cursive accents, and the color scheme of yellows, greens, and blues lightly opposed by their complementaries.

The improvisatory freedom of the strokes and glittering splendor of the color contrast with the slumped exhaustion of the dancers worn from their strenuous exertions. The expectation of soaring grace and fluttering lightness is met by the harsh reality of heavy bodies and aching limbs. This theme was one that Degas turned to often late in his life, perhaps reflecting something of his own state of mind. He remained restlessly inventive, continuously probing new possibilities, yet was, as Paul Valéry observed, "a man who, beneath the rigor of his judgments and the absolutism of his opinions, concealed I know not how much self-doubt and despair of ever satisfying himself."

Pastel on paper, 28 × 26 inches (71.1 × 66 cm)

The Saint Louis Art Museum 24:1935

Purchase

Exhibited only at Saint Louis

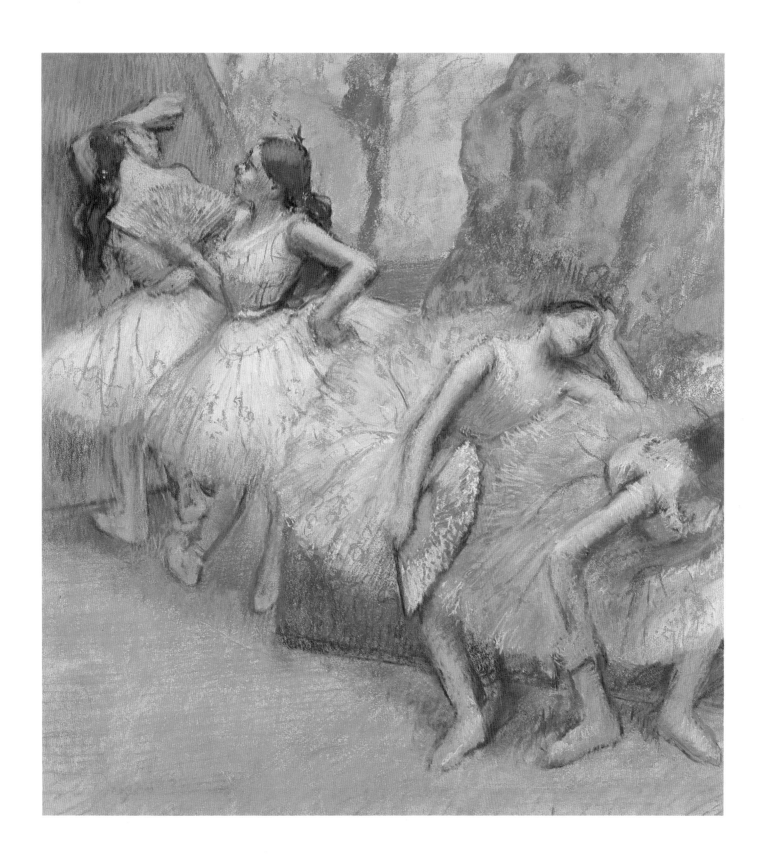

23

Little Dancer of Fourteen Years

c. 1880–81

Degas's beginnings as a sculptor are difficult to fix. He was familiar with classical and Renaissance sculpture and in the late 1850s even wrote that he was undecided whether to be a painter or a sculptor. He waited to take up sculpture, however, possibly until the later 1860s when he may have done some horses to provide models for his large oils, but it was only a decade later that sculpture became interesting to him in its own right. The *Little Dancer of Fourteen Years* was not his first sculpture, but it is the earliest for which a date can be firmly established. He listed it in the catalogue of the fifth Impressionist exhibition in 1880 but sent only its large glass case. He announced it again for the sixth in 1881, but the exhibition opened with the same empty glass case. Degas continued to work on it until about a week or so later, when it was finally placed on view. It was the only sculpture he was ever to exhibit.

Degas had begun to work on the *Little Dancer* as early as 1878, since his model for it, the young ballet student Marie Van Goethem, turned fourteen (the age specified in the title in 1880 and 1881) on February 17, 1878. In preparation, Degas produced at least seven sheets of drawings and a nude study in wax, a far more sustained process of research than for any of his other sculptures. The existence of so many studies suggests not only the importance of the project for Degas but also the caution with which he tackled a large-scale sculpture of the human figure for the first time. The sequence of work on the drawings, nude wax maquette, and finished sculpture is uncertain, but it was probably neither traditional nor straightforward.

The materials and techniques of the original are likewise complex and innovative. The figure was modelled in a deep reddish brown translucent wax over a rigged-up flexible armature of hemp rope for the arms and probably wire for the body. For accessories Degas used real materials. The hair was dark horsehair, the hair ribbon a green satin, the bodice cream-colored ribbed silk with silk-covered buttons, the knee-length skirt white muslin, and the slippers pink cloth. For the wig and parts of the clothing, Degas probably turned to doll firms, since he jotted down the name and address of one Mme Cusset, "maker of wigs for dolls," in his notebook at the time. He lightly coated the hair, bodice, and slippers with wax to protect and integrate them, and to affirm that the statuette was not a doll to be dressed and undressed but a work of art.

Degas's audacious sculptural experiment with real materials was highly unorthodox but not unprecedented. Diverse traditions in Western art sanctioned the use of real accessories, among them Roman portraits, Spanish and provincial French religious sculpture, and Neapolitan crèche figures. His aim, however, was not to re-create a specialized tradition but to create a powerfully realistic sculpture.

Actual materials enhanced the illusionistic effect of the two-thirds life-size figure whose form, features, and textures are modelled with extraordinary accuracy. The personality of the dancer is vividly conveyed by her face, pose, and attitude, and, much as for his portraits, is informed by his interest in physiognomic theories (see no. 15). The intense expression of the face, especially, is not that of a type but seems particular to the model herself. Degas seems to have been especially intent on emphasizing the awkwardness and ungainliness of adolescence. Strained and graceless, her taut pose is still able to convey a sense of composure and self-possession.

When the *Little Dancer* was exhibited in 1881, the reactions of reviewers were mixed: they were generally favorable but often nasty. If many characterized her as bestial (like a rat or monkey), depraved, and ugly, even as a pathological specimen, most recognized the startling realism and daring of Degas's enterprise. One, "Comtesse Louise," likened her to "a little fifteen-year-old Nana, dressed as a dancer," but Huysmans remarked that it is "the only really modern attempt that I know in sculpture. . . . At the first blow, M. Degas has overthrown the traditions of sculpture, just as he had long ago shaken off the conventions of painting. . . . M. Degas has immediately made sculpture thoroughly personal, thoroughly modern by the originality of his talent."

Degas kept the wax sculpture in his studio in its glass case, although the possibility arose in 1903 of selling it to Mrs. H. O. Havemeyer, the only sculpture for which there was any question of sale during his lifetime. After his death it was cast in bronze (probably in an edition of twenty-three) along with two plasters. The costume was chosen by Jeanne Fèvre, Degas's niece, and if she did not adhere precisely to his original conception, the casts nonetheless preserve its extraordinary power and uneasy tension between illusion and reality.

Bronze, h. 38⁷⁄₁₆ inches (97.6 cm)
The Saint Louis Art Museum 135:1956
Gift of Mrs. Mark C. Steinberg

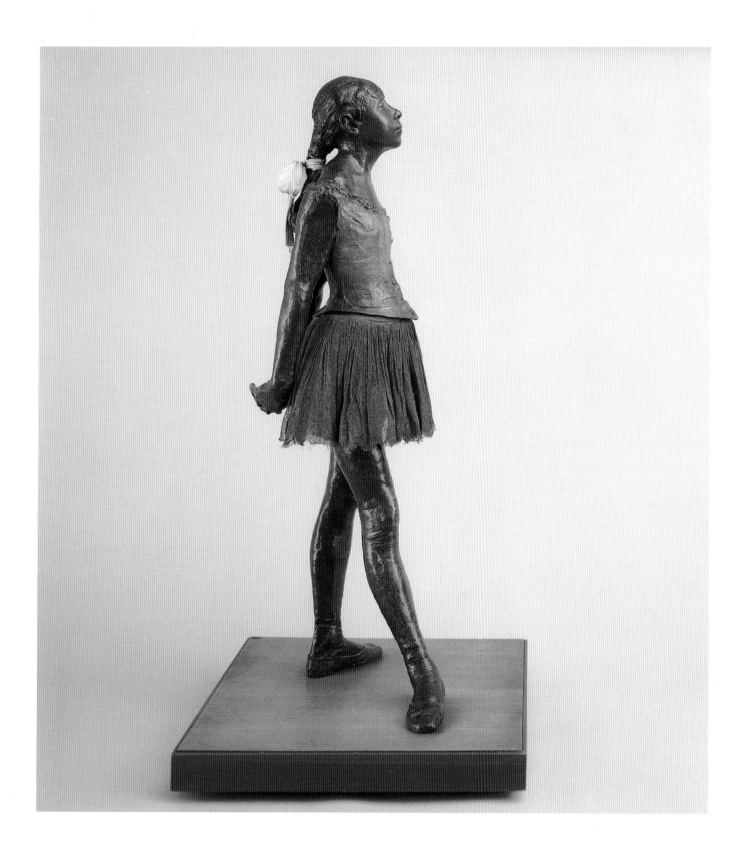

Galloping Horse

1880s

Sculpture for Degas was an end in itself, compelling for the unique challenges it presented. His initial efforts in the 1860s may have been made to provide models for paintings, but from the 1870s sculpture had become a wholly independent medium. With the sole exception of the *Little Dancer of Fourteen Years* (no. 23), his sculpture was never exhibited and was not generally known, although there were always a few kept out in his studio in glass cases. It was a private endeavor, made to impress no one. After his death about one hundred and fifty waxes, probably a fraction of his total production, were found in his studio, none in perfect condition, some in fragments, many in varying states of disintegration. Their condition was in great part due to the experimental and unorthodox techniques he employed. He jerry-rigged flexible armatures that he might extend with matchsticks, mixed incompatible modelling materials, and made repeated modifications and alterations that undermined their structural soundness. Many were not properly supported but needed to be propped up with vertical struts (as was the case for the wax *Galloping Horse*) or suspended by wires from a wooden frame.

Degas seems to have thought from time to time about having some of his sculpture cast, and around 1900 he had three molds taken and plasters made, but reportedly resisted bronze as too eternal. He enjoyed continually reworking them and hesitated to pronounce them finished. The posthumous bronze casts commissioned by his heirs thus were made without his intention, approval, or, obviously, his supervision. Of what remained in his studio at his death, seventy-two waxes, almost half, were repaired for casting. Twenty-three sets of the seventy-two were cast by the founder Adrien Hébrard using the lost-wax process. The casting began in 1919 and went on until about 1932, the first full set ready in 1921. Twenty sets (lettered A to T) were made for sale, one set each for the heirs and for the founder, and a master (*modèle*) set from which the molds of all the other casts were taken.

Fifteen of the bronzes are horses (two additional ones are jockeys that were mounted on them). The horse was another in Degas's repertoire of modern-life subjects, one that usually took the form of racetrack or training scenes. Degas had no interest in portraying famous horses or jockeys or in recording notable races. The subject's appeal was, in part, as a contemporary equivalent for the great horses of classical and Renaissance art that he had copied in his youth from the Parthenon frieze and the frescoes of Benozzo Gozzoli. All but two of the sculptures, however, are stripped of all reference to modern life, whether to racing or even to riding, and are principally involved instead with movement, space, and sculptural form. *Galloping Horse* may have been one of the exceptions, since the cloth imprint visible on its back suggests that at one point it had a cloth saddle and perhaps even a clothed jockey.

Degas's earliest horses reflect stances he knew from classical and Renaissance art and from nineteenth-century horse specialists. By the late 1870s he became more occupied with other subjects, but his waning interest was revived and stimulated, in part, by his exposure to Eadweard Muybridge's sequential photographs of horses in motion. Muybridge's instantaneous photographs demolished many conventions concerning the movement of horses and revealed their positions more truthfully. Muybridge's sequences, including one of a horse galloping, were first published in France in December 1878. A sequence of a galloping horse appeared in another article in September 1881, and Muybridge himself visited Paris in 1881 and 1882 to present his photographs. His monumental, multivolume *Animal Locomotion*, which included a number of sequences of galloping horses, was published in 1887, and Degas's drawings indicate that he was soon familiar with it.

Muybridge's various sequences of a horse galloping each contain a frame corresponding to the pose of Degas's horse. The photographs were crucial in furnishing Degas with far more accurate knowledge of a horse's rapid motion, but were not in themselves sufficient to his purposes. Each was only a planar silhouette that needed to be realized as a volume in space. Each instantaneous frame abruptly suspended time, freezing a fragment of an action that takes place continuously over several moments. As Valéry astutely noted, Degas "was among the first to see what photography could teach the painter—and what the painter must be careful not to learn from it."

In the *Galloping Horse* he modified and combined elements from two contiguous frames in Muybridge's sequences, understanding that convincing movement can most effectively be suggested by incorporating implications of previous and succeeding stages of that action. The roughly modelled surfaces loosely refer to the bulging muscles and stretched sinews of the anatomy while forcefully expressing their strain and tension. The sculpture makes the horse's dynamism and energy palpable.

Bronze, h. 12¼ inches (31.1 cm); l. 18¼ inches (46.3 cm)

The Saint Louis Art Museum 187:1946

Purchase

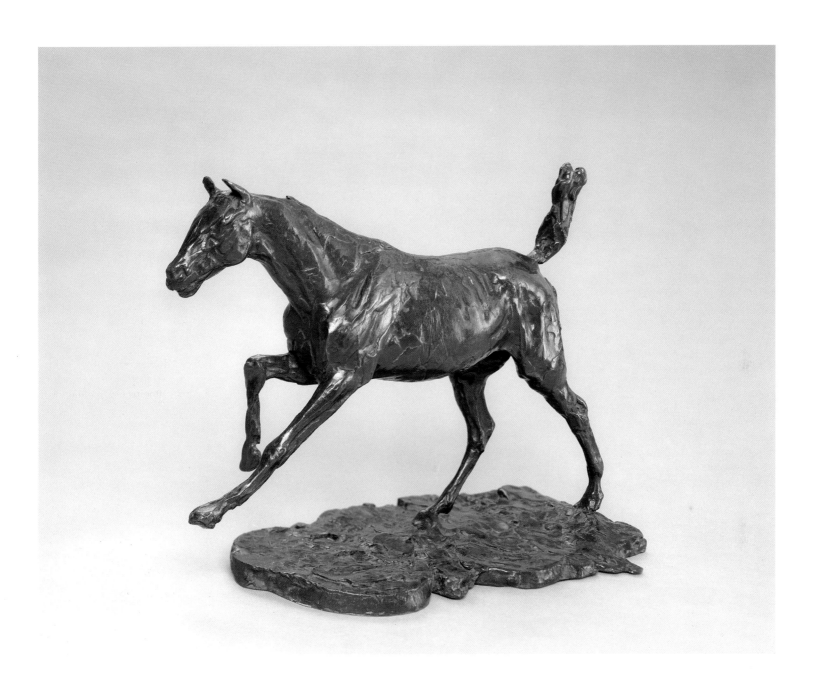

25

Rearing Horse
1880s

In this remarkable sculpture Degas explored the full spatial potential of the horse. It is close in date to the *Galloping Horse* (no. 24), since their surface handling and treatment of anatomical details are quite similar, but offers, in place of a profiled and planar organization, a configuration of striking freedom and intricacy. The horse rears and shies to the left, combining in one action forward, backward, rising, and rotating movements. The pose departs from the horizontal stances, with bodies parallel to the ground, in which he had previously represented his horses. It has no real ancestors in sculpture, nor does it correspond to any of the photographs of rearing horses published by Muybridge in his *Animal Locomotion* in 1887. Degas had studied the movement from different angles in a group of drawings and made use of it in five paintings and pastels of the mid-1880s.

The sculpture's configuration is awkwardly unstable and asymmetrical. Body forms thrust and radiate in all directions, shaping and activating a space of great vitality. The movements lift and suspend the masses in space, resisting the force of gravity. The composition of forces, forms, and spaces is held in a tensioned equilibrium, one that vividly expresses the tense and animated action of the subject.

The *Rearing Horse* is one of Degas's most spatially sophisticated horses and probably one of his last. From the earliest to the latest, his horses generally increased in movement and spatial complexity. But the possibilities the subject offered him for convincing poses in which he could discover both movement and equilibrium were far more limited than for the human figure.

Bronze, h. 12¼ inches (31.1 cm); l. 10¼ inches (26 cm)

The Toledo Museum of Art 52.70

Museum Purchase

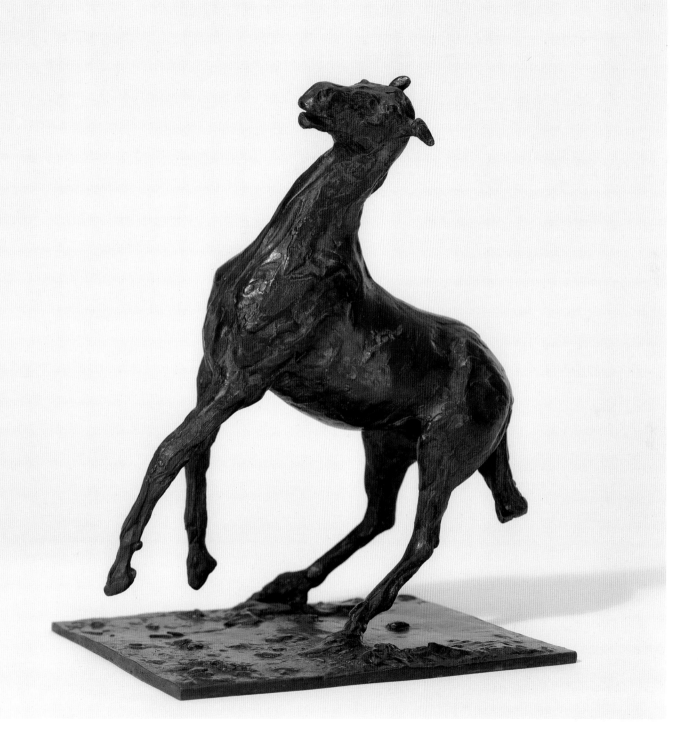

A work of great brilliance and originality, *The Tub* is unique among Degas's sculptures. His use of materials in the original of the work was heterogeneous and unorthodox, as it had been for *Little Dancer of Fourteen Years* (no. 23). The bather was modelled in red-brown wax with a small piece of real sponge in her hand, the shallow tub formed of lead, the water of white plaster, and the base of bunched, plaster-soaked rags over wood. The materials were selected, in part, for their varying colors and textural effects, but also as a form of sophisticated illusionism, for their ability to suggest something of the physical properties of real things. The experiment was not carried quite so far as for the *Little Dancer*. The forms and surfaces evidence less concern for exact description, although the plaster's rough surface and scratched marks seem designed to suggest water sloshing in the tub.

Work was probably completed in 1889, since Degas wrote to a friend in June that he had made a base of plaster-soaked cloth for a small wax, presumably a reference to the original of this sculpture. He may have begun as early as 1886, around the time of the eighth Impressionist exhibition, when he showed a number of recently completed pastels of bathers in similar shallow tubs. Those and other contemporaneous bathers in pastels, paintings, drawings, and prints are posed crouching, kneeling, or bent over, rather than lying immersed in the bath water, and demonstrate a concern to reconcile the mass and space of the figure and its environment to the flat picture surface.

The subject itself fascinated Degas (see no. 20) and also offered him the possibility of investigating the persistent sculptural problem of the horizontal yet active figure. At a time when he was increasingly involved in his own sculpture with vertical lift and gravitational resistance (see no. 25), he also chose to explore their antithesis. The reclining pose in sculpture had a long tradition in funerary sculpture and in images of death, defeat, and sleep. In the nineteenth century the pose was also commonly used for ecstatic female nudes and for struggling or writhing figures, either human or animal, in extreme physical and emotional states. In the bather Degas found a convincingly active yet ordinary subject from everyday life that was neither obscene, violent, nor melodramatic.

Degas establishes no dominant view, offering instead a continuous sequence of plausible and viable views, even from above. An elevated view brings out the sculpture's essential horizontality and reveals a fully coherent composition of the figure's angled forms inscribed within a circle framed by a square. The consideration given to the view from above is unusual for sculpture but not unique. Funerary monuments of all periods, the polychrome ceramic dishes of the French Mannerist Bernard Palissy and his circle, some of Clésinger's and Pradier's voluptuous nudes from the nineteenth century, Barye's fighting animals,

Préault's drowning Ophelia, all might sanction for sculpture a view from above. Degas's own inspiration, however, was more likely to be found in his own pastels and monotypes from the mid-1880s of bathers and sleepers seen sharply from above.

The horizontal emphasis is counterbalanced by the strong relief of the body projecting into space. Bent and angled limbs jut outward in all directions, shaping a complex pattern of solids and voids. The body forms press against the containing geometry of tub and base in a tensioned equilibrium. Freely modelled surfaces express the quiet strains of the bodily gestures, animating the tranquil and relaxed state of the bather.

Bronze, 8 × 16½ × 16 inches (20.3 × 41.9 × 40.7 cm)
Promised gift of Bruce B. Dayton to The Minneapolis Institute of Arts

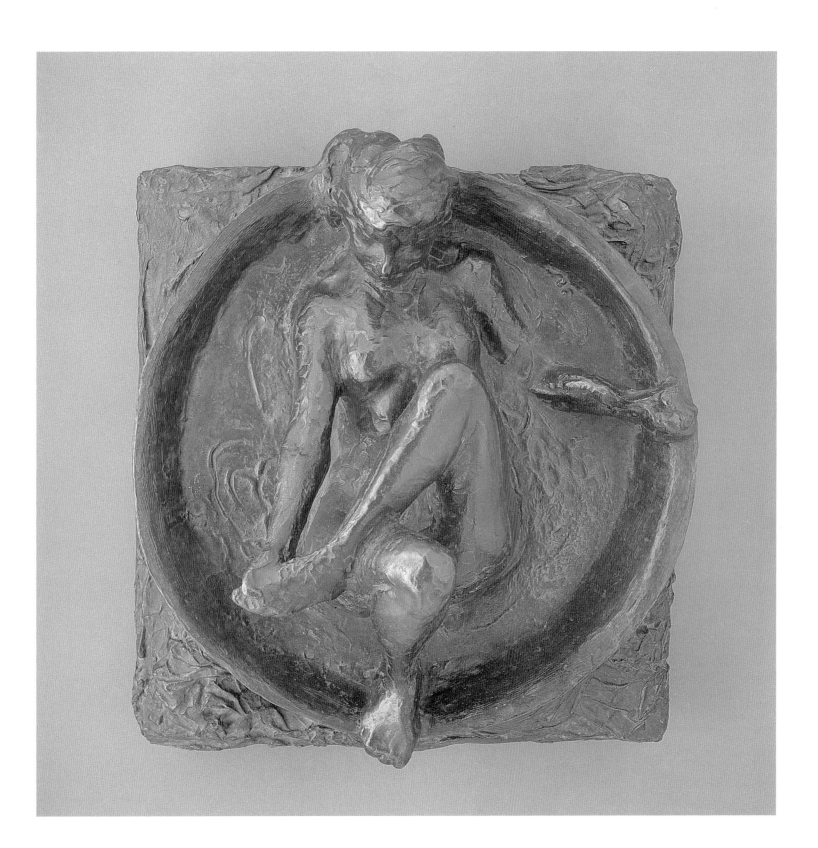

Dancer Putting on Her Stocking

As his letters and witness accounts testify, Degas was particularly occupied with sculpture from about 1900 until 1912, when he stopped working altogether. *Dancer Putting on Her Stocking* seems to fall into this late part of his sculptural career, when he was increasingly prone to repeat a few themes and poses over and over, much as he was in drawing and pastel. This is one of three sculptures in the same general pose that survived and were cast. The three differ in the precise mechanics of the pose, the weight distribution and balance, the spacing and articulation of forms, and the definition of surfaces, but they appear to be concurrent variations on a theme rather than separate stages in a progression.

The action is ordinary and trivial, like those of so many of his works throughout his career. A motif that Degas had treated in drawings, pastels, and paintings, this figure appeared in different guises from the late 1870s as a dancer in a rehearsal room pulling up her tights and as a woman/prostitute rising from bed and dressing. The pose itself closely approximates that of some late pastels of a bather standing in a tub and drying her foot, which she has lifted onto the rim. But it also recalls two copies Degas had drawn in notebooks in the mid-1850s, one from the Parthenon frieze, the other from Michelangelo's *Battle of Cascina*. The past still held important lessons for him, the poses copied from classical and Renaissance art that lodged in his memory, transforming and being transformed by his observations and experience. His remark to George Moore, published in 1890, applied more than ever: "No art was ever less spontaneous than mine. What I do is the result of reflection and study of the great masters; of inspiration, spontaneity, temperament . . . I know nothing."

Degas selected a pose not only for its resonances with the past, but also for the sculptural possibilities it offered. As in many of his later sculptures, he depicted a figure elevated on one foot, its masses suspended in precarious equilibrium between movements that rise from and return to the ground. The roughly manipulated shapes and surfaces express the elastic tensions of the body and the struggle to maintain poise. Although impossible to sustain, the pose is one in which Degas sought to create harmony and balance. As he observed to the younger artist Georges Jeanniot of the *Venus de Milo*: "Have you seen . . . how she goes beyond the perpendicular? She is in a position she could not hold if she were alive. By this detail, a fault to people who know nothing of art, the Greek sculptor has given his figure a splendid movement, while preserving in it the calm which distinguishes masterpieces."

Degas's later sculptures may seem to resemble some by his contemporary Rodin, but he disdained the symbolic and heroic themes that obsessed that sculptor. In Degas there is no allegory, nor any attempt to externalize and dramatize psychological and emotional states. Instead, he sought to realize the energy, coherence, equilibrium, and harmony of the body and of sculptural form itself.

Bronze, 16¾ × 6½ × 11 inches (42.6 × 16.5 × 27.9 cm)
The Minneapolis Institute of Arts 56.8
Gift of the Family and Friends of Mrs. D. D. Tenney

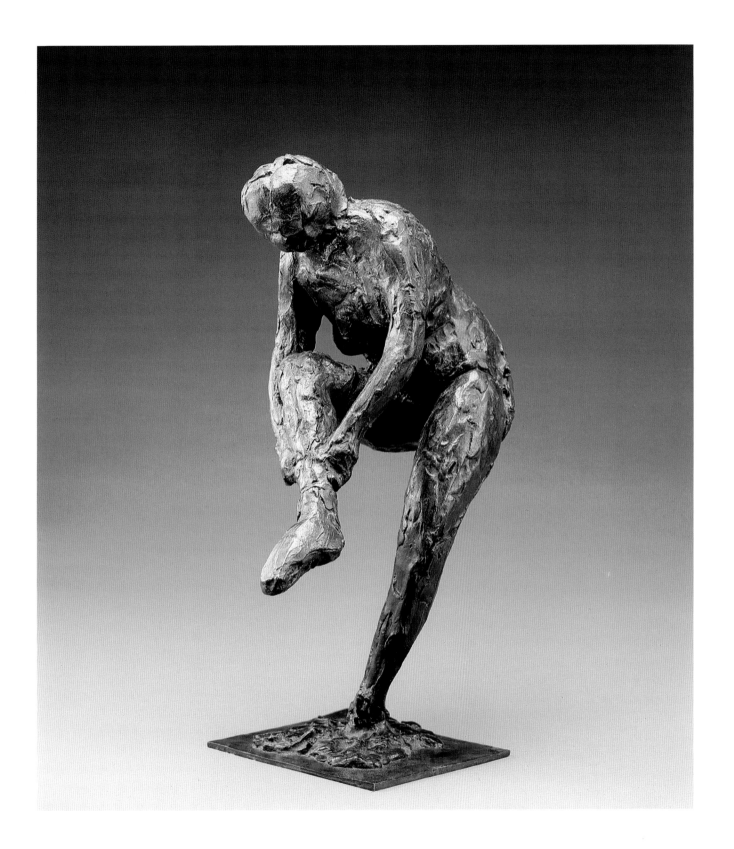

28

Portrait of Mme Roulin
1888

Between October 23 and December 26, 1888, Gauguin lived with van Gogh in Arles. Gauguin had met Vincent and Theo van Gogh in Paris in November of the previous year. After repeated invitations from both van Goghs, accompanied by plans for his financial support, he agreed to go to Arles for six months.

Gauguin was disappointed with the landscape in Arles and turned his attention instead to the local women. Early in his stay he and van Gogh may have shared some motifs, but their interests generally differed. In their relationship, Gauguin assumed the role of master, a situation van Gogh seemed willing to accept. Gauguin urged van Gogh to paint from his imagination rather than directly from nature and did paintings of subjects van Gogh was treating as a pointed form of instruction and criticism. This portrait of Mme Roulin was done, at least in part, as a kind of lesson for van Gogh.

In late November and early December, van Gogh produced a set of uniformly sized portraits of the five members of the Roulin family. In contrast to the other portraits, for that of Mme Roulin (Oskar Reinhart Collection, Winterthur) van Gogh turned the canvas horizontally, placed the figure asymmetrically, and inserted a window in place of his usual flat colored background. It was a type of portrait that Gauguin but not van Gogh had done before, thus indicating Gauguin's direct influence on him.

Gauguin probably executed his portrait of Mme Roulin at about the same time as did van Gogh, although possibly in separate sessions. The two artists' images differ slightly in clothing, but more significantly in setting and lighting. Van Gogh provided a view out a window of sprouting bulbs in tubs and a garden path, and flooded the interior with warm, yellow daylight. Gauguin, on the other hand, framed the figure with a painting of his own (an enlarged and simplified section of *Blue Trees* done at Arles) and a door with darkened panes, and illuminated the scene in a way that suggests artificial light, probably the gas lighting that van Gogh had installed before Gauguin's arrival for working at night.

While van Gogh's portrait of Mme Roulin indicates that the essential source of his art is in his direct experience of the life within nature, Gauguin instead suggests that his source is in art and the artificial, and conveys his desire to establish his distance from nature. Gauguin wrote of his views on August 14, 1888, to the artist Emile Schuffenecker: "A word of advice, do not copy nature too closely. Art is an abstraction; derive it from nature while dreaming in front of it and think more of the creation that will result." And from Arles he summarized his version of his disagreements with van Gogh in a letter to Emile Bernard of the second half of November:

In general, Vincent and I agree on very few topics, and especially not on painting. He admires Daumier, Daubigny, Ziem, and the great Rousseau, all people I can't stand. On the other hand, he detests Ingres, Raphael, Degas, all people I admire. . . . He's romantic, and I'm more inclined to a primitive state. As to pigment, he appreciates the risks of impasto . . . whereas I detest any messing around with brushwork, etc.

Gauguin exaggerated their differences, carefully avoiding mention of Delacroix, Bernard, and Japanese art, on which they agreed, and making van Gogh stand for painterliness, nature, and emotion and he for line, style, and reserve.

In spite of this, both artists sought to evoke something of what was essential in their subject rather than mere surface appearances. In their images of Mme Roulin, both attempted to render the imposing solid mass of the figure through brushwork patterns, color modulations, and boldly accentuated contours. Where van Gogh's line is broken and impulsive, Gauguin's is cursive and rhythmic; where one's brushwork is rough, vigorous, and impastoed, the other's is regular, controlled, and thin; and where one's effect is probing and passionate, the other's is detached and impassive.

Unlike van Gogh, Gauguin in his portrait of Mme Roulin looked to Cézanne, several of whose paintings he owned. Although stimulated by Japanese prints, early Italian painting, Greek sculpture, Puvis de Chavannes, Degas, and Bernard, it was in Cézanne that he best found the means to achieve monumentality, powerful relief, and taut surface structure (see no. 10). Through his forceful outlines, orderly sequences of parallel strokes, and subtly modulated passages of color, he rejected what he saw as the lack of drawing, empty virtuosity, needless complexity, and preoccupation with transitory effects of Impressionism and of his own earlier art. In his portrait of Mme Roulin, as well as in many other works of that year, he arrived at something of the pictorial "synthesis," as he termed it, that he had sought. In his simplification, condensation, and stylization of nature, he expressed his model's serene and enigmatic presence.

Oil on canvas, 19¼ × 24½ inches (48.9 × 62.3 cm)

The Saint Louis Art Museum 5:1959

Gift of Mrs. Mark C. Steinberg

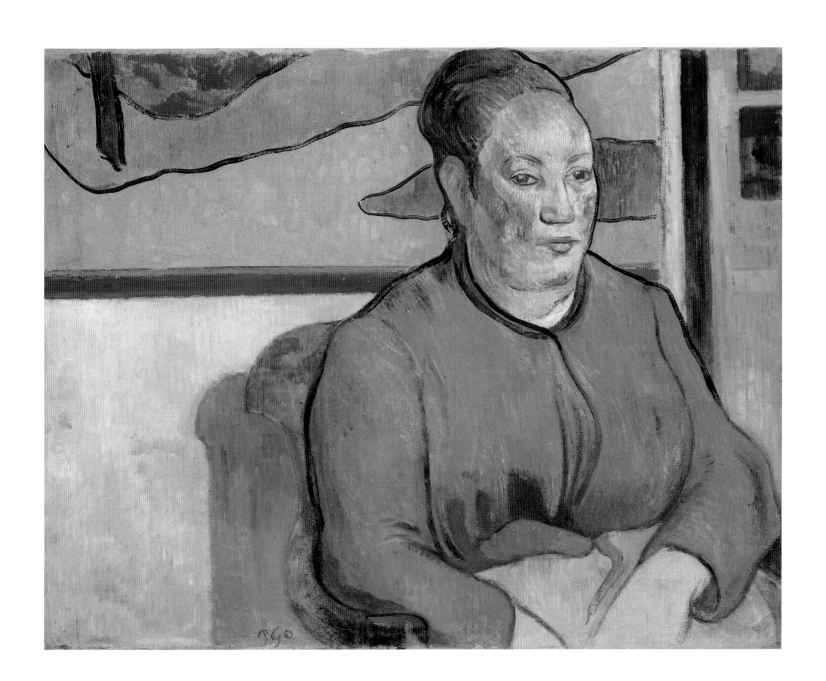

29

When Gauguin exhibited in 1889, the critic Félix Fénéon discerned in his work a "tendency to archaism" and a "taste for the exotic." Gauguin was dissatisfied with the values of modern urban culture in Europe and wanted to return to a primitive way of life lived in intimate association with nature, which he believed he would find in the tropics. His idea of Tahiti—one that was (mis)informed by travel accounts, novels, and official reports—was that of an earthly paradise of mystery, magic, strange religions, savage arts, and sensual pleasure.

He imagined, too, that he could live nearly for free off the land and that women would always be available. His main goal, however, was to renew his art through contact with a non-European, preindustrial culture, but he also thought that new and exotic motifs might have more appeal to European dealers and collectors. Since the Romantics, artists had gone in search of seemingly unspoiled societies and landscapes remote from modern Paris, travelling to North Africa and the Near East, the Forest of Fontainebleau, Brittany, the south of France, and even as close as Pontoise and Giverny.

What Gauguin found when he arrived in Tahiti did not match his expectations. The island had been severely altered by a century of colonialists and Christian missionaries who had left little of the traditional society and culture Gauguin had dreamed of finding. He disembarked in June 1891 in Papeete, the much-Europeanized capital city, and spent several months there. In September or October he moved farther out to the small village of Mataiea, but even this remote country district had been seriously tainted by European civilization.

He probably began to paint within a short time after settling there, although in letters written in early November to two French artist friends, he remarked that he had yet to finish a painting and was only accumulating "documents" for things he would do when he returned to Paris. Among these documents were several portrait drawings, the majority of them of women. *Faaturuma* is related to these drawings and seems likely to have been among his earliest Tahitian canvases. The model, who figures in many other paintings of the first voyage to Tahiti, has usually been identified as Tehamana, also called Tehura, Gauguin's young Tahitian "wife" who bore their child and whom he abandoned when he returned to France in 1893.

The painting was developed from some quick sketches in a small notebook and from a more careful and elaborate drawing of a seated woman in a long missionary dress, holding a handkerchief, and looking melancholy. The woman's pose in the drawing is closer than in the painting to what seems likely to have been Gauguin's pictorial source: a painting by Corot of a woman in fanciful Italian peasant dress. The Corot had belonged to Gauguin's guardian, Gustave Arosa, and a

photograph of it was in the collection of images he had brought with him to Tahiti. Although Gauguin greatly transformed his source in developing this painting, his image of sad and sensuous reverie remained rooted in the conventions of European genre painting.

For the handling, too, he drew heavily on European art. He looked to his own earlier works of Brittany and Arles (see no. 28) and continued to take Cézanne as his stylistic point of reference in the strong outlines, parallel strokes, and subtly modulated colors. Through his treatment, he created a monumental and powerfully modelled figure, an effect intensified by the squared-off lines, vertical strokes, and ambiguous space of the setting. Compared with his previous work, his color here has become more sumptuous and resonant, and his drawing more sinuous and ornamental.

As so often in Gauguin's Tahiti, he suggests muted undertones of sadness, disquiet, and disillusion resonating beneath the luxuriant surface of his mythic natural paradise. The small painting on the wall acts, at one level, to enhance this emotional atmosphere. Through its placement next to the subject's head, this image of a typical Tahitian dwelling (possibly a lost painting by Gauguin of a motif he often depicted) becomes like an object of her veiled thoughts, evoking vague feelings of longing, loneliness, and dislocation.

On the small painting's frame, Gauguin inscribed the title *Faaturuma*. Gauguin's Tahitian was not very accomplished, but such titles were directed toward his European viewers to enhance his works' exoticism and mystery. In this instance, it is nearly identical to the title of another painting of 1891, *Te Faaturuma*. Gauguin, on two occasions, offered three translations for this other painting's title: "The Silence" or "To Be Dejected," and "The Brooding Woman." In Tahitian, the word *faaturuma* refers to a completely overcast sky, and Gauguin used it metaphorically to imply a troubled state of mind. After his return to Paris, he showed *Faaturuma* in his solo exhibition at Durand-Ruel in November 1893, where the title was given only in French as *Mélancolique*.

Oil on canvas, 37 × 26¾ inches (94 × 68 cm)
The Nelson-Atkins Museum of Art 38-5
Nelson Fund

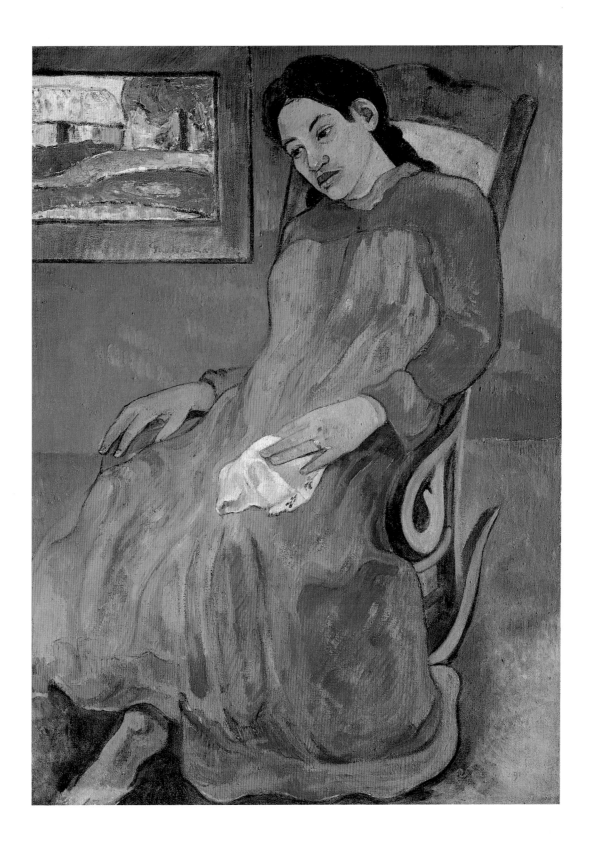

Paul Gauguin
1848–1903

Street in Tahiti
1891

Before his departure for Tahiti, Gauguin wrote to the French Ministry of Public Instruction requesting support for his trip. He modestly stated, "I wish to go to Tahiti in order to carry out a series of paintings of the country whose character and light I aim to capture." *Street in Tahiti* was among the first group of paintings he produced there during the last three months or so of 1891. He recorded it in an inventory of his paintings compiled in the spring of 1892, where it was listed as a size 50 canvas entitled *Paysage Papeete* (Papeete Landscape). This was the largest canvas he used during his first voyage to Tahiti, with the exception of one lost or destroyed attempt at a size 100.

When Gauguin arrived in Papeete, the capital of Tahiti, he was disappointed to find it shabby and Europeanized. He lived there for about three months in a rented house not far from the island's interior mountains. As he did not begin painting until after he had settled in the country at Mataiea, the Toledo canvas must result either from an undocumented return to Papeete or, more plausibly, from his drawings, memories, and imagination. Whether in France or Tahiti, he did not do much painting directly from nature, preferring instead to work according to a more deliberate and composite method.

He developed the two figures on the road, the horse, and the thatched bamboo house from pencil sketches, some touched with watercolor, which he had done in a small notebook and on a loose sheet. The seated woman on the porch he repeated from another Tahitian painting (*Te Faaturuma*, see no. 29), where she had been depicted in an interior on a large scale. For that figure Gauguin had, in turn, worked from a pastel study originating both in his Tahitian model and in one of Degas's many images of resting ballet dancers. It was his practice to work from a fairly limited repertoire of motifs built up from observation or borrowed from his own and other artists' works.

His method was highly premeditated and synthetic. He built up *Street in Tahiti* in slow stages, first spreading a thin underlayer of paint over white-primed burlap to indicate the general composition; drawing in thick, blue outlines to define the shapes; then applying two or three layers of regular strokes in subtly variegated colors. These procedures created a fairly thick and dense, if relatively flat, paint surface. While working, he changed the dress of one of the walking women from orange-red to dark blue (it had been pink in the notebook sketch) and the hat of the other one from dark blue to yellowish straw; he moved the seated woman down and to the right, heavily reinforcing her contours.

Although Gauguin's technique was controlled and deliberate, this painting, like some others of the first voyage, shows traces of his earlier Impressionist landscape style. Like Pissarro, with whom he had worked closely in the early 1880s, he represented the daily life of rural people,

placing his small-scale figures casually and integrating them with their surroundings. His organization of the landscape along a receding road is unusual in his mature work, but had been a compositional scheme quite favored by Pissarro and was one that Gauguin had adopted when he was most under Pissarro's influence. Like Pissarro, he still sought to convey something of the special character of the place—here evoking the limpid light, rich color, luxuriant vegetation, and lofty mountains—but he did not share Pissarro's preoccupation with atmosphere and other transitory effects. His aim in general, like Seurat's, Signac's, and van Gogh's, was not to re-create his sensations, but to create a suggestive pictorial equivalent for things beyond the artist's immediate visual apprehension.

The brushwork is more schematic and structural than naturalistic. Regular parallel strokes—mainly vertical along the road and diagonal elsewhere—impose a sense of order on the natural scene. The patterns of strokes often continue across the heavy outlines and shifts in color that differentiate landscape elements, thus tending to contradict what little relief is conveyed by color. Through the effect of the clear contours, tautly patterned touch, repeated curving rhythms, and simplified color, the landscape is treated as a sequence of flattened, superimposed planes. Effects of space and distance are thus collapsed, and a strong sense of decorative order is established.

Gauguin coupled this unified surface with the forceful movement into depth along the road, thereby activating pictorial tensions between surface and space. The landscape's overall effect is sumptuous and majestic, but this minor note of strain, accompanied as it is by the brooding woman and heavy cloud hanging above, introduces quiet undertones of disturbance into the placid luxuriance of this tropical paradise.

Oil on canvas, 45½ × 34⅞ inches (115.5 × 88.5 cm)
The Toledo Museum of Art 39.82
Gift of Edward Drummond Libbey

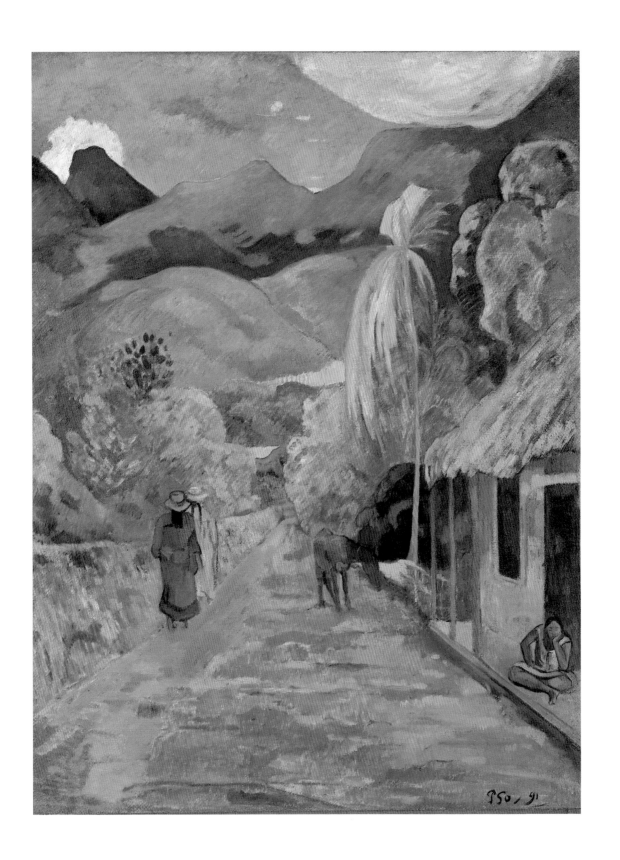

This lyrical landscape may have been among the first paintings Gauguin did in Tahiti in the last months of 1891 after he had installed himself in the country at Mataiea. Although it cannot be dated with certainty or identified with assurance with any work listed in the inventory he drew up in the spring of 1892, it may correspond to one recorded there only as *Paysage Matia* (Landscape Matia [*sic*]).

In *Noa Noa*, his fictionalized account of his stay in Tahiti written in France in 1893–94, he evoked his initial difficulties in painting these tropical surroundings:

I began to work: notes and sketches of every sort. But the landscape, with its pure, intense colors, dazzled and blinded me. . . . It was so simple, however, to paint what I saw, to put a red or a blue on my canvas without so much calculation! Golden forms in the streams enchanted me; why did I hesitate to make all of that gold and all of that sunny joy flow on my canvas? Old European habits, expressive limitations of degenerate races!

In this passage, as throughout *Noa Noa*, Gauguin transformed his experiences into a struggle of mythic dimensions to shed European civilization for a primitive and savage state. In his desire to convince his audience of the extraordinary uniqueness of the art he did there, he disregarded the radical changes he had made even before leaving France and sought instead to convey the challenges of painting the brilliant light and lush colors he encountered in the tropical environment.

Gauguin seems to have worked on *Tahitian Landscape* from direct observation or fresh impressions, perhaps in an effort to find how best to represent the special qualities of this place. In the vegetation, mountainside, and sky on the left and in the initial paint layer where it still can be seen, the handling is relatively loose, varied, and sketchlike, as if done in immediate response to his sensations of the natural scene. In most areas, however, he went back and disciplined the freedom of his initial sketch, strengthening contours, defining features, applying sequences of parallel hatched strokes, and unifying areas of color so as to establish broad zones and large rhythms. While the clear colors and even luminosity re-create the natural effects of the bright, tropical sunlight, the arbitrary and schematized patterns of forms and spaces impose on the richly varied elements of the landscape a unified and harmonious pictorial structure.

In the careful intersections, alignments, and rhythms between the foliage and the mountains, as much as in the handling and composition, Gauguin again reflected Cézanne's persistent example. Here he seems especially to have recalled a Cézanne landscape of mountains that he had bought in 1883 and then left with his wife in Copenhagen in 1885 (Cardiff, National Museum of Wales), but which he remembered vividly years later, as he did his other Cézannes. He saw in

Cézanne's paintings both specific devices to structure his compositions and a model for a synthetic and decorative art in which the essence of a subject was expressed.

The critic Julien Leclercq, guided no doubt by Gauguin, whose close friend and chosen interpreter he was after the artist's return to France, wrote in 1894 somewhat deceptively attributing some of the qualities Gauguin had found in Cézanne instead to Poussin: "His work is just as unextravagant as Poussin's; it is just as controlled, as stern; it shines with a similar dazzle of color. His barbarity? No, I would rather describe this Tahitian landscape as full of peacefulness, joy, and grace." And Gauguin, later reflecting on his earlier paintings of the Tahitian landscape during his second stay there, wrote in his manuscript, *Diverses Choses*, that he had been

eager to suggest a luxurious and untamed nature, a tropical sun that sets aglow everything around it . . . an immense palace decorated by nature itself with all the richness that Tahiti contains. Whence all these fabulous colors, this inflamed, but softened, silent air. "But none of that exists!" "Yes, it exists, as the equivalent of the grandeur, depth, and mystery of Tahiti when it must be expressed in one square meter of canvas."

Oil on canvas, 26¹¹⁄₁₆ × 36³⁄₈ inches (67.8 × 92.4 cm)

The Minneapolis Institute of Arts 49.10

The Julius C. Elliel Memorial Fund

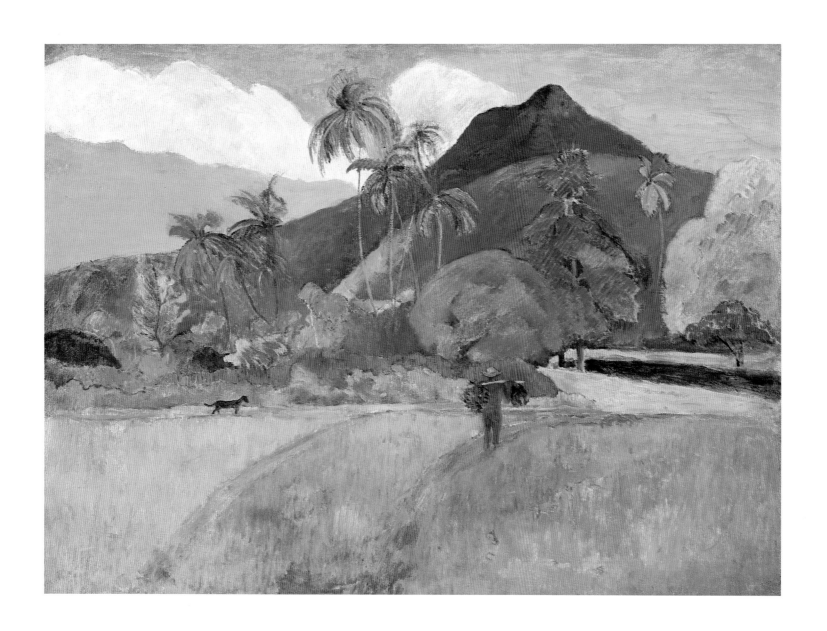

32

I raro te Oviri (Under the Pandanus)
1891

Although he painted landscapes and portraitlike subjects in Tahiti, Gauguin's greatest commitment was to figure compositions evoking native life and traditional culture. In *I raro te Oviri* he represented a scene of food gathering, a subject he had earlier treated in Brittany and Martinique. Here he depicted one woman carrying breadfruit on a stick, another holding a basket, and a distant figure fishing in the surf. Food seems abundant, work effortless, and life calm and relaxed. Through the impact of the sumptuous colors and flowing arabesques, and the gentle accord between the figures and their surroundings, this apparently ordinary scene is invested with a sense of enchantment. From the deceptive evidence of paintings like this, Gauguin appeared to find in Tahiti a reality congenial to his imagination and desires.

Gauguin painted two quite similar versions of this composition. The other canvas (Dallas Museum of Art) is slightly smaller and was probably done first, since the handling is rougher and the drawing more tentative. For the Minneapolis painting, he shifted the whole composition a bit to the left, changed the color of the skirt of the right-hand figure from red to blue, altered some of the landscape contours, darkened and strengthened the colors, smoothed the brushwork, and refined and unified the linear rhythms and ornamental patterns. It was not Gauguin's usual practice to make replicas of his paintings, and no reason is known why he did so here. Neither one appears to be clearly superior to the other. Gauguin sent the less polished version to Copenhagen for exhibition in 1893 with a group of his Tahitian canvases. At the time he shipped it, it did not have its Tahitian title inscribed on it, a task he entrusted to his friend Daniel de Monfreid, who received the shipment in Paris and forwarded it to Gauguin's wife in Copenhagen. The Minneapolis painting's title, however, was inscribed by the artist himself.

Gauguin recorded the composition in the inventory he assembled in the spring of 1892, listing it as *femmes pandanus* (women pandanus), but he did not indicate anything about the different versions. He seems to have devised the Tahitian title only afterward, by the beginning of December 1892. He translated it for his wife as *sous les pandanus* (under the pandanus).

He composed his image from a variety of sources: the woman at right, dog, and squatting woman at left were each derived from quick notebook sketches made from life; the poses of the two principal figures also may have been inspired by reliefs from the Parthenon and from Trajan's Column; the theme and overall arrangement reflect one of his own earlier prints of Martinique; and the basic idea of a simple frieze of figures in silent dialogue is indebted to Puvis de Chavannes, to whom he may here have owed his greatest general debt. His borrowings often came from any art he regarded as primitive, which for him embraced the arts of Egypt, Java, Cambodia, Japan, Brittany, pre-Renaissance Italy, and even Greece and Rome—that is, anything that seemed to him opposed to naturalism, Impressionism, and most modern Parisian art. His use of these sources enlarged his repertoire of motifs, but, more crucially, was fundamental to his quest for a means of expression that could transcend different cultures and evoke more universal levels of meaning. In *I raro te Oviri* he added to the ways he believed he could convey meaning by finding in the shrivelled pandanus leaves mysterious analogies with an archetypal Oriental script.

The fusions of observation, memory, and imagination with references to diverse cultures and artistic traditions were meant to create a complex symbolic language, whose meanings would be multiple and contradictory. Gauguin wished to avoid fixed symbols or traditional allegories, seeking instead an art of mystery, enigma, and allusion. He wrote to the critic André Fontainas in 1899 that in his painting "my dream cannot be grasped. It involves no allegory, it is a musical poem without a libretto, to quote Mallarmé." Like Seurat and Signac (see nos. 76, 77, and 80), he sought an allusive, generalized, and sensuous presentation of ideas and emotions through the arrangement of lines and colors, or what he referred to as the musical aspect of painting.

Through the lush colors, rhythmic lines, and decorative simplifications of *I raro te Oviri*, he evoked a prelapsarian world of primordial splendor, an idyllic existence lived in effortless harmony with nature. But this image was largely his invention and reflected little of the physical and social conditions of Tahitian life. It was, rather, a fiction addressed to his European audiences with their taste for fantasies of primitive paradises and with their pressing problems with the social and political questions of modern urban life. To them Gauguin offered a dreamlike vision of a far-off world, one that was, as the critic Félix Fénéon put it, "barbarous, opulent, and taciturn."

Oil on canvas, 29 × 37⅞ inches (73.7 × 96.2 cm)

The Minneapolis Institute of Arts 41.4

The William Hood Dunwoody Fund

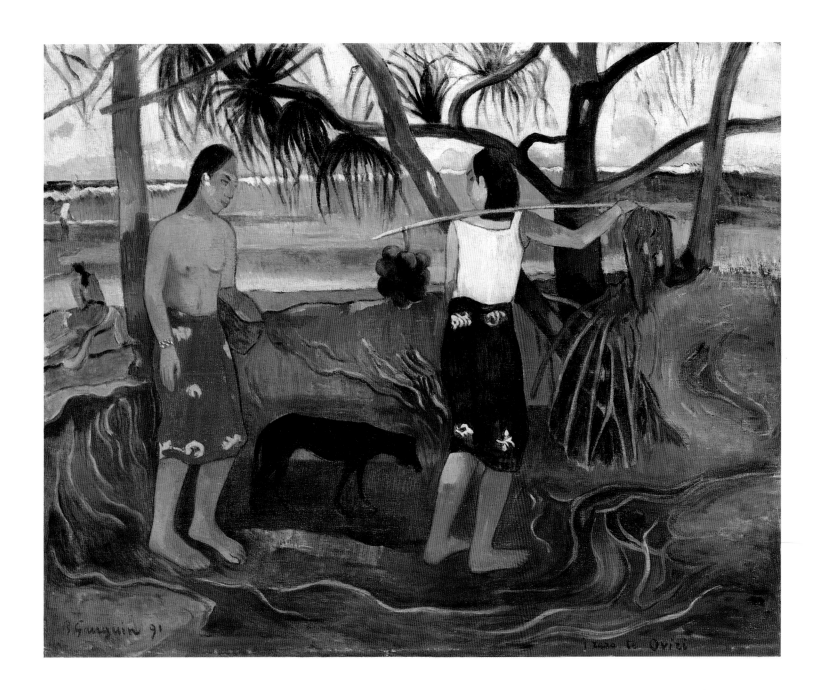

33

Moulin du Blute-Fin, Montmartre
c. 1887

Van Gogh arrived in Paris in March 1886. Before he left Holland, he already was interested in developing in his painting the expressive potential of color that he had recognized in Delacroix, but, as he later admitted, he was ignorant of Impressionism before going to Paris. He saw Impressionist painting in exhibitions and at dealers during 1886, but it had no evident effect that year on his landscape paintings, which remained somber in color and heavily impastoed in handling.

In Paris he lived with his brother Theo, an art dealer for a major Paris firm, in an apartment high up on the Butte Montmartre to which they had moved in June 1886. Within a short time he had begun to paint Montmartre subjects, at first mostly panoramic views of the hillside and of Paris seen from over the rooftops, but soon taking a particular interest in the three windmills located on the crest of the Butte. They may have reminded him of Holland, although he had done only a few images of windmills there, but he probably was attracted to them as a charming motif that recalled an older, more rural Montmartre in contrast with the modern Paris that now extended far up the slopes of the hill.

The three mills were all known loosely as the Moulin de la Galette, which was the name of a popular rustic tavern with gardens that was situated adjacent to one of them. The mill featured in the Carnegie painting and the one he most often represented also was called the Moulin Debray, or more traditionally the Blute-Fin. The Blute-Fin no longer functioned as a mill and had become instead a place people went for the view of Paris. It was indeed from here that van Gogh had painted some panoramas of Paris in the summer of 1886. It was a seemingly rural pleasure spot for nearby city dwellers, a destination for the outings of families and lovers, but van Gogh represented it as an isolated jumble of mills, market gardens, sheds, rickety fences, and empty ground, with only a glimpse of the city off to the side.

Van Gogh did images of the Moulin du Blute-Fin in the summer and early autumn of 1886 from various directions, both as part of a larger scene and as the principal feature. He spent most of the autumn and winter of 1886–87 studying in the studio of Fernand Cormon and working indoors on still lifes, portraits, nudes, and plaster casts. When he returned to painting out of doors in the late winter or early spring of 1887, one of his first subjects was again the Moulin du Blute-Fin, and it most likely was at this time that he executed the Carnegie painting. During the months since he had last done landscapes, he had studied Impressionist art and had become friendly with such young artists as Louis Anquetin, Emile Bernard, and Paul Signac, who had already assimilated Impressionism. By late winter van Gogh had tentatively begun to absorb ideas from Impressionist painting into his own

art. Like the figure behind the fence working at an easel, he placed increased importance on trying to transcribe directly the sensations he experienced before nature. In place of the subdued earth colors he had mostly used before, his palette was now far lighter, cleaner, and more refined. The colors recall Daubigny and Corot, but the generally high, even scale of values and the translucency of the tones indicate the impact on him of the *peinture claire* of Boudin, Monet, Pissarro, and others (see nos. 5, 47, and 61). The variations and inflections of color differentiate landscape elements, provide contrasting accents, suggest atmospheric perspective, and express the bright, clear light filling the scene. Van Gogh's brother Theo, noting these recent developments, wrote to his sister Lies on May 15, 1887, "Vincent's paintings are becoming lighter and he is trying hard to put more sunlight into them."

In the Carnegie *Moulin du Blute-Fin*, van Gogh deployed a new, Impressionist-inspired touch that is far more delicate, fluent, and flexible than in his earlier works. Paint is applied freely with unexpected thinness and fluidity, with impastoed or crisply graphic accents conveying the varied shapes, details, and textures of the buildings, fences, and vegetation. In the composition van Gogh also responded to the character of the actual site, effectively exploiting the vertical picture format to enhance the effect of the steeply inclined terrain at the top of the Butte Montmartre. This composition, with its prominent, open foreground and concentration on the middle distance, may recall van Gogh's own earlier Hague School landscape style, especially as it reflected the compositional formulas of such Dutch artists he respected as Jacob Maris and J. H. Weissenbruch. But the exaggerated sparseness and the somewhat flattened recession suggest too his considered scrutiny of Impressionist painting (see nos. 48 and 61) and the transforming effect it had begun to have on his art.

Oil on canvas, 18½ × 15½ inches (47 × 39.4 cm)

The Carnegie Museum of Art 67.16

Acquired through the generosity of the Sarah Mellon Scaife family

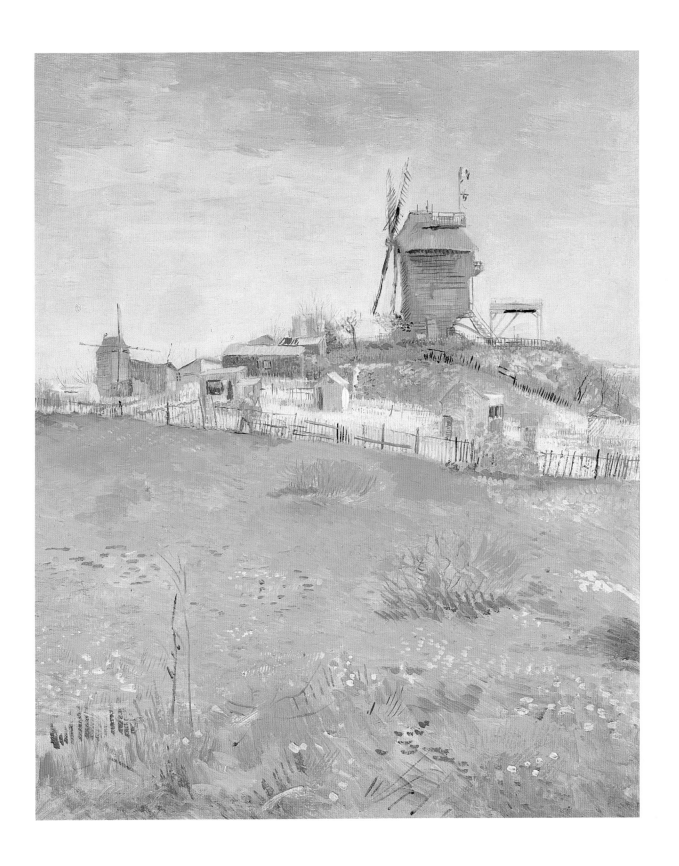

34

Factories at Asnières
1887

In the course of the winter and spring of 1886–87, van Gogh was spurred simultaneously by a number of diverse developments in contemporary French painting. He became particularly close to both Paul Signac, one of the principal practitioners of Neo-Impressionism (see nos. 78 and 79), and Emile Bernard, who was then in the process of rejecting it for what was to be called Cloisonism the following year. He spent the spring of 1887 working out of doors, first by himself on the Butte Montmartre (see no. 33), and then in the Paris suburbs with Signac and possibly with Bernard as well. Bernard left Paris by the end of April and Signac by late May, and afterward, during the summer months when he painted *Factories at Asnières*, van Gogh worked alone.

As a result of his many opportunities to study recent art of all sorts at first hand, van Gogh made a sustained effort to assimilate the rich and complex lessons of his contemporaries. He now treated the landscape in terms of color, using more variegated, luminous, intense, and, in places, hotter tones than he had earlier. He experimented with complementary contrasts, as he did here in such passages as the red and green touches along the fence, the green dots on the red roofs, and the blues and oranges interspersed in the meadow. As early as 1884 he had been aware of color theory based on Delacroix's practice, but was uncertain how to make good use of it. He seems to have needed to see Impressionist and Neo-Impressionist painting to do so. His brushwork became more varied and fragmented, and he applied a scattering of Neo-Impressionist points along with vigorously parallel or crossing directional strokes in the fields and buildings and softer, more blended ones in the smoke and sky. Through the network of touches, he introduced rich color variations and imparted an overall rhythmic animation to both the depicted scene and painted surface.

While van Gogh's stress in his handling was primarily on movement, he seems also to have found useful in Neo-Impressionism and Cloisonism the elements of order and discipline. In *Factories at Asnières* the composition is highly controlled. The simplified design of broad, parallel bands and repeated verticals furnishes a clear sense of pictorial order, with a tendency toward symmetry marked by the placement of the tall smokestack and horizon line along the vertical and horizontal medians. Perspectival coherence is rejected and spatial divisions are treated as a sequence of flattened shapes within which patterns of color and touch are elaborated.

Like the Neo-Impressionists, but also like Bernard, van Gogh sought to establish a link between pictorial experimentation and social meaning. In *Factories at Asnières* he depicted the industrial suburbs northwest of Paris, an area of factories, workshops, workers' housing, mountains of coal, and empty land (*terrains vagues*)—here a nondescript meadow sprinkled with clumps of yellow and dark green flowering plants and bordered along the temporary fence by red flowers. It was a landscape in transition, a shifting frontier, disparate and provisory, not quite city but no longer country. It was a subject that was repeatedly investigated during the 1880s by such young artists as Angrand, Bernard, Luce, Seurat, and Signac (see no. 75), but that had been of less concern to older Impressionists, if not unknown to them (see no. 50). During 1887 van Gogh frequently depicted the industrial suburbs and the areas of undeveloped terrain within the city fortifications known as the *zone*. These subjects engaged his long-standing feelings for the working poor and the landscape they inhabit, a social consciousness and humanitarian sympathy that had been born of his fervent religious convictions.

He added his own note to the subject, the tiny pair of lovers strolling through the meadow dwarfed by the factories and by the tall smokestack directly over them. The scene may possibly be reminiscent of a passage in Zola's *L'Assommoir* of 1877, a novel he had read five years earlier and may have looked at again in Paris:

With their heads lowered, [Gervaise and Goujet] made their way along the well-worn path, amid the rumbling of the factories. Then, after two hundred yards, without thinking, as if they had known the place all along, they turned left, still keeping silent, and came out into an empty terrain. There, between a mechanical sawmill and a button works, was a strip of meadow still remaining, with patches of scorched yellow grass; a goat, tied to a post, walked round in circles bleating; farther on a dead tree crumbled in the hot sun. "Really," Gervaise murmured, "you'd believe you were in the countryside."

Where Zola's image—at once melancholy, pathetic, and ironic—evokes these choked and constricted lives, van Gogh's seems to express the release and even pleasure, however temporary, to be found by these innocent souls amid yellow fields in flower under a summer sun in a setting that to others could seem so drab, desolate, and depressing.

Oil on canvas, 21¼ × 28¹¹⁄₁₆ inches (54 × 72.8 cm)

The Saint Louis Art Museum 579:1958

Gift of Mrs. Mark C. Steinberg

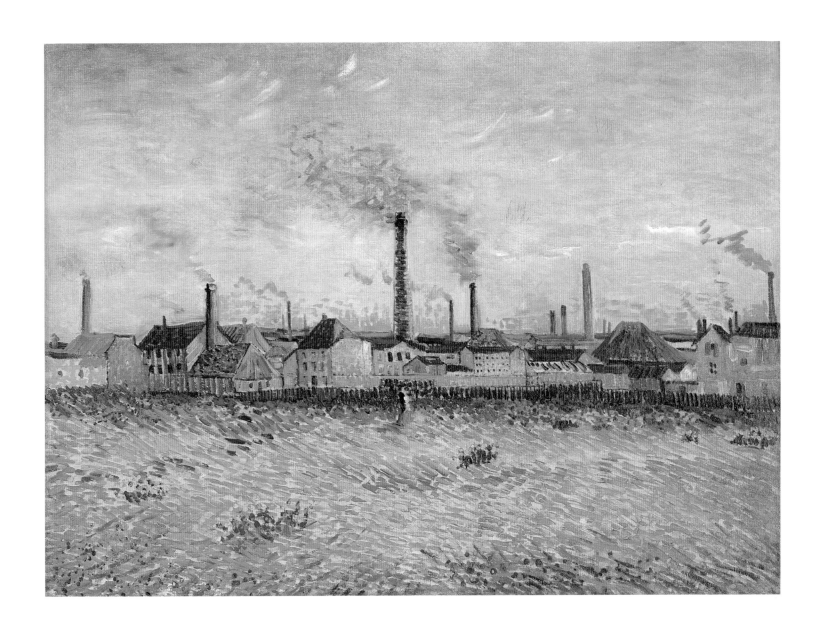

Van Gogh produced about ninety still lifes during his two years in Paris, mostly of flowers and fruits, but also of shoes, plaster casts, books, and skulls. Along with portraiture, it was the subject that occupied much of his attention during the autumn and winter months of 1886–87 and 1887–88, when he no longer wanted to work outdoors. He seems generally to have conceived of his still lifes during these years as pictorial experiments, and he referred to them more than once as "color studies."

Basket of Apples was painted in the late summer or autumn of 1887 when he again focused on still lifes, much as he had the previous year at this time. He executed a closely related group depicting fruits and vegetables. In them he seems to have set out to examine the recent Cloisonist developments in the art of his friends Anquetin and Bernard, but at the same time recalled the still lifes of apples and of potatoes he had painted two years before while still in Holland. In those earlier works he had sought to endow the objects represented with a great sense of solidity and tangibility. He wrote at the time to his brother Theo of these still lifes "to which I have tried to give *body*, I mean, to give expression to the material in a way that it becomes lumps that have weight and are firm, which you would feel if it were thrown at you, for example." It was this quality of firmness and materiality that he strove to re-create two years later.

In *Basket of Apples* he established a strong sensation of relief through the brushwork and color that model the irregular, three-dimensional volumes of the apples and wicker basket, an effect he augmented through the contrasts of impasto and color intensity between the objects and their setting. As in other paintings of that year (see no. 34), brushwork, line, color, and composition have become far more abstract and autonomous than they had been previously in his work. Long, directional strokes flow in freely curving rhythms that shape the objects, create sequences of movements across the surface, and seem to radiate outward in an undulating halo effect. The color is exaggerated and, in many places, arbitrary, as van Gogh explored the possibility of a scheme dominated by a single color enlivened by vivid and sometimes complementary contrasts. The indeterminate setting, simple design, and shallow, tilted space heighten the overall effect of a unified and rhythmically vibrant chromatic field.

The raised and angled view, shallow space, and accentuated brushwork suggest that van Gogh may have known Monet's fruit still lifes of 1879–80. As these were only exhibited in 1880 and 1883, before van Gogh's arrival in Paris, Monet's influence may have been transmitted via van Gogh's friend Signac, whose Monet-inspired still lifes offered comparable features, along with a regularized, striated touch and an extended play of complementary contrasts. But van Gogh's bold out-lines, ambiguously flattened space, and, above all, nearly monochrome color scheme point to the immediate impact of Anquetin's Cloisonist experiments with one-color painting of the summer of 1887, works that he brought back to Paris in September. In the arbitrary and daring simplifications that Anquetin, along with Bernard, had evolved, van Gogh seems to have perceived some of the means toward a more powerful and vibrant pictorial harmony capable of expressing the vital pulse he felt in all of nature.

Van Gogh developed these ideas in several still lifes of that moment. Just prior to this painting he did another, slightly larger in size and dedicated to Lucien Pissarro. It was of the same basket of apples but placed within a more defined setting that was pale yellowish white and light blue in color. In one of apples, grapes, and pears later dedicated to Theo, he elaborated even further the active touch and unified yellow harmony, extending them even into a wide, painted yellow frame.

He signed and dated *Basket of Apples* and presented it, without dedication, to Alexander Reid probably that same year. Reid much later recounted rather fancifully that after he offered van Gogh some apples, the artist gave him back a painting of them in a basket. The son of a Glasgow art dealer, sent to Paris to learn the trade, Reid met the two van Goghs late in 1886 through his work for the same firm as Theo. With Vincent he shared an interest in the artist Monticelli, and he roomed with Vincent in Theo's apartment for a short while in 1887 until Vincent precipitated an absurd falling out. Van Gogh painted his portrait at least twice, and Reid brought one of them and this still life back to Glasgow when he returned in 1889.

Oil on canvas, 18⅜ × 21¼ inches (46.7 × 55.3 cm)
The Saint Louis Art Museum 43:1972
Gift of Sydney M. Shoenberg, Sr.

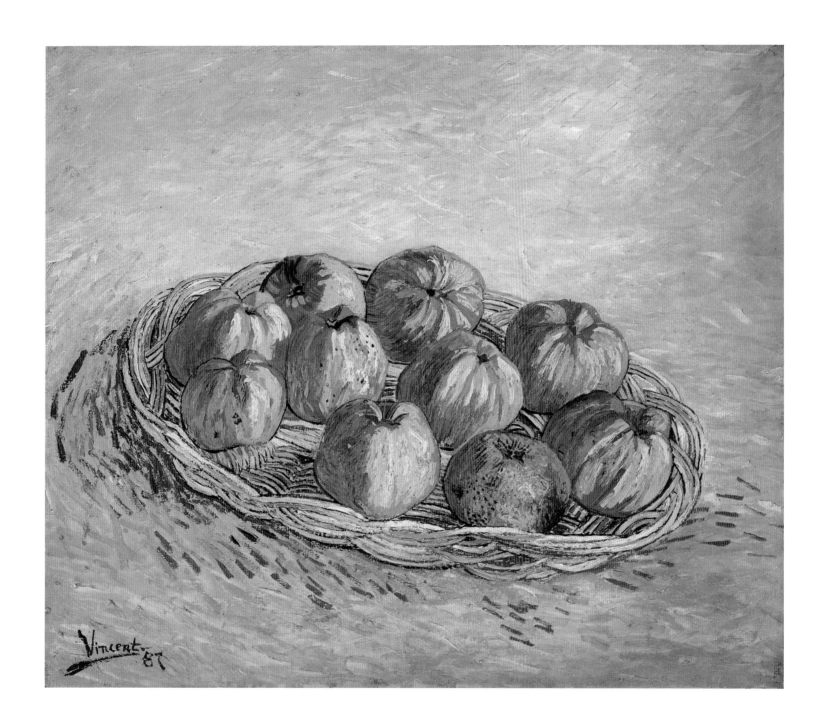

36

Olive Orchard

1889

Van Gogh left Paris in February 1888 for the south of France, seeking not only relief from the pressures of the city and his increasingly strained relationship with his brother, but also a warm, bright place where he could work in close harmony with nature. After a breakdown at Arles, he entered the asylum in Saint-Rémy (about fifteen miles from Arles) in early May 1889. During the first month he made paintings and drawings from his window and within the asylum grounds, and then in early June was permitted to work outside the asylum walls. By mid-June he had done his first paintings of a nearby grove of olive trees. He returned to the subject repeatedly and by the end of the year had produced fifteen canvases altogether. The Nelson-Atkins painting was one of the earliest of those and almost certainly was described in his letter of June 16 to his sister Wil: "I have just finished a landscape representing an orchard of olive trees with gray leaves, somewhat like those of the willows in color, their violet shadows lying on the sunny sand."

Writing a year later from Auvers to the Dutch art critic J. J. Isaäcson, he tried to explain the attraction that olive trees had for him as a motif: "The effect of daylight, of the sky, makes it possible to extract an infinity of subjects from the olive trees. Now I, on my part, sought contrasting effects in the foliage, changing with the hues of the sky." He went on to describe the scene he appears to have depicted here: "At times the whole is a pure all-pervading blue, namely when the tree bears its pale flowers, and big blue flies, emerald rose beetles, and cicadas in great numbers are hovering around it." But later in the same letter he makes clear that what he was after was far more than a record of appearances: "Ah he [Puvis de Chavannes] would know how to do the olive trees of the South, he *the Seer.* . . . I did not want to leave things alone *entirely*, without making an effort . . . let others who are better and more powerful reveal their symbolic language."

Van Gogh painted out of doors and felt strongly that observation was the essential basis for his art. He worked rapidly and with incredible facility and improvisatory freedom, but generally retouched his canvases somewhat in the studio. While he painted much of the *Olive Orchard* swiftly, wet in wet, he later added and extended the olive foliage along the right side and at the upper left over partly dry paint, thus blocking the recession to the right and bracketing the view along the sides with curving borders of vegetation.

As in Monet's paintings of Belle-Ile and Antibes (see nos. 52 and 53), van Gogh's practice extended the primarily naturalistic inspiration of earlier Impressionism, while emphasizing the subjectivity of the artist's vision. For both, color is intensified and developed in closely coordinated harmonies; touch is active and accentuated, characterizing the landscape's forms and evoking its animation; and nature is treated in terms of broad patterns and rhythms. But in van Gogh, the impasto is far heavier; the strokes larger, more regular, and more distinct; the rhythms more coursing, emphatic, and unified; the colors less varied and nuanced; and the forms and spaces more freely distorted.

The bright, vibrant colors; bold, cursive handling; winding curves and continuously flowing movements express the essential character of this landscape, as well as his own lyric feelings for nature's animation and life. In 1882 he had written to Theo that "in all nature, for instance in trees, I see expression and soul, so to speak." To represent what he experienced—both what he saw and what he felt—he took the observed landscape as a starting point, but as he commented to Bernard in October 1888:

I won't say that I don't turn my back on nature ruthlessly in order to turn a study into a picture, arranging the colors, enlarging and simplifying; but in the matter of form I am afraid of departing from the possible and the true . . . I exaggerate, sometimes I make changes in the motif; but for all that, I do not invent the whole picture; on the contrary, I find it all ready in nature, only it must be disentangled.

Days after he finished the *Olive Orchard*, he wrote to Theo that "by going the way of Delacroix . . . by the use of color and a way of drawing that is freer than illusionistic fidelity of detail, the nature of the countryside can be expressed." But as his invocation of Delacroix suggests, his purpose is not solely to "disentangle" what is "in nature," but also to give form to his own subjectivity, to convey his deepest feelings for nature and his pantheistic rapture in its fruitfulness and vitality. In the *Olive Orchard* van Gogh proceeded from his direct visual response to this landscape motif, shaped it with an eye toward pictorial harmony, and charged it with his passionate lyricism.

Oil on canvas, 28¾ × 37 inches (73 × 94 cm)
The Nelson-Atkins Museum of Art 32-2
Nelson Fund

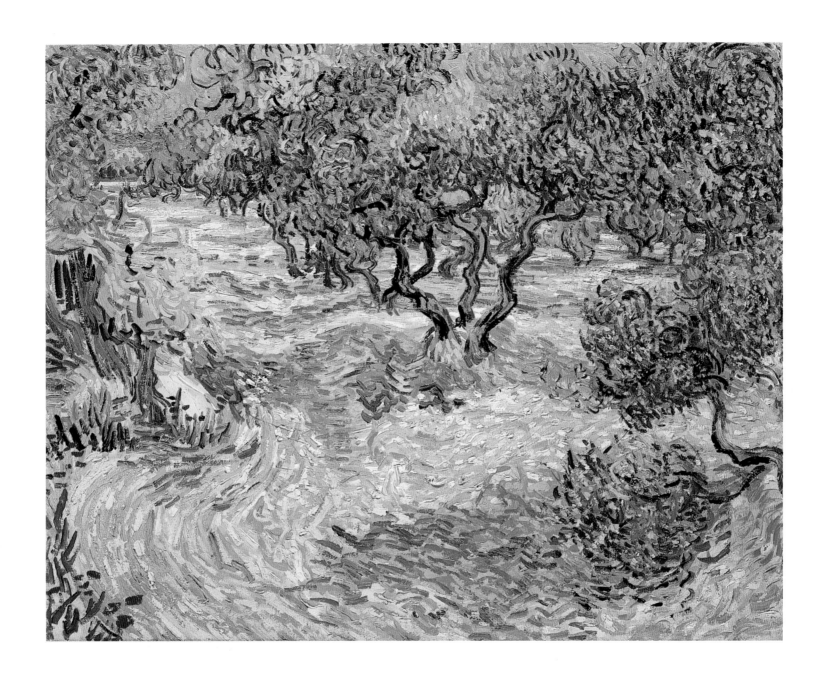

37

Olive Trees
1889

Van Gogh returned to working in the olive groves at Saint-Rémy only in late September 1889, after having done three paintings of the subject in June (see no. 36). By late November he had five large paintings of the subject well underway, and in a letter to his sister Wil of about December 9–10, he noted, "I am working on twelve large canvases, especially olive orchards . . . one with a big yellow sun," a clear reference to the Minneapolis painting, which is the only one with the sun visible. From the context of the letter, it seems reasonable to suppose that the work on this canvas was now being done in the studio.

Although he had certainly not worked on all five olive orchard pictures of this group continuously from late September, these canvases were nonetheless the objects of a more protracted effort than were those done in June. There is no lack of movement throughout the surface of the Minneapolis *Olive Trees*, but the strokes have become shorter and choppier and are aligned in more organized patterns. The paint is more densely layered in many areas, with evidence of careful reworking especially in the olive trees and sky to extend the foliage, develop its interaction with the radiating sunlight, and elaborate and adjust the patterns and rhythms of brushwork. More deliberate and less improvisatory, the painting shows signs of struggle and of more extended procedures than what he had done earlier that summer.

Van Gogh chose his motif from his immediate surroundings, but also expected his depiction of it to embody meanings deeper than the natural forms described. Olive trees already had associations for him with the south, the cycles of the seasons, and the harmonious human relationship with the landscape, but developed further layers of meaning as he worked from what he had learned of some recent paintings by Gauguin and Bernard. On November 16 Theo forwarded to him a letter from Gauguin with a description and sketch of his recently completed *Christ in the Garden of Olives*, and at nearly the same moment he received photographs of some biblical compositions by Bernard, among which was, by chance, another *Christ in the Garden*. Van Gogh's response was immediate and sharply critical. He wrote to Theo on November 17 that "it is better to attack things with simplicity, than to seek after abstractions" and that both artists avoid "getting the least idea of the possible, or of the reality of things, and that is not the way to synthesize." His reply to Gauguin is lost, but to Bernard he soon wrote a long and scathing letter condemning "that nightmare of a 'Christ in the Garden of Olives'" while reporting that he, on the other hand, was painting the olive trees instead and gathering "new vigor in reality." He went on to conclude: "One can try to give an impression of anguish without aiming straight at the historic Garden of Gethsemane; that it is not necessary to portray the characters of the Sermon on the Mount in order to produce a consoling and gentle motif." And he wrote to Theo on November 26:

Their Christs in the Garden, with nothing really observed, have made me furious. Of course there is no question of my doing anything from the Bible, and I have written to Bernard and also to Gauguin to tell them my belief that thoughts and not dreams are what concern us. . . . What I have done is a rather hard and coarse reality beside their abstractions, but it will have a rustic quality and will smell of the earth.

Despite his vehement objections, van Gogh himself had unsuccessfully attempted a Christ in the Garden of Olives in the summer of 1888. But prior to learning of Gauguin's and Bernard's paintings, his letters of 1889 gave no hint that he saw his olive trees of that year in any relation to the biblical theme. His association of the olive trees with Christ's anguish seems only to have emerged after at least some of the canvases of the fall series were in progress. As he worked, he may have tried to invest his representations of this motif with newly gained layers of meaning, much as he had on some other occasions. In his paintings, natural forms became metaphors for human passions and experiences. The *Olive Trees* may thus have come to remind him of Gethsemane and, at one level, to express suffering and salvation in the bent and twisted trees and radiant sun. For van Gogh, the sun embodied the life force, the mysterious source of nature's vitality and regeneration. But as occupied as he often was at this time with religious thoughts, he was no longer a believer and could paint neither conventional religious subjects nor allegories of the divine. What he sought instead was to convey in his representations of nature the sense of solace and renewal he found there. In paintings like *Olive Trees*, he could hope to evoke, as he wrote to Bernard in April 1888, "a more exalting and consoling nature than a single brief glance at reality . . . can let us perceive."

Oil on canvas, 29 × 36½ inches (73.7 × 92.7 cm)
The Minneapolis Institute of Arts 51.7
The William Hood Dunwoody Fund

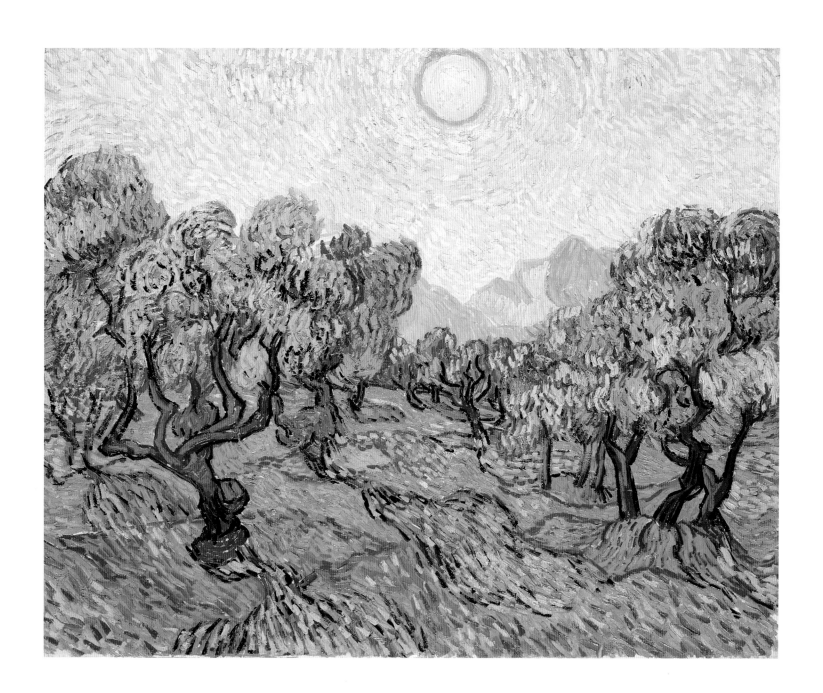

38 *Stairway at Auvers*

1890

Van Gogh left the asylum at Saint-Rémy on May 16, 1890. After stopping in Paris for a few days to see Theo, his wife, and their baby, Vincent, he continued on to Auvers-sur-Oise twenty miles north of Paris, where he arrived May 20. In Auvers he hoped to find a place where he could live and work in peace and freedom. Auvers was a large town but looked like an old, rural village, and van Gogh wrote of it as "real country." The town was well known to artists: Daubigny had lived and worked there for many years; both Pissarro and Cézanne had painted there; and it was now inhabited by a number of young artists. Van Gogh stayed at an inn on the main square across from the town hall and in *Stairway at Auvers* he did a view of the rue de la Sansonne, an old, winding street close by. It was a picturesquely complicated motif, completely irregular and full of odd elements, with a change of street levels connected by stairs.

Van Gogh did not mention the painting in his letters, and it has usually been dated to July, but, as has been plausibly proposed, it probably was executed toward the end of May, not long after his arrival. During his first week in Auvers he had done some paintings and drawings of flowering chestnut trees, as he noted in a letter of May 25. Since the small chestnut trees in *Stairway at Auvers* are also in bloom, it probably was painted at around the same time.

While he was in Auvers van Gogh was immensely productive and worked at an astonishing tempo: he could write to Theo on his fourth day there that he had already done four paintings and two finished drawings. In his seventy days there he produced some seventy canvases. Following a procedure that was, at this date, highly unusual for him, he executed the Saint Louis painting from a smaller preparatory study in oil on cardboard, presumably done directly from the motif. Although he often referred to his work variously as "studies" and "paintings," he seems generally to have meant the terms to distinguish works painted quickly from nature from those more considered and developed; the first was not necessarily a preparation for the second. However, the smaller version of *Stairway at Auvers* looks hastily executed, the paint roughly applied in a thick impasto without much sense of nuance, refinement, or pattern in the strokes, as if his purpose was to take the measure of the motif and to block out the basic arrangement. The larger painting may have been worked on in his room or on the spot, using the sketch as a guide.

In the Saint Louis painting, five figures rather than two were included, and the proportions of the composition were altered, with strips of space added on three sides. The two girls in straw hats were lifted from a sheet of studies done at Auvers where they appear virtually as they do in the painting. The grayed and muted colors of the sketch were made brighter, clearer, sharper, and somewhat more artificial. Curving patterns of brushwork were established and blue contours and accents added or strengthened to define shapes, mark off areas of color, impart a sense of order, and intensify the overall effect of energy and movement.

In spite of the more extended preparation than usual, the final painting was executed with extraordinary fluency, impetuosity, and verve. The paint was laid on with swiftness and certainty, with contours, descriptive touches, and directional accents freely applied over a relatively open and thin first layer. While the two pairs of women were there in the enlarged composition from the beginning, the man descending the stairs seems to have been a relatively late thought, increasing the density and activity at the center.

Van Gogh's broken, repeated strokes unite to form arching and serpentine curves, which are repeated, reversed, and varied across the composition in a sustained and intricate interplay of movements. The rapid convergence of the complicated perspective is an animating force and serves as much to energize as to shape the depicted space. Near and far are conceived as elements in perpetual flux, as the space dilates and contracts through the recurrence and relatively even distribution of the bright colors, accentuated strokes, and insistent arabesques. These ceaseless movements are held together, but not constrained, by the broad symmetries and perspective thrust and are stabilized, to a degree, by the weight of the squared-off forms of the buildings at the center. The rhythms and colors have an emotional force and depth that van Gogh both infused into and disentangled from the scene he represented. They convey the animation he sensed within all of nature and express his giddy and exhilarating delight in what he saw and experienced here.

Oil on canvas, 20 × 28 inches (50.8 × 71.1 cm)

The Saint Louis Art Museum 1:1935

Purchase

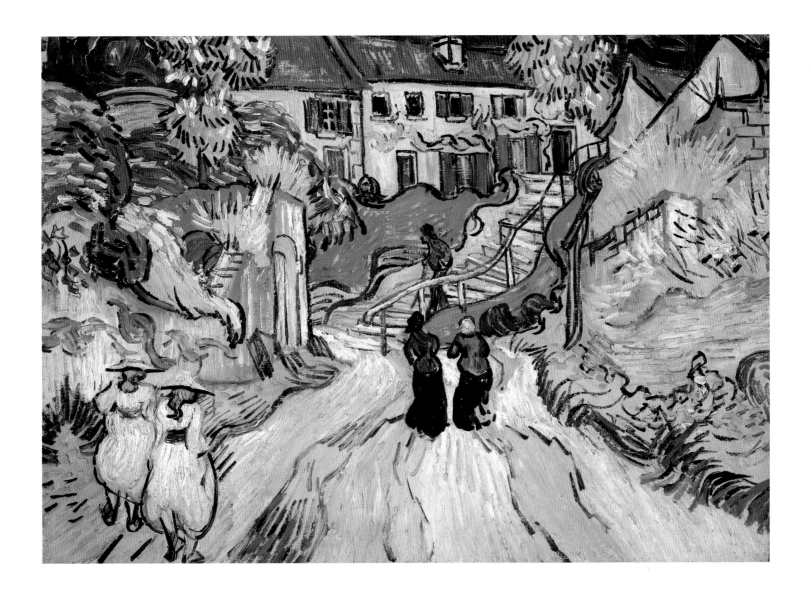

39 *Wheat Fields* (*Plain of Auvers*)
1890

Van Gogh was fascinated by the huge cultivated plains that stretched out above Auvers. During his two months there, he painted over a dozen pictures of these vast fields of wheat, a subject he persistently had turned to in Holland and in the south of France at Arles and Saint-Rémy. Even before painting the Carnegie *Wheat Fields* in July, he had already depicted the same network of fields more than once during the preceding month and wrote to his mother and sister Wil on about July 11, 1890, of his preoccupation with the motif:

I myself am quite absorbed in the immense plain with wheat fields against the hills, boundless as a sea, delicate yellow, delicate soft green, the delicate violet of a ploughed and weeded piece of ground, checkered at regular intervals with the green of flowering potato plants, everything under a sky of delicate blue, white, pink, violet tones. I am almost too calm, a state that is necessary to paint all that.

In this passage he appears to describe not a painting, but the landscape itself. He referred specifically to the Carnegie canvas in his last letter to Theo of July 23 in which he included a sketch of it along with ones of three other recently completed paintings. He wrote that it was one of "two size 30 canvases representing vast fields of wheat after the rain," a remark that may pin down its date to the preceding week following a period of rain between July 17 and 19 at Auvers.

His representations of the plains of Auvers have echoes and continuities with the past. He was reminded, he said in a letter of July 2, of the paintings of Georges Michel, only with more color. They may recall as well his own paintings and drawings of the fields and plains of Saint-Rémy and especially Arles, which he had himself earlier likened to the broad panoramas of his seventeenth-century Dutch compatriots Ruisdael, Koninck, and Hobbema. But as he worked from nature on the Carnegie painting, he also responded to the specific character and traits of the Auvers countryside before him, to the irregular patchwork of fields and the rise and fall of the terrain stretching out from the grassy knoll on which he stood.

He brought out the movements and rhythms of the landscape by the repeated zigzag patterns and the angular thrusts across and into space that play off against the three broad horizontal divisions, the basic gridlike structure, and the straight framing edges of the canvas. The colors and brushwork convey something of the natural features and textures of the scene, the soft colors describing the earth, vegetation, and sky, and the graphic vocabulary of strokes suggesting the planted furrows, grassy ground, trees, and rolling clouds. He established distinctions among the landscape elements by shifts in color; changes in the direction and shape of the strokes; dark, contrasting outlines; and hatched borders, but bound them together in an interlaced unity by the insistent rhythms of the handling. The zigzagging and tightly curling patterns of strokes activate the forms and spaces, impart speed and energy, link earth to sky, and draw the viewer into the animation of the natural scene.

In these "vast fields of wheat after the rain," van Gogh celebrated the fertility of the earth, the constant renewal of the natural world, and the universal forces present within all things. In such a landscape as this, he sensed an infinity that was, he said, inhabited, and he sought to express the comfort he found there. At a time when his letters confide his deepening feelings of "sadness and extreme loneliness" that would lead to his suicide on July 29, he could nonetheless write to Theo on about July 10 of some paintings of wheat fields, "I think these canvases will tell you what I cannot say in words, the health and restorative forces that I see in the country."

Oil on canvas, 28¾ × 36¼ inches (73 × 92.1 cm)

The Carnegie Museum of Art 68.18

Acquired through the generosity of the Sarah Mellon Scaife family

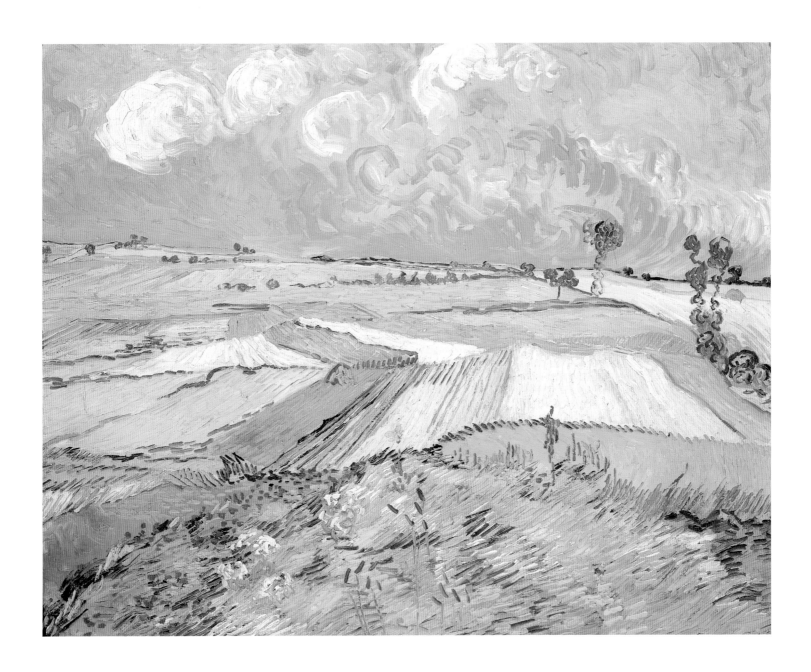

40 *Wheat Fields with Reaper*

The wheat fields around Auvers preoccupied van Gogh during the two months he was there, from late May until his death on July 29, 1890 (see no. 39). At Auvers the wheat turned ripe and was harvested after mid-July, which may indicate when *Wheat Fields with Reaper* was executed. This painting has, until now, consistently been dated to June 1888, placing it among a group of canvases of wheat fields produced at Arles during that month. But neither the stylistic features nor the particulars of the site represented make that date tenable. A comparison with two paintings, firmly dated to June 1888, of Arles viewed from the fields shows major differences in the constituent shapes of the landscape and their compositional configuration, in the character and patterns of the brushstrokes, and in the physical type and drawing of the reaper. In these and other qualities of composition and handling, the Toledo painting is quite similar to the wheat fields he painted at Auvers in July 1890.

His depiction of the site is somewhat more problematic. The view toward a distant town across wheat fields being harvested recalls one of the June 1888 Arles paintings, but it has no real counterpart among the Auvers ones. However, the rolling plain dropping off to a town tucked in against the hills is recognizably close to the topography of the Auvers countryside and not to that of Arles. The specific features of the town do not precisely correspond to those of any other image he did of Auvers and seem likely to have been partly composite and partly invented, though generally faithful to the locale. The degree of freedom with which he treated the actual landscape may suggest that the painting was executed in the studio rather than directly from the motif, a conclusion toward which the intricately varied patterns of brushwork and schematically outlined figure also may point.

Yet as carefully organized as the handling may be, the execution appears fresh and improvisatory, and the paint rapidly applied with immense assurance. The amount of later reworking was limited. One curious feature of the paint surface is the repair made by the artist himself to a long scratch through the wet paint running from below the leftmost sheaf of wheat and zigzagging down to the bottom edge. It did not puncture the canvas and was probably the result of a minor accident, perhaps with the butt end of a paintbrush.

Themes of peasants working in the fields had deeply involved van Gogh from his earliest drawings done almost ten years before. At Auvers he mainly focused on the traditional and unchanging aspects of the countryside and tended to ignore the modern ones. But in this painting he juxtaposed the traditional peasant labor of the reaper with the distant smoking factories closely surrounded by the town. He contrasted old and new, agriculture and industry, country and town, much as he had before (see no. 34). The treatment suggests that the comparison was a negative one between the tightly bunched, squared-off, static forms of the town and the expansive, complex, dynamic ones of the fields and sky.

For van Gogh, as for many other artists and writers, the peasants' labors set them in close harmony with nature's rhythms and cycles. Like Pissarro and Millet before him (see no. 64), van Gogh could still conceive of the peasant's relationship with nature as the most meaningful and exalted one. But he also saw immanent in the fields of wheat and in the figure of the reaper more generalized and symbolic meanings and sublime, almost religious emotions with which he sought to imbue his representations. He explained something of this significance in a letter to his sister Wil of July 2, 1889:

What else can one do, when we think of all the things we do not know the reason for, than go look at a field of wheat? The history of those plants is like our own; for aren't we, who live on bread, to a considerable extent like wheat, at least aren't we forced to submit to growing like a plant without the power to move, by which I mean in whatever way our imagination impels us, and to being reaped when we are ripe, like the same wheat?

He added to this in early September 1889 in a letter to Theo from Saint-Rémy discussing a recently completed painting of a reaper:

I see this reaper—a vague figure fighting like the devil in the midst of the heat to get to the end of his task—I see in him the image of death, in the sense that humanity might be the wheat he is reaping. So it is—if you like—the opposite of that sower I tried to do before. But there's nothing sad in this death, it goes its way in broad daylight with a sun flooding everything with a light of pure gold. . . . It is an image of death as the great book of nature speaks of it—but what I have sought is the "almost smiling."

Oil on canvas, 29 × 36⅝ inches (73.6 × 93 cm)
The Toledo Museum of Art 35.4
Gift of Edward Drummond Libbey

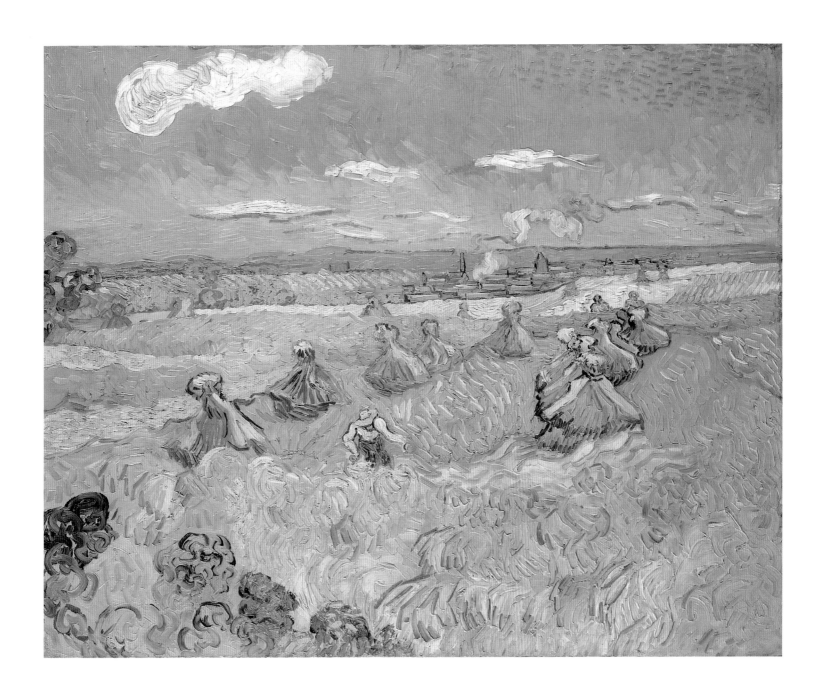

41

Entrance to Honfleur Harbor

1863

J ongkind's principal subject throughout his career was harbor scenes filled with boats. During a period of about four years in the early 1860s, his favored one was Honfleur on the Normandy coast. The harbor at Honfleur had been depicted often by Romantic landscapists, notable among them his teacher, Eugène Isabey. In place of their crashing waves, beached boats, and quaint old buildings, Jongkind instead chose to represent the workaday world of commercial vessels flanked by an ordinary harborside hotel, the Cheval Blanc, perhaps the only distinctly modern note in the scene. He blurred and softened many of Honfleur's more picturesque features, leaving only the steeple of the fifteenth-century wooden church of Sainte-Catherine on the right, a partially blocked view of the sixteenth-century Lieutenance to the left of the hotel, and a smudged hint of the tower of the church of Saint-Léonard on the left. Although Jongkind gave new prominence to the ordinary and everyday, harbor scenes like this one had a long tradition in French, English, and Dutch art and had a ready-made audience to whom Jongkind could and did appeal with his reasonably sized and priced canvases.

Jongkind's first important campaign at Honfleur took place in 1863. He wrote from his house in Paris to his friend Boudin on August 13, asking him to find him an apartment for six weeks or two months. He arrived around August 25 and remained until early November. In letters during his stay to his dealer Père Martin, he complained of rain and stormy weather, which hampered his ability to work outside. As was his usual practice, he concentrated during his stay on *plein-air* pencil and watercolor sketches of motifs from Honfleur harbor and the town and of water, light, and atmospheric effects. He would use these studies back in Paris to produce finished canvases "after nature," as he called them.

The Toledo canvas was probably executed in Jongkind's Paris studio during the last two months of 1863 based on studies brought back from his stay in Honfleur. He may have relied on a small *plein-air* oil completed during the summer, but he quite certainly made use of a watercolor inscribed "Honfleur 1 Oct 1863," which records the harbor view and three smaller sailboats found here. In the Toledo painting he slightly shifted the view, adjusted the arrangement of the boats, and filled out and developed the sky and water. During these same months in Paris, Jongkind produced a closely related etching that was the basis in 1864 for a larger painting shown in the Salon that spring. These works were in turn the starting point for Jongkind's watercolor campaign the following summer at Honfleur, in particular for a watercolor of September 14, 1864, which re-examines many of the Toledo painting's motifs.

While valuing the fresh and direct impression taken from nature, Jongkind felt no contradiction in reworking the same materials in the studio. He wrote candidly to his artist friend Smits: "I did [my paintings] after nature. Of course you understand, I did some watercolors from which I did my paintings." The Toledo painting is the first finished version of a favored subject that he continued to explore in the following months and years.

Jongkind's compositional scheme of boats before a panoramic townscape and a low horizon is one with long roots in the Dutch tradition of marine painting, notably in seventeenth-century views of Dordrecht by Cuyp and in harbor scenes by Jongkind's early teacher, Andreas Schelfhout. What Jongkind offers is a new brightness and luminosity achieved by a general predominance of clear, light-valued tones. He enhanced their effect by working them directly onto a white ground, rather than over the traditional dark underpainting. The color is relatively uniform, tending toward light blues, grays, and white, with contrasting dark browns reserved for many of the heavy and rigid forms clustered along the horizon. This use of a narrow range of high-valued colors was generally referred to as *la peinture claire* (clear, light painting; see nos. 5 and 47), but also, more appropriately for Jongkind, as *la peinture grise* (gray painting). It was Jongkind's way of translating into oil paint the clarity and transparency of outdoor light captured by him more effortlessly in watercolor.

Jongkind further developed this emphasis on overall visual effect by the rough and summary character of his brushwork. The rendering of texture and detail, whether of boats, town, water, or sky, is selective and adequate only to a general description of the subject. Instead, Jongkind gears his brushwork to convey the movement of flapping sails, choppy waves, and fleeting clouds through broken curves and short dashes. But Jongkind's paint does more: it invests this mobile and transitory world with a sense of material weight. As Boudin was later to write of his friend, Jongkind translated simultaneously this "fluidity and density. . . with an unimaginable precision."

Oil on canvas, 13⅛ × 18¼ inches (33.3 × 46.3 cm)
The Toledo Museum of Art 50.71
Gift of Edward Drummond Libbey

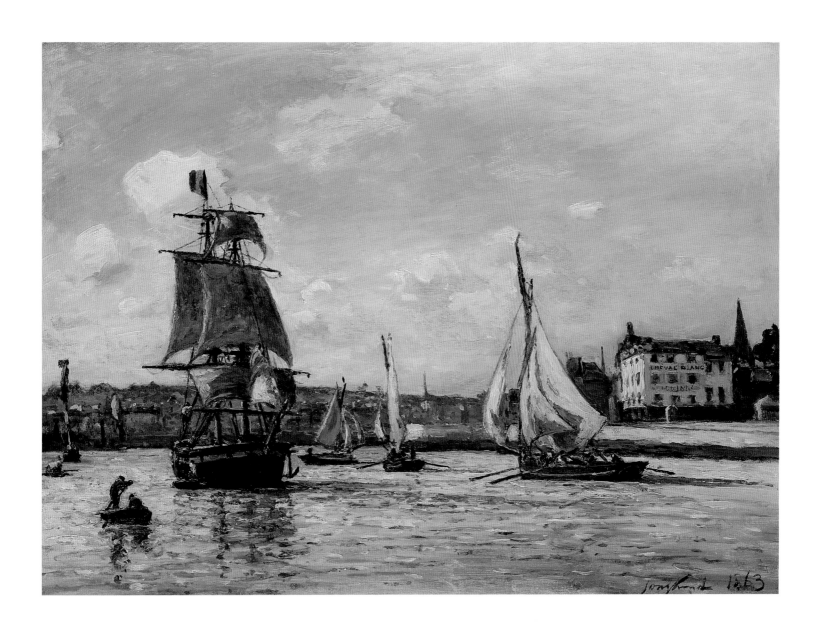

Luce was a principal figure among the Neo-Impressionist group from his debut in 1887. Through much of his career, his favored subject was Paris, initially its working-class areas but, from the early 1890s, its picturesque buildings and bridges on the Seine as well. In the autumn of 1899 he turned to the view from his studio on the left bank at 19, quai Saint-Michel, facing the Seine and the Ile de la Cité. He depicted what he could see from his window looking in both directions along the river. He did about ten paintings of Notre Dame, varying greatly in size, shape, and finish, many dated 1899, but the four most elaborate dated from 1900 to 1904.

Luce had ample precedents for the subject, but it was a peculiar choice for this artist given his political allegiances. He began his views of Notre Dame shortly after completing a five-year campaign in the industrial region of Belgium, paintings that reflected his anarchist views and expressed his concern for contemporary social realities. The contradiction between his political ideas and his choice of Notre Dame could only have been made more glaring by the second conviction of Captain Alfred Dreyfus in September 1899. Strongly anticlerical and antinationalist, Luce was a fervent Dreyfus supporter while the French Church had thrust itself into the anti-Dreyfusard struggle with a loudly anti-Semitic, anti-Protestant, pronationalist campaign.

Luce must, however, have ignored this apparent conflict and, like Pissarro painting from his hotel window in 1898 (see no. 68), seen only a beautiful motif and the artistic challenge posed by its tradition of views. The many paintings of Gothic cathedrals of the previous decade done by progressive artists must also have inspired Luce's interest, especially Monet's and Pissarro's of Rouen Cathedral (see no. 66). Luce saw the exhibition of Monet's series in 1895, and, according to his friend Signac's journal for May 21, 1895, he responded with strong reservations:

He is not enthusiastic. He finds it more curious than beautiful and thinks that these canvases lack in arrangement. These pieces of cathedral without sky, without terrain, do not give the proportions of the monument, and the painter's qualities do not seem great enough to him to overlook the absence of composition.

In his own views of Notre Dame, Luce depicted the whole building in its urban context. As he worked on his paintings, he wrote in the early months of 1900 to his friend H.-E. Cross: "I'm still grinding away at Notre Dame. I would like to do ceremonies, marriages, people coming and going, the crowd, in a word Paris." Once before in a painting of 1890 he had integrated a church into the daily life of a working-class Paris street, but in the majority of his images of Notre Dame his concentration was more on the monument itself. The effects of light, weather, time of day, and movement interested him more than the activities of the people on the bridges, quays, and streets.

The Minneapolis canvas was a product of Luce's extended procedures for creating large, finished paintings of Notre Dame. He wrote to Cross late in 1899 of the views in both directions out his window: "It's incredibly beautiful. I'm doing piles of studies and will try to make use of them for some larger canvases." He did a number of oil sketches directly from the motif; those on cardboard were small, quick, and roughly executed, while others on canvas, like this one, were larger, more careful and elaborate, and probably the result of repeated sessions. Even here, the handling is free and deft, strongly recalling the sketch technique of Monet and Renoir (see no. 73), while retaining traces of the more rigorous brushwork Luce still used in his most finished canvases. Here, through the loosely variegated touches, he wove together rich plays of related and complementary colors and contrasts of warm and cool, evoking the movements of carriages, pedestrians, water, clouds, and light.

From his accumulated studies, Luce selected one to enlarge and develop into a finished and definitive statement of the subject, while also making use of others to furnish specific details and effects. The Minneapolis painting is closely related to a large, final version dated 1900, but differs markedly in weather, color, and touch. The finished painting is filled out with more details, and more refined in its color and handling. But what Luce sacrificed was the fluency and verve of the studies. He prized the sketches as well as the finished paintings, signing, dating, exhibiting, and selling them all. He seems to have conceived of these studies both as stages toward a definitive image and as alternatives to it.

Oil on canvas, 32 × 21¼ inches (81.3 × 54 cm)

The Minneapolis Institute of Arts 61.63.13

Bequest of Putnam Dana McMillan

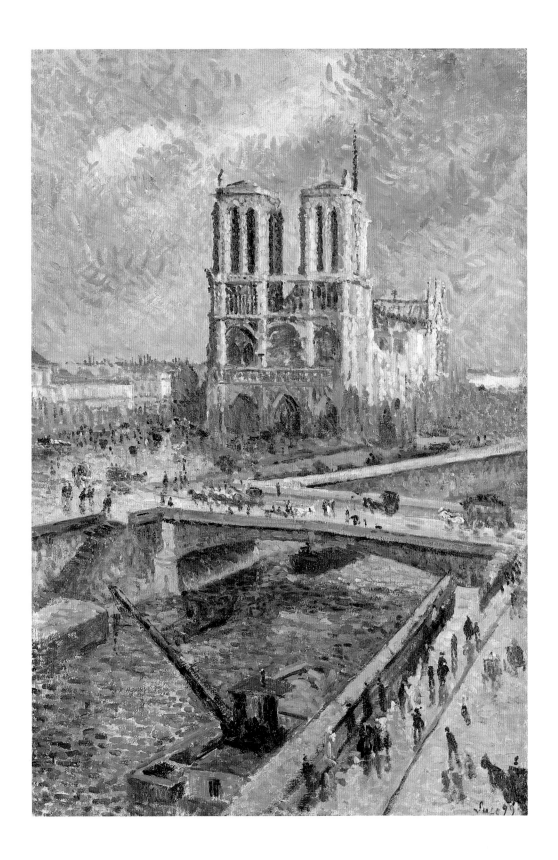

43

The Reader
1861

Painted early in Manet's career, *The Reader* is a warm and engaging work, one that offered few challenges to his contemporary audience. By the time Manet painted it in 1861, such genre subjects of humble types had become fairly commonplace in the Paris Salons. Some of them, such as this one, were a hybrid of genre and portraiture. Manet's model was Joseph Gall (1807–1888), a painter who was his neighbor when he moved his studio to 81, rue Guyot in Paris in 1861. His appeal for Manet was not his modest artistic attainments, but his picturesque, bearded appearance of a sort that Manet had painted before and was to return to regularly during the 1860s.

Manet posed him as a reader absorbed in a large, leather-bound volume, a subject with a long and distinguished history reaching from antiquity to Manet's day. Among his Realist contemporaries, Daumier, Courbet, Bonvin, Ribot, Whistler, and Fantin-Latour, among others, had created images of readers having striking affinities with this one. It was a subject, however, that Manet was to return to infrequently. Manet's own status as a reader is open to question. His lifelong friend and biographer Antonin Proust (see no. 45) claimed that he read little, and his library at his death was scanty, consisting largely of volumes sent to him by author friends. But he numbered among his close friends two of the greatest poets of his time, Charles Baudelaire and Stéphane Mallarmé.

His choice of subject in 1861 was, however, probably more a matter of Realist convention and of his involvement in earlier art in the Realist tradition, Rembrandt especially, than of any commitment to literature. Rembrandt's paintings and prints (or those formerly attributed to him), the *Evangelist Matthew* of 1661 in the Louvre, in particular, are among the many plausible pictorial sources for Manet's choice of pose, composition, and lighting and for the grave yet warmly contemplative mood.

Manet's respectful debt to tradition also extended to Velázquez, in whose painting he perceived a clean atmosphere, clear light, subtle harmonies of neutral colors against glowing, translucent grounds, a flexibility of hand, and fluidity of paint. In *The Reader* Manet sought to emulate something of Velázquez's effects without necessarily imitating his procedures. In place of the warm, toned ground of the old masters and his teacher Couture, Manet worked both darks and lights directly onto a white ground and dispensed with glazes. The techniques he avoided all tend to soften light effects and muffle contrasts. He used patches of unmodulated white, pure blacks and grays mixed from black, and clear, ruddy flesh colors in the figure, in contrast with the warm and muted browns and greens of the surroundings. The paint was applied thickly and densely in the head and hand, and more thinly and fluidly elsewhere. He achieved an overall effect of luminous transparency through his exact judgment of values and his white ground and clean tones.

If the final effect is in many respects reminiscent of the old masters, the procedure was at this point increasingly Manet's own. Nonetheless, one may feel that Emile Zola's 1867 judgment of two of Manet's contemporaneous paintings justly applies as well to *The Reader*:

[It is] firm and sound, and very sensitive, moreover, with nothing to offend the weak eyesight of the many. Edouard Manet is said to have some kinship with the Spanish masters, and he has never shown it so much. . . . [The] head is a marvel of modelling and controlled vigor. If the artist had always painted heads like this, he would have been the darling of the public, showered with money and praises; true, he would have remained a mere echo [of the past], and we would never have known the sincere and harsh simplicity that is his great gift.

Manet exhibited *The Reader* shortly after its completion. He did not send it to the Salon, which had already taken place that year, but showed it instead from August 15 to 31, 1861, at the Galerie Martinet, a picture dealer on the fashionable boulevard des Italiens who showed old masters as well as younger contemporary artists. Martinet's was one of the few places to offer a young artist like Manet the opportunity to exhibit outside the Salon. Manet seems to have had a fondness for this canvas, or else wished to offer up something safe and traditional looking along with his more provocative works, since he showed it in a number of important exhibitions.

It was bought in January 1872 for one thousand francs, a good price, by the dealer Paul Durand-Ruel, along with twenty-three other canvases. It was sold shortly thereafter to the otherwise unknown Frémyn, who resold it January 9, 1874, through Durand-Ruel for three thousand francs to Jean-Baptiste Faure, Manet's most important patron. Faure, an opera star, acquired his first two Manets in January 1873, had bought eleven more by the end of that year, and owned at various times a total of sixty-eight.

Oil on canvas, 38½ × 31½ inches (97.8 × 80 cm)
The Saint Louis Art Museum 254:1915
Purchase

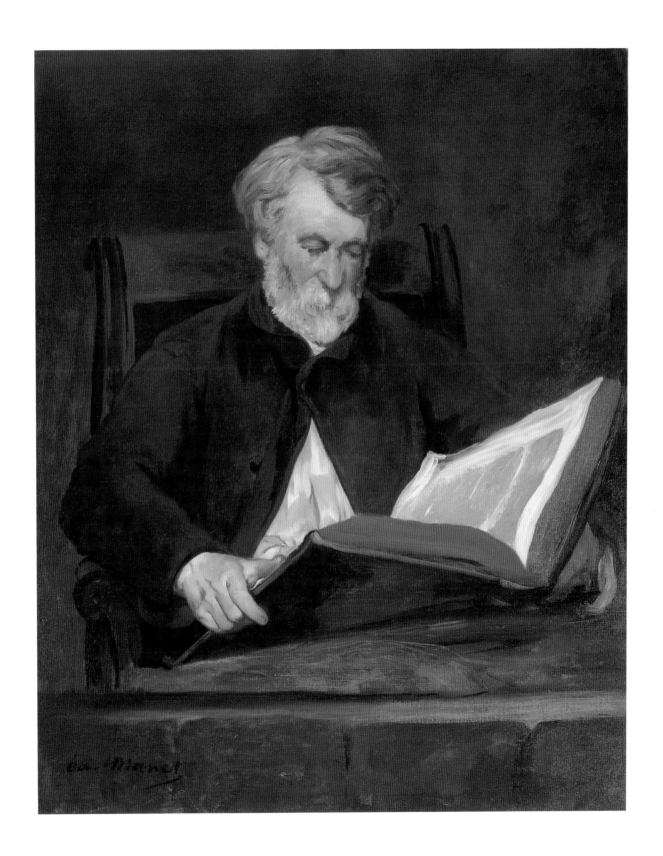

Edouard Manet
1832–1883

Portrait of Lise Campineanu
1878

By 1878, when this portrait was painted, Manet's art had changed substantially from the early 1860s. The brushwork had become freer and livelier and more overtly virtuosic than in *The Reader* (no. 43). Here the vibrant surface animation and lushly impastoed paint evoke the child's vivid presence and something of the sensuous textures of flesh, hair, cloth, suede, and metal. There is far greater emphasis on sharp, clear color, especially in the figure, and on creating closely integrated color relationships, qualities that may reveal Manet's response to recent developments in the work of Monet and Renoir. But as in *The Reader* and other early works, Manet still aims at an overall luminous transparency, which he creates in part by the light priming (beige here) and clean tones, and by painting more richly and opaquely in the bright areas and more thinly and transparently in the darker ones.

The portrait of Lise Campineanu (1872–1949) was commissioned by her great-uncle, Dr. Georges de Bellio, a homeopathic physician in Paris who was often consulted by Pissarro and who was to care for Manet during his final illness. De Bellio, a Rumanian, was also one of the leading collectors of the Impressionists during their financially difficult period of the 1870s (see no. 63). The portrait commission came about when de Bellio's nephew, Jean Campineanu, a high Rumanian government official, came to Paris from Bucharest with his family to visit the 1878 World's Fair (Exposition Universelle). De Bellio suggested that he see Manet for a portrait of his six-year-old daughter, Lise (also Elise, familiarly Lison).

Manet worked first on a composition showing her curled up in an armchair, which he partially scraped and then abandoned (Spencer Museum of Art, University of Kansas, Lawrence). For the finished painting Manet was paid five hundred francs by de Bellio, with Campineanu (according to the family) adding a tie pin in appreciation. Campineanu brought the portrait back to Bucharest, along with a painting each by Monet and Pissarro, the first Impressionist paintings to enter a Rumanian collection. The portrait remained with Campineanu and his wife and only passed to Lise (by then Mme Grégoire Greceanu) after her mother's death in 1920. Fifty years after its creation, the sitter was not satisfied with the likeness and sold it in Paris around 1930.

For the pose Manet did not look to the tradition of painting, but rather to the conventions of contemporary portrait photography. Carjat, Disdéri, Nadar, and other photographers known and anonymous used this pose of folded arms resting across a chairback, one that was little seen in painting. Manet had previously used photographs as an artistic aid, but here instead seems to have drawn on photography in an effort to create a modern portraiture that would reflect the character and conventions of contemporary society.

By the standards of photography, it is not the pose that is unconventional, but rather the personality conveyed. Around the same time she was painted, Lise Campineanu had been photographed in a pose reasonably similar to the one Manet has given her. In the photograph she looks younger and far more timid and shy, in contrast to her wide-eyed yet assured and forthright appearance in Manet's painting. Her dress was very much in fashion for young girls at that moment, but the strap seductively fallen from the shoulder, the fingerless gauntlets (*mitaines*), and gold bracelet were far more typical of a woman. She is disconcertingly precocious for six years of age, an effect that Manet reinforced by leaving out her short, dangling legs and effectively disguising her scale.

Unlike Renoir's images of children (see no. 74), so often sweet, docile, and demure, or Degas's (see no. 16), complex and psychologically astute, Manet's girl is slyly ambiguous, both innocent and knowing, child and adult. Perhaps her great-uncle de Bellio intimated something of this in a letter of August 31, 1878, to Claude Monet: "Manet . . . has done the portrait of my great-niece, ravishing eight-year-old [*sic*] child with blond hair and big blue eyes—astonished and astonishing. You'll see now what he was able to do with these ingredients and the talent that you know he has."

Oil on canvas, 21⅞ × 18⁵⁄₁₆ inches (55.6 × 46.4 cm)
The Nelson-Atkins Museum of Art 36-5
Nelson Fund

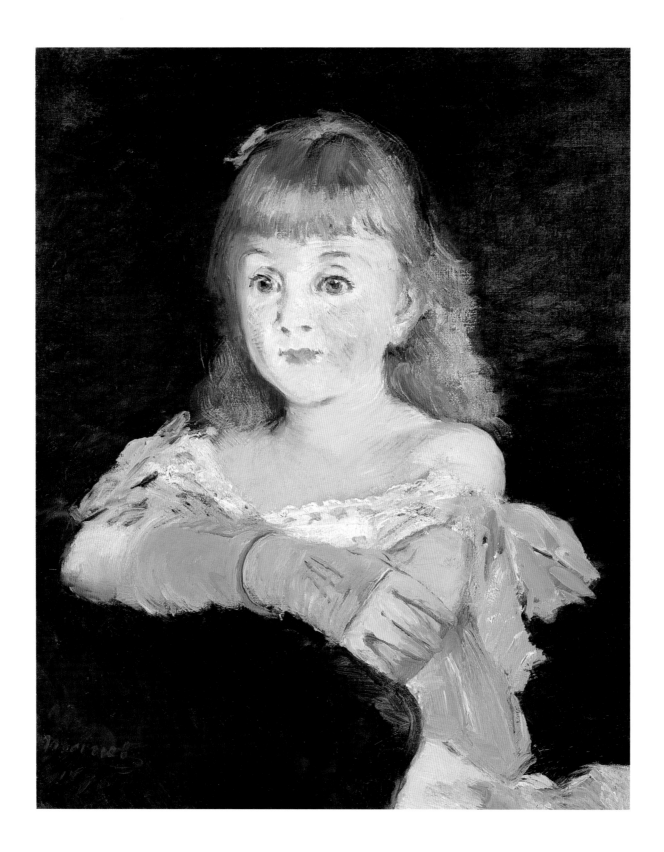

Antonin Proust (1832–1905) and Manet were friends from childhood. Fellow students of the painter Thomas Couture, they had chosen different paths; Proust had pursued a career as journalist and politician. He briefly held the position of minister of fine arts from November 1881 to January 1882, and, during that short time, quickly got Manet awarded the Chevalier de la Légion d'Honneur. Proust was a pallbearer at Manet's funeral, an organizer of his memorial exhibition at the Ecole des Beaux-Arts in 1884 (at which this portrait and no. 43 were shown), and subsequently his biographer.

Manet previously had painted Proust in the mid-1850s and had made some attempts at a full-length portrait in 1877. In 1879, as Proust later recounted, "During the course of that year . . . Manet was obsessed with two *idées fixes*: to do a *plein-air* painting . . . and to paint my portrait on unprepared white canvas, in a single sitting." The *plein-air* painting was to be *Chez le père Lathuille* (Musée des Beaux-Arts Tournai), completed in 1879; Proust's portrait was not executed until January 1880.

The two canvases were exhibited at the Salon of 1880. Manet nearly was awarded a medal that year, but the jury hesitated and refused yet again. The reviews of the portrait were mixed; some were enthusiastic about the likeness and execution, but there were other ritual complaints about Manet's drawing, modelling, color (too much blue), and finish. Manet received a pat on the head from Philippe de Chennevières, former director of the Ecole des Beaux-Arts, who wrote: "The portrait of M. Antonin Proust did Manet a lot of good this year. Everyone has agreed that this painting was an excellent preparation for a good work, and that with only a little more retouching the artist could complete the job." Neither Chennevières's reservations nor his muted praise were all that surprising: the color harmony is simple and restrained, the lighting soft, the modelling full, the focus on the face and hands clear and conventional.

This type of portrait—half- to full-length figure positioned against a flat, neutral-colored background—and pose were common in Manet's time. What distinguished Manet's *Proust* was what one critic called his "bold and decisive brushwork" and another his "spirited execution." The critic Théodore Duret, sympathetic to Manet and the Impressionists, wrote to Manet that it was "one of the best things you've ever painted, firm yet at the same time supple and spirited."

This appearance of improvisatory freedom and immediacy of response was hard won for Manet. Proust later reported:

After using up seven or eight canvases, the portrait came all at once. Only the hands and parts of the background remained to be finished. . . . "Look here [he said], that's it this time, and how well the background works! I'll finish tomorrow. The gloved hand is only just suggested. With three strokes—pique, pique, pique—it will be there."

As he did here, he generally dispensed with preliminary studies and preparatory underpainting, instead developing his compositions directly on the light ground. He would revise, scrape away, repaint, recompose, wipe out, and sometimes even discard a canvas so as to begin afresh, but the final result was the accumulated experience of the different versions. Traces of Manet's extended struggle with spontaneity are evident in the finished canvas. Extensive surface crackle, a sign of considerable rework, is visible around the head, shoulders, and arms, in the space between arms and body, on and around both cuffs and gloves, and elsewhere, recording the effort to achieve this painterly verve and brio, the bravura flourishes, and the look of casual ease.

While Manet's *Proust* is a discerning yet flattering likeness of his friend, it is also something of a portrait of the essential traits of a modern Parisian type. Proust, like Manet himself, has the air of the dandy. Elegantly urbane and impeccably dressed, he has about him, as Barbey d'Aurevilly wrote of the dandy, "an expression of finesse and concentrated irony, and in his eyes an unbelievable penetration. . . . [He] is a man who carries in himself something superior to the visible world." If Proust is to be trusted, Manet may, in fact, have had something more in mind. In a passage in his biography published in 1897 but omitted in a 1913 revision, Proust recalled Manet telling him:

There is one thing I've always had an ambition to do. I would like to paint a Crucifixion. You are the only one who could pose for this as I understand it. While I was painting your portrait, this idea pursued me. It was an obsession. I rendered you as Christ dressed in a hat and overcoat with a rose in your lapel. That is Christ going to visit the Magdalen.

But this ironical and mocking equation of Proust with Christ and the Magdalen with Olympia or Nana is finally less in evidence here than Manet's respect and affection for his lifelong friend.

Oil on canvas, 51 × 37¾ inches (129.5 × 95.9 cm)
The Toledo Museum of Art 25.108
Gift of Edward Drummond Libbey

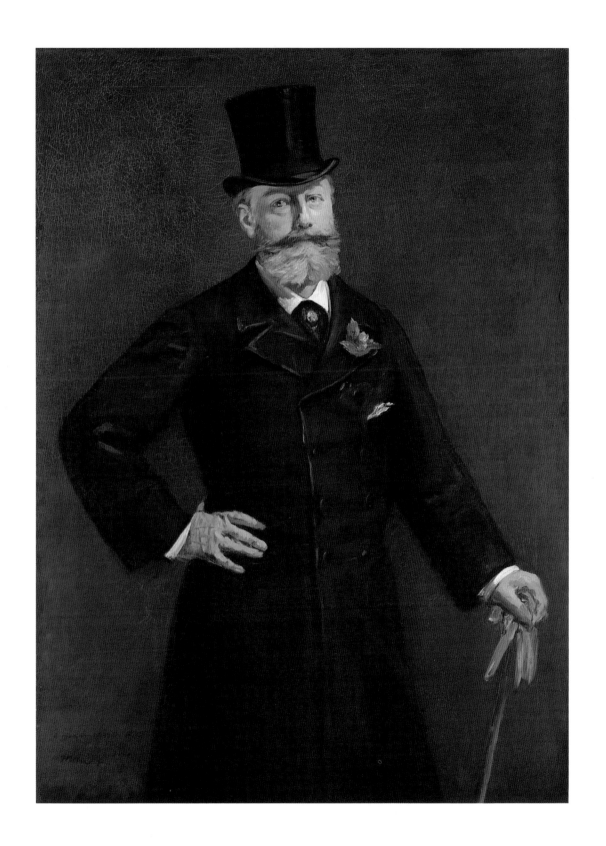

46

Still Life with Brioche

1880

This artfully charming still life was painted in 1880, the year Manet's wife received a gift of a white-muzzled black cat from the widow of the great historian Jules Michelet. The cat, named Zizi, is seen here peeking over the table edge, eyeing the rose-stuck brioche, Delftware plate, and pears. Zizi apparently was named in playful homage to Manet's close friend, the poet Stéphane Mallarmé, who had used Zizi as one of his many pseudonyms during his earlier stint in fashion journalism. Manet often depicted cats and had a great affection for them, one that he shared with others in his circle, such as the writers Gautier, Champfleury, and, most memorably, Baudelaire.

Manet had taken up still-life painting early in his career, in part in response to the revival of interest in Chardin, in part to create more modestly priced pictures. He turned to the subject often in the last few years of his life, when the debilitating disease that was to lead to his premature death made it painful and exhausting for him to stand and work at an easel for long periods. Small still lifes made it possible for him to continue to paint when he could no longer work on larger, more ambitious pictures. Such paintings were often either presents or a small source of income, generally from sales to friends and acquaintances.

Still Life with Brioche was sold in 1880 to Dr. Thomas W. Evans for five hundred francs, a good price for a small painting. Evans was a Paris society dentist, originally from Philadelphia, who at one time numbered the Emperor Napoléon III among his many prominent clients. He had met Manet through his mistress, Méry Laurent, a great beauty of her day who became one of Manet's favorite models as well as his friend in the later 1870s. Evans's taste in art was mainly for Dutch and French genre pictures, and his acquisition of some Manets was undoubtedly the result of Méry Laurent's taste rather than his. After his death in 1897, the painting passed to the Thomas W. Evans Museum and Dental Institution in Philadelphia, then to the University of Pennsylvania, which absorbed the institution in 1912. It subsequently disappeared into a basement storeroom, only emerging in 1972.

Manet had previously made a flower-decorated brioche the subject of two other still lifes. The first, dated 1870, was more lavish and elaborate in the objects displayed and their composition. Manet had been inspired by Chardin's *Brioche* of 1763 (this one with an orange blossom twig sticking from it), which had just entered the Louvre in 1869. He returned to the motif again at the end of the 1870s in a somewhat more casual but no less elaborate composition. This, in turn, seems to have been the basis for the Carnegie painting of 1880, which shares with it the rose-stuck brioche with top askew, some pears, and the wallpaper with a flower and trellis design. The Carnegie still life is distant from the Chardin in many respects, but Manet remained inspired by Chardin's rich colors, his varied and sensuously impastoed handling, and his

seemingly random yet rhythmically taut arrangement of forms and spaces.

Manet placed his forms asymmetrically, pushing the brioche and plate off the center and cropping the cat and pears along the edge. He unified this arbitrary-looking arrangement by the repeated horizontals of the plate, knife, table edge, dado, wallpaper, and the vertical alignment of the pears and cat. This rectilinear organization, reinforced by the tabletop tilted upward and flattened, establishes a tension between surface pattern and structure in depth. The color enhances the composition's coherence. Those of the brioche are repeated throughout, even in the flecks on the cat's ears and the mottling on the pears' skins. The wallpaper gently draws together the painting's major chromatic triad.

However simple, casually conceived, and freshly painted the arrangement may appear, it was, as usual for Manet, the product of numerous revisions and adjustments. He painted out a small piece of fruit, probably a plum (faintly visible in the disturbance above the signature), modified the placement and shape of the brioche, plate, and flower, repainted the ground around them, and shifted the table edge higher. It was only after the composition was underway that he thought to add the cat. The refined whimsy of the composition, along with the sensuous appeal of the colors and paint, seems to reflect the casual elegance of Manet's world and the pleasures the ailing artist still found in modern life.

Oil on canvas, 21¾ × 13⅞ inches (55.2 × 35.2 cm)

The Carnegie Museum of Art 84.8

William R. Scott, Jr., Fund

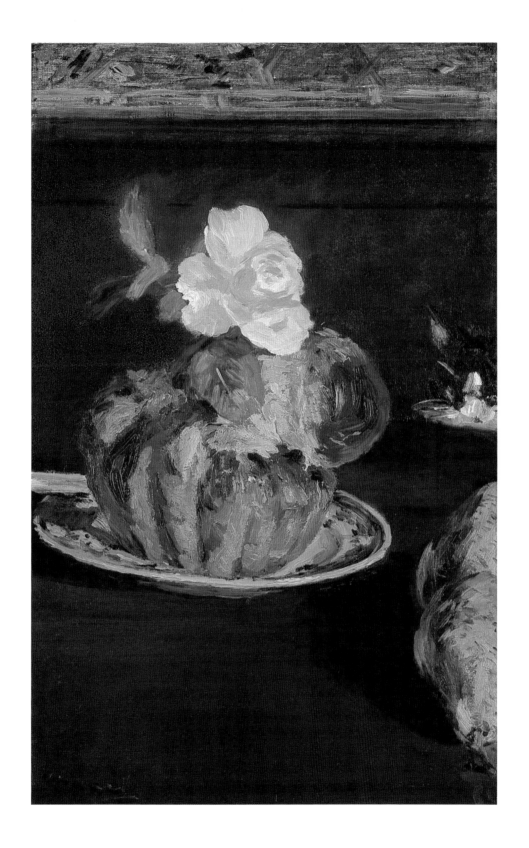

Monet's first extended campaign of painting from nature took place during the summer and early autumn of 1864. In mid-May he travelled with his friend and colleague Bazille from Paris to the Channel coast. They stayed in Honfleur but made a short trip in late May or June by steamer to Le Havre across the Seine estuary and to Sainte-Adresse just to the northeast, where Bazille had relatives and Monet's family had a summer house. After Bazille's return to Paris sometime in June, Monet remained at Honfleur, returning to Sainte-Adresse for a day in August and about a week in mid-October. It was during one of these visits, probably the first with Bazille, that Monet painted this view along the coast from near Sainte-Adresse toward Le Havre seen in distant profile on the horizon.

Monet's way of seeing and rendering nature had been shaped by the examples of Boudin and Jongkind (see nos. 5 and 41). He was to spend time in August and September of 1864 with them at Honfleur, but he had already worked alongside both artists a number of times. He had met Boudin around 1856 and Jongkind in 1862. Both artists taught Monet to scrutinize nature and be faithful to its appearances, lessons that underlay his lifetime's struggle to depict his response to nature's mutability. He summarized his aims at the end of his life in a letter to an English critic: "I have always had a horror of theories; my only merit is to have painted directly from nature, seeking to render my impressions in front of the most fugitive effects."

Boudin and Jongkind also provided Monet with strategies and techniques for giving pictorial form to his perceptual experiences. The wide format, low viewpoint, and broad expanse of sky seen here were modelled on both artists' coastal views. The concise, flexible brushwork that suggests the varied textures and rhythms of beach, water, and sky relates to both artists' techniques. The subdued but light and clear colors, the narrow range of values, the close harmony of gray, beige, and green over a gray-beige priming derive from the *peinture grise/peinture claire* used by Boudin and Jongkind to express the luminosity of the landscape. The deep perspective view along the coast, with curving shore and broad stretch of water framed near and far by forms extending horizontally, was a compositional convention favored by Jongkind and numerous other painters of the coast as a formula for structuring the landscape view. If Monet's painting is deeply informed by the examples of Boudin and Jongkind, it is more subtly distinguished by the broad and fluent brushwork, the sensuous fluidity of the paint, and above all by the richness, warmth, and translucency of the color.

Far more than either of his mentors, Monet worked on his paintings directly in front of nature seeking a rapidity of effect, of response, and of rendering. The practice of sketching in oils outdoors was not Monet's innovation but had existed since the late eighteenth century. At this early stage in his career, Monet's views on the value of this practice were firmly established, but its role and place in his production of finished paintings for exhibition and sale were not settled. In the 1870s he exhibited smaller paintings done largely outside, upgrading to the status of exhibition picture a type of painting conventionally seen only as a study. In 1864, however, Monet himself referred in his letters to such paintings as *études* (studies), and he could write to Bazille in October 1864 of making studio copies of his outdoor *études* for sale to a wealthy collector in Bazille's hometown of Montpellier. He also painted two large-scale canvases in his studio that winter for the Salon of 1865 that were enlarged, synthesized, and adapted from his outdoor work of the previous summer. Even his *études* were, in most instances, finished in the studio, thus blurring any clear or absolute distinctions in his painting practice at that time.

The *View of the Coast at Sainte-Adresse* was most probably such an *étude* carried to completion in the studio. The final layer of strokes clarifying and refining shapes and rhythms in the water and rocky foreground, the careful contour drawing defining the crest of the dunes and the distant profiled layers across the horizon, the out-of-scale rowboat that sits more on than in the water, all seem to be the product of a stage of work subsequent to the notation of responses before nature. From the beginnings of his career, Monet in his art engaged in a continuing dialogue between out-of-doors and studio work, sketch and finish, spontaneity and deliberation, the rapid transcription of fleeting natural effects and the unity and coherence of a work of art, or, as Monet himself simply phrased it in a letter to Bazille of July 1864, between "observation and reflection."

Oil on canvas, 15¼ × 28¾ inches (40 × 73 cm)

The Minneapolis Institute of Arts 53.13

Gift of Mr. and Mrs. Theodore Bennet

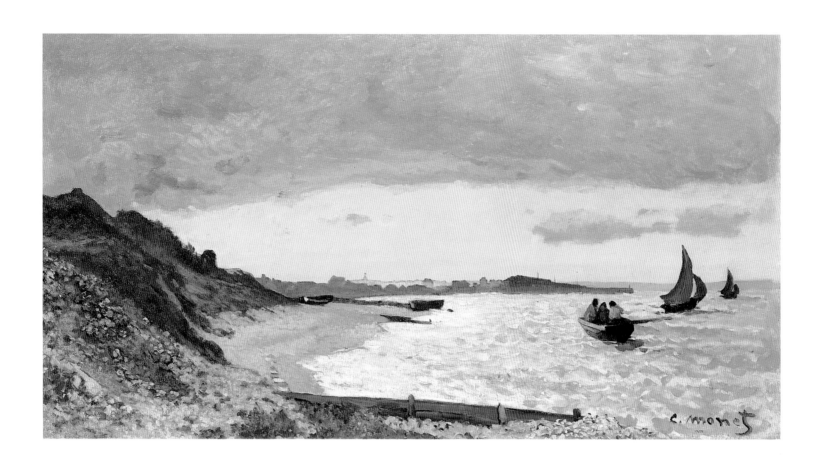

This view along the Channel coast in the direction of Le Havre was painted not far from where Monet had worked on his *View of the Coast at Sainte-Adresse* in 1864 (no. 47). Monet stayed with his family at their residence in Le Havre or their summer house in Sainte-Adresse in 1866, the summer of 1867, the winter of 1868, and again in the summer of that year. This canvas probably dates from his winter sojourn in Le Havre during the early months of 1868, when he returned to his family to reduce his expenses and to work on a large painting, *The Jetty at Le Havre*, for submission to the Salon of that year. Similarities in light, color, texture, and brushwork between the painting destined for the Salon (where it was rejected) and the far smaller *The Sea at Le Havre* suggest they were done at about the same time.

Sainte-Adresse was a fashionable seaside resort undergoing rapid development and transformation during the 1860s. Monet had depicted this aspect of the locale in a number of works the previous summer. The subject was one favored by Boudin (see no. 5) and Manet, and to which Monet was to devote his attention in *The Jetty at Le Havre* and in some small paintings executed that same winter of 1868. In *The Sea at Le Havre*, however, Monet represents neither this modern seaside nor the wild and dramatic seascape of Romanticism with its intimations of poetry and profound significance. Instead, the scene is nearly featureless by conventional standards, displaying little that might ordinarily be regarded as a subject. Monet has included neither tourists and vacationers nor picturesque cottages and quaint local types; indeed, he has left it without event, narrative, or ancedote. In this sparseness, Monet was following the leads offered by Boudin's outdoor pastel studies of the late 1850s and by Whistler's and Courbet's seascapes of the mid-1860s. For each artist, however, the focus was somewhat different; for Monet it was primarily on giving pictorial definition to his sensations of rapidly changing natural effects.

Monet's bold and forceful brushwork evokes the vigorous movements of sea and sky; variations in size, shape, and direction of the strokes suggest the range of nature's features—the choppy surf, breaking waves, sweeping clouds, and rocky shore. The paint is manipulated with great freedom to notate shifting states even while its own weight and thickness are asserted. The narrow range of light and clear colors, predominantly gray-blues and white, is subtly varied to render the effect of outdoor light on an overcast day and establishes an integrated harmony of closely related tones. The role of value contrasts to model forms and define space is minimized. In place of a traditional system of highlights calculated to provide order and focus, lights and darks are widely and evenly distributed. They describe various natural features, suggest the even dispersal of outdoor light, and serve as bold and active accents within the rhythmic patterns of movement.

Depth is expressed by the diminished clarity of forms and size of brushwork, but Monet dispenses with any direct or strong perspectival lead-in to the view, thus lessening the effect of recession. Land, sea, and sky are instead disposed in extended strips or broad panels that meet and abut along the horizon. The denial of perspective is reinforced by the simple and approximate geometrical structuring of the picture surface. The horizon nearly divides the picture in half, and the sailboat marks off the square of the left side of the canvas, a scheme that emphasizes a sense of abstract and planar ordering. This flattening of space and affirmation of surface is enhanced by the emphatic painterliness and relatively even spread of light.

As did Manet and Whistler in their Channel coast seascapes of the mid-1860s, Monet attempts to rethink spatial representation and to free painting from the domination of perspective. Like them, he looked to the lessons of Japanese prints in flattening space and stylizing the landscape, but far more than theirs at this moment, his aim was to convey his sensations of the shifting complex of natural phenomena. To this end, he seems to have painted this canvas rapidly and largely out of doors. The broken, fragmented strokes, the minimal layering of paint, and the lack of evidence of reworking all suggest the spontaneity and immediacy of his account. But as convincing as this effect may seem, it is incomplete. The painting is equally an artful and calculated creation, a product of rehearsal, memory, imagination, and intelligence that expresses both the acuity of the artist's response and something of the elemental force and mutable grandeur of nature.

Oil on canvas, 23⅝ × 32⅛ inches (60 × 81.6 cm)
The Carnegie Museum of Art 53.22
Purchase

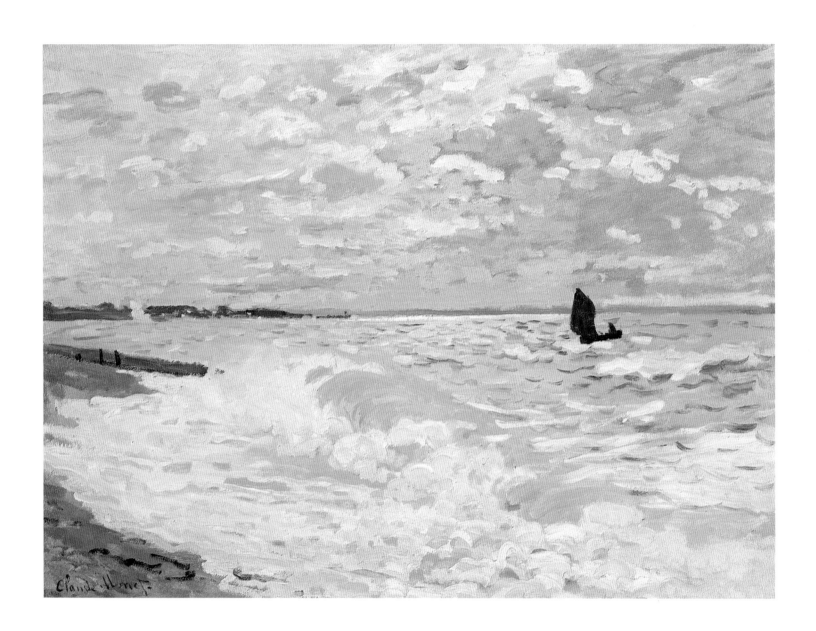

Paris was in the 1860s and 1870s the quintessential modern subject for artists whose ambition was to be of their time. The radical gesture of Manet, Monet, Degas, and their colleagues was to embrace the modern urban landscape, and their mission was to devise a kind of painting that could express the urban milieu. Their endeavor was in part spurred by the radical transformations that Paris itself had been undergoing. But even more, it was a response to the demands of some critics, most notably Baudelaire, for a painting of modern life. No single subject could summarize everything essential in the urban experience, but the cityscape of streets and boulevards laid plausible claim.

It was possibly in connection with a search for suitable premises for the first Impressionist exhibition that Monet did two paintings in the autumn of 1873 of the boulevard des Capucines, one of the liveliest and most fashionable streets in the center of Paris. The view appears to have been painted from the recently vacated studios of the photographer Nadar in the two upper floors of 35, boulevard des Capucines, the rooms where the first Impressionist exhibition would be held. Monet looked sharply to the right along the boulevard in the direction of the just completed place de l'Opéra a block away. Instead of the narrow, twisted streets and run-down buildings of old Paris celebrated in literature and popular prints, he chose a broad, commercial street at the heart of modern Paris.

Monet's aim, however, was to produce neither a documentary record of a particular section of Paris in 1873, nor an investigation of urban development and its attendant social problems, but rather a celebration of the city's essential character. He makes it hard to decipher the precise layout and details of buildings and streets, since he screens off the place de l'Opéra with a line of trees and covers the pavement with a blur of traffic. He also makes unclear the social identities and relationships within the crowd. He values instead a feeling of the perpetual flux and mobility of pedestrians and carriages as much as of atmosphere and light. In proposing that the momentary and ephemeral are significant traits of modern urban life, Monet was guided by Baudelaire's idea in *The Painter of Modern Life*: "By 'modernity' I mean the transitory, the fugitive, the contingent." Like Baudelaire, Monet's attitude toward experience is that of the inquiring yet detached observer, accepting the random and fortuitous without finding or imposing order, narrative, or meaning.

Monet conveys this by his way of representing the view. The brushwork is loose and fragmented throughout; the free and variegated touch seems to dematerialize form, as if under the action of atmosphere and light. It also suggests an overall animation that expresses fleeting movements and ephemeral effects. The apparent speed of execution becomes an equivalent for the tempo and mobility of what it represents and thus denies to the depicted world the expected stability and permanence. The notation signals momentary action, an immediacy of response, and a spontaneity of transcription that seem to make the painting a record of a fragment of time and experience.

The abrupt and disrupted recession, confusion and elision of distances, arbitrary and seemingly accidental point of view, abbreviated and fragmentary description of forms, and shifting and mobile brushwork together create a dispersion of focuses. In place of a conventional and hierarchically ordered composition, Monet's *Capucines* seems random and fortuitous, with no one aspect more significant than another. Like those of Degas (see no. 18), Monet's pictorial strategies are designed to make painting seem instantaneous and direct, to re-create the fleeting glance. They suggest the viewer's passive and disinterested acceptance of whatever is framed by the edges of the canvas, rendering the painted representation distanced, neutral, objective, and thus candid and truthful.

This seemingly objective view may make Monet's vision appear photographic, but there is little in the photographs of Monet's day to indicate anything but the most limited debt. The view is comparable to stereoscopic photographs of city streets, but while photographers aspired to sharpness and precision, Monet sought to render flux and motion. His complex manipulations of perspective, light, tempo, and clarity are wholly alien to contemporaneous photography, and what photography offered him by way of choosing and framing his view also could be found in topographical lithographs and popular illustrations.

Monet enhanced his emphasis on time and change as fundamental constituents of experience by painting a pair to this view on the same size canvas but turned horizontally (Pushkin Museum, Moscow). Within certain constants, these paired paintings are varied in reference to each other in oppositions of morning:afternoon, overcast:sunny, snowy:clear, cool blue:warm golden, sparse:dense, deep:shallow, vertical:horizontal, soft:sharp, loose:tight, less finished:more finished. The paired paintings reveal more fully the complexity of both the city and nature, and suggest the relativity and contingency of knowledge.

Oil on canvas, 31¼ × 23¼ inches (79.4 × 59 cm)

The Nelson-Atkins Museum of Art F72-35

Acquired through the Kenneth A. and Helen F. Spencer Foundation Acquisition Fund

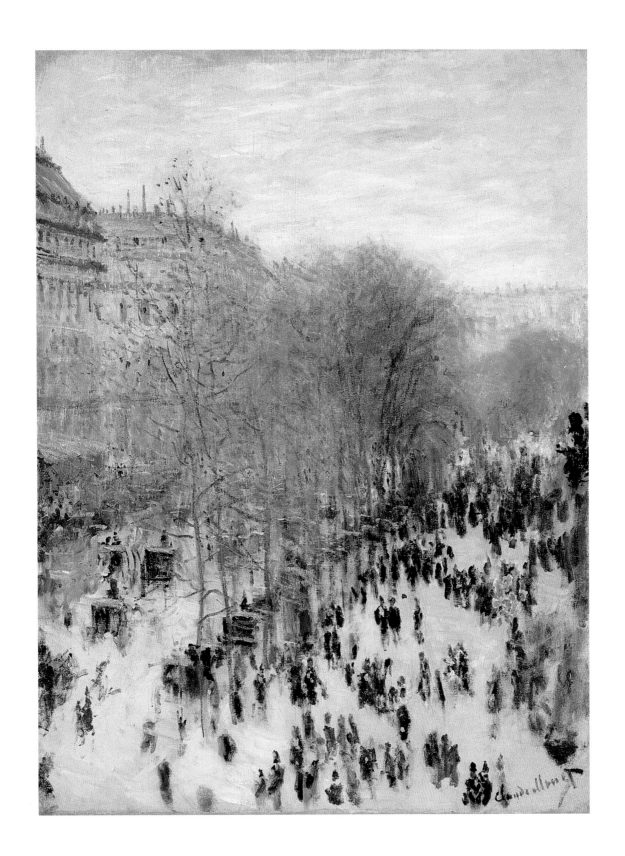

50

Monet moved to Argenteuil, a town on the Seine a short distance downriver from Paris, in December 1871 and remained there until January 1878. Argenteuil had in the past been principally an agricultural village, but with the opening of a railroad line from Paris in 1851 it underwent rapid expansion and industrialization. It also became an important center for recreation within easy reach of Paris, popular for sailing, promenades, and picnics along the Seine. In the town and surroundings, Monet found a wide variety of subjects and painted over 150 canvases during his six years there. For the most part what attracted him was the modern built landscape, neither precisely urban nor rural, marked and shaped by human presence, rather than the isolated, rustic, and seemingly timeless landscape preferred by previous generations of artists.

Monet concentrated on the river with its sailboats, promenades, villas, bridges, and quieter reaches, and to a lesser extent on the developing edges and rural outskirts of the town and on the garden of his rented house. During the winter of 1874–75, hindered or attracted by the weather, he depicted the snow-covered area of town near his house in a group of sixteen paintings. The house into which he had moved in October 1874, just next door to his first, was located on the boulevard Saint-Denis just down the street from the railroad station. The area had undergone drastic alterations since the early 1860s—the rail line was extended, the station built, factories established, houses constructed, new streets laid and old ones resurfaced, and trees planted. Monet had until that winter ignored his neighborhood in paintings, but in this *View of Argenteuil, Snow* for the first and only time he recorded what he could see from an upstairs window in his house. The view is down onto the boulevard Saint-Denis looking toward the large railroad station at center, with a small, tree-lined square to its left, a few factories and other railroad buildings to the right, and the hills of the côte de Sannois behind. Scattered figures, perhaps on their way to or from the station, trudge through the snow.

Monet generally screened out or avoided altogether Argenteuil's factories and industrial facilities, with the exception of the railroad, or represented them at a distance, embedded in a harmonious landscape of sailboats, spires, bridges, smokestacks, and trees. But here, softened and made more picturesque by snow, he seems to have found something worth painting in the immediate scene. Monet's concern seems not to have been particularly political or sociological, but may have stemmed from an interest in exploring vague sentiments about the equivalence of modernity with progress and improvement as played out in the view from his window. As dispassionate observer, from a vantage much like that from which he had painted Paris (see no. 49), what Monet saw were new streets and squares alongside fenced-off wasteland, planted trees and overgrown scrub, industrial buildings and rural countryside, all abruptly juxtaposed in a barely planned sprawl.

It is a landscape in transition—disparate, unfocused, and unruly—to which Monet is faithful, yet within which he seeks to discover some harmony and unity. His composition lightly stresses a loose geometry formed by streets, fences, buildings, and trees. Various zones and features of the scene, separate in space and distinct in character, are drawn together by overlapping, by softened and dissolved edges, and by freely mobile brushwork. The overall brightness and luminosity and narrow range of repeated colors—predominantly chilly blues, blue-violet, and white over a cool gray priming—unify the forms and convey the sharp and clear winter atmosphere and light. Color is stronger and more brilliant than it was previously in Monet's paintings. Its shifts and modulations subtly express modelling and distances without recourse to extensive light–dark contrasts. Monet even sees in factory smoke a unifying element as it wafts across the landscape and turns into clouds. He paints the rural past transformed and consumed by the urban-industrial present and tries to find in that landscape some charm and luminous beauty.

Oil on canvas, 21½ × 25⅝ inches (54.6 × 65.1 cm)

The Nelson-Atkins Museum of Art 44-41/3

Gift of the Laura Nelson Kirkwood Residuary Trust

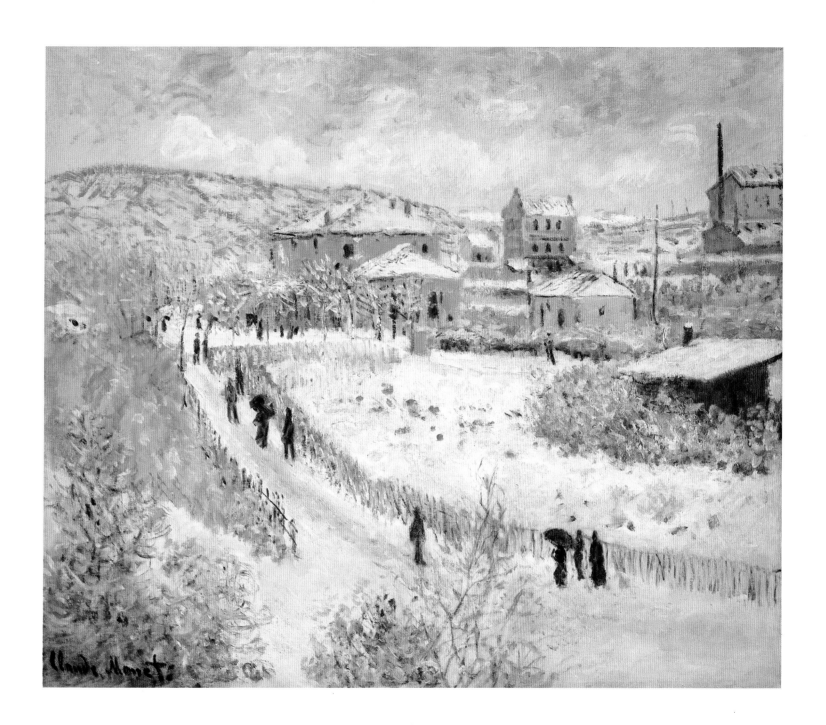

Claude Monet
1840–1926

51 Still Life with Pheasants and Plovers
c. 1879–80

After leaving Argenteuil in January 1878, Monet moved in August to Vétheuil, a quiet village farther down the Seine, where he remained until December 1881. He lived there with his wife, Camille, and their two sons in a house shared with Ernest and Alice Hoschedé and their six children in a complicated ménage. Neither family's finances were particularly sound—Monet was having trouble selling and Hoschedé had recently gone bankrupt—and the health of Monet's wife had been in decline following the birth of their second child in March 1878. When Camille died on September 5, 1879, Monet fell into a great despair. His life seemed in shambles: he felt guilt and sadness about his wife and was left with two young children to care for, his financial situation was worsening, his sales prospects were poor, and he was disillusioned with the Impressionist exhibitions and was considering a return to the Salon. He also suffered through one of the worst autumns and winters that the Paris region had ever experienced, which with his depressed state kept him from painting out of doors. Instead, he finished some works previously undertaken and devoted his attentions to still-life compositions.

Monet had only occasionally painted still lifes earlier, but between 1878 and 1882 he produced the largest group of any time in his career. His concentration on the subject following Camille's death may have grown out of mourning; still life in French, *nature morte*, literally meaning dead nature. But Monet previously had found still lifes easier to sell than landscapes and for far better prices, so financial reasons also may have played a role in their production.

After painting some fruit, Monet turned to game birds during the hunting season. Three paintings of a brace of pheasants with other birds exist, all the same size, two horizontal and one vertical, but none dated. Monet included one of the three in his first solo exhibition, held in June 1880 in a gallery on the premises of the journal *La Vie moderne* in Paris, as one of a series of exhibitions organized by Edmond Renoir, the artist's brother. Two of the three paintings of game birds had already been sold by then, and it is likely that it was the as-yet-unsold Minneapolis canvas that was included.

Two years later, in 1882, in the seventh Impressionist exhibition, Monet's first since 1879 and the last in which he participated, he again showed a game birds still life, one of six still lifes among his thirty-five pictures that year. Although it was undescribed in the criticism, a satirical cartoon clearly indicates that the painting was a horizontal one. Given what can reasonably be surmised, the Minneapolis painting seems the most plausible of the two candidates. Monet's inclusion of a *Still Life with Pheasants and Plovers* in these two important exhibitions suggests their value to him both as a representa-

tive selection of his current wares and a demonstration of what he considered strongest and most notable in his recent work.

In his still lifes of 1879–80, Monet was working within the tradition of such eighteenth-century French artists as Chardin, Oudry, and Desportes and of its nineteenth-century revival. However, he made an effort to loosen what had become some of the conventions of the Chardin tradition, much as did Manet at the time (see no. 46). He adapted strategies from his landscape paintings, in particular the raised and angled view. This composition, as well as that of its horizontal companion, is otherwise spare and straightforwardly geometrical, the birds carefully aligned with the edges and folds of the draped table.

The brushwork, too, is comparatively restrained and is less fluid and mobile than in his landscapes of the preceding years. It represents the features, textures, and modelling of the birds and also the woven geometrical pattern and long folds and creases of the damask tablecloth. Although relatively tight and descriptive, the painterly touch breaks up the surfaces to evoke the play of light and weaves rhythmic arabesques within the taut overall structure. The color is perhaps the most striking aspect of the treatment; Monet evidently was fascinated and challenged by the iridescent coloring of the pheasants. The rich glow of their wide spectrum of colors is effectively set off by the cool, subdued whites, grayed blues, and greens. The yellowish tan priming warms the colors and reinforces the golden tones of the pheasants' plumage. The pheasants especially must have given Monet trouble, as there is evidence of reworking in both.

The deliberate handling, descriptive color and detail, and simple arrangement seem designed not only for ready sale but also to meet growing criticism from patrons and supporters of hastiness and insufficient finish. Some of Monet's decisions may have been made with an eye to the market, but the gravity and rigidity of this image offer intimations of pathos and grief as well.

Oil on canvas, 26¾ × 35½ inches (67.9 × 90.2 cm)

The Minneapolis Institute of Arts 84.140

Gift of Anne Pierce Rogers in memory of John DeCoster Rogers

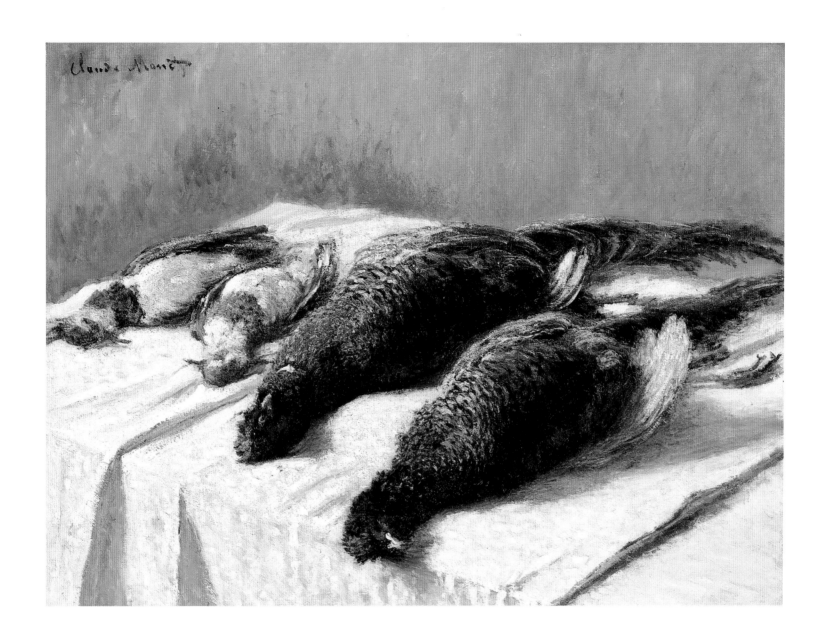

Monet travelled extensively during the 1880s, looking for new landscapes and effects that would challenge him to extend the range of his painting. He was no longer interested in the modern, public landscape but sought out places little affected by industrialization or tourism. He spent from September 12 to November 24, 1886, at Belle-Ile, a small island off the south coast of Brittany. Brittany's reputation for primitiveness had made it increasingly attractive in the 1880s to travellers and artists, but Belle-Ile was virtually new territory for painting.

The island was a rugged and barren place of spectacular black granite cliffs and off-shore rock formations, high seas, and fierce weather that Monet characterized as "sinister, somber, and terrible." He concentrated on the side of the island that faced the Atlantic known as *la Côte sauvage* (the wild coast). He wrote to his friend Caillebotte:

As for me, I've been here a month and I'm grinding away; I'm in a magnificent region of wilderness, a tremendous heap of rocks and a sea unbelievable for its colors; well, I'm very enthusiastic although having plenty of trouble because I'm used to painting the Channel and of course I had my own routine, but the Ocean is something completely different.

This painting represents one of the principal motifs Monet selected at Belle-Ile, four off-shore rocks known variously as *les îles de Port-Domois* (the isles of Port-Domois) and *les rochers de Radenec* (the rocks of Radenec), named for two nearby hamlets. Monet painted these rocks five times on two different-sized canvases, one of them turned horizontal. Although the view was fixed from canvas to canvas, Monet varied the time of day, light, tide, movement of the sea, weather, atmosphere, and framing. This was a more intensive scrutiny of a site than he had ever before undertaken. The Saint Louis painting depicts the low, late afternoon sunlight across a moderately calm sea, while others show stronger light and a choppier surf, an overcast sky and turbulent waters, and sunset over rough seas.

In all of the canvases, Monet sought to convey the sinister awesomeness he found in the landscape. In his desire to capture what the site offered him, his effort took on the quality of a contest with nature. He wrote to his companion, Alice Hoschedé, of his terrible struggles and then, triumphantly, that "the painter has won the upper hand and I see beautiful things all about me." As much as these paintings may be about elemental oppositions and the incessant battle between sea and land, they are also about the artist's attempt to master nature by painting it.

Monet remained faithful to the arrangement and proportions of the actual landscape but framed it arbitrarily to form a bold, asymmetrical design. The high horizon, steep perspective, and artful cropping silhouette the jagged rocks against the flat sea and straight line of the horizon. In place of the looser compositions of the 1870s, mass and space are translated into broad, linked shapes and flattened patterns in ways that reflect the lessons of Japanese prints.

The brushwork conveys the distinct characters of the rocks, water, and sky through changes in length, weight, shape, and direction, but with little differentiation of more specific features and textures. The touch has become freer and more calligraphic, establishing intricate sequences of movements across the picture surface. The emphasis is on elaborating patterns and rhythms within the broad, simplified shapes, but the loose, sketchlike, yet deliberate handling also serves to evoke the vigorous animation and fugitive effects of nature.

The colors are more intense than those Monet had used earlier and also are heavier and more somber. Bold contrasts are established to reinforce the distinctions among landscape elements. Modulations and variations evoke the unifying effects of light and atmosphere. The colors throughout are closely coordinated, the dominant contrasts forming the basis for rich and nuanced harmonies within a narrow range of hues. The principal colors in one area are introduced as accents and inflections in another, binding the whole into a single color composition.

During the 1880s Monet's working procedures grew increasingly complex. To deepen his response to the landscape, he found repeated sessions with the same painting out of doors necessary and complained of his difficulties in finishing his work at the site. His paintings often were densely worked with multiple layers built up over time. But in his concern to make his paintings more coherent and integrated, he increasingly resorted to the refinement of his canvases in his studio at Giverny. The period of studio work was extended to strengthen and harmonize the color organization and rhythmic patterns, clarify the forms, and sharpen the basic contrasts of elements. This late, more deliberate stage of work served to enrich rather than transform the painting, reconciling fleeting natural effects with balanced pictorial design, spontaneous response with calculated re-creation, and observation with memory and imagination.

Oil on canvas, 28½ × 23 inches (72.4 × 58.4 cm)

The Saint Louis Art Museum 218:1975

Gift of Mr. and Mrs. Joseph Pulitzer, Jr.

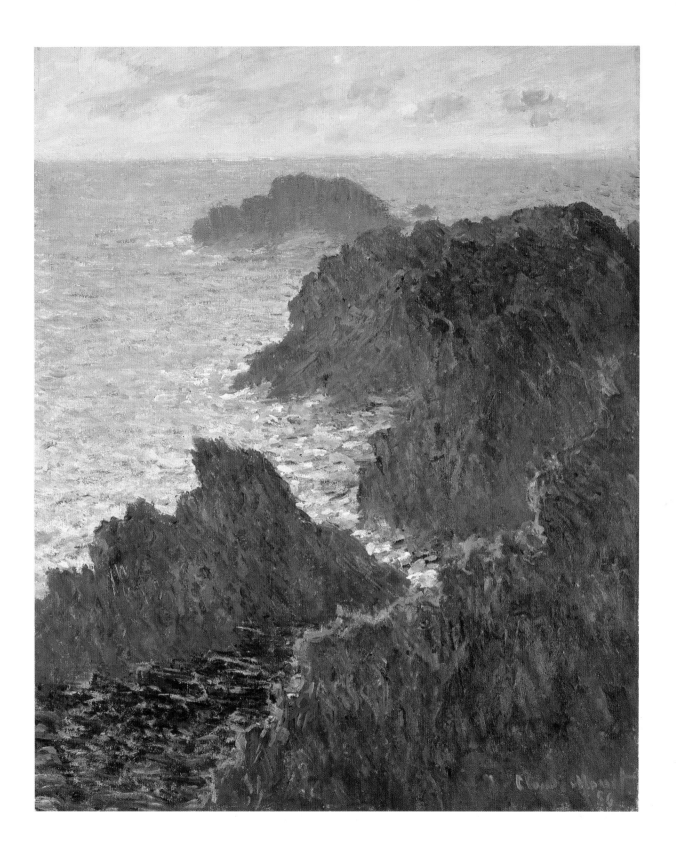

53

Antibes Seen from La Salis
1888

Monet did not travel in 1887, but in mid-January 1888 he went to Antibes on the Mediterranean coast, where he stayed until the first days of May. Antibes, a popular and celebrated seaside resort, was an exceedingly picturesque site whose appeal must initially have seemed far too banal for Monet. He wrote shortly after his arrival, "It may be beautiful but it leaves me cold." The commercial possibilities for paintings of the place may have swayed him, but more likely it was the challenge offered by the extremely sumptuous natural effects.

He first painted some views of the town from nearby, then moved farther away to the gardens of La Salis, a local beauty spot, planting his easel at the bottom of the gardens close to the water. The Toledo painting depicts this view of Antibes, with the tower of the old Château Grimaldi and the historic Fort Carré to its right, framed by olive trees in the foreground.

Monet's letters testify to his difficulties in rendering the brilliant southern light and atmosphere of this unfamiliar place. He wrote to Rodin on February 1: "I'm fencing and wrestling with the sun. And what a sun it is. In order to paint here one would need gold and precious stones. It is quite remarkable." To Alice Hoschedé, his companion, he wrote two days later, "What I will bring back from here will be sweetness itself, white, pink, and blue, all that enveloped in this magical air; it has nothing in common with Belle-Ile." And in March he wrote to the critic Théodore Duret, "After terrifying Belle-Ile this will be something tender."

Monet's repeated references to Belle-Ile suggest that he intended the Antibes paintings as a group to form a contrast with his paintings of that "sinister, somber, and terrible" island in the Atlantic (see no. 52). As he noted, he found it tender rather than terrifying and evoked that mood through shorter, more delicate, less directional brushstrokes; light, warm, high-valued pastel tones; gently curving forms and undulating arabesques; and softer distinctions among elements. The compositional structure—a tree-framed vista across water toward a distant picturesque motif—is strongly reminiscent of the idyllic landscapes of Claude Lorrain, Corot, and other artists, rather than recalling the Romantic tradition of rocky precipices and storm-tossed seas as Monet had at Belle-Ile.

Monet was certainly concerned to represent this splendid site, but he was as much if not more interested in capturing the atmospheric envelope that surrounds and absorbs it. He wrote two years later to the critic Gustave Geffroy that what he was seeking to render was "'instantaneity,' above all the 'envelope,' the same light spread over everything." He evoked the shimmering and scintillating permeation of the colored light of Antibes by using bright, high-keyed colors mixed with white and emphasizing vivid contrasts throughout the painting. As his letters indicate, the dominant opposing hues in his Antibes paintings are pink and blue, and each here is accompanied by oranges and yellows, greens and lilacs respectively. Modulations and contrasts of color as well as of brushwork differentiate landscape elements and suggest distances. Through his manipulation of color, Monet re-created the lush light and atmosphere, established order and coherence in his composition, and expressed the emotions the landscape aroused in him.

Although Monet's concern was with instantaneity and fleeting insubstantial effects, the painting was deliberately executed. Few parts of the canvas are thinly covered and all show signs of at least two, and in places three, stages of work. Over a warm, pinkish tan priming, the lower layer was worked in thin, freely brushed strokes, establishing the basic composition of colors and shapes. A thicker, more impastoed layer was then applied after the first layer had dried, giving greater definition to the forms and the overall rhythmic patterns, elaborating or modifying the colors beneath, and, in the trees and rocks at right, setting up a scheme of contrasts. Another, thinner layer of smaller and finer touches was added, most extensively in the trees and rocks but also in places elsewhere, refining details and adding further nuances and variations to the already complex patterns of color and brushwork created below.

The Toledo picture is one of four Monet did of this view. Each represents a different time of day, from dawn to early morning, mid-afternoon (Toledo), and evening. The changes are otherwise more subtle and limited: in the size and shape of the canvas, in the vantage, in the cropping of the image, and in other small-scale relationships in framing and spacing. Light and color are the most striking differences, and together the four paintings constitute a continuous cycle of the transformations this landscape underwent in the course of a day. Although the four formed a cohesive and linked group, Monet never exhibited them together.

Oil on canvas, 28⅞ × 36¼ inches (73.3 × 92 cm)

The Toledo Museum of Art 29.51

Gift of Edward Drummond Libbey

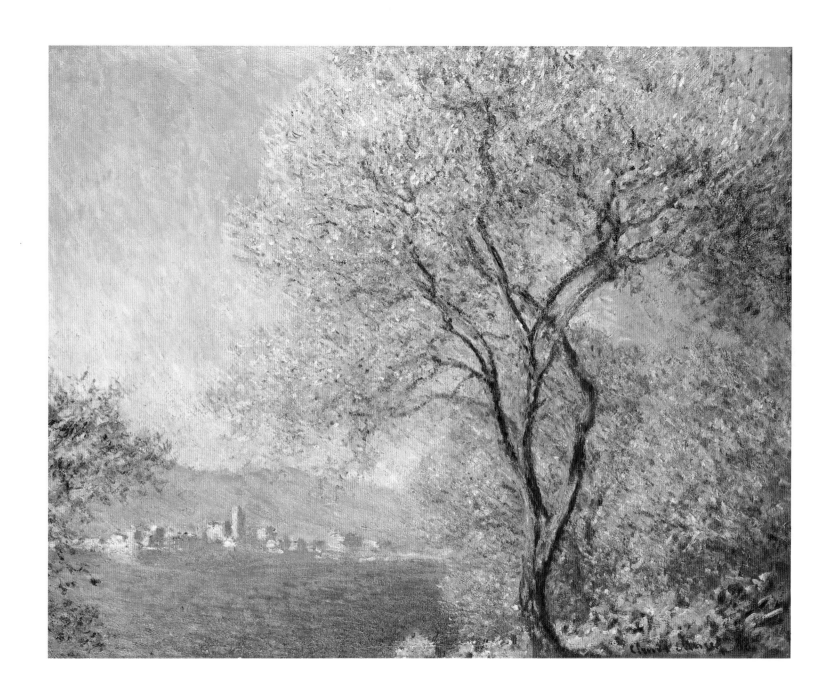

From the later 1880s on, Monet was increasingly preoccupied with painting multiple studies of a single motif under rapidly changing natural conditions. In such a series, Monet's focus shifted away from the distinctive character, textures, and details of a site toward the ways in which the envelope of light, air, and weather modifies and transforms its appearance. He commented in 1895, "The motif is insignificant for me; what I want to reproduce is what lies between the motif and me."

Monet worked in London from September to November 1899 and returned soon after from February to April 1900 and at the same time the following year. He devoted his attention to three motifs on the Thames: Waterloo Bridge, Charing Cross Bridge, and the Houses of Parliament, painting the two bridges from the balcony of his room at the Savoy Hotel. Waterloo Bridge, to his left, was a great stone bridge with arched spans and paired Doric columns fronting the piles above the water line. Although at some level Monet may have responded to its architecture, its Anglo-French historical associations, and its modern juxtaposition to smoking factories on the far bank, his professed interest was exclusively in the effect the elements had on it. He remarked later to the dealer René Gimpel: "I adore London, it's a mass, an ensemble, and it's so simple. Then in London, above all what I love is the fog . . . without the fog, London would not be a beautiful city. It is the fog that gives it its marvelous breadth. Its regular, massive blocks become grandiose in this mysterious mantle."

Monet worked systematically before the motif, painting rapid notations of fleeting effects. He changed canvases when the effect changed and eventually had about fifty canvases underway of Waterloo Bridge alone. The effort was enormously difficult and exasperating—the effects varied continuously, disappeared quickly, and often seemed never to return. His troubles at the site led to repeated stays in London and to longer and more extensive work in his studio at Giverny. Since the early 1880s Monet had used the period of studio work to elaborate and coordinate the color structure and the rhythmic patterns of brushwork, but his retouching and adjustments now also involved securing the unity and coherence of the ensemble. As Monet remarked to the Dutch critic Byvanck in 1891, for him the paintings in a series "only achieve their full value in the comparison and succession of the entire series."

The Carnegie painting is distinguished by the afternoon sunlight, seen through a smoggy haze, which provides relatively direct illumination of the bridge and creates a shimmering reflection on the water. The bridge is neither backlit nor shrouded in heavy fog, but is made to stand out clearly by the warm yellow light on the light-colored stonework and the delicate shadows that pick out features and establish

relief. The color harmony is carefully balanced to evoke the specific light and atmosphere; the warm yellows and oranges of the bridge and its reflection are set against the cooler blues and violet-pinks of the surroundings, with small touches of all colors repeated throughout.

Compared with other Waterloo canvases, the brushstrokes are long and vigorous, conveying a quickened sense of movement while simultaneously differentiating elements of the scene and suggesting the general structure of the bridge and factories. The layered buildup of the bridge makes it more solid and substantial than in most other paintings of the series, where the atmosphere and reflections paradoxically tend to have a greater tangibility. But, as in the rest of the series, the brushwork weaves a seemingly impalpable colored web from which the forms emerge and back into which they dissolve.

Monet inscribed a few canvases with dates that coincide with his visits to the site, but most reflect the long amount of studio work. Many, like this one, were dated 1903 in preparation for the exhibition he had planned for that year at the Galerie Durand-Ruel. However, he delayed the exhibition until the following May in order to carry on his retouching and adjusting. He was still adding finishing touches to some paintings in 1905, probably including the Carnegie canvas, which he sold to Durand-Ruel on October 30, 1905.

In this *Waterloo Bridge* and other late paintings, the role allotted to spontaneous response and rapid transcription was greatly diminished in favor of memory, invention, conscious artistry, and imagination. In the language Monet himself used to discuss his paintings during this period, he emphasized not only vision but also emotion and mystery. The Symbolist poet Stéphane Mallarmé, a friend of Monet, had said in 1893 of the Impressionists generally that they fascinated him because their aesthetic was close to his own: they left more to the imagination than they expressed. In the London paintings Monet sought to evoke the poetry and mystery of the landscape, but without sacrificing natural phenomena, visual sensation, and subjective response.

Oil on canvas, 25⅜ × 39½ inches (64.4 × 100.3 cm)

The Carnegie Museum of Art 67.2

Acquired through the generosity of the Sarah Mellon Scaife family

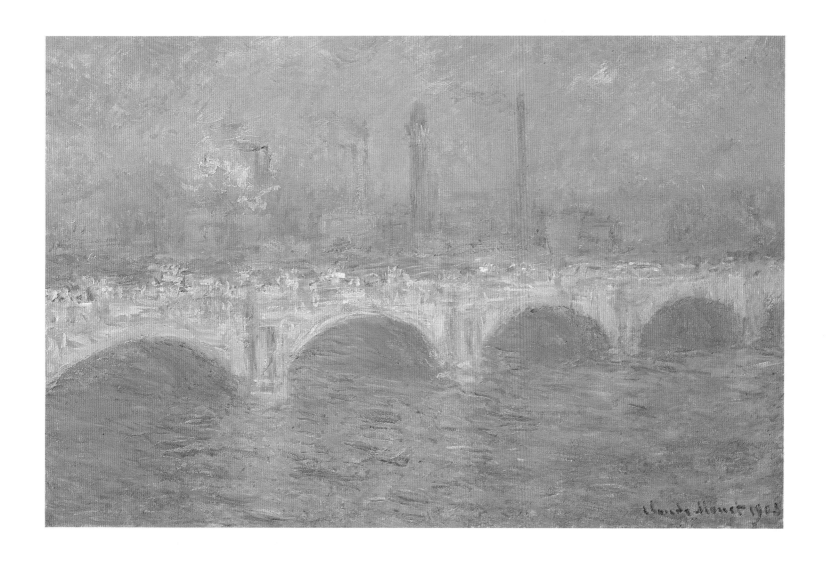

55, 56

Water Lilies

c. 1916–26

These two large paintings of water lilies originally formed the right two-thirds of a triptych; the left third is in the Cleveland Museum of Art. The triptych was conceived and executed as a single composition destined for the monumental *Water Lilies (Nymphéas)* decoration installed in the Orangerie des Tuileries in Paris. The three now-scattered panels were finished by early 1921 and were titled by Monet *The Agapanthus (L'Agapanthe)*, the name of the flowering pond plant that then figured in the lower-left corner of the triptych. Monet subsequently reworked the composition but did not include it in his final selection for the Orangerie cycle.

Throughout his career Monet was fascinated by water and the play of reflections on its surface, a preoccupation that earlier had led Manet to gibe that he was the "Raphael of water." During the last thirty years of his life, Monet's water garden and the paintings made of it constituted his final retreat from the world of mundane matters and modern life into a tranquil realm of meditation, reverie, and peace.

Monet's water garden was located at Giverny, a quiet town on the Seine where he moved in 1883. He constructed his garden with a pond on a small plot of land below his house and planted a variety of exotic species of water lilies. He embarked on his first series in 1899 with the Japanese bridge as its subject.

Even before he began to paint his lily pond seriously, he was already dreaming of making it the subject of a decorative scheme. He confided to the critic Maurice Guillemot in August 1897:

Imagine a circular room whose wall . . . would be entirely filled by a horizon of water spotted with these plants [water lilies], the walls of a transparency sometimes green, sometimes almost mauve, the calm and silence of the still water reflecting the flowering display; the tones are vague, deliciously nuanced, as delicate as a dream.

The idea of a decoration for a room was an outgrowth of his practice of painting and exhibiting in series. It also emerged from the context of French art of the 1890s when there was a surge of interest among many artists in painting decorations.

After exhibiting the first series in 1900, Monet bought another parcel of land alongside the water garden, which was then greatly enlarged by costly excavations, diverting a stream, and extensive new plantings. Between 1902 and 1909 he painted a new water garden series, this one devoted to the water lilies floating on the pond and, after his usual delays, exhibited forty-eight in 1909. He commented with unintended foresight at the time to his friend the critic Gustave Geffroy: "These landscapes of water and reflections have become an obsession. It is beyond my aging powers but I want nonetheless to succeed in rendering what I feel."

Monet probably intended to start on a new series of pond pictures in 1909, and in 1910 had more alterations made to the pond itself, probably with this aim in view. Any progress, however, was thwarted by the chronic illness of his wife, Alice, and her death in 1911. His grief and depression were heightened by increasing problems with his sight. It was only in 1914, at the urging of his friend the politician Georges Clemenceau, that Monet committed himself to the water lilies decorative project. He had a vast new studio constructed at Giverny to accommodate the huge canvases he envisioned, ordered many 2-by-4.25-meter panels (his term), and had special easels on wheels built for working on them. The new studio was ready by spring 1916, but he had already been working enthusiastically for two years on the project.

The Agapanthus triptych was underway by November 1917 when the dealer Durand-Ruel had a set of photographs made of the paintings in progress in Monet's studio, probably with an eye to their possible sale. The triptych's center and left panels appear in two of the photographs, showing that, at this point, the composition was only beginning to emerge. The paint seems loosely and thinly applied in broad areas of color. There are clear indications of a clump of agapanthus on the left and a tight circle of lily pads in the lower-right corner of the left panel; more vaguely defined rafts of lilies are scattered elsewhere. The triptych and other similarly sized panels were completely executed in the studio, but were conceived and developed from smaller, but still substantial studies painted outdoors beside the pond. Existing studies, some as tall as the decorative panels themselves, supplied motifs and groupings of agapanthus and lilies and notations of light and color effects to be elaborated in the triptych.

The three panels of *The Agapanthus* triptych were among about thirty in progress by 1918, but Monet seems to have had no firm idea of their destination or arrangement. When the Armistice was declared on November 11, 1918, Monet was moved to write Clemenceau, then premier, to offer to the nation a recently completed diptych to celebrate the Allied victory. Clemenceau, however, persuaded him to donate a complete decorative cycle, to be installed at government expense in a specially designed space. Monet worked with renewed energy toward this goal, but the plans were upset by Clemenceau's defeat in the election of January 1920. Monet withdrew his offer, but the original idea of his donation to France was made public by a journalist, and the project was revived.

Negotiations with the state were begun again in the summer of 1920 for a pavilion to be built in the gardens of the Hôtel Biron in Paris. The Hôtel Biron had been bequeathed in 1917 by Rodin to the nation as his museum. By the autumn of 1920, an architect had been selected and

Monet had settled on the four sets of panels to be installed: *The Agapanthus* triptych; another triptych, *Clouds*; a quadriptych, *Three Willows*; and a diptych, *Green Reflections*. Monet's preference was for an elliptical room, but by December the architect proposed, and Monet accepted, a design for a tall, circular space. The paintings were far advanced, if not already finished, by this date, and three of the four sets, including *The Agapanthus*, were photographed in mid-February 1921 for a book on Monet. The photographs show that *The Agapanthus* and the *Three Willows* had been linked into a continuous composition by a tuft of agapanthus leaves that appeared to extend from one set of panels into a corner of the other.

The Hôtel Biron pavilion was rejected by the government in late December 1920, but negotiations proceeded until spring when it was proposed that, to save money, an already-existing building be considered. After extended wrangling, Clemenceau convinced Monet to accept the Orangerie des Tuileries, for which Monet then decided to donate eighteen rather than the original twelve panels on the condition that the space be curved. A new architect was engaged, and by the end of the year one room had become two and the number of panels increased again to twenty. A plan for two oval rooms in the Orangerie was drawn up in January 1922. *The Agapanthus* was to be reduced from three panels to two, presumably the left two-thirds of the triptych since, at that point, only the leftmost panel (the one now in Cleveland) showed an agapanthus plant. Another plan was drawn up in March, then in April agreement was reached on the January plan with one significant modification: *The Agapanthus* composition was replaced by a single 6-meter panel.

The contract was signed in April 1922, committing both artist and architect to be ready in two years. Over the next four years Monet's work frequently was disturbed or interrupted by his severe vision problems, but he persisted in rethinking and modifying his panels with the specific spaces and arrangements in mind. He continued to drop and add panels as his scheme for a completely integrated ensemble kept changing. During this period he reworked *The Agapanthus* triptych, along with other sets and individual panels that would, in the end, be left out of the definitive selection, probably with the idea that he might still use them in some way in the decoration.

In this process, *The Agapanthus* triptych was deprived of its title, since the agapanthus plant was painted out. Some rafts of lilies were expanded, but others were diminished or dissolved in the added layers of intertwined strokes. The lilies in the 1921 photographs were more densely grouped and sharply defined against the more tightly woven strokes of the water. In Monet's repainting, contrasts were attenuated and distinctions between substances blurred in the soft mesh of multicolored strokes. Lilies, water, and grassy depths were melded into a subtly varied but continuous and unified surface, one that enfolds the viewer in a rarefied world of serenity and delight.

After Monet's death the *Water Lilies* decoration, now twenty-two panels, was removed from his studio and glued unvarnished to the walls of the Orangerie, as he had specified. The former *Agapanthus* triptych remained with his son for thirty years, until it was sold to dealers and then dispersed.

55

Oil on canvas, 78¾ × 167¾ inches (200 × 426.1 cm)

The Saint Louis Art Museum 134:1956

Gift of the Steinberg Charitable Fund

56

Oil on canvas, 78¾ × 167½ inches (200 × 426.1 cm)

The Nelson-Atkins Museum of Art 57-26

Nelson Fund

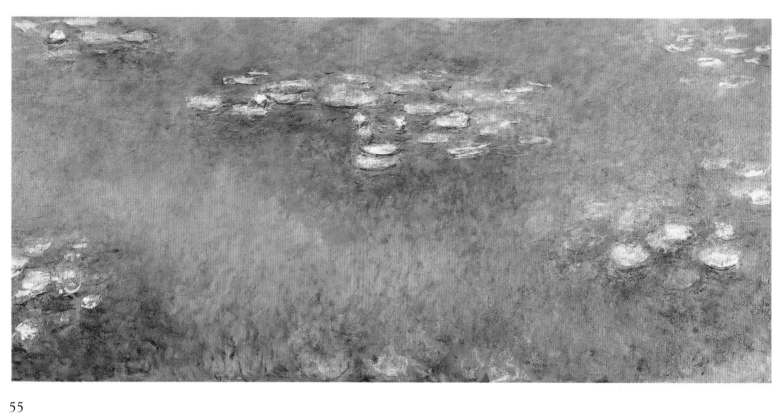

55

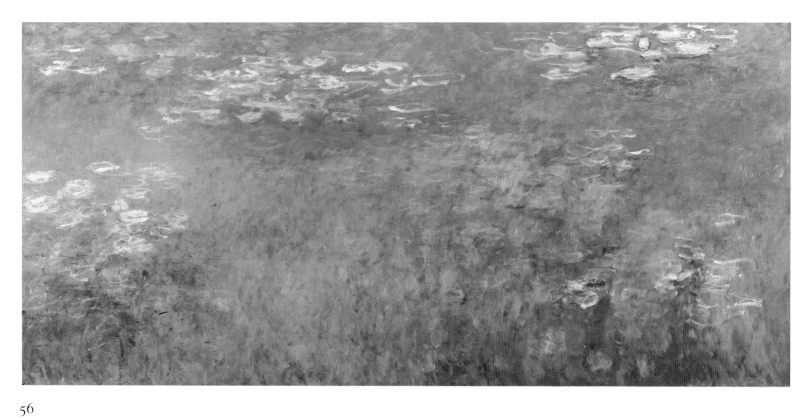

56

57

In paintings of his water garden, Monet repeatedly explored the counterpoint between floating lilies and reflections of trees and sky on the pond surface. This elusive motif was the principal subject of the *Water Lilies* decoration that he began in 1914 and that continued to vex and preoccupy him for the remaining twelve years of his life (see nos. 55 and 56). This enormously wide painting, one of six of this size in existence at Monet's death, was conceived and executed as part of that grand project. It probably was one of three such 6-meter canvases that Monet had in progress by the end of 1920. He wrote in December of that year to the critic Arsène Alexandre, who was preparing a monograph on him, enumerating the contents of his studio. At that moment, he said, they included "45 to 50 panels constituting about 14 series . . . these panels all measuring 4.25 by 2 meters—3 alone are a single panel of 6 meters by 2."

When Monet wrote this letter, plans had already taken shape for a pavilion in the gardens of the Hôtel Biron in Paris to house the decoration. Four sets totalling twelve panels had been designated, but none was of the 6-meter size. Only a few months earlier, however, Monet seems to have envisioned using one 6-meter panel by itself to decorate the pavilion's vestibule. The Carnegie painting is one of two likely candidates.

In spring 1921 the Hôtel Biron scheme was renounced and a new site found in the Orangerie des Tuileries, an already existing building that would be remodelled to suit Monet's needs. He favored two connecting oval rooms containing eighteen panels altogether, and in November 1921 specified that there would be two 6-meter panels in the second room, but which ones he had not yet determined. In a plan drawn up in January 1922, he had increased the total number of panels to twenty by adding two more 6-meter ones. The four 6-meter panels were to be installed on the long side walls of Room II. A new plan was proposed in March, again with four 6-meter panels, but this time placed in Room I, flanking two diptychs of 4.25-meter panels facing on opposite walls. This intriguing arrangement was quickly rejected, and agreement was then reached in April on a modified version of the January plan. This one had two separated 6-meter panels on each of the side walls in Room II, and an additional 6-meter panel in Room I in place of a diptych of 4.25-meter panels. In the act of donation that Monet signed in April 1922, the group of four 6-meter panels in Room II was entitled *Morning*. The Carnegie painting was almost certainly meant to be one of these four.

At the time of the contract, Monet presumably had at least five 6-meter panels underway. The Carnegie painting and one other 6-meter panel are visible in a photograph taken in his studio during the summer of 1922. It appears to have been close to the state of finish in

which Monet would finally leave it. Other panels, however, continued to be extensively elaborated and reworked over the next four years. At some point between 1922 and 1926, Monet had a near total change of mind about the contents and arrangement of Room II in the Orangerie decoration. He jettisoned the four 6-meter panels specified in the April 1922 agreement and replaced them with two triptychs of 4.25-meter panels. Ultimately, only one 6-meter panel, located in Room I, was selected by Monet for installation in the Orangerie.

Like all the panels made for the decoration, the Carnegie painting was executed completely in the studio. For the light effects, color harmony, and overall design, Monet followed closely a smaller painting dated 1919 that he had worked on out of doors in the summer of that year. This canvas was one of a series of about a dozen, the majority 1 by 2 meters in size, all employing the same basic composition but differing subtly in light, color, rhythm of strokes, and precise configuration of lily pads and reflections of sky and willow trees.

The one on which the Carnegie painting was based was sold in November 1919, raising the possibility that this painting may have been begun before its model had left Monet's studio. The large decorative panel is twice as high but three times as wide as the 1919 painting. To accommodate the new format, Monet stretched out the original composition rather than add new sections at the sides. The rafts of lilies were elongated, the brushstrokes made bolder and more sweeping, the spaces more open, and the sense of recession diminished in favor of surface expansion and breadth. In a vast field of color, Monet re-created, as he had since the beginning of his career, his sensations of the ceaseless flux and movement of nature.

Oil on canvas, 77¹⁵⁄₁₆ × 234⅞ inches (198 × 596.6 cm)

The Carnegie Museum of Art 62.19.1

Acquired through the generosity of Mrs. Alan M. Scaife

Exhibited only at Pittsburgh

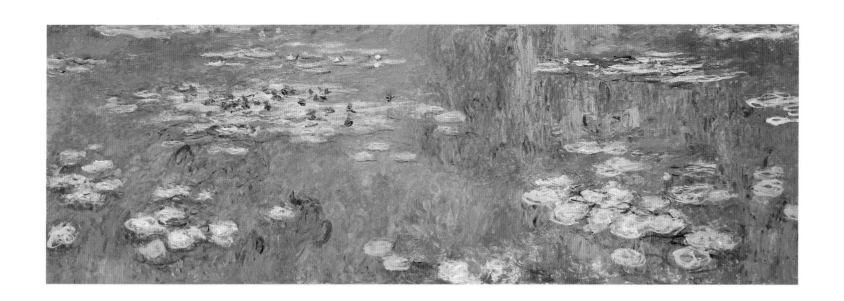

58

The Japanese Bridge

c. 1923–25

From 1914 until shortly before his death in 1926, Monet devoted much of his time to the *Water Lilies* decorations (see nos. 55–57). He also worked on a number of other paintings, generally far smaller in size, that were unrelated to the decorative program. He did two subjects from his rose garden and a large weeping willow tree by the lily pond, but returned most often to the Japanese footbridge that arched over the pond waters. He first painted the bridge in 1895, the very first of his Giverny garden motifs, and made it the subject of a series in 1899–1900 that he exhibited in 1900 under the simple title *Water Lily Pond (Bassin aux nymphéas)*. After the pond was enlarged and modified, Monet added an arched trellis to the bridge in about 1904, onto which wisteria was trained. Within a few years the wisteria had densely overgrown the bridge, considerably changing its appearance.

Monet returned to the motif in about 1918 or 1919 in a small group of pictures, mostly very elongated in format. One was signed and dated 1919 when it was sold in November of that year, and was exhibited in 1921 with the title *Footbridge over the Water Lily Pond (La Passerelle sur le bassin aux nymphéas)*, evidently Monet's preference for paintings of this subject. He may have continued to paint the bridge during the following years or, more likely, may have taken it up again a few years later, either somewhat before or somewhat after his cataract operations in January and July of 1923.

During these years Monet had been troubled by problems with his sight. Bilateral cataracts had bothered him since 1908 and had been diagnosed in 1912. He submitted to one operation, then to another on the same eye, then struggled on and off with corrective glasses, complaining of grossly distorted color vision and depth perception. He had successive periods of recovery and discouragement, but seems to have continued to paint no matter what. It is not at all clear what Monet could see either of his motif or of his painting, and he seems to have relied even more on memory and experience and on the precise knowledge of what he wanted to achieve. He was constantly frustrated and enraged and, by his own reports, was driven in his fury to slash or burn canvases.

Sometime after the operations, Monet began painting the Japanese bridge again, according to the account of a young artist friend André Barbier. Whether the Minneapolis canvas and others closely related to it date to this period or from before the operation is impossible to establish. The paintings probably were done during the summer and early autumn when the afternoon heat in his studio prevented him from working on the *Water Lilies* decorations and drove him out of doors. He evidently continued to paint from the motif, his aim still the presentation of his direct experience of nature. But when the later *Japanese Bridge* paintings are compared with those of 1899–1900, it is apparent that both his experience and his presentation of it had changed drastically.

Paintings of the earlier series display a relatively close description of natural textures and features, a finely modulated scheme of light and color, small-scale restrained brushwork, and a focused recession held in balance with a precise surface design. In the later series Monet stepped further back from the motif, but retained the basic frontal and symmetrical organization he had used previously. Far more than in any earlier paintings, however, color and brushwork are dissociated from object and effect. In the Minneapolis canvas, color is not just intensified but overheated and seems to smolder with an inner illumination. The color is less nuanced and modulated than before and is set off in bold, clashing contrasts. The paint handling displays a raw vigor, with long, sweeping movements and tangled, twining skeins of strokes. The large, free gestures seem to have been carried over to these small-scale canvases from the expansive *Water Lilies* panels. The advancing colors and clotted thicket of strokes make the air and space as dense as the bridge and foliage. Near and far are collapsed and fused into a palpitating colored screen, given structure by the arced and vertical shapes of the bridge, willows, and pond grass.

Monet carried to a new, fevered pitch the expressive manipulations of color, brushwork, and space he had evolved since early in his career. He developed the implications of his own subjectivity (as such artists as van Gogh and Kandinsky had already done), releasing in his painting an impassioned emotivity. Such late paintings as *The Japanese Bridge* may have derived their force from Monet's frustration and anguish over his own aging and frailty, his deteriorating sight, and his perennial struggle to realize his vision. Yet in them, as Monet remarked earlier to the critic Roger Marx about his water landscapes, one beholds "the instability of the universe transforming itself every moment before our eyes."

Oil on canvas, 35⅛ × 45¾ inches (89.2 × 116.2 cm)

The Minneapolis Institute of Arts 61.36.15

Bequest of Putnam Dana McMillan

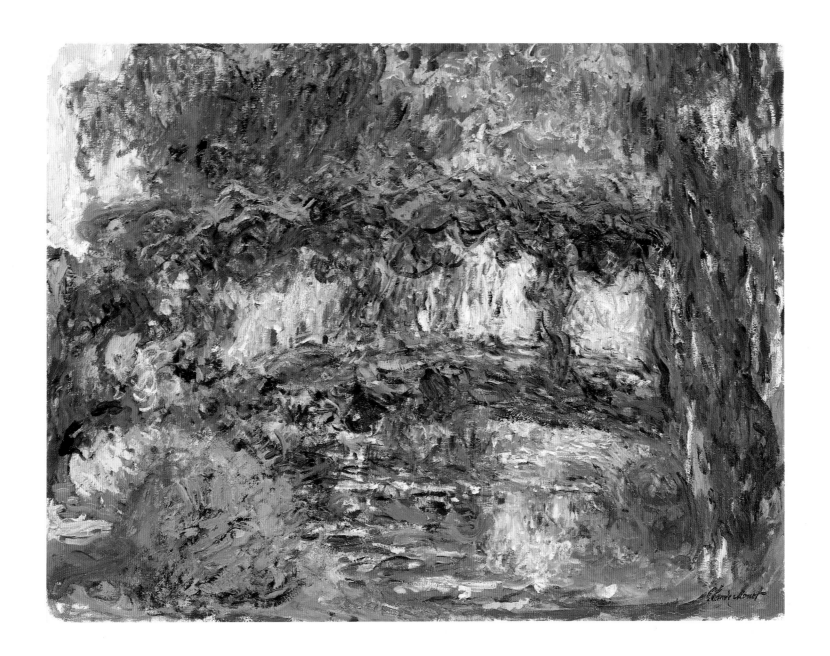

59
In the Garden at Maurecourt

c. 1884

Throughout her career Morisot often represented a woman and child in a park or garden, a popular theme both in Impressionist art and in modern-life painting for the Salon. The motif figured prominently in her relatively limited repertoire of subjects taken from the world of the modern, upper-middle-class woman, the sphere to which she restricted herself following the social conventions and constraints of her gender and class. Her subjects were chosen from her family and domestic circles and from the places familiar to her.

In this painting she depicted the well-tended garden of the country estate of her married sister, Edma Pontillon, located at Maurecourt, twenty miles north of Paris. Morisot frequently visited her sister there and in the early 1870s had often painted her with her children in the garden or in the surrounding countryside. After that time Morisot had stopped portraying her, presumably at her sister's request. In a small watercolor of the mid-1880s inscribed "Maurecourt," on which she based this painting, Morisot appears to have depicted Edma, then about forty-five years old, but this same figure appears rather younger in the painting. Although any identification of this figure is difficult and tentative, she may conceivably have become one of Edma's daughters (Jeanne, b. 1870, or Blanche, b. 1871), or perhaps the nursemaid of the child to her right, who is, almost certainly, Morisot's own daughter, Julie (b. 1878).

Whatever their actual identities may have been, their attitudes toward each other appear casual and detached, without signs of affection or even of attention, despite the suggestion of a maternal relationship that such a juxtaposition routinely conveyed. Instead, Morisot, as her brother-in-law Manet also did on occasion, drained from them the air of sentiment and sanctity—the suggestion of the modern madonna—so common and expected in images of a woman and child during this period, whether in the works of Salon painters or of her friend and colleague Renoir. She made no attempt to represent a relationship, or even an event, presenting only a loosely defined situation of aimless leisure. Her aim was not to indicate a legible narrative, but to express flux and immediacy in nature and experience.

The diffuse and flickering light, raised and angled view, and blurred and variable focus (fading out toward the corners and edges) suggest something of the fleeting and fragmentary in the appearance of the scene. It is Morisot's technique, however, that is most striking and effective in conveying the momentary and immediate. At a time when other Impressionists were seeking more deliberate order and durable values, Morisot continued to investigate the possibilities of the free and rapid oil sketch. Rivalling, or perhaps exceeding, Manet, Monet, and Renoir (see nos. 44, 49, 72, and 73), she produced here a performance of extraordinary freshness and bravura. The paint was applied with remarkable fluency, agility, and spontaneity. The bold and vigorous streaks, dashes, and dabs seem to zip across the surface in animated and energetic rhythms, blurring forms, obliterating drawing, and weaving the pieces together. Unlike other Impressionists who painted landscapes, her tangled, ragged brushstrokes provide only the most rudimentary characterization of features and textures, and offer relatively scant indications of shape and modelling. But what she may have lost in the way of precise notation, she gained in verve and brio, in exuberant virtuosity.

Her improvisatory handling was the subject of frequent critical comment, none more evocative than that of the poet Jean Ajalbert, who noted of her paintings shown in the 1886 Impressionist exhibition that "she eliminates cumbersome epithets and heavy adverbs in her terse sentences. Everything is subject and verb. She has a kind of telegraphic style." Here, on a warm tan priming, she roughly sketched in the figures in oil following the preliminary watercolor, then loosely blocked in their darker tones and the broader shapes of the setting in thin washes, and added the final layers in freely varied impastoed strokes. In her brushwork she developed contrasts of size, direction, and velocity, and elaborated darker and lighter accents and contrasting touches of color to express the sparkling play of sunlight and shadow. Morisot regarded this painting, although summary in its execution, as completed, since she signed it, which was something she did not routinely do.

This rhythmic surface conferred on the essentially calm and static forms of the scene an overall and continuous mobility. The apparent speed of execution became a sign for the tempo of change in the phenomena, incident, and experience represented. Through the vitality and abandon of her handling, she imbued this lush scene of confined and tranquil domesticity with a startling liveliness and freedom. But this peculiar match between subject and expression, between the physical and emotional restraint of the one and the vivid display of the other, adds an unsettling and perplexing note to this image of the familiar pastimes of bourgeois life.

Oil on canvas, 21¼ × 25⅝ inches (54 × 65 cm)

The Toledo Museum of Art 30.9

Gift of Edward Drummond Libbey

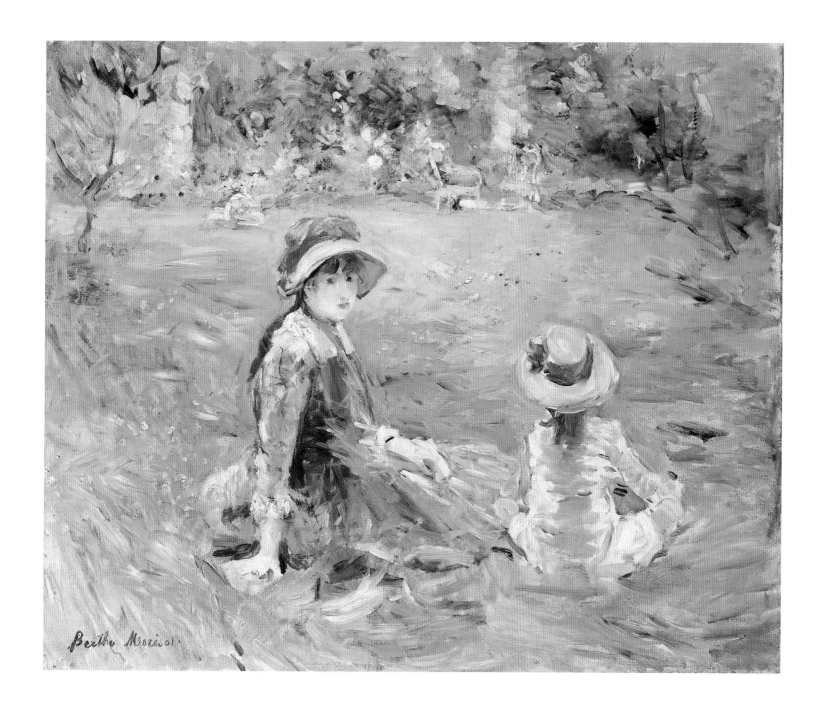

Bertha Morisot

60

Still life was not one of Pissarro's favored subjects. This one is an exceptional work not only for its choice of subject, but especially for its ambitious size and extraordinary boldness and breadth of execution. Still lifes such as this one of humble, common objects in an ordinary setting were a typical Realist theme of the 1850s and 1860s descended, principally, from the paintings of Chardin and his followers. Pissarro indicates his familiarity with the conventions of Realist still life already established by Bonvin, Cals, Fantin-Latour, Manet, Ribot, and others, but seems to look most closely to Chardin himself, in particular to *The Meat Day Meal* of 1731, one of a pair of still lifes that had entered the Louvre in 1852. He heeds Chardin's model in the shallow, frontal space; the angled, projecting elements—here bread and knife—that establish recession; the contrasting play of shapes, textures, and visual effects—rough:smooth, opaque:transparent, simple:complex, concave:convex, closed:open, standing:hanging, horizontal:vertical—and perhaps even in some of the objects he selected to represent. Above all, he is inspired and challenged by Chardin to create the tight-knit asymmetrical arrangement and carefully calculated internal rhythms.

What sets Pissarro's *Still Life* apart from Chardin and his mid-nineteenth-century progeny is the brusque forcefulness of its handling. The powerful character of its surface may be traced back to Courbet—to his landscapes rather more than his comparatively refined still lifes—via Pissarro's own recent landscapes. Like Courbet, for whom it had become a kind of trademark, Pissarro made extensive use of the palette knife, employing it, as did Courbet, along with wide, stiff-bristled brushes to build up thick, tactile paint surfaces. For both artists, these rugged and heavy paint textures became an equivalent for and means to express the solidity and materiality of the objects and surfaces represented, as well as a sign of artistic truthfulness and sincerity (see no. 1). Pissarro, however, dispensed with Courbet's typical dark ground and strong, enveloping shadows in favor of an even, ambient light and warm gray-beige priming, seeking an overall luminosity and warmth. His paint handling also far exceeded Courbet's in coarseness and vigor.

In this *Still Life* and a very few other paintings of the same year, Pissarro seems to have been goaded to this new liberty and audacity of execution by the paintings of his friend Cézanne. Cézanne invested his figure subjects, portraits, landscapes, and still lifes of this time with an extreme painterliness to which Pissarro's work in 1867 is directly comparable. Yet unlike Pissarro, Cézanne's intentionally crude touch was often allied with more narrative, symbolic, or suggestive imagery whose charge of meaning and emotion it expressed.

Pissarro instead asserted the physical properties of his subject. Beginning from a simple, broad drawing of shapes done with a large brush,

he constructed his forms with wide, rough, heavily loaded strokes applied with both brush and palette knife. The strokes shift direction to model and indicate the positions of planes, and also to convey something of surface texture or detail. The broad, horizontal bands of tablecloth, panelling, and wall were built up around the objects, with the contours brought out again in places by scratching back through the thick paint layers. The setting is as densely impastoed as the objects themselves, establishing a unified wall of vigorously worked paint.

Pissarro's greatest stress is on the material and tangible character of things—on conveying thickness, density, and tactility—and on creating a tautly rhythmic sequence of weighty, bulging volumes and palpable spaces. Through the powerful order and intensely active paint surface, he evokes something of the elemental force of matter itself and the process of artistic creation. Emile Zola, writing as critic in 1868 about Pissarro's paintings, extolled in them "a simplicity, a heroic frankness. . . . The painter's insight has wrested from daily truth a rare poem of life and strength."

Oil on canvas, 31⅞ × 39¼ inches (81 × 99.6 cm)

The Toledo Museum of Art 49.6

Gift of Edward Drummond Libbey

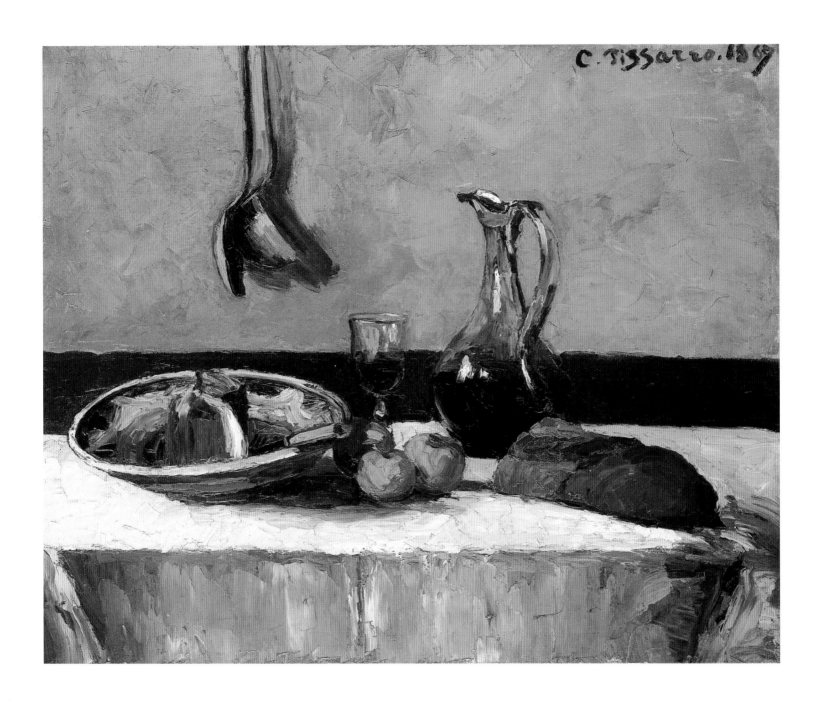

61 *The Crossroads, Pontoise (La Place du Vieux Cimetière à Pontoise)*
1872

Pissarro lived and worked in Pontoise from 1866 to 1868 and again from 1872 to 1882, and it is the place with which he has been most closely associated. Twenty miles northwest of Paris, Pontoise was a thriving market town in the midst of a rich agricultural region. It had a distinguished history going back to the Middle Ages and some notable medieval architecture, but was also undergoing a limited process of industrialization and modernization. During the first few years following his return, Pissarro surveyed a variety of Pontoise subjects, painting some of the more modern aspects of the town as well as the surrounding rural landscape of fields, farms, kitchen gardens, woods, and village paths he more generally preferred. Unlike Monet, Renoir, Manet, Boudin, and others, the subjects he depicted were rarely the popular sites of recreation or the traditionally admired picturesque or historic motifs. Instead, he chose the places of ordinary lives and everyday events.

The Crossroads, Pontoise was executed within two or three months of his move back to Pontoise in the late spring of 1872. It depicts an open space near what had been a medieval gateway to the old town. Although the site lacked much intrinsic interest for the Parisian audience for which it was destined, Pissarro nevertheless carefully specified the precise location in the title with which he sold it as *La Place du Vieux Cimetière à Pontoise*. He selected a view that avoided the nearby historic monuments and turned away from the dramatic sweeping panorama of the Oise valley. Instead he concerned himself with a vacant patch of dirt and grass, a few dispersed figures, some ordinary trees and overgrown scrub, a jumble of houses and rooftops—none particularly picturesque or noteworthy—and a broad expanse of nearly cloudless sky. The view is detached and without focus: no feature is singled out; no compelling drama or diverting anecdote is suggested. The subject is quite deliberately without poetry, charm, or conventional beauty. Pissarro carefully excluded those expected elements that ordinarily make a landscape interesting and attractive.

What engaged Pissarro instead were the rise and fall of the terrain; the open, featureless foreground and the complex of forms situated at different angles and levels in the middle distance; the variety of houses and vegetation; the sparse scattering of figures; and the brilliant, even light, transparent atmosphere, and bright, clear sky. Pissarro had painted similar compositions during his earlier years at Pontoise, but since then had become far more responsive to the varying effects of light and atmosphere and less to the material and tangible properties of his subjects. Like his friend Monet, with whom he had painted in 1869 and 1870, he increasingly sought to transcribe the sensations he experienced directly before nature and thus gave more emphasis to extended outdoor work, even in his most ambitious canvases. He

lightened his palette and narrowed his range of values, like Monet, Boudin, and Jongkind, and Corot before them, applying the principles of what was called *la peinture claire* to the task of representing the luminosity of the landscape (see nos. 5, 41, and 47). Color, although brighter overall, remains relatively tonal and is restricted to a limited range of reddish tans and greens with the most striking and unusual effect provided by the intense, vivid blue of the sky.

The small-scale modulations of color and value both articulate the complicated arrangement of forms in the middle distance and enliven the picture surface to evoke the play of light across the scene. The brushstrokes are smaller, thinner, looser, and more flexible than in his earlier work, their changing patterns differentiating textures and suggesting the lively shifts and vibrations of light. Pissarro's touch here is more tightly regulated than Monet's (see no. 49) and contributes toward the overall structure of the painting. As he does in many other works, he orders the composition by a simple division into horizontal bands, the wide strips of the sky and ground locked in balance by the middle distance of buildings and trees. Recession is limited, and space is bounded and enclosed by the architecture. The tightly integrated arrangement gives emphasis to the foreground and sky, which become open fields for the elaboration of light, color, and touch. This idea of giving prominence to a broad, open, featureless foreground also engaged other artists of the period (see nos. 7, 33, 34, 48, and 82), including on occasion older artists like Millet, but seems most of all to have entranced Pissarro, who repeatedly explored its rich, if seemingly modest, possibilities.

Pissarro sold *The Crossroads* shortly after its completion to the dealer Paul Durand-Ruel on August 23, 1872. Durand-Ruel later sold it, probably in the late 1880s or early 1890s, to Catholina Lambert, a silk tycoon of Paterson, New Jersey.

Oil on canvas, 21⅝ × 37 inches (54.9 × 94 cm)

The Carnegie Museum of Art 71.7

Acquired through the generosity of the Sarah Mellon Scaife family

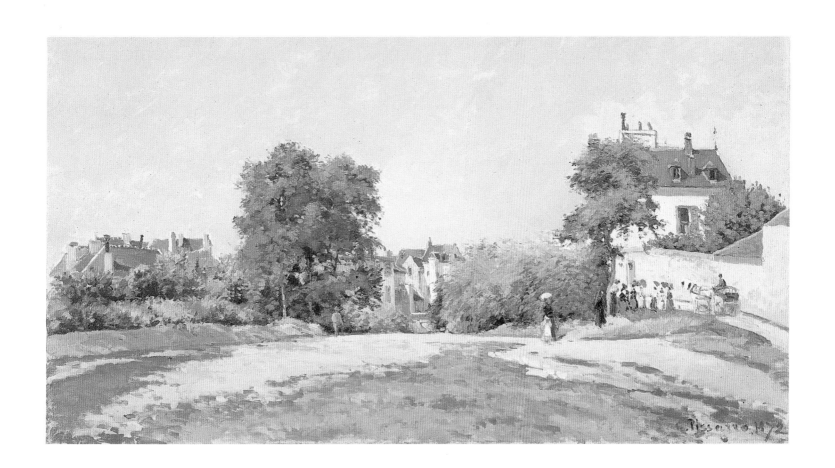

62

The Garden of Les Mathurins at Pontoise
1876

Among the paintings Pissarro did at Pontoise, *The Garden of Les Mathurins* is unusual for its large size and tight finish, but above all for its subject of a richly planted garden and large house enjoyed by a well-dressed woman. Garden subjects were favored by many of the Impressionists (see nos. 9, 59, and 71), Monet and Renoir especially, but had far less appeal for Pissarro, who had little taste for those gardens of the wealthy of the sort he depicted here. He generally was contemptuous of the upper classes and of their cushioned lives gained, as he saw it, through exploitation. Their omission from his repertoire of Pontoise subjects appears not to have been a question of access so much as of attitude.

Les Mathurins, a former convent, was located on the same street on which Pissarro lived in the semirural Hermitage section of Pontoise. It may have been made acceptable to him as a motif for painting because of his amicable feelings toward its owners, the Desraimes sisters, for whom the building was a summer residence. One of them, Maria Desraimes, was a political writer and Realist playwright, a committed republican who served as deputy for Pontoise in the National Assembly during the Third Republic. She and Pissarro were on good terms, and her political philosophy seems to have been reasonably close to his own. Whatever the nature of their relationship, it appears to have led him to set aside his decidedly antibourgeois opinions and to celebrate the virtues of the comfortable life. The well-groomed garden is lush with flowers and foliage ordered in tidy beds and neat lawns and is fashionably furnished with small trees in large planters, decorative iron furniture, and a mirrored-glass reflecting globe on a stand. It was not the sort of milieu that Pissarro's politics generally disposed him to paint, but there is nothing to suggest that this picture was designed to mock or to provide an understated social commentary.

More than anything, Pissarro seems instead to have conceived this painting in response to Monet's recent garden pictures, many of which are notably similar in subject and structure. It also may have been an attempt to reach new, presumably more prosperous clients at a time of declining support from his dealer Durand-Ruel and of intermittent sales. Monet's *The Luncheon* of c. 1873 (Paris, Musée d'Orsay), shown at the second Impressionist exhibition in April 1876, probably inspired the garden subject, large size, careful finish, accentuated touch, rich palette, and figure placement deep within the setting, much as it did for Renoir at almost the same moment (see no. 71). It seems plausible too that Pissarro's picture, like Monet's, was intended as an independent decoration without specific destination or function in mind. In the years after 1870, when he had ceased submitting to the Salon, Pissarro had rarely painted large-scale canvases with the significant exceptions of two decorative projects, one of 1872, the other 1875.

Like a number of other artists of the Impressionist group, he may have been seeking to attract decorative commissions or to promote sales of paintings that might serve this function. To that end he chose a conventionally attractive subject and painted a second, upright canvas —slightly larger than this one in one dimension—of a different corner of the same garden. He exhibited the two together in the third Impressionist exhibition of April 1877, where they hung in company with Monet's and Renoir's own decorative panels and numerous other works with garden subjects.

The size and finish of both paintings of the Mathurins garden, as well as the date of 1877 with which the upright one was inscribed in spite of its summer subject, indicate that they were both extensively if not totally executed in the studio. The Nelson-Atkins canvas is heavily worked and fully developed, with only the sky more loosely and thinly handled. The richly textured paint surface is composed of variegated but small, tight, and evenly distributed strokes that convey shapes, textures, and directional flow. Like the design of the garden itself, the brushwork brings order and discipline to the raw material of nature. Pissarro warmed and brightened the colors by painting over a white ground and mixing in a great deal of yellow and white, even in the darker tones. The color is carefully balanced and coordinated and is structured around repeated contrasts of red-oranges and pinks against greens, with blues in the shadows and yellows in the strongest lights. This concern for complementary contrasts to enhance the painting's luminous shimmer and re-create the natural effects is found in Monet's and Renoir's work of this same time. The overall composition is very firm—in parts even geometrical—the areas and shapes strongly defined within a carefully laid out space. The arrangement establishes a rigid framework for the finely nuanced elaboration of color and light and conveys the stringent luxury of the scene.

Oil on canvas, 44⅝ × 65⅛ inches (113.3 × 165.4 cm)
The Nelson-Atkins Museum of Art 60-38
Nelson Fund

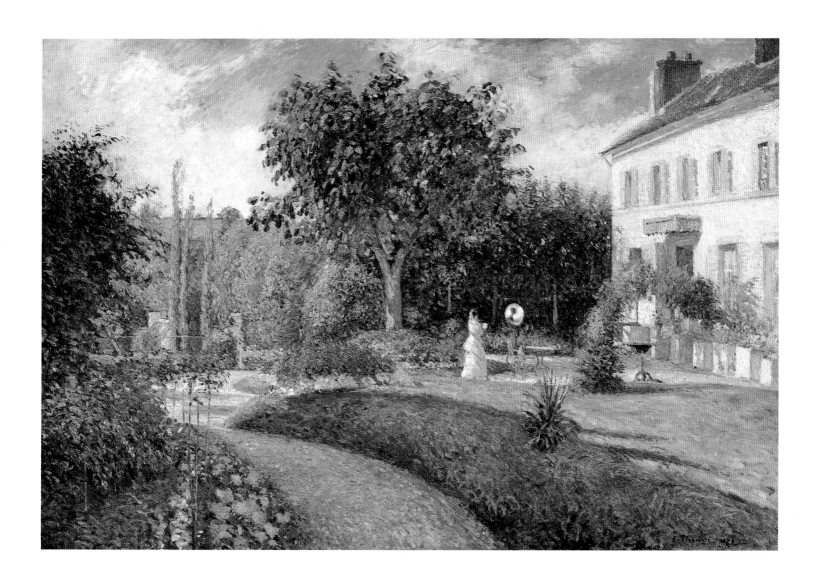

Throughout his long career, Pissarro continually stressed the importance of his sensations for his art. For him as for his Impressionist colleagues, the artist's direct experiences before nature constituted the essential basis for his individual knowledge of the phenomenal world. In *Wooded Landscape* Pissarro's concern is not so much with the particulars of the difficult-to-decipher site or with the relationship between the natural and the built landscapes, as it is with the process of observation and the complex challenge of re-creating his sensations as an organized and coherent picture surface. The painting's basic motif is one he repeatedly sought out from 1877 to 1879: a dense screen of twisting trunks and branches and tangled undergrowth stretched across a view of buildings set against a hillside. Pissarro shared his appreciation for this motif with Cézanne, with whom he painted at Pontoise during the 1870s (see nos. 11 and 13), and to a lesser extent with Monet, who briefly explored it in a group of paintings of 1878.

In this view through the thicket of foliage, the identities of things are disturbed, continuities are disrupted, and spatial intervals confused. This effect is intensified by the small, thick, broken strokes, of a sort Pissarro likened to knitting, whose relatively uniform size and texture do little to differentiate the shapes and features. Color establishes some general distinctions—especially the red and blue roofs and white walls of the houses—but the palette is rather limited, if also subtly varied and nuanced, and the same few tones are repeated and carried throughout. As a result, solidity is compromised, objects and spaces fragmented, and distances collapsed. The disparate elements of the scene are unified by the networks of curving rhythms and coordinated colors, by the elisions of near and far, and by the overall tactile surface.

Like many of his Impressionist colleagues, Pissarro was involved in an ongoing exploration of new forms of spatial representation and compositional coherence (see nos. 8, 11, 18, 48, 49, and 71). What also engaged him was the desire to investigate and paint the distinction between sensation and perception, between an instinctive response to the sensory data registered from this intricate and jumbled view and the cognitive process of its ordering and comprehension. Through his manipulation of the discontinuities and blurred distinctions of the forms and spaces within *Wooded Landscape*, Pissarro attempted an imaginative and practiced re-creation of his willed acts of quasi-naïve observation of the landscape.

The issue of seeing and knowing in Impressionist painting in general was addressed by some critics in 1882. An anonymous London critic writing in the *Standard* remarked that Impressionism "aims generally to record what the eye sees, and not what it knows the eye ought to see." Ernest Chesneau, in his piece on the 1882 Impressionist exhibition in the *Paris-Journal* observed more fully that the Impressionists were devoted "to translating not the abstract reality of nature, not nature *as it is*, as the mind of the scientist would conceive it, but nature *as it appears to us*, nature as the phenomena of light and atmosphere create it for our eyes, if we know how to see." But Chesneau went on to stress that it was impossible that these artists could directly reproduce this appearance, that they could seize "phenomena in the fleeting moments of their duration" since "they pass, leaving only an impression on our retina and in our memory, a memory of enchantment of color and movement. . . . It is that memory that [the Impressionists] wish to and know how to fix."

These critical formulations point toward questions about observation raised in Pissarro's painting and also toward the increasingly protracted endeavor his paintings entailed in his search to give pictorial form to nature's transitory and intangible effects. He found it necessary to resort to more prolonged periods of work on his canvases—both out of doors and in the studio—and to more extended procedures. In *Wooded Landscape* the multiple layers of paint and often heavy and deliberate touch attest to the process of repeated modifications to which he subjected the painting. Like Monet at this same time, Pissarro sought a more deeply considered and fully developed effort and less a direct and immediate response.

Shortly after this painting was executed, Pissarro made an etching in which he repeated its composition almost exactly but in reverse. He annotated many impressions of the etching with the title *Paysage sous bois à L'Hermitage, Pontoise*, the title now also given to the painting. He showed four states of the etching in the fifth Impressionist exhibition in April 1880 but never exhibited the painting. It was sold at an early date to the Rumanian-born collector Dr. Georges de Bellio, a faithful supporter during the 1870s. De Bellio, who also owned no. 62, was a well-to-do homeopathic physician whom Pissarro consulted for medical advice. In 1878 he was cited as among the dozen leading collectors of Impressionist painting (see no. 44).

Oil on canvas, 18⁵⁄₁₆ × 22¹⁄₁₆ inches (46.5 × 56 cm)
The Nelson-Atkins Museum of Art F84-90
Gift of Dr. and Mrs. Nicholas S. Pickard

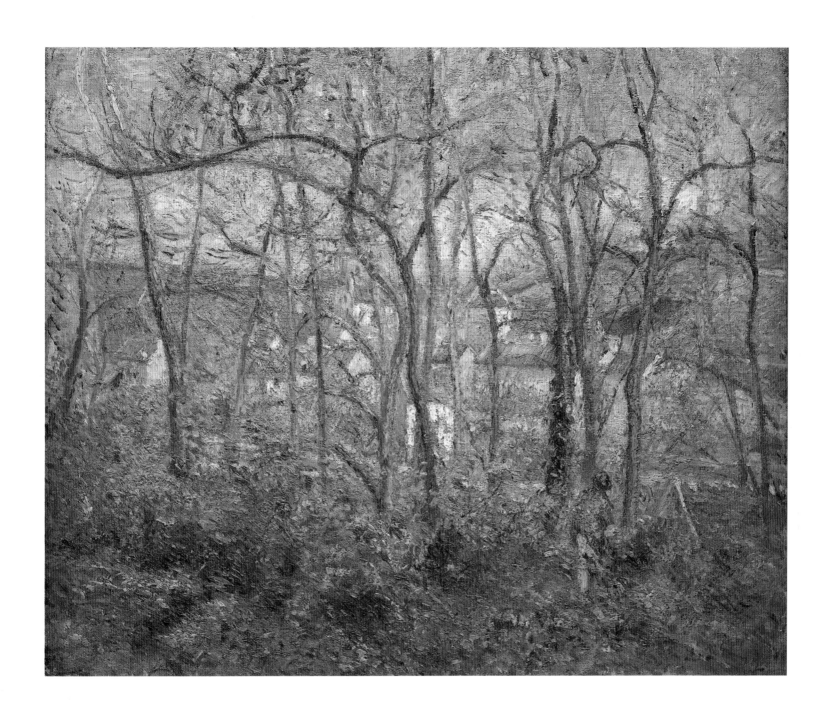

64 *Peasants Resting* (*Figure Study in the Open Air, Sunlight Effect*)
1881

At the end of the 1870s, Pissarro gave a new importance to the human figure in his paintings, above all to the image of the peasant in the open air. Previously he had tended to subordinate figures to their surroundings, often submerging them in the middle distance of a broad and varied landscape. By 1881 he had brought them forward and narrowed the setting, thus increasing their scale and prominence. There were, undoubtedly, numerous reasons for his reassessment of the role of the figure at this time. His idea of doing large-scale figures in the open air must have been stimulated by his admiration for Millet's peasant images and, at a time of extreme financial hardship, by the enormous success of some of Millet's followers and successors.

Toward the end of the 1870s, Pissarro may have seen the large-scale figure as a way of giving his compositions an immediate and relatively simple order and focus. These tendencies toward a concentration on the figure may have been nurtured by his closeness in the late 1870s and early 1880s to Degas. Along with Millet's peasants, it is Degas's images of working women that seem to stand behind Pissarro's figure paintings of this period (see nos. 18 and 19). Although Pissarro was far less interested than Degas in precisely describing the routine actions of a profession and showed little attraction to momentary attitudes, he was influenced by Degas's passion for the human figure and his typical strategies for representing it. In *Peasants Resting* the informal poses, scattered figures, asymmetrical arrangement, oblique downward view, tilted ground plane, high horizon, and abrupt jumps in space recall Degas's ballet pictures of the later 1870s.

Pissarro's choice of peasants rather than dancers or milliners may have been an expression of his feelings for rural life as well as of his evolving anarchist philosophy. He wrote to his son Lucien on December 28, 1883, that he considered modern society to be "rotten and in the process of decomposition." He believed instead that peasant life held the basis for a harmonious society that would be humane and rational. His utopian vision of rural life was not, however, represented in any programmatic way in his paintings, but may have informed their general avoidance of toil and their typical mood of idyllic tranquillity.

Pissarro carefully selected his peasant subjects. He infrequently depicted men, and even when he did rarely gave them any prominence. His peasant women occasionally work hard, but more often they relax, converse, or reflect. Unlike Millet and his followers, Pissarro rejected drama, sentiment, poetry, and rhetoric in favor of emotional distance and impassiveness. At times in his images of the early 1880s, his women show signs of fatigue, as they do here, but *Peasants Resting* is unusual for the degree to which one of the principal figures, the woman on the left, makes a direct, if understated, appeal for the viewer's sympathy. Her countenance and the attitude of her body clearly convey a feeling of weariness and of well-earned rest from toil. The emotional effect is restrained by comparison with works of other, more popular painters of peasants, but shares with them its appealing tinge of pathos.

Pissarro executed a careful pastel study of the two principal figures, indicating the importance that drawing had assumed in his procedures. In his figure paintings, he seems largely to have renounced working from nature, conceiving and executing them in the studio. While the composition was established in the pastel, Pissarro left it for his work on the painting to elaborate the setting, light effects, and brushwork that are integral to the total effect. The landscape, for all its intricacy, responds to the figures, its bending path and curving trunks adjusted to their broad shapes and contoured rhythms. The high horizon, tipped-up ground plane, diverted path, and tangled foliage counter spatial recession and bring the landscape forward to enfold the figures. As in Renoir's paintings of the mid-1870s, light falls in irregular, dappled patches that spread across and unify the disparate forms and surfaces. The continuous shifts and variations of light and color are conveyed by the small, crisp, regular crisscross strokes that are a rationalization of his densely worked surfaces of the later 1870s. The fine gauge, repetitive rhythm, and even distribution of the brushwork impose order and coherence on both the varied natural features and the pictorial surface.

Pissarro's treatment expresses the harmonious integration of the figures with each other and with their surroundings. It evokes as well a sense of an essential relationship between woman and nature, a standard equation that Pissarro, however, deprives here of its conventional suggestions of sexuality and fertility. Instead, his connection of the peasant woman with the natural order presents a utopian vision of a harmonious rural existence—one with convincing roots in the observed world of the French countryside—in which work and rest, the human and the natural are integrated.

Oil on canvas, 32 × 25¾ inches (81.3 × 65.4 cm)

The Toledo Museum of Art 35.6

Gift of Edward Drummond Libbey

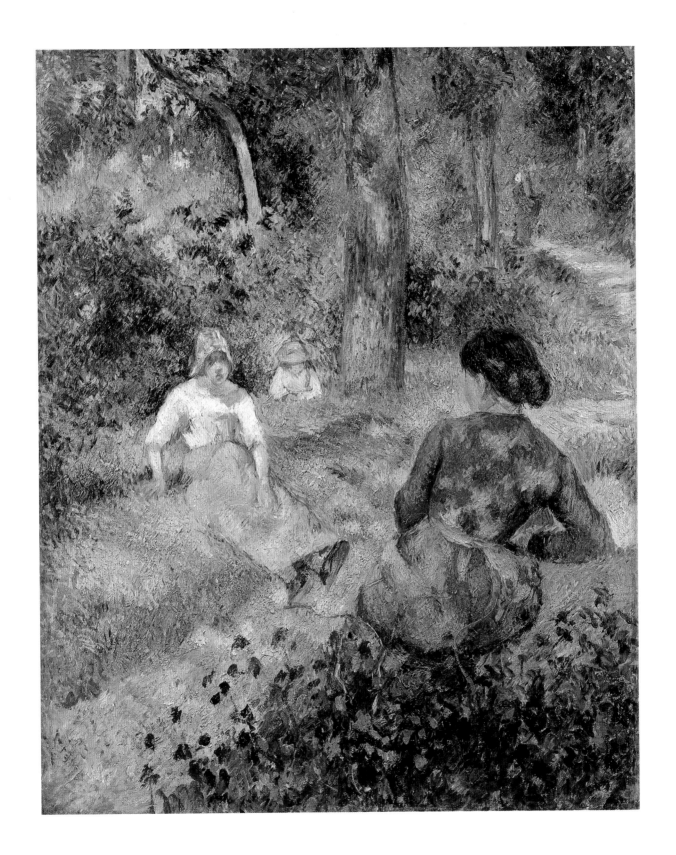

Although this painting traditionally has been titled *Market at Gisors*, Pissarro annotated impressions of his 1895 lithograph of the same composition *Marché à Pontoise* (Market at Pontoise). He had moved from Pontoise in 1882 but seems to have returned on occasion and continued to depict Pontoise subjects, especially its markets, from his stock of images. In this late work he offers only a general description of the setting, one that he had used in a number of earlier market scenes.

Pissarro had broadened his range of subjects in the early 1880s and had begun to paint markets in 1881, depicting ones in both Pontoise and Gisors. The subject had become popular among the Salon-oriented painters of peasant genre, who generally emphasized the picturesque aspects—quaint locales, traditional costumes, and peculiar customs. Pissarro seems to have enjoyed the bustle of the crowd, a contrast with his quiet and sparsely populated images of fields and woods, and favored a vertical format for his market images to enhance this impression. He was interested, too, in the mingling of a wide range of rural types and, at times, classes, although *Market at Pontoise* seems to be relatively homogeneous socially. The outdoor market was his rural equivalent for the crowded urban subjects of Manet, Degas, and Renoir.

His attraction to the subject also may have been related to his political views. Representations of such markets as this one showed the peasant as a subject not only of nature but also of economic structures. They gave image to an independent, self-sufficient local economy, which Pissarro's anarchist philosophy viewed as a desirable element in the integrated agrarian communities to which he felt society should return. For Pissarro, such evocations of a harmonious ideal might have purpose. He suggested in a letter of 1892 to the critic Octave Mirbeau that he believed it possible that they might have value in bringing about his dream of a utopian society.

If his market pictures of the early 1880s were somewhat prettified, they still could be regarded by critics as being painted with rustic vigor and truth of observation. By 1895, however, his images had become far more idealized and monumental. His earlier naturalism had, in general, by then given way to a far greater degree of formal stylization. He based his later market images on his past paintings, drawings, and experiences of the subject, returning to older motifs that he reconsidered and reworked in a practice similar to Cézanne's and Degas's (see nos. 12, 20, and 21). Although not a repetition of a previous work, *Market at Pontoise* recycles stock compositional devices that Pissarro had developed for the subject in his market scenes of the early 1880s. The formula of a linked trio of large-scale figures in the foreground behind which the crowd is compressed, the sharply tilted ground plane, and the layout of buildings and spaces, as well as some specific poses and motifs, were common to many of his earlier compositions. Since the early 1880s, the figures had become less particularized in their physical characterization, their poses and gestures less complex and animated, their contours less irregular and elastic. By 1895 they are more generalized, more stable, more grand and stately, their gestures almost ritualized.

Far more than in the early 1880s (see no. 64), the forms are emphatically bounded by strong, simple, blue contours that Pissarro drew first on the light gray ground and retained or reinforced while elaborating the composition. In the wake of his Neo-Impressionist phase, the brushwork is even smaller, denser, and more concise, crossing the picture surface in tight patterns. Through it Pissarro introduced and controlled the fine weave of colored nuances. The color, influenced by his Neo-Impressionist experience, has become richer and more brilliant if also more patently artificial. Its calculated harmony is geared not to convey a specific natural light effect but to confer on this nearly idyllic scene a luminous shimmer and sumptuous glow.

Pissarro's synthesizing treatment of shape, color, and space, along with the monumentality of his figures, allies him with artists of the new generation such as Gauguin and Seurat (see nos. 28, 32, and 75), and perhaps with aspects of the later work of Cézanne, Degas, and Monet as well. His son Lucien wrote to him on April 19, 1891, "In synthesizing your figures and your landscapes haven't you given them a character that is less episodic, more general, and as a result more symbolic?" He perceptively pointed out that the distinguishing character of Pissarro's new vision was that it was more distant from nature, more synthesized and subjective, more generally suggestive, and thus closer to Symbolist thought. Pissarro himself, although averse to Symbolist aesthetics, seems to have confirmed these views in writing to Lucien on April 26, 1892, "I am more than ever in favor of the impression via memory: things become less material, vulgarity disappears and lets float there only the truth as it is perceived and felt."

Oil on canvas, 18¼ × 15⅛ inches (46.3 × 38.3 cm)

The Nelson-Atkins Museum of Art 33-150

Nelson Fund

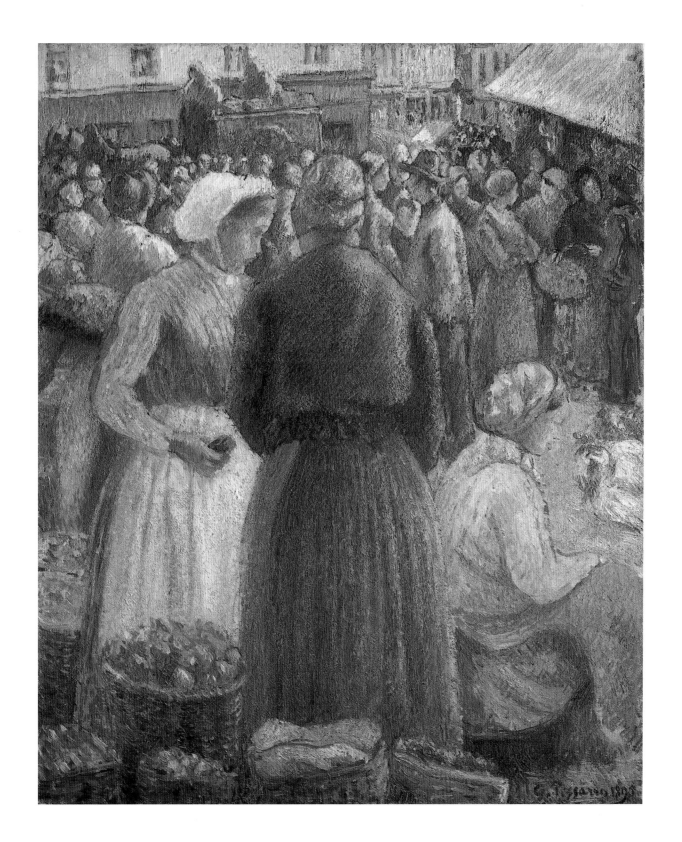

Camille Pissarro
1830–1903

66 The Roofs of Old Rouen, Gray Weather
1896

The Roofs of Old Rouen, Gray Weather was one of over a dozen paintings of Rouen Pissarro executed during his stay there in 1896 from January 20 until the last days of March. At a time of strong demand for Impressionist pictures and of Pissarro's own dissatisfactions with the predominantly studio-based and synthetic character of his art (see no. 65), he seems to have been determined to reconsider the tenets of his Impressionist past. He turned to modern urban subjects typical of Impressionism of the 1870s, but which he himself had rarely treated before, and depicted them essentially as they were. He focused again on the exact rendering of transitory effects—on the envelope of light and air—and recovered a sense of fresh observation that he had subordinated in his more deliberate and intellectual picture making of the 1880s and early 1890s. He gave renewed emphasis to work done rapidly before nature and completed his paintings of Rouen on the spot, thus revaluing his direct sensations and spontaneous responses.

These general changes in Pissarro's art in the mid-1890s are evident in the Toledo painting. The handling is broader and more vigorous; the brushwork is again more responsive to and dependent on the motifs, the short, slablike strokes in the roofs and chimneys evoking almost one by one their tiles and bricks. Color is less vivid and artificial, and the remarkably refined and subtle range of grays balanced by warmer reds, oranges, and pinkish tans suggests the unifying effect of the gray, wet weather. The tones are softer and less pure than before and are in many places brushed wet into wet, slurring and mixing the separate touches of color. Tightly knit and geometrical, the intricate composition brings order to the jumble of motifs. Repeated horizontal and vertical elements interlock in somewhat irregular sequences, their patterns of overlappings and alignments and the cropping of the tall steeple at the painting's upper edge asserting the unified and decorative character of the design. But Pissarro was again concerned with spatial recession, expressing distances by diminishing the strength of the colors and the size and clarity of the strokes, and by the rough perspective system whose lines converge on the rose window of the cathedral's south transept.

A month after his arrival in Rouen, Pissarro came upon an unexpected view of the great Gothic cathedral from a room high up in the Hôtel de Paris, facing away from the river. He wrote in his excitement to his son Lucien on February 26:

I think I shall stay here until the end of March, for I found a really exceptional motif in a room of the hotel facing north, ice cold and without a fireplace. Just imagine: the whole of old Rouen seen above the roofs, with the cathedral, Saint-Ouen church, and the fantastic roofs, really amazing turrets. Can you picture a size 30 canvas filled with ancient, gray, worm-eaten roofs? It's extraordinary!

In 1883 Pissarro had done three paintings of the cathedral seen from down along the river, compositions clearly reminiscent of the well-established topographical tradition of Rouen views. He had also seen and admired Monet's *Rouen Cathedral* series in May 1895. Out of deference, no doubt, to Monet and to the topographical tradition, he initially avoided the cathedral motif, but his discovery of a new and unusual view stirred his desire to paint it. He worked quickly and finished the canvas in less than ten days, by March 7.

In *The Roofs of Old Rouen* Pissarro transformed the way in which the cathedral was represented. In place of Monet's metamorphosis of the motif by the serial repetitions, the close-up view, and the extraordinary paint surfaces and effects of light and color, Pissarro's image is bound closely to the particulars of the site and to ordinary effects of light, atmosphere, and weather. Unlike Monet, he embeds the cathedral in its proper context of urban domestic architecture. Conventionally, Gothic church architecture had been analogized with nature. Pissarro instead roots the institutions and structures of religion in the everyday social environment. The cathedral emerges from the buildings of the old city: the blurred contours, overlappings, and similarities of colors and shapes at the lowest points at which it is visible relate it to the turrets, chimneys, and rooftops below.

Pissarro confided to Lucien on March 17, 1896: "I don't want to exhibit it on account of Monet's cathedrals; I am afraid it isn't good enough to stand the comparison, although it is quite different. You know how much backbiting is going on." But when the time came for him to make the selection for his exhibition of recent works at Durand-Ruel that April, he included it in spite of his modest reluctance. He wrote to Lucien on April 16, the day after the opening: "In my opinion, in that of Zandomeneghi, Degas, etc., it is the outstanding work. I don't understand how I was able to get this completely gray picture to hold together!"

Oil on canvas, 28½ × 36 inches (72.3 × 91.4 cm)

The Toledo Museum of Art 51.361

Gift of Edward Drummond Libbey

154

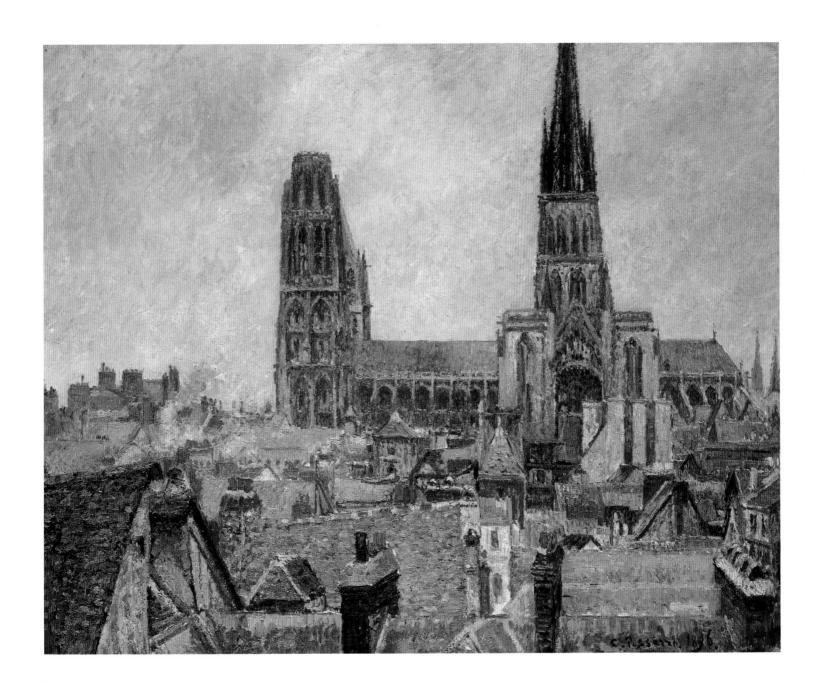

67

Le Grand Pont, Rouen

Pissarro returned to Rouen later in 1896 for a second campaign of painting (see no. 66). His trip was financed by Durand-Ruel following his successful exhibition in April–May of recent works, including eleven Rouen pictures done earlier that same year. He again stayed at a hotel overlooking the river and docks, remaining for about two months and completing fifteen canvases between September 8 and November 12. As he had during his previous visit, he went to Rouen to paint scenes of commerce and industry along the Seine, the quays, bridges, factories, warehouses, railway stations, and workers' housing, the loading and unloading of ships and comings and goings of port traffic, and the new industrialized areas across from his hotel. He made these his principal subjects and ignored the well-known and expected motifs, as such other painters of Rouen as Boudin and Monet, and before them Turner, Corot, and Bonington had not. He wrote to his son Lucien on October 2, 1896, of the scene outside his window:

I have a motif which should be the despair of poor Mourey [a critic]: just conceive, the new Saint-Sever quarter right opposite my window, with the hideous Gare d'Orléans all new and shiny, and a mass of chimneys from the enormous to the tiny, all with their plumes of smoke. In the foreground, boats and water, to the left of the station the working-class district which extends along the quays up to the iron bridge, the Pont Boïeldieu. . . . Well now, that fool Mourey is a vulgarian to think that such a scene is banal and commonplace. It is as beautiful as Venice, my dear, it has extraordinary character and is really beautiful! It is art, and viewed through my own sensations.

In *Le Grand Pont*, Pissarro focused on one of the two major bridges crossing the river outside his window. The Pont Boïeldieu, also known locally as the Grand Pont (the Great Bridge), was an iron bridge built in the mid-1880s, replacing a famous seventeenth-century bridge frequently described in guidebooks and depicted in views. Pissarro had made this bridge, viewed from the left, a significant feature of five paintings during his earlier campaign in 1896 and did about six more, now viewed from the right. In this canvas he emphasized the tall smokestack of what is probably the main gasworks, situating it directly over the far end of the bridge, but left the new train station, the Gare d'Orléans, in this instance just beyond the right edge of the painting.

Pissarro seems to have considered industrial labor to be harsh and degrading. Just three years earlier he had done a drawing of stevedores on the Rouen docks bent over in backbreaking work for the May 1, 1893 issue on anarchism of the journal *La Plume*. But in this and other paintings of industrial Rouen, Pissarro conveys little sense of grimness or hint of social criticism. Instead, he appears to celebrate the distinct character and beauty of which he had written to Lucien and to take pleasure in the continuous animation and life of people and things. He expressed this in the refined and luminous color harmony of grayed blues and soft reds and the supple, nuanced strokes suggesting the constant mobility of light, atmosphere, water, smoke, and steam and the bustling activity along the bridge and quays. The low-arching perspectival thrust of the bridge adds to the overall movement and, with the other architectural motifs, establishes a firmly plotted framework for the evocation of flux and change. As he wrote to Lucien from Rouen on November 11 just before leaving, "I tried to represent the movement, the life, the atmosphere of the harbor. . . . I painted what I saw and felt."

Le Grand Pont was part of an extended series of Rouen views. Following Monet's lead, Pissarro in the 1890s began to work in series. His definition of a series was looser than Monet's (see no. 54), encompassing a group of paintings of diverse views and motifs of a single locale—in this instance, along the Seine at Rouen. For him, the terms of a series allowed for a greater range of motifs and activities; subtle and radical shifts in angle, position, and direction of view; effects of light, atmosphere, weather, and tempo of change; and nuances of color and touch. While Monet claimed in 1895 that for him the motif was insignificant, Pissarro remained concerned with the particulars of the site. For him, it could be modulated, inflected, and vitalized, but not masked, dissolved, and transformed by the envelope of light and atmosphere in which he experienced it.

The painting was shown in 1900 in the fifth International exhibition of the Carnegie Institute, Pittsburgh, the third time in three years that Pissarro sent one of his Rouen paintings there. It was acquired from the exhibition by the Carnegie Institute, making it one of the first Pissarros to enter a U.S. museum.

Oil on canvas, 29⁵⁄₁₆ × 36¼ inches (74.5 × 92.1 cm)
The Carnegie Museum of Art 00.9
Purchase

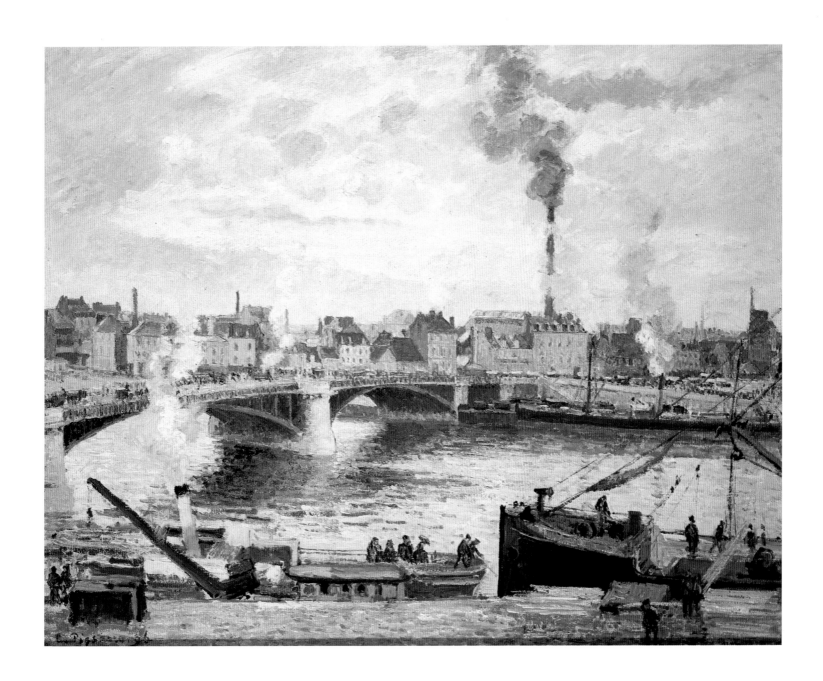

Pissarro turned to cityscapes far later than most other Impressionists. During his last decade, he undertook campaigns in Paris and Rouen (see nos. 66 and 67) at a time when the attention of his contemporaries had long since turned elsewhere. With the exception of a few pictures from 1879–80, Pissarro's interest in the modern aspects of Paris only began in 1893 and flowered in 1897, when he produced groups of paintings of three different streets in central Paris. On December 15, 1897, he wrote to his son Lucien of another Paris site he was getting ready to paint that year:

I found a room in the Grand Hôtel du Louvre with a superb view of the avenue de l'Opéra and the corner of the place du Palais-Royal [place du Théâtre Français]! It is very beautiful to paint. Perhaps it is not very aesthetic, but I am delighted to be able to try to do these Paris streets that people usually call ugly, but which are so silvery, so luminous and so lively. . . . This is completely modern!

His effort was directed toward an upcoming exhibition of his recent work at Durand-Ruel scheduled for April 1898. After moving into the hotel on January 5, 1898, for an extended stay, he worked quickly and confidently: by February 22 he announced he had six canvases done and four more underway. He was able to defer the exhibition until late May in order to complete this series, on which he continued working until April 11. He finished fifteen paintings on the spot, this picture among them. Pissarro's enthusiastic immersion in work came at an extremely difficult time. He recently had been devastated by the death of his son Félix and was dismayed by the Dreyfus Affair, then at its peak. But he wrote to Lucien, "Despite the grave turn of affairs in Paris, despite all these anxieties, I must work at my window as if nothing has happened."

His subject, the avenue de l'Opéra and place du Théâtre Français, was in an opulent quarter at the heart of Paris. Pissarro painted his subject essentially as he found it; he seems to have delighted in the deep vista opening out in all directions at irregular intervals. This distinctly modern setting—all but the Théâtre Français at near right had been built within the past forty years—offered him extended spaces for the activity of the daily traffic of pedestrians, carriages, and omnibuses. His attention to flux and mobility and his strategies for representing them were similar to and informed by Monet's paintings of the nearby boulevard des Capucines of twenty-five years earlier (see no. 49). As in Monet, the lively and fluent rhythms of the brushstrokes and continuous shifts of color convey the fleeting movements and ephemeral effects of light, weather, and atmosphere. Points of interest are scattered throughout, but Pissarro, more than Monet, vitalized and structured the view through perspective, contrasting the telescoped space of the overlapped buildings and trees on the right with the plunge into depth along the avenue toward the distant Opéra. The composition expresses the artist's experience of the random character and rapid tempo of city life, an emphasis strengthened by his recent practice of painting and exhibiting in series.

Nothing in these views of modern Paris seems to signal negative social judgments, but they may, when considered with his contemporary images of peasant society, intimate something of his views of city and country life. The differences between city and country were widely discussed by anarchist writers whom Pissarro read sympathetically and, in some cases, knew personally. For them, the city was the scene of exploitation, isolation, and despair and the country of mutual dependence and common good. It may be that Pissarro viewed as meaningful the contrast between his dignified peasant figures harmoniously integrated with their environment and the unfocused, random movements of small-scale and anonymous traffic crisscrossing large urban spaces. If he attached particular social significance to these cityscapes, his reticence in expressing it now seems very great. But when the series was shown in 1898, at least one critic, Gustave Geffroy, discerned in them a program of social commentary:

In this inharmonious setting the *mêlée* of carriages and traffic changes direction, crisscrosses and intermingles with that remarkable sense of rhythmic pattern that is often induced by crowds. Again and again the social conflict visible in the restless comings and goings in the streets is caught and abstracted by Pissarro, and one of the chief beauties of this series of canvases, is the depiction of the senseless agitation of human beings living out their lives against their ever changing backgrounds.

It may seriously be questioned whether what Pissarro sought to represent was "social conflict" and "senseless agitation" or instead the great pleasure he experienced in these modern and elegant surroundings and in the perpetual animation of the city life and natural effects that filled them.

Oil on canvas, 29 × 36 inches (73.7 × 91.4 cm)
The Minneapolis Institute of Arts 18.19
The William Hood Dunwoody Fund

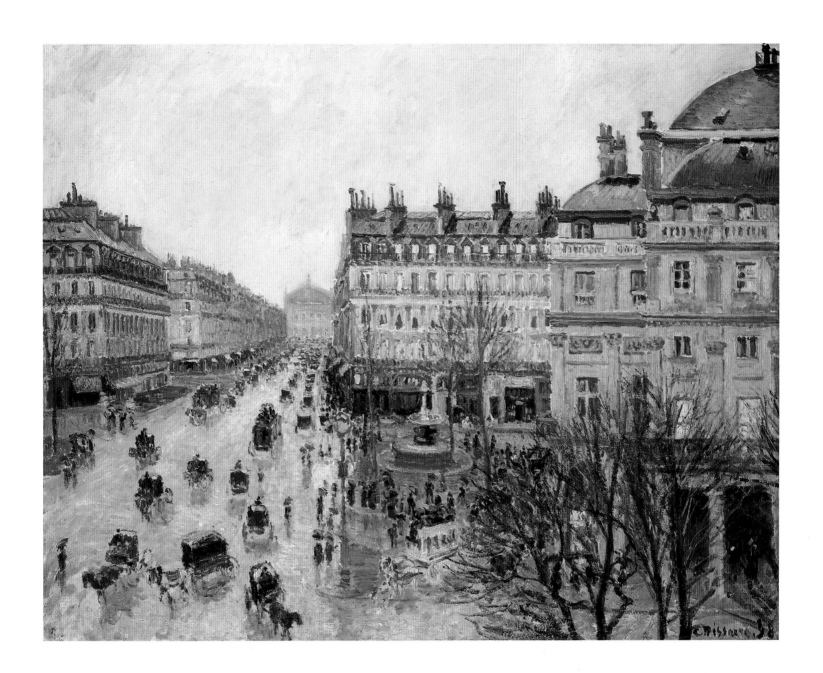

After having painted the Louvre in 1899 and 1900 from the rue de Rivoli looking into its courtyard and the Tuileries gardens, Pissarro took an apartment on the tip of the Ile de la Cité in March 1900 to paint it from a new direction. He wrote to his son Lucien on March 16, 1900: "I have found an apartment on the Pont Neuf. It has a very fine view. I am going to move in July. . . . I am afraid of failing once again to avail myself of a picturesque part of Paris." He occupied this apartment in a historic building at 28, place Dauphine only in November and soon after began the first paintings of what would eventually become an extensive series. From his studio he did views of the arm of the Pont Neuf leading from the Ile de la Cité to the Right Bank; the equestrian statue of Henri IV (known as le Vert Galant) and the tree-filled square du Vert Galant behind it; and the Seine, the Pont des Arts, and the Palais du Louvre. These motifs of old Paris were hackneyed, but must have appealed to Pissarro for their picturesque beauty, for their contrasts with the architecture and traffic of modern Paris he had recently represented (see no. 68), and for their harmonious intrusions of nature into the city.

He worked from November 1900 until February 21, 1901, when he wrote to Lucien that he had finished a winter series and would begin a spring one in late March or April. He returned to the apartment to paint the same motifs again in November 1901 and in November 1902, all three times staying until the spring. Over the course of the three campaigns, he produced a total of fifty-four paintings, thirty of them of this view of the Seine and the Louvre. As had been his practice in his previous series of cityscapes, he worked quickly and finished his canvases on the spot as he went. Like those of the earlier series, the paintings of this one vary in terms of the size and shape of the canvas, the precise angle and direction of the view, the traffic on land and water, the light and atmospheric conditions (mostly wintry), and the color and brushwork.

The Saint Louis picture probably dates from the winter series of his first campaign, although there is no way of knowing with any certainty whether it was in fact done in the winter, early spring, or late fall of 1901. In it Pissarro shows the steps leading up to the unseen equestrian statue on the far side of the Pont Neuf, with a few scattered figures strolling or conversing in the square and some barges and tugs on the river under the soft light of the morning sun. Pissarro invests the expansive view with rich, painterly effects and cursive rhythms and a warm, luminous harmony of red-tans balanced by blues in a limited but finely nuanced range of colors. Here, as in others of the finest works from the end of his life, Pissarro commanded a freshness of touch and color and an effortless control, the products of his long experience of expressing what he saw and felt in nature.

Oil on canvas, 29 × 36½ inches (73.7 × 92.7 cm)
The Saint Louis Art Museum 225:1916
Purchase

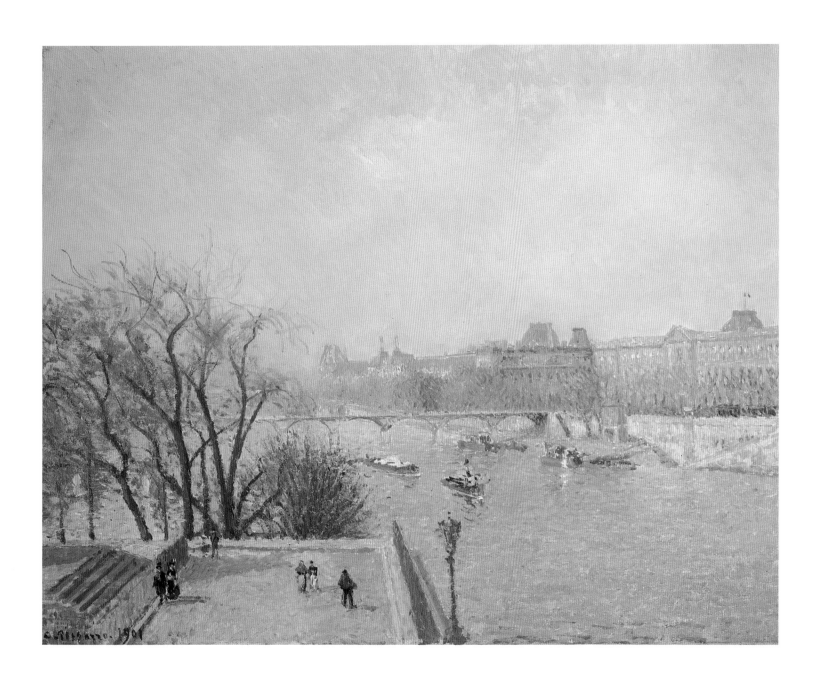

70 *Portrait of the Artist's Father, Léonard Renoir*

1869

Renoir was one of the notable portraitists among the Impressionists. During the 1860s his output consisted mainly of portraits and figure paintings for the Salon, and for about the first twenty years of his career, portraits formed a significant portion of his total production. He painted not only the commissioned portraits that accounted, during this time, for his major source of livelihood, but also friends, fellow artists, family, and himself. Although his portraits generally lack a strong sense of psychological characterization, this small and intimate painting of his seventy-year-old father conveys a rather tough and forbidding sternness by his pose and demeanor.

Léonard Renoir (1799–1874) was a tailor, first in Limoges where Renoir was born, then from 1844 in Paris. He retired and moved in 1868 to Voisins-Louveciennes, a village about ten miles west of Paris. This portrait was done during the summer of 1869, when Renoir, in desperate financial straits, was staying with his parents. It was painted only shortly before he joined Monet, who was living nearby, to work at La Grenouillère on some lively and colorful open-air sketches of modern riverside entertainments. In the late 1860s Renoir pursued simultaneously a variety of modes and directions in his art. For him, as for his colleagues, it was a time of wide-ranging experimentation and of dialogue with tradition and the recent past.

In this painting, Renoir respects the conventions of Realist portraiture, adhering most closely to Manet in his emphasis on spirited, fluent brushwork and on the summary handling of forms and values (see no. 43). In a group of paintings of this period, he displayed his admiration for the clarity and vigor of Manet's work. He was included in Fantin-Latour's 1870 group portrait in homage to Manet and painted his own tribute to the older artist in 1871 in the form of a still life.

Following Manet's lead, he restricted his palette in this portrait to black, white, gray, and flesh colors, seeming to take up the challenge of the poet and critic Baudelaire that "great colorists know how to create color with a black coat, a white cravat, and a gray background." Although Renoir wrote to his friend Bazille during this same summer, "I'm doing almost nothing because I don't have many colors," the limitations on color in this portrait were more likely self-imposed in emulation of Manet. Like Manet, Renoir laid his colors over a light ground—here gray—which unifies them and enhances their luminosity, but which in this case also lends a chilly gray pallor to the flesh.

The color is applied with great confidence in broad, barely modulated patches and dashing, impastoed strokes. The swift movements of the brush freely describe the folds and wrinkles of the flesh and the wispy fringes of hair and evoke the play of light and the solidity of forms against the flat, loosely brushed background. The lively surface and luminous tones soften somewhat this patriarch's rigid posture and severe expression, but the overriding effect remains somber and austere.

Oil on canvas, 24 × 18 inches (61 × 45.7 cm)
The Saint Louis Art Museum 37:1933
Purchase

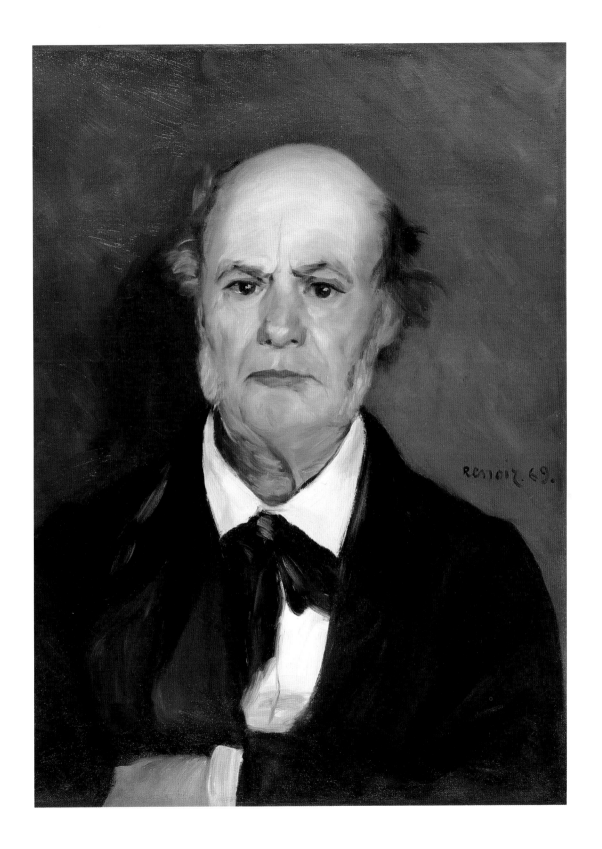

71 *The Dahlias* (*Garden in the rue Cortot, Montmartre*)
1876

In the spring of 1875 Renoir rented a temporary studio at 12, rue Cortot in Montmartre. He chose it for its location close to the Moulin de la Galette, which he wanted to paint, but was also particularly pleased with its large, overgrown garden. He kept this studio until the autumn of 1876 and worked there not only on his large canvas of the nearby dance hall, but also on some scenes set in his garden. This undated painting of flowering dahlias with two men conversing across a fence was probably executed in the late summer when dahlias are in bloom. The two men have been identified variously as Monet and Sisley or Monet and Renoir, but the features are not clear enough to permit certain identification.

Despite its large size, the painting was probably worked on in front of the motif, either out of doors, since Renoir would not have had to carry it far, or from his studio window overlooking the garden. He re-used an already-painted canvas, as he had done a number of times to save money. An X ray taken of one section of the canvas near the top to the right of center where the left-hand figure now stands reveals that a head of a man with a mustache is underneath. The large vertical canvas is of a size and shape Renoir often used for portraits and other figure subjects, but one that is relatively rare for a landscape. He had previously done a number of small horizontal pictures of figures in a garden, but seems to have been inspired to paint one so large and so thoroughly worked by Monet's *The Luncheon* of c. 1873 (Paris, Musée d'Orsay), shown in the second Impressionist exhibition in April 1876. Monet's garden scene, exhibited under the title *Decorative Panel*, was neither commissioned nor made with any particular destination in mind. Renoir's painting seems to have been similarly conceived as an independent decoration.

He sent it in April 1877 to the third Impressionist exhibition with the title *The Dahlias*. It was described by his close friend Georges Rivière in the quasi-official journal of the exhibition, *L'Impressionniste*, as a "splendid decoration, a large panel with magnificent red dahlias seen in a tangle of grass and vines." The idea of showing a decorative project appears to have been part of Renoir's strategy of using the Impressionist group exhibitions to generate portrait and decorative commissions as well as to sell already existing works. In 1876 and 1877 he showed mostly portraits and portraitlike figure subjects, along with some landscapes and scenes of modern life. But in 1877 he also publicized his virtues as a painter of decorations in an anonymous article he wrote for *L'Impressionniste* and exhibited *The Dahlias* presumably to display an example of his work.

Gardens, both public and private, proliferated in the 1877 Impressionist exhibition, more than in any previous year (see no. 62). The subject of the figure in the garden was a favored one in Impressionist art (see nos. 9 and 59), one that was also quite popular from the 1870s in modern-life painting for the Salon. The figures typically were either well-dressed, graceful women shown alone, in pairs, or with children, or were courting couples. An image of two men at ease in friendly conversation was unusual, especially so in Renoir's art where male companionship was a notably infrequent theme.

His emphasis here, however, lies less on the two figures than on the lush profusion of flowers and foliage. Like Monet in his garden pictures of the mid-1870s, Renoir reverses the normal positions of figures and flowers, placing his two men off center at the back. His focus instead is on the vibrant interplay of complementary colors, the delicate fluctuations of dappled light and shade, and the overall mobility of flexible and variegated brushstrokes. The high horizon, blocked entry, and linking of near and far flatten the space into a colored screen within which the shimmering vibration of atmosphere and light is evoked.

The dispersed and asymmetrical composition as well as the abrupt spatial breaks and elisions suggests an accidental and fragmentary view of the scene. Like Monet, Degas, Manet, and others at this time (see nos. 8, 18, 48, 49, and 63), Renoir is engaged here in an investigation of ways of expressing flux and immediacy in vision and experience, and in a reconsideration of traditional notions of perspectival recession and compositional coherence. This exploratory effort appears at odds with Renoir's desire to appeal to prospective clients for decorative commissions. Yet unlike his colleagues, his pictorial experiments were not geared to represent social disjunction and uncertainty in modern life, but rather to construct new visions of the harmonious integration of the human and the natural. As an anonymous interviewer observed in 1892, he felt in the world around him a "horror at its tormented aspects. . . . He loves everything that is joyous, brilliant, and consoling in life."

Oil on canvas, 59¾ × 38⅜ inches (151.8 × 97.5 cm)
The Carnegie Museum of Art 65.35
Acquired through the generosity of Mrs. Alan M. Scaife

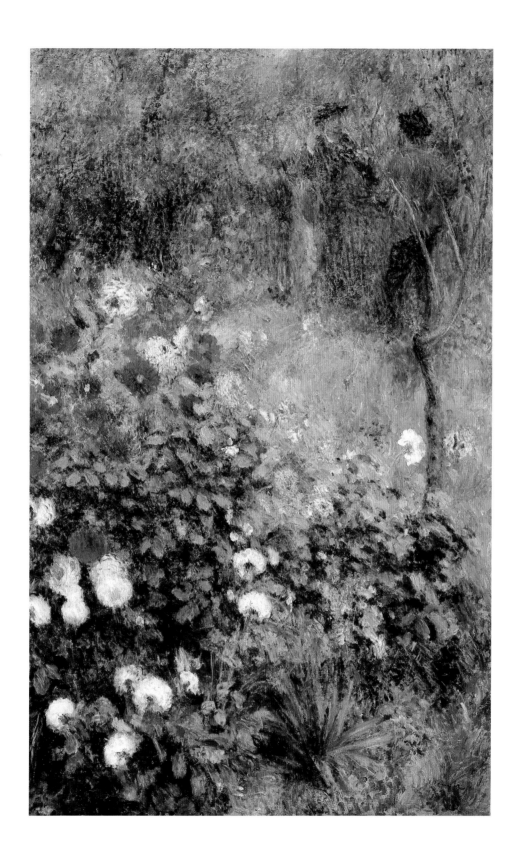

72

Road at Wargemont
1879

This dazzling tour de force of fluency and luminosity was painted during Renoir's stay with the Bérard family in the summer of 1879 at their château at Wargemont in Normandy not far from the Channel coast. He had been introduced to them only a few months earlier, when the Bérards were looking for someone to do a portrait of their eldest daughter. Paul Bérard was a well-born diplomat and banker with whom Renoir, despite great differences in background and temperament, formed a close and long-lasting friendship. During the first and longest of his many stays at Wargemont, from July to September 1879, Renoir was extremely productive, doing family portraits; small decorative works for the château; genre subjects; landscapes; and even a "portrait" of the château and its extensive rose gardens. Although Bérard eventually owned close to thirty Renoirs, among them various Wargemont subjects, it is unlikely that this landscape was among them. Bérard kept his pictures for the duration of his friendship with Renoir, selling them only shortly before his death in 1905. Other Wargemont paintings were sold by Renoir to collectors and dealers, this one to Durand-Ruel sometime before 1891.

During the later 1870s and early 1880s, Renoir was increasingly dependent on portrait commissions for his success and livelihood. In 1879 he did not exhibit with the Impressionist group, and instead sent four portraits to the Salon, two of them quite large and elaborate. He followed that with a solo exhibition at the gallery of the Paris journal *La Vie moderne*, which consisted mainly of portraits, mostly in pastel. Successful portraits demanded stereotyped poses, flattering likenesses, and an emphasis on the conventions of drawing, modelling, space, local color, detail, and disciplined composition to make them pleasing and acceptable. They also entailed a great deal of time and energy, necessitating some forty sittings in the case of an important one of Mme Charpentier and her two children that he sent to the Salon of 1879. By 1880 Renoir was frequently complaining of his boredom and frustration with society portraits.

Perhaps as a release from formal portraiture, perhaps as a continuation of his own earlier experimental endeavors, during these years Renoir also painted smaller works in which he cultivated many of the qualities that had been found objectionable when he earlier showed with the Impressionist group: spontaneity of execution, dissolution of form, and vivid contrasts of color. He practiced a form of free and rapid color sketch, which he did extraordinarily well but which he generally seemed to value less than did many of his Impressionist colleagues, Monet and Morisot especially. Above all, he developed an exceptional suppleness and translucency of handling, unmatched by perhaps any artist but Rubens in his oil sketches. The Toledo painting may arguably be regarded as among his supreme attainments in this vein.

Road at Wargemont is a remarkable virtuoso performance. It seems to have been impulsively and spontaneously made, without thought or hesitation, but nonetheless it is thoroughly and effortlessly unified in its composition of colors and rhythmic touches. As he did in some other works of this period, Renoir painted over a smooth, glossy white ground to achieve the greatest transparency and glow from his colors and to obtain the least resistance to his washlike technique. The paint is exceptionally thin and fluid, applied in loose, deft, and flexible strokes with no apparent revisions. A few passages, like the dark foliage at lower right and center, are more opaque and impastoed to accentuate some significant lines and junctures in the composition. In others, the paint has nearly been rubbed away, leaving only a delicate, tinted film onto which spare touches of contrasting color have been worked.

Drawing in the traditional sense is virtually abandoned. Contours are dissolved and features suggested through shifts in color and modulations in touch. A premium is placed on ceaseless, unimpeded flow. The landscape falls away from a high vantage, the road winds back, and the terrain undulates in sinuously curving movements. The overall rhythm is shaped by broad, arcing patches of tone and is punctuated by subtly stressed nodes, but is not arrested by any fixed or stable focuses. By widely accepted contemporary standards, the composition borders on formlessness and incoherence.

The color organization is tightly knit, with a limited range of generally cool, contrasting hues varied and repeated throughout and, in places, inflected or modified by thin washes applied over them. The chromatic scheme is striking and artificial, invented perhaps to suggest the colors of twilight, but conveying a sumptuous richness and pulsating luminosity. The translucent, glowing color and fluid, animated touch evoke the effect of an ethereal light filling the landscape and express the essential vitality of nature.

Oil on canvas, 31¾ × 39⅜ inches (80.6 × 100 cm)

The Toledo Museum of Art 57.33

Gift of Edward Drummond Libbey

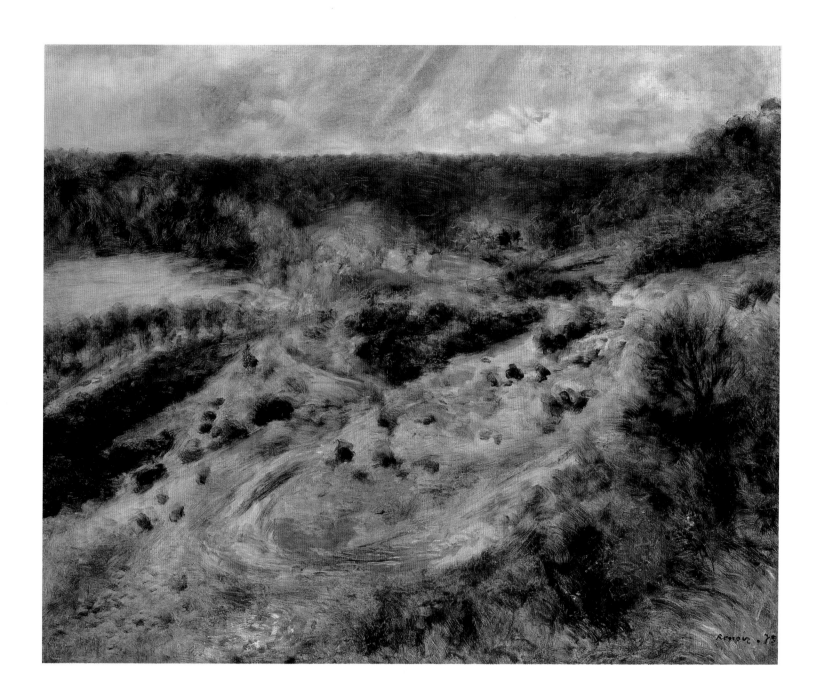

73

Piazza San Marco, Venice

1881

Until 1881 Renoir had never gone far from Paris, but that year he travelled first to North Africa and then, in late October, to Italy. His success with portrait commissions, combined with recent large purchases by Durand-Ruel, gave him a new feeling of prosperity and allowed him to travel. He went in order to get away from his problems with patrons, portrait commissions, and exhibitions, but also to reassess and renew his art. His two journeys were, by 1881, conventional ones, following Delacroix to Algiers and Ingres to Italy. The artists and destinations represented opposing traditions in French art, both equally valued by Renoir at that time. Although only four years earlier he had scorned such a pilgrimage to Italy to study Raphael and the classical tradition, it now had a new relevance for the classicizing direction in which his art was moving, above all in his commissioned portraits and Salon figure paintings.

His first stop in Italy was Venice, where he arrived in late October and stayed on into early November. He had gone to see the sights and to look at Venetian painting, Veronese in particular. But it was also a working trip during which he painted views of famous sites, hackneyed subjects for which he could find ready clients in Paris. In letters from Venice to friends and patrons in Paris, he self-consciously mocked his conventional choice of subjects and expressed his uncertainty about his real goals in being in Italy. To Mme Georges Charpentier he wrote:

The fever to see the Raphaels has taken me. . . . Now I will be able to respond directly, yes sir, I have seen the Raphaels. I have seen Venice, Venice the beautiful, etc., etc. . . . San Marco stunning, the Doge's Palace, everything stunning. I prefer Saint Germain Lauxerrois [the last a Paris landmark and a sly and flattering allusion to the former location of his patron's Paris residence.]

He continued in this sarcastic vein to another patron, Charles Deudon: "I'm sending two rotten studies back to Paris. . . . Tell me if it reminds you of Venice. I did the Doge's Palace as seen from San Giorgio across the canal, it had never been done before, I think. We were at least six in line."

The two paintings mentioned to Deudon were finished in Venice and shipped back for sale to Durand-Ruel. Other canvases were brought back to Renoir's Paris studio for necessary elaboration and retouching, among them this view of the Piazza San Marco. Unlike most of the rest, it was left in the state of a rough sketch. Although it was the largest landscape he painted in Italy, Renoir may indeed never have intended to finish it. In a letter from Venice of November 1, 1881, to his friend and patron Paul Bérard (see no. 72), he is probably speaking of this picture when he remarks that he will bring back "'for information' a study where I've piled chrome yellow on top of bright yellow. You'll see how bad it is." When he included it (with the title *La Place*

Saint-Marc) in his large retrospective at the Galerie Durand-Ruel in 1892, it was described in the catalogue introduction as an *ébauche*, a first stage to be worked up into a finished painting.

Even as he was searching for confirmation and support for his recent classicizing tendencies, Renoir extended his commitment to the rapid *plein-air* color sketch. The canvas is loosely covered with bold, slashing touches of bright, contrasting, comparatively unmixed color in an approximation of the general features and effect. Changes in the shape and direction of the strokes suggest the forms of the architecture, pattern of the pavement, sparkle of light, movement of the sky, and thrust of the perspective recession. The handling is, however, devoid of detail and of small, local differences of color. The people passing in the square and the pigeons fluttering about are summarized in broken dabs and dashes, recalling Monet's treatment of figures in his Paris views of 1873 (see no. 49). The insistent rhythms and close harmony of colors draw the composition together and focus on the façade and domes of San Marco gleaming in the sunlight. As trite as the subject had become through endless, often vulgar images, Renoir's response was surprisingly personal and exploratory, a brilliant evocation of this extraordinary place.

Like many of his freest sketches, this painting appears not to have been sold through a dealer, but went directly from Renoir to the journalist, critic, and novelist Robert de Bonnières in the later 1880s. In 1912 it was one of several works given anonymously to the Munich Staatsgalerie in memory of Hugo von Tschudi, a courageous museum director and proponent of modern art. After World War II the Staatsgalerie exchanged the picture with an American dealer.

Oil on canvas, 25¾ × 32 inches (65.4 × 81.3 cm)

The Minneapolis Institute of Arts 51.19

The John R. Van Derlip Fund

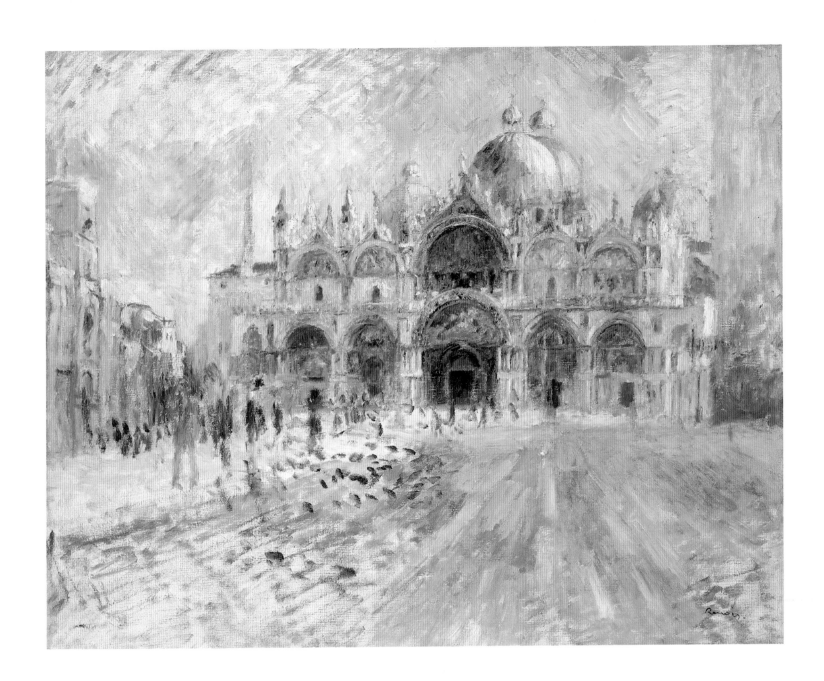

74

Paul Haviland, born June 17, 1880, was only three or four when he was painted by Renoir. His portrait was commissioned by his parents, Charles Haviland, co-owner and director of the Haviland et Cie porcelain works at Limoges, and Madeleine Burty, daughter of the well-respected critic and supporter of the Impressionists, Philippe Burty. Charles Haviland and Renoir had numerous mutual friends and acquaintances in the art world, and Renoir shared Haviland's professional interest, since his first job had been painting porcelain. They may only have met around 1884, when Haviland was already collecting Japanese objects and prints and older nineteenth-century French painting. He had recently bought a number of works by Degas and, by the time he commissioned this portrait, may possibly have just begun to acquire some of Renoir's paintings.

Between about 1875 and 1885 Renoir produced many commissioned portraits of children. They were an important source of his reputation and income during those years. However, he became dissatisfied with the seemingly constant demand for them and often complained of painting too many. About the time he did Paul Haviland's, he remarked in disgruntlement to a young protégé that if "it's a portrait, it's necessary for a mother to recognize her daughter." Portraits tended to give him a good deal of trouble, in this one the extensive surface crackle in the background and clothes suggesting that its simplicity was hard won. In an effort, no doubt, to please, his portraits of children typically lack much specificity of either personality or physiognomy, providing instead a generalized image of prettiness and innocence.

Paul Haviland's portrait was painted at a time when Renoir, reacting to what he perceived as his earlier tendencies toward imprecision and formlessness, had replaced his free and sketchy technique with an emphasis on distinct contours and firmness of form. This return to a species of classicism, undertaken since the later 1870s and affirmed by his recent trip to Italy (see no. 73), is manifested here in his reconsideration of the conventions of Neoclassical portraiture, those of Ingres in particular. After visiting Rome, he had written to his dealer Paul Durand-Ruel in November 1881 of his admiration for the great beauty of Raphael's frescoes, but went on to remark, "I prefer Ingres in oil paintings." This portrait recalls Ingres in the stable, formal pose; clear studio light with its conventional focus on face, upper torso, and hands; restrained, essentially local, color; and shallow modelling. He lays great stress on linear patterns and rhythms in the crisp drawing of the facial features, the flowing curves of the white piping of the boy's sailor suit, and the abstract contours of the body—in an arc along the back, parallel to the table leg at right, and straight slopes along the shoulders.

The brushwork is smooth and polished in the face and somewhat softer and freer elsewhere, although still tending toward dryness. In an effort to achieve a more structured paint surface, Renoir treated the background as well as patches of the costume and hair in loose, parallel hatches reminiscent of Cézanne. The two artists were especially close at this moment, painting together in 1882, 1883, and again in 1885, and this element of Renoir's handling may reflect the lessons of Cézanne (see no. 10). As in his other works of this period, Renoir was aiming for a greater control of his forms and a tauter pictorial organization, but here still sought to convey the refined and delicate sweetness of youth.

Oil on canvas, 22⅝ × 17 inches (57.5 × 43.2 cm)
The Nelson-Atkins Museum of Art 55-41
Nelson Fund

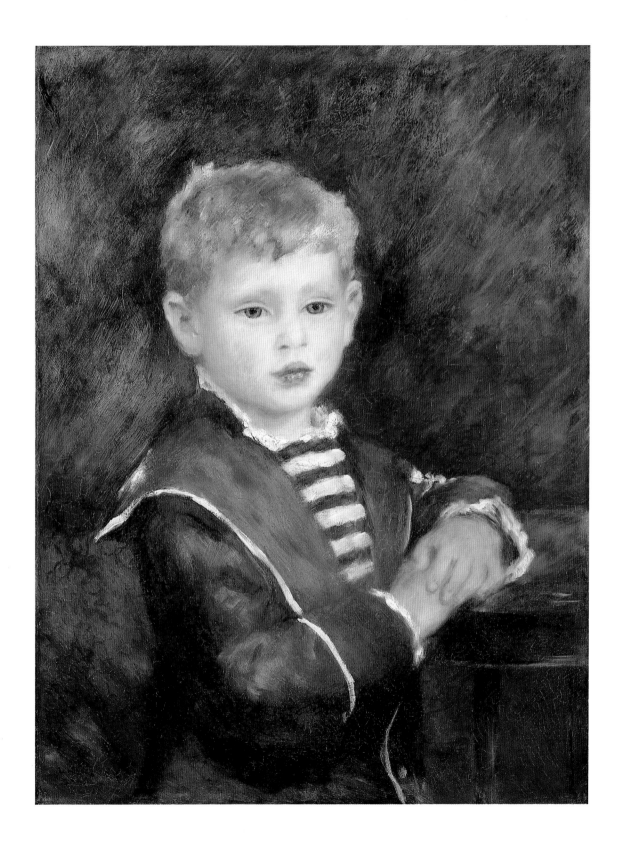

During the early 1880s Seurat treated subjects of modern Paris in small oil sketches and crayon drawings. In 1883 he undertook a large painting of a suburban figure subject for the following year's Salon, a work that in its scale and ambitions was clearly designed to make his reputation. The two-by-three-meter canvas was completed by March 1884 and submitted to the Salon jury, but was rejected and presented instead in May in the only exhibition of the just-formed Groupe des Artistes Indépendants with the title *Une Baignade, Asnières* (*A Bathing Place, Asnières*) (London, National Gallery). The Nelson-Atkins panel is one of the group of studies for that canvas.

In the large painting and its studies, Seurat depicted a view along the left bank of the Seine at Asnières toward the railroad bridge and the factories of Clichy. He featured young men relaxing and swimming in front of factories, a subject of working-class leisure amid a suburban industrial landscape. Recreation had been a familiar theme in Impressionist art, but what had attracted the artists was the leisure of the middle classes and its specific character, activities, and locations.

By the 1880s themes from the industrial suburbs had become relatively common, especially in Naturalist literature (see no. 34). This was, at least in part, a response to the increasingly rapid growth and industrialization of the suburbs in recent years. In the early 1880s these changes were a frequent subject of debate involving questions about the city and the suburbs, about the working classes and the conditions of their lives, about work and leisure. In *A Bathing Place, Asnières*, Seurat engaged such issues, even as he seemed to refrain from direct social comment.

If the subject was topical, Seurat's procedures in developing his composition were essentially traditional. Before beginning work on the large canvas, he did a great many studies during the second half of 1883: some oil sketches, which he called *croquetons* (little sketches), done on wooden cigar-box lids, and some Conté crayon drawings. Of the fourteen surviving oil sketches, the majority appear to have been quickly executed outdoors. A few of the sketches, including this panel, seem to have been done in the studio as a composite of earlier studies and a rehearsal of Seurat's ideas. In them, he refined the poses of the figures and their relationship with their surroundings and set the basic color scheme and the rhythmic patterns of brushwork.

Seurat's long and elaborate procedures in developing his composition seemed antithetical to the Impressionists' apparent emphasis on direct and immediate response to visual sensations. Nevertheless, he learned much from Impressionist color and handling. In 1883 his work gave evidence that he was looking closely at Monet, and most likely at Renoir and Pissarro as well. As a result, he gradually abandoned earth colors, although he continued to paint his sketches directly onto the reddish brown of the wooden panels. In his studies for *A Bathing Place, Asnières*, the impact of Impressionism is apparent in the light and varied hues dispersed fairly evenly to create an overall colored luminosity. Through color, he re-created particular effects of light and atmosphere, but also, through repetitions and variations of a few principal hues, established pictorial unity and harmony.

In brushwork and composition, this small panel, like the other studies, recalls Monet's and Sisley's riverside scenes of the 1870s in the broken and freely applied touches, and Pissarro's recent peasant images (see no. 64) in the harmonious interplay between figures and their setting. But in Seurat, the handling is tauter, more even and orderly; the natural features and textures are simplified; the figures are less complicated in pose and view; and the composition is more formal and regular. Like many of the first generation of Impressionists, Seurat appears to question the earlier stress on spontaneity and immediacy (see nos. 52, 64, and 74), but he goes further in submitting Impressionism to a rigorous discipline and sense of order. He imposed on his figures strict contours, regularity of forms, and careful tonal modelling, and stripped them of casual and anecdotal features. The figures and setting are locked together in a sequence of intersections, echoes, and alignments, taking up the crisp lines of the trees, factories, bridges, riverbanks, and inlets in the limbs, torsos, shadows, and discarded clothing of the figures. In spite of these compositional links, there is no feeling of continuity or connection between the figures, and each remains utterly isolated and self-absorbed. Seurat may have endowed his image of working-class leisure with a sense of harmony and equilibrium, but in the end his meaning may remain remote and elusively poetic.

Oil on wood panel, 6⅞ × 10⅜ inches (17.5 × 26.3 cm)
The Nelson-Atkins Museum of Art 33-15/3
Nelson Fund

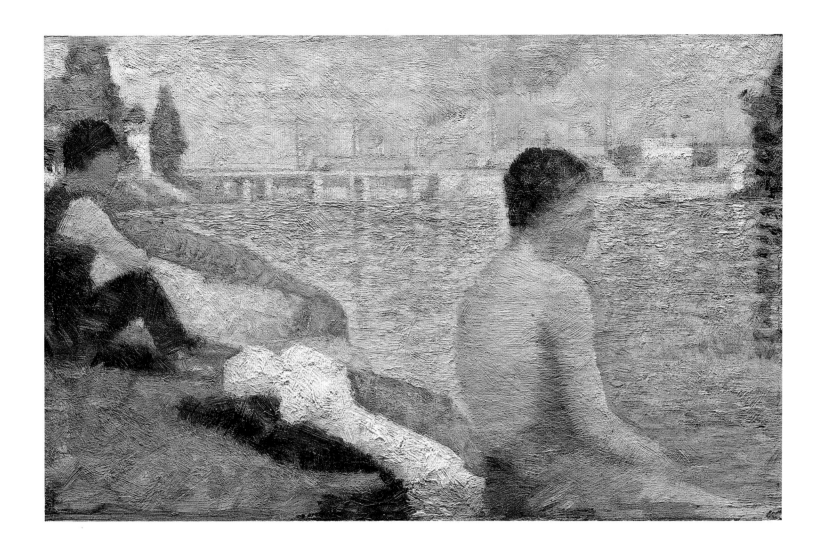

76 *Port-en-Bessin (The Bridge and the Quays)*
1888

77 *Port-en-Bessin (The Outer Harbor, Low Tide)*
1888

Although Seurat is probably most noted for his large figure paintings of modern-life subjects, his landscapes constitute a significant portion of his finished canvases, and they were often more easily appreciated by the public and critics during his lifetime. From 1885 until his death in 1891, he regularly devoted his winters to major figure compositions and his summers to landscape campaigns along the Channel coast. He told the critic Emile Verhaeren that he worked at the coast in summer "to cleanse his eyes of the days spent in the studio and to translate as exactly as possible the luminosity of the open air, with all its nuances." The motifs he chose and the pictures he did there are consistent with the tradition of outdoor painting along the Channel coast established in the works of Boudin, Jongkind, Monet, and others (see nos. 5, 7, 41, 47, 48, and 72).

In the summer of 1888 Seurat visited Port-en-Bessin, a small fishing port on the Normandy coast near Bayeux. He remained there from August until late October, a slightly longer stay than was usual for him. Port-en-Bessin was a rather ordinary and unpicturesque port with no historic architecture and little in the way of splendid vistas. The town was set into a break in the cliffs at the outlet of a small river and had an outer harbor formed by two long breakwaters, an inner harbor, and an open, ironwork fishmarket (visible in the Minneapolis painting) on one of the piers. Seurat did six paintings of the site, each markedly different in angle, direction, and aspect of view, which cumulatively provide a sort of survey of the small harbor and its immediate surroundings. The Minneapolis canvas depicts a view to the west along the harbor-front quays, with the channel to the inner harbor and the bridge across it in the foreground. In the Saint Louis canvas, the view is from one of the long breakwaters back across the outer harbor toward the inner harbor at low tide. In two of the six paintings, there are sailboats passing through the harbor, but in all of them, activity is sparse or absent altogether, and a sense of solitude and stillness prevails.

Seurat seems to have been quite taken with the complex and tight-knit interrelationships among the water, quays, jetties, houses, and hills, but was not greatly interested in the life of the local population. The Minneapolis painting is the exception, and is the only one among all his coast landscapes in which he attempted an inhabited scene. He represented a few types, but he seems to have deployed them only tentatively and without much concern for the social conditions of their lives (see no. 75).

For his seaside landscapes, Seurat usually followed a somewhat orthodox procedure. He made small oil sketches or crayon drawings and did some work on the canvases in front of the motif, but completed them in his Paris studio. At Port-en-Bessin, however, he departed from his usual practice for the first time and did no preliminary studies, but instead began directly on the canvases. He probably did a considerable amount of work at the site, but still had much left to do in his Paris studio to elaborate, refine, and finish the paintings for exhibition. This process seems to have taken him through the autumn and part of the winter, and it appears that as a result he produced no large figure composition that winter, although there is also no evidence that he had had any such plans. His ensemble of summer landscapes thus acquired something of the status of one of his major figure paintings.

At least five of the six Port-en-Bessin paintings, including both the Minneapolis and Saint Louis ones, were ready by February 1889 when he sent them to Brussels for the annual exhibition of the avant-garde Belgian group Les XX with whom he had shown once before. He exhibited the Minneapolis picture again, this time in Paris, in September 1889 in the Salon des Indépendants. It was his sole Port-en-Bessin painting in the exhibition and was seen with the only two landscapes he had done during his campaign of the summer of 1889. The Minneapolis painting was coolly received by the critic Félix Fénéon, who until then had been Seurat's staunch advocate and prime interpreter. Fénéon wrote, somewhat less abstrusely than usual:

One might wish the figures walking along the Port-en-Bessin quay to be a bit less ankylotic [stiff]: if the stray "baby" has a charming and accurate look, the [undefined] customs officer and the woman carrying firewood or seaweed are improbable; we have known the customs officer for two years now: he was the stage-manager of the *Parade* by the same Monsieur Seurat.

He showed the other five Port-en-Bessin paintings, including the Saint Louis one, in March 1890 at the Salon des Indépendants, along with his two most recent figure compositions completed that winter. At this time, the Saint Louis painting was catalogued as belonging to a M. de la Haut. It was the only one of the six to leave Seurat's hands during

his lifetime and for that reason the only one that did not have a painted border subsequently added over the edges of the composition by the artist, a practice he seems to have begun in 1889.

As reported by Verhaeren in 1891, Seurat stated that his aim in his landscape paintings was "to translate as exactly as possible the luminosity of the open air, with all its nuances." And Fénéon in 1886 likewise presented the goal of his art and that of the other Neo-Impressionists as the accurate translation into paint of the effects of light and color in nature, a goal obviously similar to that of the Impressionists. In such paintings as these of Port-en-Bessin, Seurat conveyed his scrupulous attention to his sensations and, through his extremely subtle control of color and touch, re-created the shimmer and vibration of light and atmosphere in the landscape. Although owing a great debt to Monet and Pissarro in his color and handling (as Fénéon recognized in 1886 in naming the new movement Neo-Impressionism), Seurat forcefully repudiated Impressionism's look of spontaneity and improvisation, its appearance of directly responding to the transitory in nature, its sense of providing a fleeting glimpse of space and time, and its stress on individuality and temperament in execution. The artist and his allies sometimes lauded his endeavor as more rational, disciplined, objective, complete, and thus more truthful than Impressionism's. But the sheer artfulness, calculation, arbitrariness, and antinaturalism of his means—his color, touch, drawing, and design—and of his effects may suggest that his purpose was as much if not more to express things beyond phenomenal effects and visual appearances and to obtain something more than pictorial harmony and coherence. His art originates and remains rooted in observation, but, like van Gogh's and Gauguin's, it seems to strip away the superficial and fortuitous to discover the essential and immutable within nature.

By 1887 Seurat's painting had begun to be interpreted in the context of Symbolist ideas. In 1887 the Symbolist poet and critic Gustave Kahn, a friend and supporter of Seurat, observed that in Impressionism "nature is in a permanent convulsion . . . [the Neo-Impressionists] chose calm landscapes, less troubled waters, and tried to convey a more permanent image of the landscape rather than its momentary appearance. . . . They suppressed indifferent rhythms and aimed at synthetic creation." Fénéon in that same year was somewhat more direct in his characterization of Neo-Impressionism in Symbolist terms. He saw their aim as "to synthesize a landscape in a definitive aspect which perpetuates the sensation [it produces]. . . . For them, objective reality is a simple theme for the creation of a superior and sublimated reality in which their personality is transfused." Fénéon spelled out the connection between Symbolist literature and Neo-Impressionist painting in 1889: "M. Gustave Kahn and M. Paul Adam, striving to convert the everyday into a logical dream, cautious about more complex rhythms, concerned for precise and efficient means of expression, saw analogies with their own researches in the work of the Neo-Impressionists." And Kahn himself remarked in 1891, after Seurat's death, on "his truly pictorial and artistic search for the symbol (without worrying about the word), in the interpretation of the subject and not in the subject itself." In the utter calm and preternatural order that Seurat extracted from these landscapes, he made the mundane and ephemeral convey eternal essences and express a strange and enigmatic poetry.

76

Oil on canvas, 26⅜ × 33³⁄₁₆ inches (67 × 84.3 cm)
The Minneapolis Institute of Arts 55.38
The William Hood Dunwoody Fund

77

Oil on canvas, 21⅛ × 25⅞ inches (53.7 × 65.8 cm)
The Saint Louis Art Museum 4:1934
Purchase

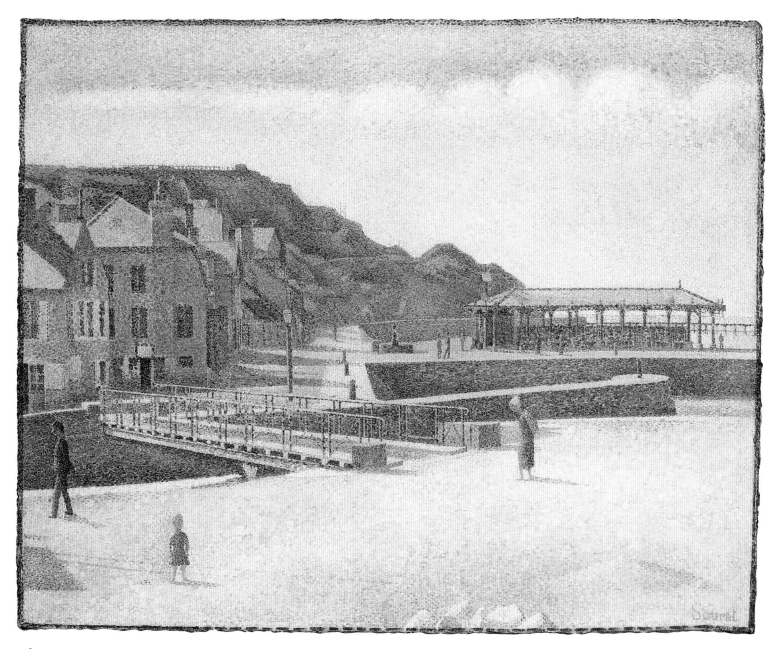

76

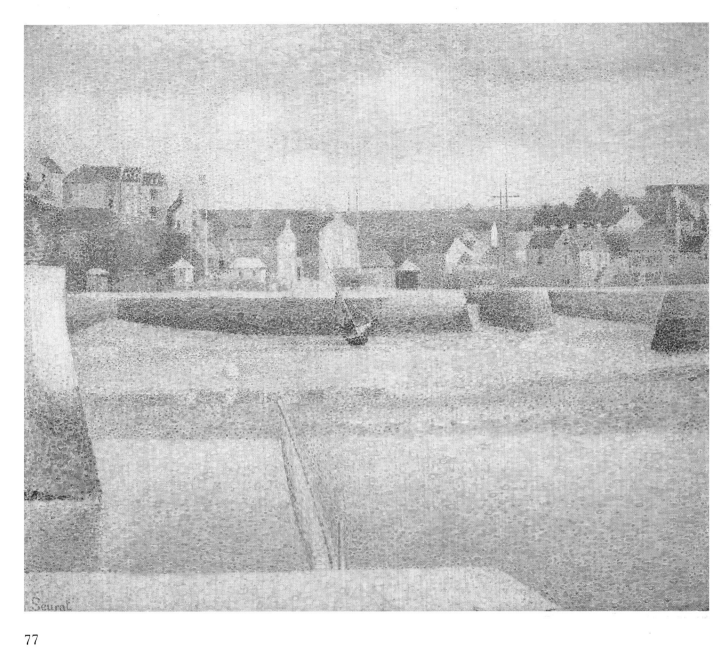

77

78

Boulevard de Clichy, Snow
1886

Signac was mostly self-taught as an artist and, in his early painting, was guided by Impressionism. Until about 1885 he served a kind of apprenticeship to Monet, and, to a lesser extent, to Guillaumin, Renoir, and Pissarro as well, producing Impressionist-type landscapes with free brushwork and strong, broken color. He had met Seurat in 1884 and by late 1885 had begun a process of regularizing his touch and systematizing his color following Seurat's example. Like Seurat, his aim was to translate accurately and objectively the effects of light, color, and atmosphere in nature, while giving as organized and coherent an account of his sensations as possible.

Boulevard de Clichy, Snow was one of the earliest paintings in which Signac made extensive use of the dot—first widely used by Seurat in his reworking of the *Grande Jatte* during the winter of 1885–86—as a fundamental component of his technique. In the list he kept of his works, Signac recorded this painting as number 128, the second item for the year 1886, and, in an exhibition the following year, specified the date further as January. He first presented it in May 1886 in the eighth Impressionist exhibition with the title *Snow, Boulevard Clichy*. Signac and Seurat were brought into this last of the Impressionist group exhibitions by Pissarro, who had begun to assimilate the new style of his younger colleagues, and their presence was one of the many causes of dissension in the group that year. Signac displayed both works that he had done in the previous two years showing a clear debt to Impressionism and examples of his recent researches into divided touch and color.

The motif is the boulevard de Clichy in snow seen from the place Blanche; at near right is the striped stonework of a guard post, a spot not far from Signac's studio. The type of subject was not new and already had become fairly common in pictures by Renoir, Pissarro, and Monet (see nos. 49 and 50) as well as in the more fashionable Impressionist-derived art of Boldini, Béraud, Goeneutte, and de Nittis. A likely source of inspiration could have been a pastel by Pissarro that had been shown in the 1881 Impressionist exhibition. Pissarro depicted a different stretch of the boulevard de Clichy, again covered in snow but now sunny, with scattered pedestrians and vehicles. Pissarro's view is slightly raised and looks nearly straight back along the center island, but Signac could have found in it a model for his distanced and objective image of routine urban happenings on a snowy day rendered in delicately broken touches and bright, clear, luminous tones.

As indebted to Pissarro's and Monet's work of the early 1880s as Signac may still have been, he, more evidently than had they, was seeking more measured, calculated, and ordered qualities in his art. His brushwork, in its scale and regularity, appears more disciplined and rationalized, even if its debt to Impressionist handling is still evident.

His technique is mixed, with dots and dashes for the snow; large crisscross strokes for the sky; broad, flat patches for the buildings and pavements; and long, dragged touches in the trees, all loosely covered with an overlay of dots of varying sizes and shapes. The falling snow, shimmering light, and angular filigree of trunks and branches presented Signac with suitable challenges for his recently evolved technique. He adapted his brushwork in a given area to the description of the local features and effects, but also used it to create a mobile and integrated surface for his painting.

With these small, controlled touches, Signac began to interweave contrasting, often complementary colors into his compositions, probably following Seurat's lead. He responded to scientific and quasi-scientific ideas about light and color in nature and in painting, and in *Boulevard de Clichy, Snow* tentatively developed the opposition of complementary hues, especially blue and orange-red in the guard post and adjacent tree at right and, to a lesser extent, scattered across the buildings and pavements. He did not, however, deploy color systematically; rather, he used it primarily, as the Impressionists did, to express light and shade, to describe features, and to furnish vivid and enlivening contrasts with the predominant tones.

His efforts were appreciated by the Symbolist writer Paul Adam when he saw this and other new works by Signac in the 1886 Impressionist exhibition: "Still very young, Signac possesses admirable tone: a sense of Parisianism, but a Parisianism that avoids caricature and ugliness." Indeed, in representing city streets softened and transformed by snow, Signac imparted to the prosaic scene a dreamlike veil and delicately poetic effect.

Oil on canvas, 18⁵⁄₁₆ × 25¹³⁄₁₆ inches (46.5 × 65.6 cm)

The Minneapolis Institute of Arts 61.36.16

Bequest of Putnam Dana McMillan

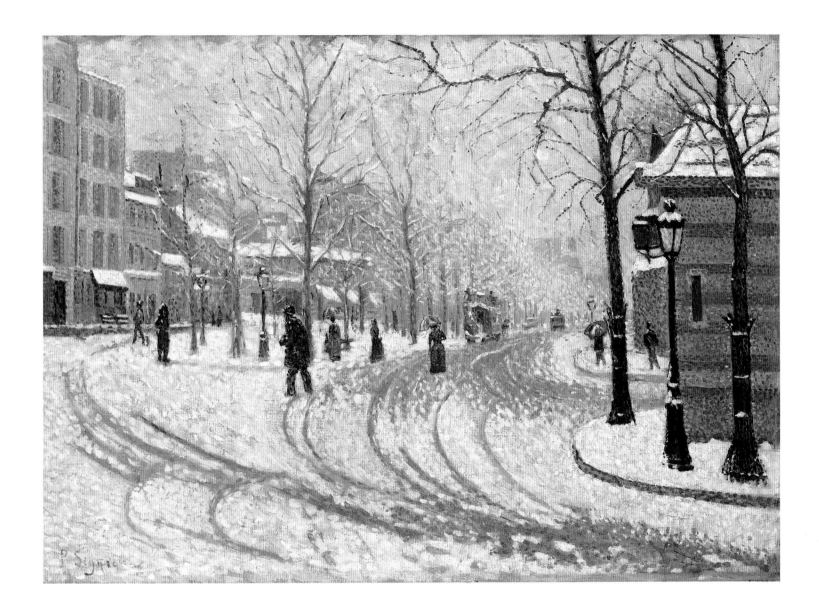

79

Château Gaillard, Seen from the Artist's Window, Petit Andely
1886

Even before the close of the 1886 Impressionist exhibition in which a number of his works were on view (see no. 78), Signac left Paris on June 14 for Petit Andely, a small village on the Seine between Paris and Rouen. He went there with Lucien Pissarro (Camille Pissarro's son), a close friend of the same age and fellow Neo-Impressionist. Pissarro returned home in July, while Signac stayed on into September. During his first two months at Petit Andely, Signac completed three landscapes and worked on four more during the last month or so he was there. He exhibited the first three in Paris in the second Salon des Indépendants, which opened on August 21, among them one titled in the catalogue *The Château Gaillard, Seen from My Window. —Petit Andely.—June–July 1886.* All three were finished at the site and most likely executed wholly or principally from the motif. In them, he worked in direct response to the light, color, features, and textures of the landscape, while seeking to regulate and order his sensations and to unify and harmonize his compositions.

At Petit Andely Signac concentrated on a variety of motifs along the Seine. In the Nelson-Atkins painting, however, he turned away from the river and focused on the Château Gaillard, the area's most noteworthy monument. The Château Gaillard, a ruined fortress perched high on chalk cliffs above the Seine, had been built by Richard the Lion-Hearted in the twelfth century and was linked with many historical events. Quite well known, it was often described in guidebooks and depicted in topographic albums. Signac's image is of a type relatively new to painting: it represents the famous ruins but emphasizes the contemporary and ordinary aspect of the scene by juxtaposing it with the modern villas and low trees of the town below.

His idea of showing a historic monument as part of an everyday landscape probably had its roots in photographs and tourist prints, but also served to visualize the theme of landscape contrasts favored by Signac and other Neo-Impressionists during these years (see nos. 34 and 75). Here the composition seems to have been designed to point up the opposition between medieval ruins and modern constructions, the old and the new, military and domestic, picturesque and practical, extraordinary and typical. He compressed space and elided distances: like the Impressionists, he thus conveyed the odd but characteristic ways in which the world is seen and experienced, but also depicted the abrupt contrasts in the landscape.

Signac's attraction to the subject may have been a question of theme or only one of convenience, since it was the view out his window. However, it also offered, in the motif of the screen of trees recalling Camille Pissarro (see no. 63), a formidable challenge to his eye and his hand and to what his new technique was capable of rendering. His brushwork here is more uniform and fine-grained than in earlier paintings of that same year, if still mixed and in many places descriptive, and the color more varied and divided. If local colors are still emphasized, they are, loosely following theory, modified and inflected by the action of sunlight with, in the shadows especially, more elaborate play of complementary contrasts induced by the optical reactions to a given color. A decade later Signac recalled his early Neo-Impressionist canvases of 1886 as being painted "solely with pure tints, divided and balanced, and mixing optically, following a rational method." In actual practice, his method was not entirely rational but, in good measure, based on subjective response and pictorial harmony. In works such as this one, the optical mixture of divided hues fails to take place at a normal viewing distance (defined by Camille Pissarro at this time as three times the diagonal measure of a canvas), and the rich weave of colors produces instead effects of luminous vibration and scintillation.

Félix Fénéon, chief critical interpreter and peculiarly eloquent advocate of Neo-Impressionism—which he had recently named—twice in 1886 singled out Signac's Petit Andely paintings for praise. He observed that "the polychrome verve of M. Signac heightens the uproar of his new canvases, landscapes of les Andelys," and enthused that, of his works to date, they were "the most luminous and most complete. In them, colors are provoked to frantic chromatic scalings, they exult, they shout . . . beneath a sun that fans into flames some high-roosted ruins,—*Château-Gaillard from My Window.*"

Oil on canvas, 17¹¹⁄₁₆ × 25⁹⁄₁₆ inches (45 × 65 cm)

The Nelson-Atkins Museum of Art F78-13

Acquired through the generosity of an anonymous donor

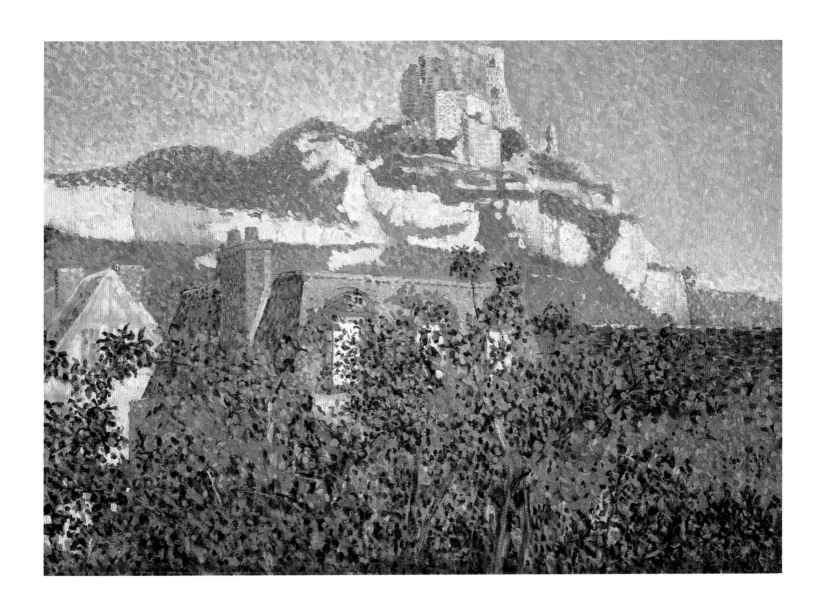

Paul Signac
1863–1935

Place des Lices, Saint-Tropez
1893

In the spring of 1892 Signac discovered Saint-Tropez, then a quiet and isolated little fishing port on the Mediterranean coast. He had spent time in the region twice during the summers of 1887 and 1889, but this time decided to settle there. He did this in part to indulge his passion for sailing, in part to withdraw from Paris life, of which he had wearied. At Saint-Tropez he was struck by the luxuriant vegetation of the area, most especially by the majestic trees, which he often featured in paintings from his arrival until about 1900. He exhibited the Carnegie canvas, along with other early works of Saint-Tropez, with the simple title *Les Platanes* (The Plane Trees) in February 1894 in Brussels at La Libre Esthétique, the successor to the Belgian modernist group, Les XX.

Although Signac painted it in the summer of 1893, it was almost certainly executed completely in his studio. From about 1892 he abandoned the practice of working on his finished canvases largely or entirely from nature, producing them instead from information he collected in small oil sketches or notations in pencil or watercolor, even, at times, with assistance from written notes. He wrote of this change to his friend and fellow Neo-Impressionist H.-E. Cross in 1892: "I shall no longer worry about nature. It is very difficult to paint properly from nature, where one is distracted by its harmonies, by the slightest reflection, the least change of effect." He seems to have grown tired of his earlier goal of accuracy and objectivity in translating his visual sensations. As Félix Fénéon recognized in 1890, what he was seeking instead was "to create exemplary specimens of an art of great decorative development, which sacrifices anecdote to arabesque, nomenclature to synthesis, fugitive to permanent, and confers upon Nature, which finally grew tired of its precarious reality, an authentic Reality."

Signac changed his painting practices at a time when his style was becoming increasingly decorative and distant from natural appearances. In *Place des Lices* he strengthened his color and fortified and extended the play of complementary contrasts. His treatment of color was freer, more exaggerated and artificial than before, and was determined less by theory, analysis, or observation than by harmony and beauty of effect. He wrote in his journal on August 23, 1894, "Nowadays, I am content to say: I paint like this because it is the technique that seems to me best suited to produce the most harmonious, the most luminous, the most colorful result . . . and because I like it this way."

In his approach to natural motifs, Signac felt free to rearrange and invent in order to create ornamental patterns and linear rhythms. He treated the trees, foliage, filtered light, and dappled shade of the square in swaying and swirling arabesques geared far more to decoration than to description. In its glowing colors, sinuous rhythms, and decorative effects, Signac's vision of the Mediterranean landscape has parallels with Monet's pictures of Antibes (no. 53), but Signac's is much more arbitrary and stylized; it more willfully sacrifices natural appearance to pictorial harmony and emotional expression.

From the late 1880s the essential antinaturalism of Signac and Neo-Impressionism often was viewed by artists as well as writers as an expression of the musical tendencies of modern painting. Signac himself, as well as sympathetic Symbolist critics, discerned analogies between light waves and sound waves, pictorial harmonies and musical harmonies, and thus between painting and music. From 1887 until about 1894 Signac even designated his finished paintings by opus numbers in the manner of musical compositions, as he did here in the Carnegie canvas by inscribing it "Op. 242." Through such analogies, Signac expressed his desire that his paintings might attain the pure and unfettered expressivity of music; beauty, emotion, and meaning would be conveyed by linear rhythms and chromatic harmonies. But if the effect of *Place des Lices* is determined by its "curves and arabesques . . . tints and tones," as Signac later put it, its mood of solitude and tranquillity is equally conveyed by the represented subject (one that recalls his friend van Gogh's works), a small figure sheltered beneath the arching canopy of the plane trees. In his journal on September 15, 1898, Signac wrote that his aim in such images was to try "to convey through beautiful lines and beautiful colors the emotion which, at a given moment, [one] has experienced before a beautiful view of nature."

Oil on canvas, 25¾ × 32³⁄₁₆ inches (65.4 × 81.8 cm)

The Carnegie Museum of Art 66.24.2

Acquired through the generosity of the Sarah Mellon Scaife family

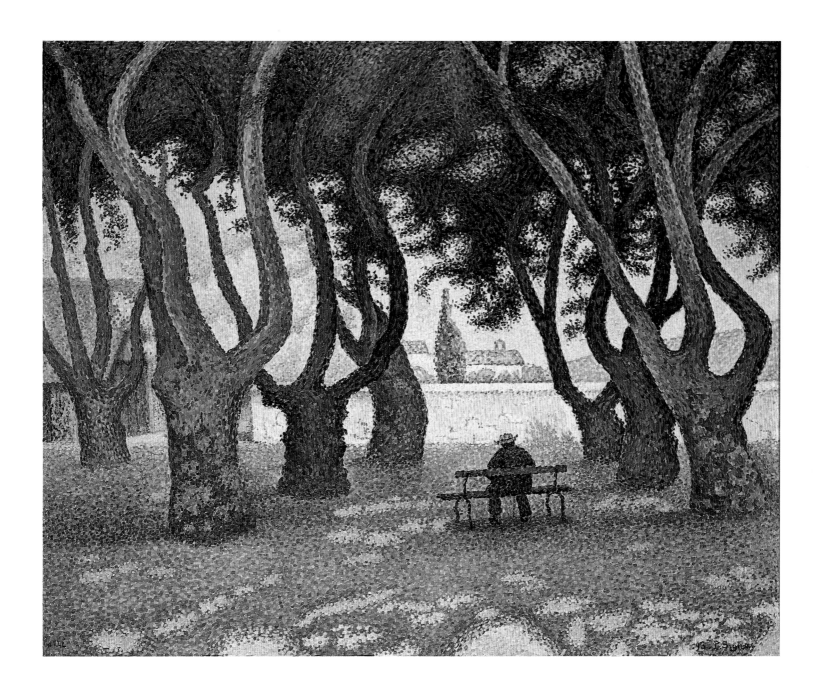

81 *Entrance to the Grand Canal, Venice*

1905

Signac was a passionate yachtsman and, from the late 1890s, made a series of sailing trips to the harbors and cities of the Mediterranean and northern Europe. Over the years he visited Marseilles, Genoa, Rotterdam, and Constantinople and returned to his villa in Saint-Tropez to do paintings of these places. In May 1904 he sailed to Venice for the first time, a trip no doubt partially stimulated by his enthusiasm for Ruskin's writings and Turner's paintings. That any artist or any sailor should seek out Venice, however, is no surprise. The city had long enjoyed artistic immortality through the works of Canaletto, Guardi, Turner, and Whistler, among others, and had attracted such artists as Manet, Monet, Boudin, and Renoir (see no. 73).

For his watercolors and oils Signac chose popular tourist views, the standard and hackneyed motifs depicted by almost every artist to visit Venice, but for which there was always a ready audience and healthy market. The Toledo painting shows the view from the Piazzetta near the Doge's Palace looking past moored gondolas toward the Dogana di Mare, Santa Maria della Salute, and the Grand Canal, a view that, as Renoir had joked in 1881, Signac probably had to stand in line to do. As in most of his landscapes, he displayed little interest in the daily life of the city—here barely defining the gondoliers docking their boats and their passengers disembarking—concentrating instead on the fantastic spectacle of the architecture, boats, water, and sky illuminated by the gaudy light of the late afternoon sun.

Signac showed four paintings of Venice in December 1904 in a solo exhibition, but continued to work on Venetian subjects afterward. He finished and dated the Toledo canvas in 1905, then presented it in his next solo exhibition in 1907 along with six other paintings and seven finished watercolors of the place. Since the early 1890s he had ceased to paint from nature (see no. 80). He executed the Venice paintings in his studio at Saint-Tropez, working from watercolors and drawings done, at least in part, on the spot. These notations furnished him with information about color, layout, and significant details of the motifs. At least one watercolor, dated 1904, relates to the Toledo painting. He explained his practice in 1905 to Matisse, writing, "The quickest method of notation is still the best. It provides you with the most varied information and, at the same time, leaves you free to create afterward." He relied increasingly on memory and imagination, sometimes working entirely without studies from nature. He thus created an art still loosely based on observation, but freely invented and quite distant from immediate experience.

In the Toledo painting and others of this period, Signac purged most lingering elements of naturalism from his art. He broadened and enlarged his brushwork, retaining something of the regularity and homogeneity of the dot while sacrificing its refinement and finesse to achieve stronger effects of color. The square and rectangular touches were applied with great control and deliberation directly onto the white priming. There is little layering or overlapping of the strokes, and most are slightly separated, thus incorporating the white priming directly into the bright tonal scheme. The blocks of color were placed in loose, geometrical alignments, with slight shifts in orientation to describe the boats, architectural features, and other represented forms. When his first Venice paintings were exhibited, the brushwork reminded many critics of mosaic technique. Signac, however, had evolved this handling in the years prior to first seeing the brilliant color effects of medieval mosaics and had shown no signs of any serious interest in the medium before his voyage to Venice.

Well before 1905 Signac's brushstrokes had become far too large to allow any sort of optical mixture of his divided colors at a normal viewing distance. Since 1886 optical mixture had generally been cited as among the main justifications for Neo-Impressionist touch and color. But by 1905 the concept had little relevance to Signac's actual practice. His new brushwork was designed to intensify the effect of his color, which now, like his touch, was bolder, more arbitrary and artificial. He no longer attempted to re-create natural appearance through color, but sought instead to imagine chromatic fantasies equivalent to sunlight that expressed the splendor of the subject. In the Toledo view of Venice, Signac sustained his quest for a precisely balanced pictorial harmony, but one that now also expressed his emotional response to what he saw. He envisioned a fantastic and iridescent landscape, one that, as Gustave Kahn wrote in 1935, "evokes a radiant poetry" and expresses "the enchantment of light."

Oil on canvas, 28¹⁵/₁₆ × 36¼inches (73.5 × 92.1 cm)

The Toledo Museum of Art 52.78

Gift of Edward Drummond Libbey

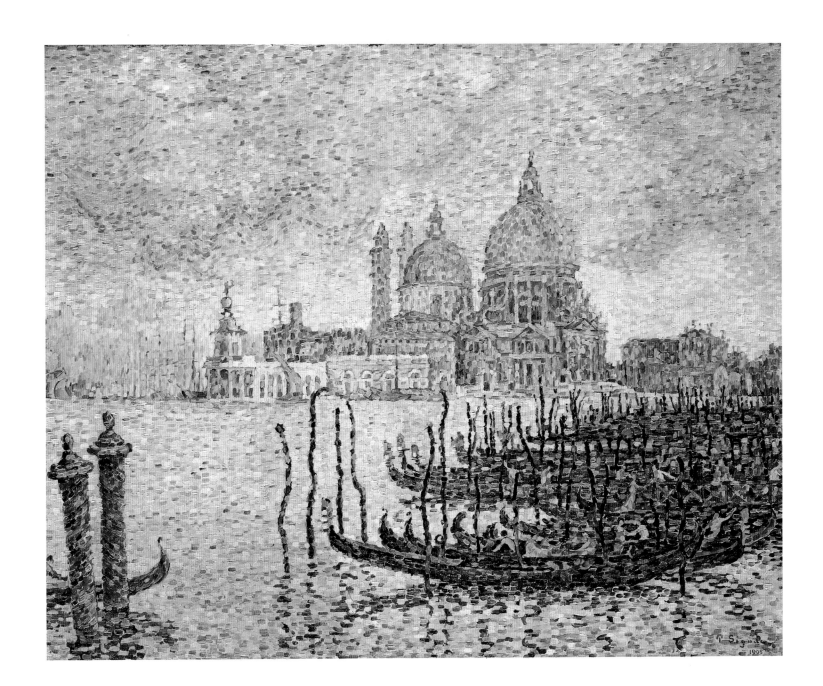

82

The Aqueduct of Marly
1874

Of all the Impressionists, Sisley was the one most completely dedicated to landscape painting. He most often chose to depict rather ordinary aspects of the landscape, and largely avoided crowded pleasure spots, modern constructions, and other signs of the intrusions of modern life into the French countryside. During the years from about 1871 to 1877, when he lived at Louveciennes and Marly-le-Roi, neighboring villages in the country about ten miles west of Paris, he mainly devoted himself to views of the woods, fields, rivers, towns, villages, roads, and paths of the area, much as Pissarro did at Pontoise (see no. 61). But between about 1873 and 1876 he also repeatedly turned to some of the area's most renowned landmarks and historic monuments: the hydraulic machine, the aqueduct, and the pool of Marly.

These were the major remnants of a vast waterworks system built in the late seventeenth century for Louis XIV. The machines pumped water from the Seine at Port-Marly up the steep banks and through the aqueduct (actually located in Louveciennes) to the reservoirs at Louveciennes and the storage pools at Marly. From there, the water fed the extensive fountains and cascades of the royal château at Marly, and was then in turn carried on to the fountains of the royal park at Versailles. The château at Marly was destroyed in the Revolution and, over the years, much of the waterworks system was as well, but the pieces that remained still constituted imposing reminders of what some regarded as the glorious French past.

Although little survived but the château's surrounding park, a single pool, the aqueduct, and the machine, these sights were featured and recommended in guidebooks of the period and were widely depicted in prints and paintings, the aqueduct especially. Pissarro, Monet, and Renoir had worked in and around Louveciennes during the late 1860s and early 1870s, and had all painted the aqueduct glimpsed from afar as a small feature of a wider scene. But they had otherwise avoided the historic aspects that were to attract Sisley only a short time later.

Sisley may have selected these motifs out of a nostalgia for lost grandeur, or in an attempt to appeal to collectors and critics at a time of serious and persistent financial difficulties. He may have shown this painting of the aqueduct in the 1876 Impressionist exhibition along with one of the pool at Marly, while in 1877 he exhibited a view of the machine.

In this painting of the aqueduct, the only one he did from nearby, Sisley was not interested in situating it in the modern, changing landscape of the region. Instead, he chose to view it from a road as old as the aqueduct itself. He included only a solitary horseman, a member of the local militia, with no sign of tourists or pleasure seekers. He embedded the aqueduct in the natural landscape, enmeshing it in a network of unifying analogies and relationships. It fits tightly into the firmly interlocking compositional structure of broad, curving, horizontal bands; steeply raked diagonals; and irregular vertical punctuations. It emerges from a dense screen of trees whose rising diagonal it appears to extend, while seamlessly shifting directions in space—projecting rather than receding. The line of the aqueduct is parallelled by the streaky clouds and is freely echoed in the thin shadows on the road cast by trees outside the picture and in the low wall and bushes crossing the grassy slope. A loose scheme of rhymes and analogies relates the aqueduct's tall arched openings to the profiled shapes of the trees, bushes, and clouds. The closely coordinated color, consisting of a narrow range of related hues repeated, varied, and mixed, evokes the unifying effect of a warm, bright, even light and a transparent atmosphere. The supple brushwork, varied to suggest features and textures, creates a delicate vibration and shimmer across the elements of the scene.

Like Corot, one of his early models, Sisley harmonized the huge structure with the modest surrounding landscape. He thus neatly consolidated the built and the natural and tied this relic of the royal past into the continuous life of nature. In doing so, he may have quietly, if perhaps unintentionally, raised questions of history and politics in the unstable climate of France after its defeat in the Franco-Prussian War. By integrating something so imbued with historic memories into the fabric of the landscape, Sisley may have seemed to signify its unity with the fundamental, enduring, and "natural" identity of France itself. But his stance is not at all clear, and ideology and representation may be joined here in no easier a relationship than they were so often for other, more politically committed artists (see nos. 42, 68, and 75). Indeed, his serenely radiant image may express no other concern than to celebrate the impressive sights, gentle beauty, and graceful harmony of *la douce France*.

Oil on canvas, 21⅜ × 32 inches (54.3 × 81.3 cm)

The Toledo Museum of Art 51.371

Gift of Edward Drummond Libbey

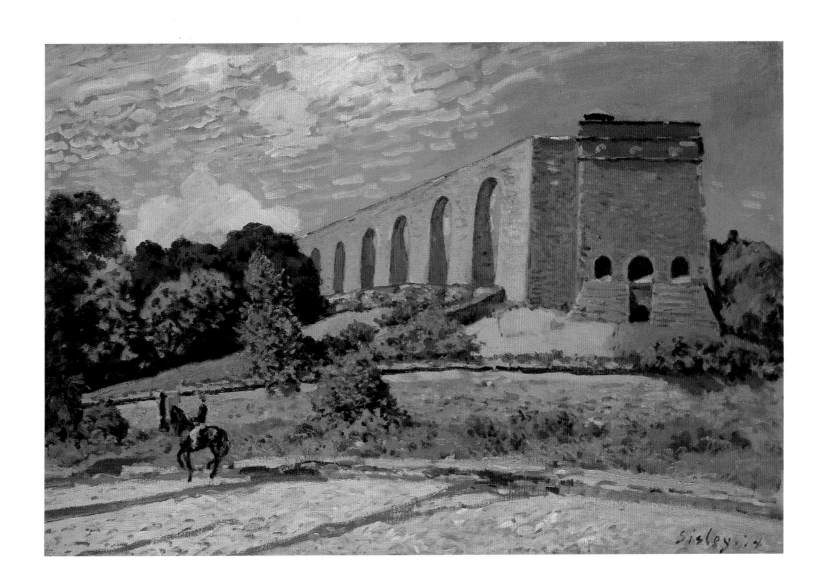

83 *View of Saint-Mammès*

c. 1880–81

In 1880 Sisley moved from the area west of Paris where he had lived and worked since 1871 (see no. 82). He settled in the vicinity of Moret-sur-Loing, forty miles southeast of Paris and just south of the Forest of Fontainebleau, where he was to remain for the rest of his life. He relocated, in good part, for reasons of economy, but also, like Monet in his departure from Argenteuil, from a desire to go farther out into the country, away from the increasingly suburbanized region around Paris. Sisley's move was also, perhaps, symptomatic of his break with the Impressionist group, which had already led to his unsuccessful attempt to return to the Salon in 1879.

He found the landscape around Moret full of attractive motifs for painting and even wrote to Monet, at a time when that artist was considering another move, to recommend the area for its picturesque aspects. During the early 1880s Sisley returned regularly to the village of Saint-Mammès just to the north of Moret, located at the confluence of the Seine and Loing rivers. Its location gave it its significance as a stopping place for river traffic. Although it was a rather drab and unexceptional rural village, Sisley nevertheless painted many views of it from all directions, under different effects of light, atmosphere, weather, and season.

In about half a dozen canvases done during his first year or two in the region, he recorded the view of Saint-Mammès from the opposite bank of the Seine from a variety of vantages up and downstream and under somewhat varying light and atmospheric conditions. For the Carnegie painting he stood almost directly facing the village, looking across the densely reeded bank and narrow expanse of water toward a few scattered boats, the clustered houses with a sawmill to the right, and the open country beyond.

The simple composition he used here was of a type he had favored from the early 1870s: a broad panorama with low horizon, expansive sky, open foreground, and the main motif in a narrow strip of middle distance. Here the arrangement neatly divides the picture in half along the line of the roofs, which is in turn loosely echoed in the bank of reeds. The broad, contrasting bands of water, ground, and sky are simultaneously set in succession into depth and stacked flatly up the picture surface. The composition is open and dispersed, and lacks any strikingly picturesque features to dominate or give focus to the spacious view. Instead, the scene is enlivened and unified by brushwork and color.

Since the mid-1870s Sisley's handling, like Monet's and Pissarro's, had become livelier, more flexible and intricate. Through it, he established more insistent and continuous patterns and rhythms. But, more than theirs, Sisley's remained essentially descriptive and responded to the varied features and textures of the motif. Here the brushwork is thin and cursive for the reeds, shorter and more blended for the water, thick and angular for the houses, soft and wispy for the sky. In the late 1870s Sisley also strengthened his color, as did Monet and Renoir, using richer, bolder, more intense hues, which are, as a result, more exaggerated and less naturalistic. Color still works here to describe and differentiate, and to evoke subtle variations of atmospheric light through modulations and contrasts. The cool, rich palette of luminous blues, deep purples, and dark greens, only weakly warmed by scattered accents of pinkish oranges and yellowish greens, also establishes a nuanced harmony, which integrates the scene into a unified chromatic composition. But this sumptuous color, allied with the fluent brushwork, serves too to impart to the natural scene a gentle flow and shimmer expressing the continuous animation of the landscape.

Oil on canvas, 21¼ × 29 inches (54 × 73.7 cm)
The Carnegie Museum of Art 99.7
Purchase

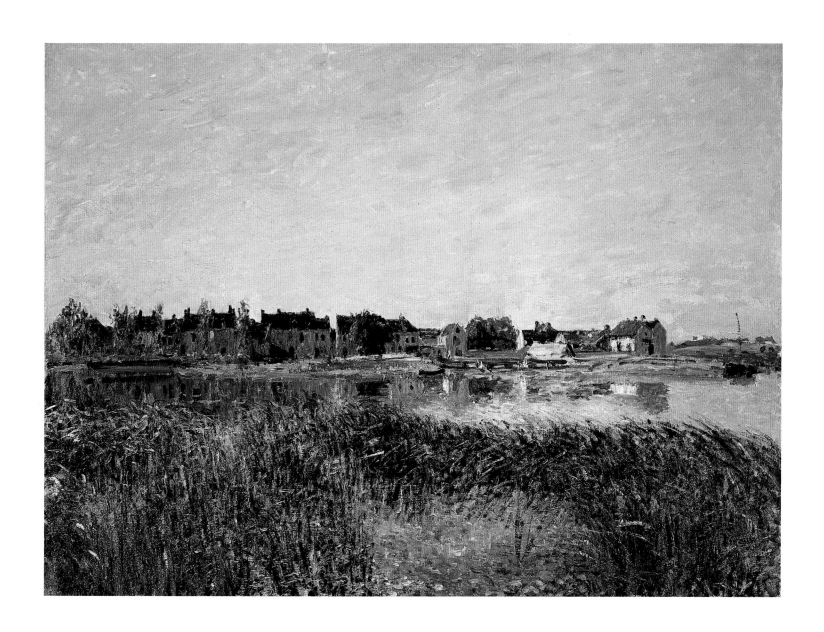

84

Portrait of Dr. Henri Bourges

Cafés, dancehalls, theaters, circuses, and brothels—the nightlife of Paris—were Lautrec's principal subjects, but portraits occupied a significant place in his work as well, one larger than for any other artist of note of his time. As he was well supported by his aristocratic family and thus had no worries about selling, he chose to do portraits of his intimate circle of friends, relatives, and favored models, and only rarely took on portrait commissions. He reportedly quipped: "I don't do portraits either of dogs or people. I paint my friends." In this commitment to portraiture, as well as in the pictorial strategies he employed, he was close to Degas, his idol among living artists. In his portraits, Lautrec extended Degas's Naturalist ideas, seeking to capture the distinctive attitudes, gestures, and expressions of his sitters and to locate each in a setting that could suggest something of his or her character, profession, or interests (see nos. 15–17).

Here Lautrec portrayed Dr. Henri Bourges, a lifelong friend with whom he shared an apartment in Paris from 1887 until 1894, moving out reluctantly only after Bourges had married. He placed him just inside the doorway to his studio (located a few blocks away from their lodgings), beside a Japanese hanging scroll and a stack of portfolios or canvases, thus situating him in his relationship to the artist.

The portrait of Bourges was one of a group of six Lautrec did of male friends and relations in the early months of 1891. In them he took up an idea he had tried out three years earlier—one he seems to have borrowed from Degas—depicting in each an impeccably attired, dandy-ish gentleman, shown full length, informally posed in a corner of his studio. He wrote to his mother in about February 1891, reporting, "I'm busy with my exhibition, with three portraits in the works: Gaston [Bonnefoy], Louis [Pascal], and Bourges." He exhibited these three, along with one other from the same group, in the Salon des Indépendants in late March 1891. In them he varied the pose, costume, angle of view, and format (in one cutting the figure off at the knees), while keeping the color scheme and the essentials of the setting constant, thereby bringing out, in quasi-serial fashion, subtle distinctions of personality among them.

The actions he represented are trivial and carry suggestions of the fleeting and insignificant events of everyday life. Here he showed a momentary, if static, situation in which Bourges, on his way out after a visit, pulls on his gloves. A certain liveliness is expressed by the cursive and fluent drawing—especially of his crisply elegant silhouette—by the loosely streaked handling and summary rendering of the surroundings, and by the angled view and raked space. The image looks deceptively casual, but was studiously contrived to concentrate attention on the figure: the soft colors and sketchy surroundings set him off, and the repeated tall rectangles enframe and echo his form.

The critic André Rivoire recalled in an obituary article in 1901 that Lautrec "never painted a portrait without having thought about it for months, sometimes years, without having lived in actual daily contact with his model. . . . But the actual execution . . . was rapid. Two or three sittings, sometimes only one, were enough for him. . . . And all of these portraits are manifestly true, even without knowing the models." Yet for all that Lautrec's study of Dr. Bourges may convey of his friend's character, the dispassionate depiction withholds from him, as from so much else he represented, any real and convincing sense of intimacy, warmth, or significance.

Oil on cardboard mounted on wood panel, 31 × 19⅞ inches (78.7 × 50.5 cm)

The Carnegie Museum of Art 66.5

Acquired through the generosity of the Sarah Mellon Scaife family

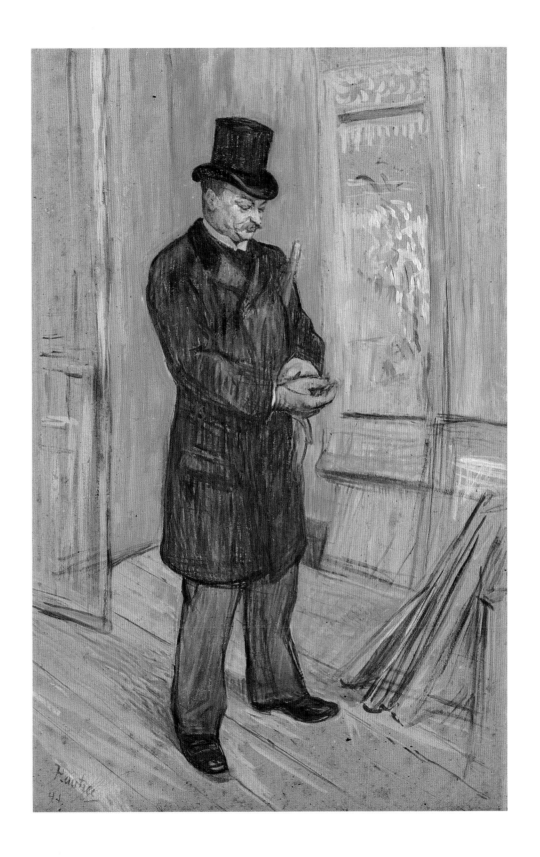

85 *The Art Dealers* (*The Bernheim Brothers*)

c. 1908

Vuillard's favored theme was intimate domestic scenes, largely peopled by his family and close friends. After 1900 he continued to depict this world, but also painted a broader range of portrait subjects coming both from the widening social circles he now frequented and from the increasing number of portrait commissions he received. In this double portrait, traditionally dated to 1908, he recorded Gaston and Josse Bernheim, then his principal dealers, at work in their gallery. At back, Josse is seated at his desk absorbed in his papers, while Gaston is casually perched on the arm of a chair, he and the picture lights next to him seemingly poised in readiness for the next client. Gaston's long, sharp-featured face and angular, animated silhouette give him a sly, predatory look that verges on satire. Between them, another figure examines a framed painting, which largely hides him from view.

Vuillard enmeshed the figures in their surroundings, making the image as much situation and scene as portrait. His ideas about portraiture were somewhat akin to those of Degas (see nos. 15–17), an artist for whom he felt a growing admiration after 1900. He sought to reveal his sitters' personalities through the depiction of unguarded and habitual attitudes and gestures, and to identify and explain their character, profession, and interests by an appropriate and meaningful setting.

The Bernheim family had been in the art trade since the eighteenth century, and the brothers' gallery, Bernheim-Jeune, had been founded by their father, who had turned the business over to them by 1900. Bernheim-Jeune was among the largest and most prestigious Paris galleries, achieving its success by a mix of popular Salon artists, the Impressionists (of whom their stock was second only to Durand-Ruel's), and established modern masters. They rarely handled little-known artists and had taken up Vuillard only in 1899, after he had exhibited for nearly ten years. They gave him the first of a series of solo shows in 1903 and, until 1914, regularly bought and showed his work. They were responsible, in large measure, for the commercial success and financial security he enjoyed after 1900.

The Bernheim brothers were not only his dealers, but also his patrons and friends. They socialized with him and commissioned, together or separately, portraits of their wives and children and a decoration for their summer residence in Normandy. This double portrait may well have been the result of such a commission, as Vuillard took a good deal of care with it. The Saint Louis painting was not the end product, but rather the full compositional study for the finished version that he dedicated and delivered to the sitters. Like Bonnard, his friend and colleague (see no. 2), Vuillard grounded his art in observation, but he worked from memory prompted by drawings and studies, and seldom painted directly from his subject.

The finished portrait of the Bernheim brothers (Marion Koogler McNay Art Museum, San Antonio) differs in many small ways from this developed study. The format is narrower, cutting the composition off along Josse's shoulder and Gaston's outstretched foot. While not as highly finished as other, more formal portraits Vuillard did at this time, the light effects and space are more carefully defined than in the study, the modelling more complete, and the figures, surrounding objects, interior architecture, and window view more elaborately described. Although still somewhat sketchy, the brushwork in the final painting is less bold and animated, and is instead geared more to delineating shapes and details. The third figure was eliminated, and both brothers were treated more respectfully, with less sense of witty commentary on the picture trade and somewhat more of routine, daily business.

Vuillard portrayed the Bernheim brothers again in 1912 in a large painting executed in the more formal style he used for his portrait commissions from about 1905. Carefully and elaborately rendered, with great attention to detail, this later image is staid and dignified, lacking altogether the informality, intimacy, and humor that Vuillard had affectionately bestowed on them a few years earlier.

Oil on canvas, 28^{13}/$_{16}$ × 26 inches (73.2 × 66 cm)

The Saint Louis Art Museum 66:1953

Gift of Mr. and Mrs. Richard K. Weil

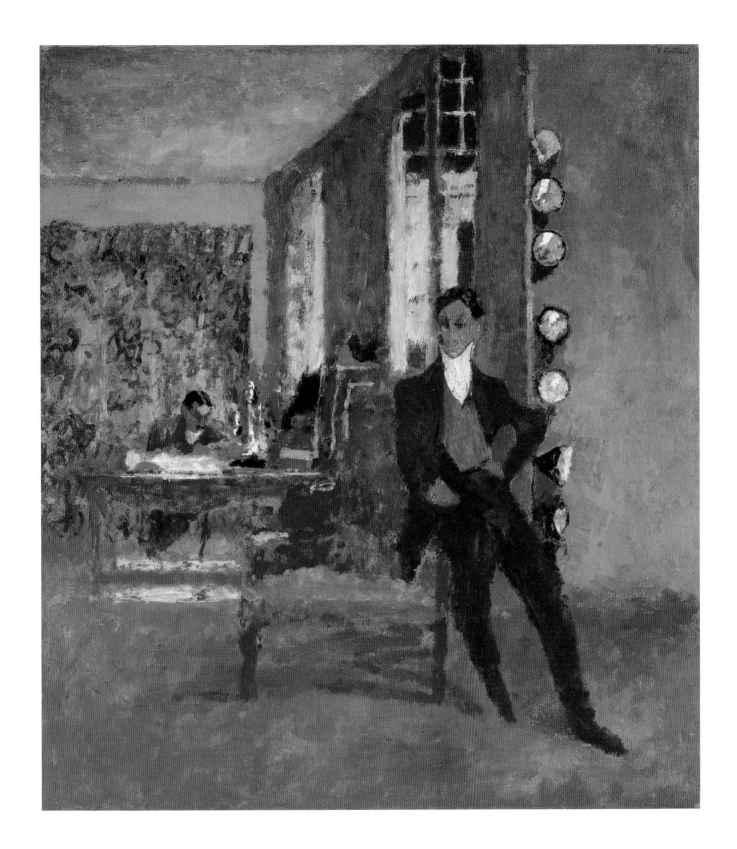

Further Reading

This selected bibliography offers suggestions for further reading about Impressionism and Post-Impressionism. The citations are chiefly of English-language publications, most of which have been published in recent years.

General

Callen, Anthea. *Techniques of the Impressionists*. London, 1982.

Clark, Timothy J. *The Painting of Modern Life: Paris in the Art of Manet and His Followers*. New York, 1985.

The Crisis of Impressionism, 1878–1882, exh. cat. Joel Isaacson. Ann Arbor, The University of Michigan Museum of Art, 1979.

A Day in the Country: Impressionism and the French Landscape, exh. cat. Richard R. Brettell et al. Los Angeles County Museum of Art, 1984.

Garb, Tamar. *Women Impressionists*. New York, 1986.

Goldwater, Robert. *Symbolism*. New York, 1979.

Hamilton, George Heard. *Painting and Sculpture in Europe, 1880–1940*. 3rd ed. Baltimore, 1981.

Herbert, Robert L. *Impressionism: Art, Leisure, and Parisian Society*. New Haven, 1988.

House, John. *Impressionist Masterpieces: National Gallery of Art, Washington*. New York, 1985.

Impressionism: A Centenary Exhibition, exh. cat. New York, The Metropolitan Museum of Art, 1974.

Impressionism: Its Masters, Its Precursors, and Its Influence in Britain, exh. cat. John House. London, Royal Academy of Arts, 1974.

Impressionist and Post-Impressionist Masterpieces: The Courtauld Collection, exh. cat. John House et al. Washington, D.C., International Exhibitions Foundation, 1987.

Isaacson, Joel. "Impressionism and Journalistic Illustration." *Arts* 56 (June 1982), 95–115.

Loevgren, Sven. *The Genesis of Modernism: Seurat, Gauguin, van Gogh, and French Symbolism in the 1880's*. Rev. ed. Bloomington, Ind., 1971.

Manet and Modern Paris, exh. cat. Theodore Reff. Washington, D.C., National Gallery of Art, 1982.

Neo-Impressionism, exh. cat. Robert L. Herbert. New York, Solomon R. Guggenheim Museum, 1968.

The New Painting: Impressionism, 1874–1886, exh. cat. Charles S. Moffett, ed. The Fine Arts Museums of San Francisco, 1986.

Nochlin, Linda. *Realism*. Baltimore, 1971.

Pool, Phoebe. *Impressionism*. New York, 1967.

Post-Impressionism: Cross-Currents in European Painting, exh. cat. John House, MaryAnne Stevens, et al. London, Royal Academy of Arts, 1979.

The Realist Tradition: French Painting and Drawing, 1830–1900, exh. cat. Gabriel P. Weisberg et al. The Cleveland Museum of Art, 1980.

Rewald, John. *The History of Impressionism*. 4th rev. ed. New York, 1973.

———. *Post-Impressionism*. 3rd rev. ed. New York, 1978.

Rosenblum, Robert, and H. W. Janson. *Nineteenth-Century Art*. New York, 1984.

Roskill, Mark. *Van Gogh, Gauguin, and the Impressionist Circle*. Greenwich, Conn., 1970.

Sutter, Jean, ed. *The Neo-Impressionists*. Greenwich, Conn., 1970.

Thomson, Belinda. *The Post-Impressionists*. London, 1983.

Van Gogh à Paris, exh. cat. Bogomila Welsh-Ovcharov. Paris, Musée d'Orsay, 1988.

Varnedoe, Kirk. "The Artifice of Candor: Impressionism and Photography Reconsidered." *Art in America* 68 (January 1980), 66–78.

———. "The Ideology of Time: Degas and Photography." *Art in America* 68 (June 1980), 96–110.

Vincent van Gogh and the Birth of Cloisonism, exh. cat. Bogomila Welsh-Ovcharov. Toronto, Art Gallery of Ontario, 1981.

Visions of City and Country: Prints and Photographs of Nineteenth-Century France, exh. cat. Bonnie L. Grad and Timothy A. Riggs. Worcester Art Museum, 1982.

Bazille

Daulte, François. *Frédéric Bazille et son temps*. Geneva, 1952.

Frédéric Bazille and Early Impressionism, exh. cat. J. Patrice Marandel et al. The Art Institute of Chicago, 1978.

Bonnard

Bonnard and His Environment. New York, The Museum of Modern Art, 1964.

Bonnard: The Late Paintings, exh. cat. Sasha M. Newman, ed. Washington, D.C., The Phillips Collection, 1984.

Dauberville, Jean and Henry. *Bonnard: Catalogue raisonné de l'oeuvre peint*. 4 vols. Paris, 1965–74.

Pierre Bonnard, exh. cat. John Rewald. New York, The Museum of Modern Art, 1948.

Boudin

Boudin: Aquarelles et pastels, exh. cat. Lise Duclaux and Geneviève Monnier. Paris, Musée du Louvre, 1965.

Jean-Aubry, Georges. *Eugène Boudin*. Trans. Caroline Tisdall. Greenwich, Conn., 1969.

Schmit, Robert. *Eugène Boudin, 1824–1898*. 3 vols. Paris, 1973.

Caillebotte

Berhaut, Marie. *Caillebotte, sa vie et son oeuvre: Catalogue raisonné des peintures et pastels*. Paris, 1978.

Varnedoe, Kirk. *Gustave Caillebotte*. New Haven, 1987.

Cassatt

Breeskin, Adelyn D. *Mary Cassatt: A Catalogue Raisonné of the Oils, Pastels, Watercolors, and Drawings*. Washington, D.C., 1970.

Mathews, Nancy Mowll. *Mary Cassatt*. New York, 1987.

Pollock, Griselda. *Mary Cassatt*. London, 1980.

Cézanne

Cézanne: The Late Work, exh. cat. William Rubin, ed. New York, The Museum of Modern Art, 1977.

Chappuis, Adrien. *The Drawings of Paul Cézanne: A Catalogue Raisonné*. 2 vols. Greenwich, Conn., 1973.

Rewald, John. *Cézanne: A Biography*. New York, 1986.

———. *Paul Cézanne: The Watercolors*. Boston, 1983.

Schapiro, Meyer. *Paul Cézanne*. New York, 1952.

Shiff, Richard. *Cézanne and the End of Impressionism*. Chicago, 1984.

Venturi, Lionello. *Cézanne, son art—son oeuvre*. 2 vols. Paris, 1936.

Degas

Boggs, Jean Sutherland. *Portraits by Degas*. Berkeley, 1962.

Brame, Philippe, and Theodore Reff. *Degas et son oeuvre: A Supplement*. New York, 1984.

Degas, exh. cat. Jean Sutherland Boggs, ed. New York, The Metropolitan Museum of Art, 1988.

Degas 1879, exh. cat. Ronald Pickvance. Edinburgh, National Gallery of Scotland, 1979.

Degas in the Art Institute of Chicago, exh. cat. Richard R. Brettell and Suzanne Folds McCullagh. The Art Institute of Chicago, 1984.

Degas: The Dancers, exh. cat. George T. M. Shackelford. Washington, D.C., National Gallery of Art, 1984.

Lemoisne, Paul-André. *Degas et son oeuvre*. 4 vols. Paris, 1946–49.

Lipton, Eunice. *Looking into Degas: Uneasy Images of Women and Modern Life*. Berkeley, 1986.

Millard, Charles W. *The Sculpture of Edgar Degas*. Princeton, 1976.

The Private Degas, exh. cat. Richard Thomson. London, Arts Council of Great Britain, 1987.

Reff, Theodore. *Degas: The Artist's Mind*. New York, 1976.

Rewald, John. *Degas: Sculpture, The Complete Works*. New York, 1956.

Thomson, Richard. *Degas: The Nudes*. New York, 1988.

Gauguin

The Art of Paul Gauguin, exh. cat. Washington, D.C., National Gallery of Art, 1988.

Field, Richard S. *Paul Gauguin: The Paintings of the First Voyage to Tahiti*. New York, 1977.

Goldwater, Robert. *Paul Gauguin*. New York, 1957.

Hoog, Michel. *Paul Gauguin: Life and Work*. Trans. Constance Devanthéry-Lewis. New York, 1987.

Thomson, Belinda. *Gauguin*. New York, 1987.

Wildenstein, Georges, and Raymond Cogniat. *Paul Gauguin*. Vol 1. *Catalogue*. Paris, 1964.

Van Gogh

Faille, Jacob Baart de la. *The Works of Vincent van Gogh: His Paintings and Drawings*. Amsterdam, 1970.

Hulsker, Jan. *The Complete van Gogh: Paintings, Drawings, Sketches*. New York, 1980.

Pollock, Griselda, and Fred Orton. *Vincent van Gogh: Artist of His Time*. New York, 1978.

Schapiro, Meyer. *Vincent van Gogh*. New York, 1950.

Van Gogh in Arles, exh. cat. Ronald Pickvance. New York, The Metropolitan Museum of Art, 1984.

Van Gogh in Saint-Rémy and Auvers, exh. cat. Ronald Pickvance. New York, The Metropolitan Museum of Art, 1986.

Vincent van Gogh, exh. cat. Tokyo, National Museum of Western Art, 1985.

Jongkind

Hefting, Victorine. *Jongkind, sa vie, son oeuvre*. Paris, 1975.

Jongkind and the Pre-Impressionists, exh. cat. Charles C. Cunningham et al. Northampton, Mass., Smith College Museum of Art, 1976.

Luce

Bouin-Luce, Jean, and Denise Bazetoux. *Maximilien Luce: Catalogue raisonné de l'oeuvre peint*. 2 vols. Paris, 1986.

Cazeau, Philippe. *Maximilien Luce*. Lausanne, 1982.

Verneilh, Béatrice de. "Maximilien Luce et Notre-Dame-de-Paris." *L'Oeil*, no. 332 (March 1983), 24–31.

Manet

Adler, Kathleen. *Manet*. Oxford, 1986.

Edouard Manet, exh. cat. Charles F. Stuckey et al. Tokyo, Isetan Museum of Art, 1986.

Hamilton, George Heard. *Manet and His Critics*. New Haven, 1954.

Hanson, Anne Coffin. *Manet and the Modern Tradition*. New Haven, 1977.

Manet, 1832–1883, exh. cat. New York, The Metropolitan Museum of Art, 1983.

Rouart, Denis, and Daniel Wildenstein. *Edouard Manet: Catalogue raisonné*. 2 vols. Lausanne, 1975.

Monet

Gordon, Robert, and Andrew Forge. *Monet*. New York, 1983.

House, John. *Monet: Nature into Art*. New Haven, 1986.

Isaacson, Joel. *Claude Monet: Observation and Reflection*. New York, 1978.

Seiberling, Grace. *Monet's Series*. New York, 1981.

Stuckey, Charles F. "Blossoms and Blunders: Monet and the State, II." *Art in America* 67 (September 1979), 109–125.

Stuckey, Charles F., and Robert Gordon. "Blossoms and Blunders: Monet and the State, I." *Art in America* 67 (January–February 1979), 102–117.

Tucker, Paul Hayes. *Monet at Argenteuil*. New Haven, 1982.

Wildenstein, Daniel. *Claude Monet: Biographie et catalogue raisonné*. 4 vols. Lausanne, 1974–85.

Morisot

Adler, Kathleen, and Tamar Garb. *Berthe Morisot*. Ithaca, 1987.

Bataille, Marie-Louise, and Georges Wildenstein. *Berthe Morisot: Catalogue des peintures, pastels, et aquarelles*. Paris, 1961.

Berthe Morisot—Impressionist, exh. cat. Charles F. Stuckey, William P. Scott, et al. South Hadley, Mass., Mount Holyoke College Art Museum, 1987.

Pissarro

Homage to Camille Pissarro: The Last Years, 1890–1903, exh. cat. Michael Milkovich, Martha Ward, et al. Memphis, Dixon Gallery and Gardens, 1980.

Lloyd, Christopher. *Camille Pissarro*. New York, 1981.

———, ed. *Studies on Camille Pissarro*. New York, 1986.

Pissarro, exh. cat. London, Arts Council of Great Britain, 1981.

Pissarro, Ludovic-Rodo, and Lionello Venturi. *Camille Pissarro, son art— son oeuvre*. 2 vols. Paris, 1939.

Renoir

Callen, Anthea. *Renoir*. London, 1978.

Daulte, François. *Auguste Renoir: Catalogue raisonné de l'oeuvre peint*. Vol. 1. *Figures, 1860–1890*. Lausanne, 1971.

Renoir, exh. cat. John House, Anne Distel, et al. London, Arts Council of Great Britain, 1985.

White, Barbara Ehrlich. *Renoir: His Life, Art, and Letters*. New York, 1984.

Seurat

Broude, Norma, ed. *Seurat in Perspective*. Englewood Cliffs, N.J., 1978.

Dorra, Henri, and John Rewald. *Seurat: L'Oeuvre peint, biographie et catalogue critique*. Paris, 1959.

Hauke, César M. de. *Seurat et son oeuvre*. 2 vols. Paris, 1961.

Homer, William I. *Seurat and the Science of Painting*. Cambridge, Mass., 1964.

Thomson, Richard. *Seurat*. Salem, N.H., 1985.

Signac

Cachin, Françoise. *Paul Signac*. Trans. Michael Bullock. Greenwich, Conn., 1971.

Signac, exh. cat. Marie-Thérèse Lemoyne de Forges. Paris, Musée du Louvre, 1963.

Sisley

Alfred Sisley, exh. cat. Christopher Lloyd. Tokyo, Isetan Museum of Art, 1985.

Daulte, François. *Alfred Sisley: Catalogue raisonné de l'oeuvre peint*. Lausanne, 1959.

Shone, Richard. *Sisley*. New York, 1979.

Toulouse-Lautrec

Adriani, Götz. *Toulouse-Lautrec*. Trans. Sebastian Wormell. New York, 1987.

Dortu, M.-G. *Toulouse-Lautrec et son oeuvre*. 6 vols. New York, 1971.

Thomson, Richard. *Toulouse-Lautrec*. New York, 1977.

Toulouse-Lautrec: Paintings, exh. cat. Charles F. Stuckey with Naomi Maurer. The Art Institute of Chicago, 1979.

Vuillard

Edouard Vuillard, 1868–1940, exh. cat. John Russell. Toronto, Art Gallery of Ontario, 1971.

Preston, Stuart. *Vuillard*. New York, 1972.

Thomson, Belinda. *Vuillard*. New York, 1988.

Index

This index includes personal names, place names, subjects, and concepts covered in the text. Works of art are listed after the name of the artist. Museums and other collections are listed by city.